The
Arturo Alfandari
Collection

The **phoenix** is an ancient symbol
of the eternal creative spirit.

PAINTING IN RENAISSANCE FLORENCE

1500–1550

David Franklin

PAINTING IN RENAISSANCE FLORENCE

1500–1550

YALE UNIVERSITY PRESS

New Haven & London

For Claudette and Gordon, my parents

Designed by Gillian Malpass

Printed in Singapore

Library of Congress Cataloging-in-Publication Data

Franklin, David, 1961–
Painting in Renaissance Florence, 1500–1550 / by David Franklin.
p. cm.
Includes bibliographical references and index.
ISBN 0-300-08399-8 (cloth : alk. paper)
1. Painting, Italian – Italy – Florence – 16th century. I. Title.
ND621.F7 F725 2001
759.5′51′09031 – dc21 2001033328

A catalogue record for this book is available from
The British Library

Frontispiece Pontormo, *Holy Family with Saints* (detail),
Florence, S. Michele Visdomini

Page i Pontormo, *Joseph with Jacob in Egypt* (detail),
London, National Gallery

CONTENTS

ACKNOWLEDGEMENTS

IN THE COURSE OF WRITING THIS BOOK I have accumulated far too many individual debts to enumerate them here. For their support I am grateful, above all, to the Warden and Fellows of All Souls College, Oxford, where I was fortunate enough to be a post-doctoral research fellow from 1994 to 1998. Only in that uniquely creative environment could I have conceived this text. The seeds of the book were planted at Lincoln College, Oxford, and I thank the Fellows for their encouragement. This book is based on lectures given for the now defunct Diploma course in art history in Oxford, and I thank profoundly, and with sincere humility, the late Professor Francis Haskell for trusting me to teach as part of such a distinguished programme. I should like also to thank my students at Oxford for always challenging me and for encouraging me to publish a version of some of my lectures. It is not meant to be unfair to the rest to single out for special mention – for their particular help – Rebecca Daniels, Minna Moore Ede, Dennis Geronimus, Blake Gopnik, Richard Reed, Ben Thomas, Claire Van Cleave and Fiona Whitehouse.

I should like also to pay respect here to those I regard as my most important teachers: Lorne Campbell, Caroline Elam, Michael Hirst and Pat Rubin. In Oxford I also benefited from many conversations with Diego Gambetta, George Holmes and Gervase Rosser. In Florence I received much individual assistance from Elena Fumagalli, Alessandra Giovannetti, Antonio Natali and Louis Waldman. In Ottawa I should like to credit Colin Bailey for encouraging me to fine-tune the text despite the pressures of a new position, as well as the Director of the National Gallery of Canada, Pierre Théberge, for his beneficence. David Ekserdjian and Nicholas Penny kindly read drafts of the entire book and made many pertinent comments. My editor, Gillian Malpass, has again been tirelessly patient and supportive. My greatest, inexpressible debt, however, is to Antonia Reiner who read every word more than once and supplied translations of the sources, not otherwise credited. I also thank our son, Thomas, whose impatience to get to far more interesting reading material has pushed me more than any editor could to complete the book.

INTRODUCTION

ACCORDING TO THE STANDARD VIEW, the High Renaissance style of painting formed, matured and peaked between about 1480 with the rise of Leonardo da Vinci and 1520 with the death of Raphael. This movement was born in Tuscany and in particular Florence – where Leonardo, Michelangelo, Raphael, Fra Bartolomeo and Andrea del Sarto have been identified as the main protagonists – even if its history was to unravel in Rome. The briefly flourishing High Renaissance surpassed the Quattrocento style of Verrocchio, Domenico Ghirlandaio and others, while it was itself eclipsed by another style now usually called Mannerism. Indeed, the High Renaissance could not exist without its Mannerist nemesis. The notion of a normative or 'classical' High Renaissance has proved irresistible as a foil to definitions of that compound known in varying guises as Mannerism, first as a period of spiritual anxiety and, more recently, as one of intensive formal sophistication. Yet while modern definitions of Mannerism have been increasingly debated, discredited, modified and even completely rejected, that of the High Renaissance, and the prestige attached to it, remains curiously intact. Borges's comment about fame being the worst type of incomprehension comes to mind here. The purpose of this book, then, is to examine the basis of this term of style in painting by analysing individual works, which in turn should alter what might possibly be meant by the Mannerist period, while providing a speculative, critical introduction to some of the best-known of all Italian painters.

Despite widespread usage of the terms, few surveys treating both the High Renaissance and Mannerism equally have been undertaken. Yet there are good reasons for believing that the half-century in Florence from 1500 to 1550 is best approached in its entirety and that, inevitably, focusing studies on either term produces distortions. One of these is the fixation with apparent watershed dates like 1520, with little justification. The need to find a strict break between these two periods can be justifiably resisted, and the spurious opposition between them undermined. A survey of Sarto's development, for example, suggests that, even accepting their basic validity, the two terms might be reversible in one instance. The *maniera moderna* of Giorgio Vasari, who is, after all, the main published source for this age, loosely groups together artists from Leonardo to Francesco Salviati, and so his term is too general to account for any of the significant differences that the author himself fully recognized.

In the end, two terms seem too few, so many are the variants within the span from 1500 to 1550. Over a century distinguished by a number of individual *maniere*, the issue of labelling is now for some irrelevant. This is a position with which one could have much sympathy, were it not for the realization that figures like Leonardo and Michelangelo were unusually quickly, if not immediately, perceived to have created images of a beauty and stature never before seen. To appreciate the nature of their innovation during a transitional period remains the first imperative for anyone interested in sixteenth-century art, for it is at this chronological moment in Florence around 1500 that a new conception of art can be defended as having fully taken root. Notions of intentional progress and artistic value are not, therefore, imposed on the material. Nevertheless, the overall concern here will be to promote heterogeneity, not linearity, by isolating artistic strands rather than to argue for general historical trends of an indefensibly loose and monolithic nature. Indeed, it is as well to state at the outset that no alternative terms will be presented, respecting the belief that such terms by their very nature create rigid and undesirable distinctions by forcing total unity on a period, while implicitly rejecting contradictory alternatives and orientations. For the first half of the sixteenth century in particular there is an overriding need to recover what has been underestimated or ignored precisely because of stereotypical style terms. Broadly speaking, it may be possible to form the painters into two groups, one filled with the innovators of heterogeneous styles who were mainly preoccupied with the complexities of process (and were more than willing to challenge patrons, not to mention sometimes the very notion of what constituted a finished work). The other group comprised more respectful and complacent

artists of homogeneous and artificial styles, who were inclined to repeat themselves with preset formal solutions. The publication of Vasari's first edition of the *Lives of the Artists* in 1550 provides a natural conclusion to this study, because its appearance completely altered art history, both as practice and as subject. Like the date of 1500, 1550 was one after which the history of Italian art was irrevocably changed.

The sources yield little support for analysing the period after 1500 in Florence according to the narrowly defined classical High Renaissance inherited from various critics. This endlessly perpetuated term of convenience is especially partial to artists like Raphael of his Florentine period and Fra Bartolomeo, whose painting has a dry monumentality and serial nature closer in spirit to the increasingly redundant Pietro Perugino than any model that can be extrapolated from Leonardo's example. Bringing the retrograde art of Ridolfo Ghirlandaio back into the mainstream supports the notion that many of the qualities which have been assumed to form the High Renaissance style are more accurately approached as a local form of entrenched conservatism, with which Raphael was very comfortable but out of which he attempted to develop while in Florence. This view will have implications for how Mannerism, and with it fairly subjective concepts of eccentricity, might be understood, for there was no normative High Renaissance for the artists so labelled to contradict. If there was an orthodoxy it was best represented by the Umbrian Perugino and among Florentines Ridolfo and to some degree Fra Bartolomeo, but how their styles could be considered 'classical' in any very specific sense is most problematic, since the formal balance and unity of their work was largely the result of a repetitive working practice, rather than a distillation of qualities from ancient art – without even entering into the semantic problem of the term 'classical', which is itself a nineteenth-century construct. Leonardo and Michelangelo were just as critical of a Peruginesque 'classicism' as nearly every other younger Florentine artist. So, if the 'eccentrics' cannot seriously be defined in relation to that standard either, how can they be analysed?

Whatever their differences in characterizing the term, Mannerism, which some still view as the dominant style in Italy from about 1510–20 until as late as 1600, has provided all scholars with a convenient dialectic between the commonplace notion of a canonical High Renaissance art that is apparently rational, coherent, resolved, clear and so on, and the opposites of these qualities sought and found in so-called Mannerist art, such as discordant, introspective, subjective, antagonistic, self-conscious, instinctive or referential. But if we accept that the received assessment of the High Renaissance is doubtful, such a neat binary equation breaks down. This, in turn, has ramifications for which artists might be judged

to constitute the High Renaissance canon and, ultimately, for our assessment of Mannerist art as a fully autonomous style. Even before questioning the validity of these two terms with such different literary origins – one a purely modern construct and the other derived from a word occurring in various ways in the period itself – it certainly remains pertinent to consider on visual grounds alone how an image like Michelangelo's Doni Tondo might possibly be classed with a more restrained domestic painting by Fra Bartolomeo. Without deep qualification, it seems difficult to retain any work of Michelangelo and Leonardo in the High Renaissance according to received definitions of that term, but how at the same time can the basic stylistic incompatibility of these two artists be negotiated? Looking ahead to following generations, how Pontormo and Vasari can be grouped under the same umbrella term seems equally problematic, given that the latter artist took so much from recent Roman models which could be at odds with the traditionally Florentine ones favoured by the former.

It thus appears that there is good reason to overcome the restrictions imposed by increasingly agile and ingenious efforts to legitimate that multifarious word *maniera* as it was used in the sixteenth century. The fact that the word has always had multiple meanings does not exactly make it dependable for use by historians, and an analysis of Vasari's own Life will demonstrate how it would not have occurred to anyone in the period to classify innovative art based on any development of this concept. On the contrary, it has never been denied, though not sufficiently respected, that for Vasari and other contemporaries like Lodovico Dolce writing in Venice, the word was most specifically elaborated relative to their critique of a routine art practice that produced monotonous images, such as those by Perugino, and not as a singular or positive term of style. There seems, therefore, to be a need to redefine our notions of value for Italian painting of the first half of the sixteenth century, with more focus on attitudes towards the creative process relative to particular situations, and how this affected the appearance of specific paintings.

In order to produce a new synthetic account of the period, this book will be concerned primarily with exposing as far as possible what seems essential to the artistic styles of individuals. The principal method will be that of formalist analysis informed by a close awareness of patronage and context. I do not accept that historical events like the Sack of Rome, or patrons like the Medici, could determine style in its most original manifestations, which does not mean to say that a consideration of patronage or career patterns will not influence how the appearance of any object can be interpreted. Yet even the most sophisticated Florentine patrons naturally

commissioned work from a variety of artists rather than attempting to support the innovators alone. Whether Renaissance Florence should continue to be viewed as a golden age of patronage also becomes a more complex question which cannot be fully answered here: an illustrious tradition can breed conservatism in its audience as much as a tolerance of originality. In this regard, it is notable how many of the most innovative works by Florentine Renaissance painters were produced away from the centre in regional towns for patrons of less discriminating taste. Similarly, social values relating to family pride, devotion, not to mention decoration, probably remained stable during the period. In terms of painter–patron relations, what did change most significantly after 1500 was the artist's individual attitude towards patrons when the more inspired ones came to exploit an apparently closed contractual system for their own ends, often with a resulting conflict. It is not surprising that this was the first age of consistently unfinished and rejected work. A review of Rosso's Florentine career provides the best direct examples of such instances, although Leonardo and Michelangelo supplied key precedents for this rather defiant attitude towards those who commissioned their art.

The decision to concentrate discussion here on painting might seem artificial and unfortunate, given that so much of the debate thus far concerning these two terms has already been centred on painted work – a fault that can, however, be traced back to period texts themselves. Nevertheless, while blending the different arts together can be essential and insightful – and, certainly, the development of printmaking in this period was crucial to the history of European painting in general – it also leads to vague generalizations. Specifically, one of the major sources for the misunderstanding of the High Renaissance style of painting has arisen because words such as balance and symmetry used to analyse architecture like that of Bramante have infiltrated a discussion of painting and caused distortions that have yet to be rectified, as in the misleading characterization of Fra Bartolomeo altarpieces, starting with Wölfflin in his *Classic Art* of 1898. Similarly, sculpture had an independent history in this period which has yet to be comprehensively written, with a full absorption of the primary sources.

The other decision – to concentrate largely on Florence – should not be taken as another example of Florentine-centric scholarship. The assumption here is that the gains from such a focus will compensate for any losses in not making a broader sweep. Few would deny Florence's fundamental importance, not least because of the bias of Vasari's *Lives*, and a still clearer understanding of its place should, paradoxically, help now to retrieve the undeniable significance of other parts of Italy by exposing its strong prejudices. Even though several key artists were active in both cities, Rome in particular presents different problems of interpretation and context because of the papacy. So, by isolating Florence, one of the aims of this book is to comprehend its essential differences from Rome, which are too often discussed as sister cities in accounts of this era, in part because there were Medici popes for almost two decades of the period. It is absolutely critical that Florence could *not* boast examples of Raphael as a mature public artist of real significance, and that many of the most dominant artists in Florence, including Sarto, Franciabigio, Ridolfo and Pontormo, never worked in Rome. If those later Florentine-born painters, such as Salviati and Vasari, who experienced Raphael's Roman production and, significantly, a Raphael with a burgeoning critical historiography, had an impact on Florentine art, there is a danger of projecting the Urbinate artist's genuine later influence too far back and into a city that never attracted his full attention. Despite its centrality in more recent discussions of the art of this period, there seems little explicit evidence that the sort of private domestic painting of the Holy Family that Raphael supplied with such frequency in Florence changed the face of art in that city. Such works are of greatest interest for understanding the artist's own internal development away, in fact, from more retrograde stylistic principles.

The shift of the origins of 'Mannerism' from Florence to Rome in some recent critical thinking, in contrast, has also left Florence as a subject exposed in the still important period of the 1520s onwards. Yet it manifestly did not become a backwater (Vasari himself operated there for long stretches even when executing work to be exported), and so how art developed in these later years is ripe for analysis. A review of Florentine painting in the second half of this period towards 1550 and beyond reveals Pontormo as the last great exponent of a deeply localized approach to the creative process based on excellence in drawing and design. That approach struggled to survive the impact of the art produced in Rome. If Vasari codified this attitude of Florentines in the *Lives*, he also sounded its death knell for art history because of his overriding respect for Raphael. Perhaps it is in Vasari's undermining of a particularly Florentine approach to creativity that the end of Renaissance for the history of painting should be located.

I

PERUGINO AND THE ECLIPSE OF
QUATTROCENTO MANNERISM

IN REDEFINING THE 'HIGH RENAISSANCE' in Florence, certain questions need to be addressed first. When did it begin? Who were the key protagonists? Did anyone anticipate our notions of a High Renaissance, or was the period assessed in other ways? In categorizing that time we are fortunate to have at our disposal some early literary sources pertaining to art. These should be studied first, although, as will be argued, they have important limitations and contradictions and, ultimately, do not provide support for any of the style terms currently in use. They will, however, provide some evidence for establishing a demarcation line between the fifteenth and sixteenth centuries, which remains of analytical value. The two most significant writers about the art pertaining to Central Italy in the first half of the sixteenth century were Paolo Giovio in some fragmentary biographical sketches of the 1520s[1] and Giorgio Vasari in his majestic *Lives of the Artists*, published first in 1550 and then in a revised edition in 1568.[2] Vasari's text is naturally the more important because the historian Giovio could never bring himself to complete and publish his few manuscript writings about art, so they must have been considered even by him as inadequate. Vasari was also a major artist and his shadow is cast across the full length of this study. It is in their very differently conceived texts that the origin, as well as some of the formal stylistic character of what might be taken as a more historically rooted High Renaissance emerges. By this inelegant compound it will be accepted that some sort of definite change was perceived as having occurred in the history of painting around 1500.

The apparent decline of the reputation of the Umbrian painter Pietro Perugino in Florence and of those practising cognate styles against Leonardo da Vinci's example specifically provides the background for what was most explicitly and vividly perceived by Giovio and Vasari as the qualitative differences between the best art of the late Quattrocento and that of the early Cinquecento. Few would have argued that

Perugino was not the most famous Italian artist around 1500; as Ortensio Landi wrote succinctly at mid-century, 'Maestro Pietro Perugino fu ne' suoi giorni la vaghezza del mondo.'[3] Giovio, in a Latin text probably begun before Perugino's death in 1523, also describes him in a now familiar passage as having been the most celebrated painter of the period, but supplies an important account of his downfall that is central to our concerns: 'Indeed, who has ever practised the art of painting while in his prime, with greater fame and acclaim than Perugino, who, even now, as an octogenarian, continues to paint with rather a steady hand, although no longer with glory? . . . No one, in fact, could represent the faces and countenances of divinities, and especially angels, with greater suavity and seduction . . . But after the brightest stars of perfect art, Leonardo, Michelangelo and Raphael, at once risen from centuries of darkness, they obscured his name and his fame with their marvelous work. In vain did Perugino, emulating and studying his betters, strive to preserve that degree of eminence he once held, because the sterility of his imagination always drove him to return to those pretty faces on which he had fixed since his youth; thus he could barely tolerate the shame, while the others depicted with splendid variety and in any given genre the naked limbs of majestic figures and the struggling forces of nature.'[4] Even in the 1520s Giovio could still muster praise for the charm of Perugino's placid, contemplative art and in particular for the physiognomies of his sacred figures, but, with the rise of the Leonardo, Michelangelo and Raphael triumvirate, the painter was reduced to a truly mannered style, able only to repeat the lighter, prettier features of his earlier work. For Giovio, Perugino's failure to represent the nude well and to vary his approach were the principal negative features of his predetermined later efforts.

Giovio's analysis of another non-Florentine painter, Lorenzo Costa, offers a parallel to his and what proved to be Vasari's attack on the obstinate style of Perugino: 'The

Mantuan Costa depicts with mellow colours, men of mild aspect and dignified gestures, so that it could be said that nobody surpasses him in the pleasant rendition of clothed and armed figures. However, experienced critics demand from him veiled, or even nude figures, a far greater challenge to his art, one not easily overcome by someone who has been unable to put stronger knowledge and techniques to the service of his painting, contenting himself instead with far more limited preparation.'[5] This unpublished passage reinforces and expands their set of terms for measuring the decline of a formerly revered style against the emergence of artists such as Leonardo. Like Perugino, Costa had a poised and gentle style, mildly pleasant according to Giovio's testimony, but a banal technique betraying sterile invention and, again, an inability to represent the nude were irredeemable failings. The undertone of the critique touching on the dissatisfaction of certain experts with Costa's art is significant, for it signals that by the sixteenth century there was a growing number of commentators on, collectors of and writers about art who hoped to place conceptual demands on artists as creators. In turn, many of these artists were seemingly unprepared or unwilling to accept criticism and consider their work in the larger stream of innovation stimulated by Leonardo's model. The reference to conceptual failings in Costa's approach is equally noteworthy, for it suggests that his art required greater preparation and intellectual sophistication in order to be taken seriously in a charged Central Italian context. Presumably, Leon Battista Alberti's *De Pictura*, published in 1435 (and in the vernacular in 1436), had retained its potency for artistic debates until 1500.

This general testimony introduces some written background for the single most important event for tracing the apparent shift in Florentine art of this period: the major commission from the Servites of SS. Annunziata in Florence to complete Filippino Lippi's *Deposition from the Cross* (fig. 2) after his death in 1504. Recent technical examination reveals that the Florentine finished only the men on the two ladders and that Perugino completed the rest, including the figure of Christ.[6] Perugino's contribution is brought into focus by juxtaposing what appear to be later painted versions recording Lippi's final design, with very few differences between them. One of these survives in the Metropolitan Museum in New York (fig. 1), while the other was recently on the art market with an attribution to his follower Niccolò Cartoni.[7] They demonstrate that, as would be expected, Perugino followed Lippi's underdrawing fairly closely even for those figures he had to finish. The Umbrian did, however, delete extraneous details from the picture, such as the skull and bones at the base of the Cross, and, more significantly, he overlaid Lippi's Magdalen with one of his stereotypical poses of restrained,

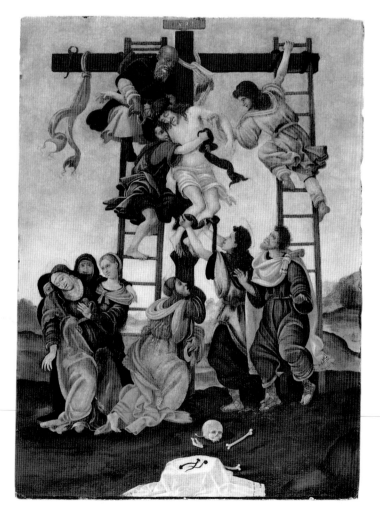

1 Workshop of Filippino Lippi, *Deposition from the Cross*, The Metropolitan Museum of Art, New York.

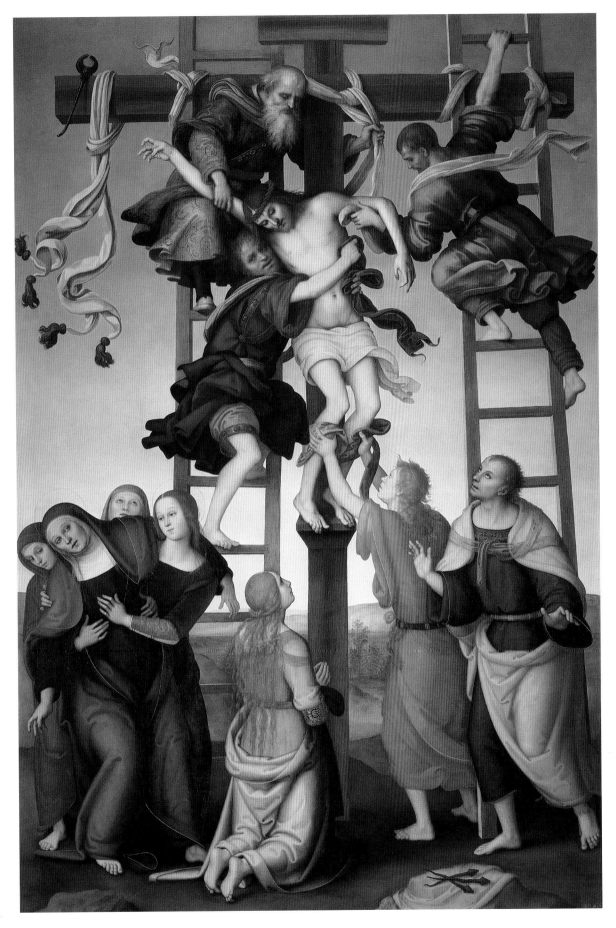

2 Filippino Lippi (completed by Pietro Perugino), *Deposition from the Cross*, Florence, Accademia.

reflective piety, in contrast with her dramatically charged embrace of the Cross as seen in the copies. Perugino also opened the Virgin's eyes as if he found the opposing treatment too specifically tense and pessimistic. Generally, this comparison reveals some essential differences in the sensibilities of a native Florentine artist compared with those of a foreign one, who was nevertheless trained there.

The project also involved the creation of another panel altarpiece, the *Assumption of the Virgin* (fig. 4), that was to form the other side of the Lippi *Deposition*, for which Perugino produced a work so bland, according to Vasari, that it was instead turned towards the choir.[8] This appears not to have been the case, since we know from the contract with the Servites that the *Assumption*, which remains on a side altar in the church, was always intended to face the choir, but it is still telling from a historical perspective that Vasari believed the story enough to commit it to print. Vasari's viewpoint here is that of an artist, not a patron who would have commissioned art from Perugino with complete knowledge and confidence in the result. The now lost framework for this altarpiece – which, appropriately enough, was the grandest ensemble of its kind in Florence in this entire period – was constructed by the distinguished local architect and wood-carver Baccio d'Agnolo following a contract of 1500.[9] For this project Perugino also painted six saints special to the Servite order and when the whole structure was installed 'it received no little censure from all the new craftsmen, particularly because Pietro had availed himself of those figures that he had been wont to use in other pictures; with which his friends twitted him, saying that he took no pains, and that he had abandoned the good method of working, either through avarice or to save time. To this Pietro would answer: "I have used the figures that you have other times praised, and which have given you infinite pleasure; if now they do not please you, and you do not praise them, what can I do?"'[10] This quotation from Vasari retains its potency for highlighting how Perugino would tolerate re-using cartoons of the figures evolved for one physical context and subject in another, and would shrewdly compose entire pictures from stock models. Originality of design for him was eventually limited to the admittedly sophisticated and ingenious exploitation of old finished drawings, while beauty was equated with pure symmetry and a type of complete, schematic refinement, which the re-use of his cartoons also encouraged.[11] With this method of Perugino, the emotional content of his paintings could only ever be affected, if superficially attractive.

It appears that following this unfortunate episode, Perugino received no more major Florentine commissions, though his workshop there remained open past 1510,[12] and he returned to the safety of his native Umbria where he worked successfully for fifteen years until his death, in at least one case granting a significant reduction to his compatriots in the sort of fee he had commanded in Florence. Naturally, his style was not suddenly reviled by every Florentine: even the *Deposition from the Cross* was taken as a model for early altarpieces by Domenico Puligo in Anghiari, Rosso Fiorentino in Volterra (fig. 138) and even Vasari (fig. 184), though artists would have known quite well that Lippi had invented it. Perugino himself attempted to become more up-to-date when, in Rome around 1508, he asked Jacopo Sansovino to make him a high relief of the same subject of the Deposition, identified with a technically complex sculpture now in the Victoria and Albert Museum in London.[13] Perugino's docile style had residual formal influence through the likes of Fra Bartolomeo and Puligo, who remained faithful to it in Florence throughout the 1510s. It deeply affected less talented locals like Bachiacca (who had probably been, along with his older brother Bartolomeo, a Perugino pupil), born in 1494.[14] Following Perugino's obstinate model, which provided a formula for the easy placement of bodies in space and for devotional expression and gesture, Bachiacca laboured to perfect forms borrowed from any number of artists, instead of dwelling much on the creative process, as is apparent even

3 Bachiacca, *Baptism of Christ with Saints*, Badia a Buggiano.

4 Perugino, *Assumption of the Virgin*, Florence, SS. Annunziata.

in a rare documented late work at Buggiano (fig. 3).[15] Bachi-acca was perhaps the least original painter of his calibre in Florence during the sixteenth century. Vasari could praise him for the excellence of his small figures, but that his abridged biography was abruptly added to the life of Bastiano da Sangallo reveals no urgent desire to draw attention to his work, thus exposing an underlying Tuscan prejudice against art that was too precious, decorative and timid.[16] It is also clear that artists like Perugino who worked, above all, to please patrons with definite expectations continued to be successful in Florence, as with Ridolfo Ghirlandaio and Fra Bartolomeo to mention only the two most prominent. Nevertheless, it is safe to conclude that Perugino's contemplative and infallible style of painting, which in the 1490s in altarpieces like the *Vision of Saint Bernard* (formerly in Santo Spirito; fig. 5) reached an admirable degree of sensitivity and undeniably high quality, had largely been eclipsed in his adopted city of Florence.

Looking at any of the rigidly posed saints in niches (figs 6–7) which Perugino supplied for this commission around 1507, the basis of the strong criticism of his formulaic style is made manifest. They have no volume – a problem which the symmetrical drapery folds do not alleviate. The lack of turn to these hourglass bodies gives them an expressionless neutrality, carried also in the vapid, interchangeable faces and the stylized posing of the hands, revealing that Perugino

5 Perugino, *Vision of Saint Bernard*, Munich, Alte Pinako-thek.

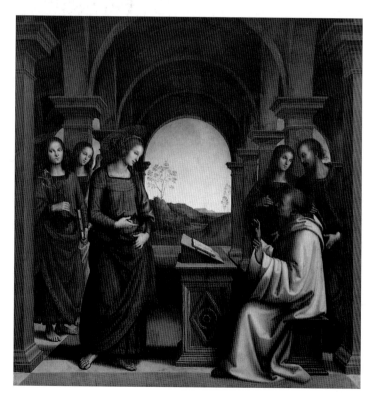

chose not to follow the profound and potent models suggested by contemporary Florentine artists – as does the clear lighting and the tempera-like handling distinguished by its laboriously laid in, unfused strokes. If wooden, the figures are at least large, but Perugino's limited technique prevented him from achieving a truly monumental style. It is, above all, in the lack of original invention intrinsic to a limited method based on expediency that the ageing Perugino could only be attacked in the heightened critical climate fostered by the return of Leonardo and Michelangelo to Florence in this period after 1500. Leonardo explicitly echoed these criticisms in his notebooks in censuring those painters who did not seek sufficient variety in their proportions such that all their figures appear to be relatives.[17]

The foil for Perugino's experience at the Annunziata is conveniently but significantly provided by Leonardo, who had exhibited (in the modern sense of the word) a work at the Servite church in 1501, having been offered the chance to paint the high altarpiece there by the artist who had already received the commission – Filippino Lippi, who, according to Vasari, withdrew deferentially so that Leonardo could take over the project.[18] It has also been suggested that the friars, whose relations with Filippino were not entirely trusting, themselves approached Leonardo to take over the high altarpiece commission and gave him lodgings at the monastery.[19] If true, this provides yet more proof of the contemporary respect given, somewhat undeservedly, to the returning painter. The Servite commission was later restored to Filippino and completed by Perugino, as we have seen.

Eventually Leonardo began instead a mysterious, drawn cartoon featuring, for reasons of subject and purpose still not entirely clear, Saint Anne, the Virgin, the Christ Child and the Young John the Baptist. His lost original is probably now recorded in related paintings attributed to Andrea del Brescianino (figs 8–9).[20] The former of these sets the group in a landscape, with the young Baptist in the background, while the latter has them in a bare architectural niche. It cannot even be ruled out that Leonardo's work, which could easily have been for an altarpiece, or perhaps just the core of an altarpiece design, was ordered by a different patron and for a different location; but that it was started by him while being given hospitality by the Servites is generally accepted. The theme honouring Saint Anne was certainly a very Florentine one because she was a patron saint of the city. The Servites seem also to have habitually provided painters with such accommodation (as they did for the young Vasari in 1536 while he was producing an altarpiece for export to the confraternity of San Rocco in Arezzo), and it does not necessarily follow that Leonardo was creating work directly for them in this instance.[21] Another possibility to be considered

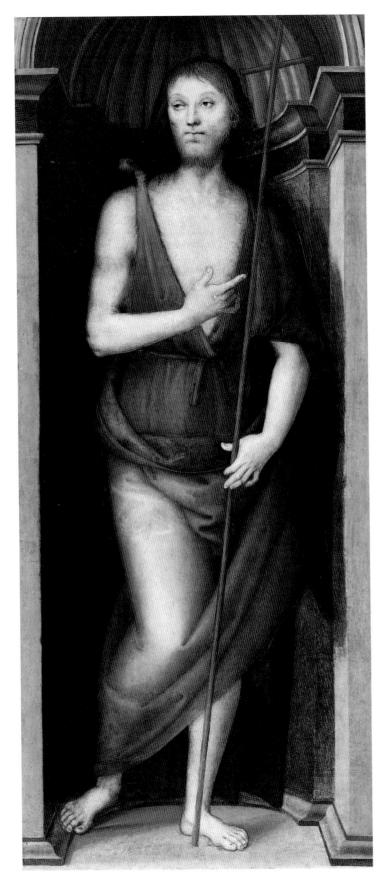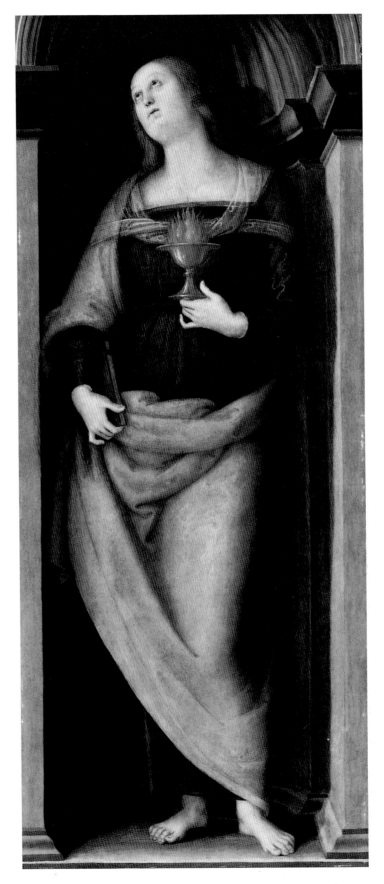

6 Perugino, *Saint John the Baptist*, The Metropolitan Museum of Art, New York, Gift of The Jack and Belle Linsky Foundation, 1981.

7 Perugino, *Saint Lucy*, The Metropolitan Museum of Art, New York, Gift of The Jack and Belle Linsky Foundation, 1981.

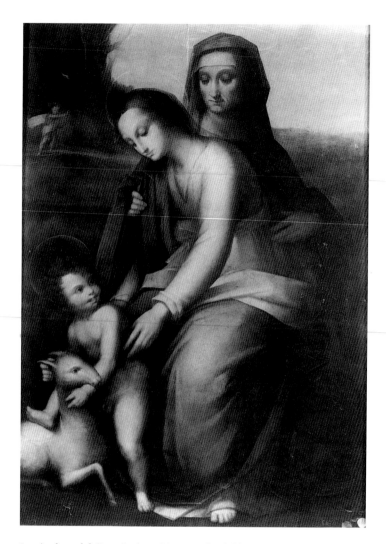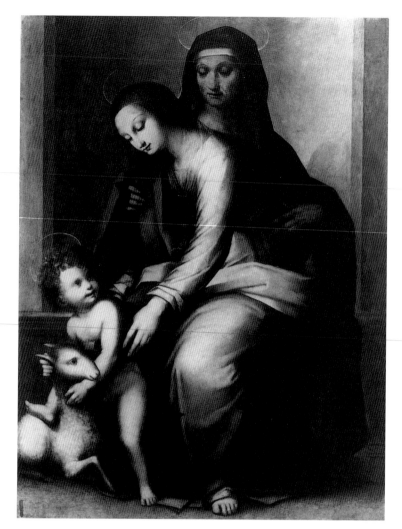

8 Andrea del Brescianino, *Virgin and Child with Saint Anne*, Madrid, Prado.

9 Andrea del Brescianino, *Virgin and Child with Saint Anne*, formerly Berlin, Kaiser Friedrich Museum (destroyed).

is that Vasari was confused about a painting that, after all, was never executed, and that Filippino had instead given Leonardo the option to produce a design for his *Saint Anne* altarpiece already commissioned in 1498 by the Gonfaloniere, or Standardbearer of Justice for life, Piero Soderini, for the Palazzo della Signoria.[22] In whichever way it is interpreted, this curious episode suggests that Leonardo was himself rather intimidated upon his return to Florence after an almost twenty-year absence in Milan and, hoping to demonstrate his excellence to an audience of fellow artists rather than patrons, was driven to unusually audacious and opportunistic means in that more competitive environment.

Vasari related how the cartoon, which was the first important new work Leonardo produced in Florence, caused a sensation during its two-day exhibition around Easter 1501 (although there is no corroborating evidence from any other source of the details of the actual event).[23] Perhaps this

atypical form of exhibition was demanded by heightened public expectation of what Leonardo, after such a long absence, could achieve. While it was undoubtedly more common than can now be documented for new religious paintings to be escorted in lavish public processions for installation on their intended altars, viewing of unfinished works of art on the occasion of feastday devotions may have been a new or revived phenomenon of this period. In his unequivocally admiring account of the drawing, Vasari recorded no irony here about its not having been turned into a finished painting, as if the image's greatness compensated for the lack of a finished product in this emblematic instance. The incident is remarkable, not least for Leonardo's choosing to let public and artists alike judge and admire his personal invention through a large drawing of a religious subject viewed totally out of its intended context. Vasari described the design as featuring Saint Anne with the Virgin holding

the Christ Child in her lap and with a Saint John the Baptist playing with a lamb. Not having examined the original design or a copy, it might plausibly be assumed that Vasari conflated descriptions of different compositions featuring Saint Anne, because the surviving copies do not include a young Baptist, but rather the Christ Child in the active position suggested by the writer. A letter of 3 April 1501 written by an eyewitness, Fra Pietro Novellara (Isabella d'Este's Mantuan agent in Florence), more accurately describes what must be the same cartoon: 'He is portraying a Christ Child of about one year old who is almost slipping out of his Mother's arms to take hold of a lamb which he then appears to embrace. His mother, half rising from the lap of Saint Anne takes hold of the child to separate him from the lamb (a sacrificial animal) signifying the Passion. Saint Anne rising slightly from her sitting position, appears to want to restrain her daughter from separating the Child from the lamb. She is perhaps intended to represent the Church which would not have the Passion of Christ impeded.'[24]

Reconstructing the work in the absence of the cartoon, which was itself never finished, permits an analysis of only the basic composition. It contains the Virgin in the lap of her mother, Anne, who, with both hands, attempts to restrain her daughter from interfering with the play of the Christ Child and the smaller animal. Typically, Leonardo conceived the image in a forthright, compelling manner. Anne is fairly frontal in pose, but the design is otherwise unbalanced. It is significantly weighted to the viewer's left and into three-dimensional space, both by the Virgin's powerful lean and twist in that direction, and the location of the angled bodies of the Christ Child and lamb crowded precariously into the lower corner. The overall image is thus disposed laterally and abandons the strict verticalized focus found in earlier treatments of the same subject matter. The turning head of Leonardo's Virgin and the rotation of the shoulders initiate an almost violent tension and rhythm in the design, which presses forward like a sculptural relief. The sweeping downward gesture of her left arm as she attempts to embrace her child is equally insistent and powerful. With all of these formal qualities, Leonardo's literally fleeting work motivated artists of the new century more as a pure inspiration than as a direct model. The fully radical nature of this dynamic, disassembling solution is demonstrated by the recognition that such artists as Fra Bartolomeo and Ridolfo Ghirlandaio returned to a strictly hierarchical layout when painting this theme and not even in the later 1520s dared to attempt an imitation of Leonardo's precedent.

Some idea of the surface quality of the lost work is provided by the so-called Burlington House cartoon (fig. 10), as a never utilized cartoon by Leonardo, composed of various

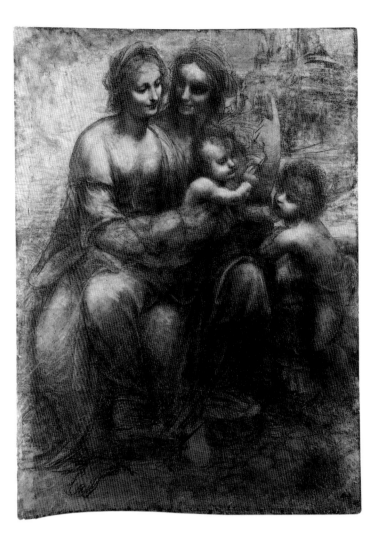

10 Leonardo da Vinci, *Virgin and Child with Saints Anne and John the Baptist*, London, National Gallery.

sheets of thick paper but still preserved, fortunately having been deliberately saved after its production. Especially notable are the sweeping black lines strongly seeking the contours and the dramatic, rough overall appearance. This cartoon (an assemblage of sheets drawn as the last stage before execution of the final image itself) must relate to a different commission and was drawn later in the decade, as the design is more formally advanced than that recorded, admittedly second-hand, for the drawing exposed at SS. Annunziata. Even if it has suffered from rubbing of the black and white chalks and other damages over time, it is significant that the composition appears never to have been completely resolved: typically, Leonardo may have abandoned the work, perhaps in frustration or mere lack of interest at this stage, as he had apparently previously done with the SS. Annunziata cartoon.

Also relevant to the passing of the Peruginesque style in Tuscany is a less celebrated incident involving Rosso

Fiorentino supplanting an irate Niccolò Soggi for the commission of images in fresco of the Virgin in the atrium of SS. Annunziata in Arezzo in 1528: Soggi had been a Perugino pupil.[25] Again, Perugino's circle of admirers may have felt especially aggrieved at Vasari's presentation of this episode for, like Leonardo at the Annunziata in Florence, Rosso never completed the project. As with the earlier incident, it demonstrates how the promise of original innovation could lead patrons to sacrifice the likelihood of a professional if banal final result, to their disappointment in each case. Like the display of unfinished works, this seems to have been another artistic phenomenon of this period without much precedent.

In the context of discussions of art of the 'Mannerist' period, it is important to stress from reading about this clash between Perugino and Leonardo how Vasari, like Giovio, writing with even greater hindsight more than twenty years later, also accused the Umbrian painter of having a mannered art because his style had become formulaic: 'Pietro had done so much work, and he always had so many works in hand, that he would very often use the same subjects; and he had reduced the theory of his art to a manner so fixed [*ed era talmente la dottrina dell'arte sua ridotta a maniera*] that he made all his figures with the same expression.'[26] Repetition even of an attractive and perfect style was, according to their assessments, unnaturalistic and therefore negative. Lodovico Dolce in his *Aretino* dialogue of 1557 borrowed this formulation in the context of praising the variety of Raphael's figure style in Rome.[27] The explicit and succinct application of the term to a style of painting, to indicate stagnation, monotone and repetition, is germane for general classifications of Renaissance art. It seems misleading for modern scholars to expand on a term used in the period in a specifically pejorative sense to mean quite another style than that exemplified by artists such as Rosso or Perino del Vaga.

What points emerge, then, from these diatribes against Perugino, and also Lorenzo Costa and Francesco Francia, written with some knowledge of Leonardo's work in Florence after 1500? The refusal of these painters to change sufficiently was considered a form of mannerism, and so the avoidance of repetition was an impulse identifiable as of new critical importance. The delicate elegance, timidity and charm of the Peruginesque style were judged to be outmoded stylistic qualities to be challenged by their opposites, that is something sturdier, more vigorous and powerful in figural terms, while being less emotionally saccharine. In a related way, monumentality was an alternative quality, indicating both grand scale and, more importantly, a forceful general effect. The preparation and technique of these painters were also insufficiently intensive or sophisticated in what they could achieve. Their inability to depict convincing nude form was

another crucial lapse. Most directly, the new painting implied by the censure had to attempt to express a range of vivid emotions and individual types. Vasari's placement of Perugino's Life as the final one in the second section of the first edition of the book, with a reference to the rise of Michelangelo at the end, graphically reinforces the division between the two ages. If one had to identify the overriding standard promoted by Florence from the accounts of Giovio and Vasari, it would be simply that of originality of design and the related notion of artistic ingenuity.[28] With this pressure a willingness to accept difficulty in the creative process was now judged necessary for good art, for example in the production of agitated movements and foreshortenings – whether the result was beautiful or not – and in the treatment of subject matter, where an original development of content is encompassed by Giovio and Vasari in their critiques of those older painters born outside the Tuscan region.

From examining the written sources, therefore, a crucial historical break can be discerned in Florence in the first years of the sixteenth century. This falls between Perugino-type mannerism and the painting style encapsulated initially by Leonardo, who arrived from Milan after a long absence in April 1500. The wider chronology of events leaves no doubt that it was artists rather than writers about art who were responsible for this transformation, even if their writings naturally provide us with a set of basic characteristics to extract from this apparently new style of painting. It should not be surprising to learn in this context that in the first half of the sixteenth century there occurred the birth of what we would recognize as art history through the writings of Vasari and Giovio, one of whom was an artist and the other a historian and antiquarian with close artistic contacts. The emergence of the subject is itself symptomatic of the general search for novelty on the part of certain painters which, correspondingly, almost demanded appreciation and so the need for experts to be more responsive to the greater range of available styles. Similarly, the eventual foundation of an academy specifically for artists in Florence in 1563 betrays a desire to codify the pride and awareness of the distinguished achievements of their immediate predecessors, the most celebrated and controversial of whom, Michelangelo, was still alive. It was a pretension that displeased some academics, to judge by the blunt attack on the aspirations of artists by the lawyer and court secretary to the Gonzaga, Mario Equicola in his *Institutioni* published in a posthumous edition of 1541: 'And painting being more a physical than a spiritual labour, very often practised by the unlearned.'[29]

For Giovio and Vasari the crucible of this progressive style was Central Italy, and it is no coincidence that the artists presented as foils, namely Perugino, Francia and Costa, are

Umbrian, Bolognese and Ferrarese. In Perugino's case, this is despite the fact that he had been, along with Leonardo, a pupil of Verrocchio in Florence: these writers narrowly refused to acknowledge him as a surrogate Florentine even though there were grounds for it. Indeed, the very way in which Leonardo and also Michelangelo were seized upon provides evidence of a particularly fierce manifestation of self-perpetuating and self-serving local pride that had its roots much deeper than the sixteenth century. The prejudicial, combative element in this criticism is blatant and on many levels insupportable. Perusing such written testimony makes it especially apparent how the art history composed in the Renaissance was created initially as a form of civic panegyric combined with the history of famous, preferably deceased men of a type about which Florentines were particularly obsessive. The interest in biography was conditioned too by a rhetorical impulse to emulate ancient Roman biographies more than it was by the reaction to specific art works: much of the discussion even in Vasari dwells on career and elevated patronage rather than analysing stylistic properties. Tuscans like Vasari and Ugolino Verino, who composed an epigram praising Florentine art perhaps around 1488, were among the first to protect their heritage and to express a monolithic notion of a progressive and progressing style, and so for them modern art meant the art of Florence, and non-Florentines inevitably suffered against this model.[30] Giambattista Gelli, for example, in the text of a public lecture given at the recently founded Florentine Academy and published in 1551, expressed a common, if unsubtle general view for Florentines, in seeing an unbroken, uncontaminated development from Giotto through his pupils, to Masaccio, others like Filippo Lippi and Andrea del Castagno, then Leonardo, and culminating in Michelangelo, who was at the pinnacle of all three arts.[31]

The case of Donatello and Vasari's *Lives*, because it falls prior to the period treated here, is especially instructive in this context of the valuing of Tuscan art as the universal best and perennially the most up to-date. Donatello is unique among the artists included by Vasari in the second part of the *Lives* in that the Aretine biographer seriously considered placing him in the climactic third section of the book. The *Annunciation* sculpture for the Cavalcanti altar in the church of Santa Croce in Florence, usually dated around 1433–4, so enamoured Vasari that it was the first work to be discussed in the Life, out of chronological sequence. Vasari settled his uncertainty – brought about by chronological concerns – by classifying Donatello as representing the highest standard of second-period artists, combining all the best qualities of that group. Vasari was preceded by Geoffroy Tory in his *Champ Fleury*, published in 1529, who listed Leonardo, Donatello,

Detail of fig. 4.

Raphael and Michelangelo as the greatest artists of his age, though the main grounds for assessment in his case were technical rather than stylistic: the four are superior to others in perspective, mathematics and measurement.[32]

Yet it can be objected in the face of this generalizing account that the stance of these writers vastly oversimplifies the historical reality of the situation even in Florence, not least because it neglects the contribution of a group of still vibrant older artists working around 1500, such as Filippino Lippi and especially Piero di Cosimo. Similarly, those Florentines who were felt by writers to betray their expressed tradition came in for as much criticism as the non-Tuscans (there is considerably less evidence that artists themselves felt this way). This group likewise needs to be thoroughly investigated. One of the most startling cases in Vasari's book is the attack on Jacopo Pontormo, as will be explored later, but other explicit examples of Vasari's hostile attitude towards Tuscan-born artists emerge in his discussions of Piero di Cosimo, Bachiacca, Jacone and Baccio Bandinelli. As much as reflecting opinions genuinely held by Vasari, his treatment of these figures betrays some inflexibility in the critical vocabulary for negotiating the varied art produced in Florence in the period after 1500: even Leonardo suffers against literary models. At the same time, Vasari's unfortunate handling of them anticipates his exploitation of the notion of the superiority of Florentine art, but to his own specific ends in a thoroughly contemporary context. The paradoxes of Vasari's position should be stressed: he was Aretine by birth and formed partly in Rome, but he freely promoted the priority of the Florentine tradition at a vulnerable time in its development. Explaining why that tradition was insufficient for Vasari's needs is one of the main concerns of this book.

In addition to Florentine partisanship, there is also a stereotypical element of humanist nostalgia, or elegy, in the perceived significance of Leonardo, Michelangelo and also Raphael for the history of art. This is suggested when we realize that the trio were not linked together as creators of a new period of art history until the 1520s, after two had died, and after a process amounting to deification of Michelangelo had already begun in some circles. Simply by isolating the triumvirate, Giovio implied that they had recently changed the course of the history of art above and beyond other artists, and he was apparently the first writer to group the three artists alone for special mention, in his short laudatory biographies drafted probably in the later 1520s. The fact that his viewpoint, like Vasari's, was partially retrospective alerts us to the likelihood that the historical reality was much more complex, disunified and uncertain, not least because the

notion of 'modern style' is itself a literary formulation. Indeed, while Vasari's *Lives* are the main source for the biographies and art of the period prior to the mid-sixteenth century, they are also a loaded text that will always present special problems of interpretation. In addition, the *Lives* are a prescription for Vasari's own work as a painter, and this should be kept in mind when using them as a source for others. So if Vasari, above all, provides a basic structure for understanding the newly innovative art in Florence using the popular demise of Perugino as a foil, it is a model that will always have to be refined when examining individual artists and works of art.

To conclude: there is evidence that the appearance in Florence of a newer style, as distinct from that of the Quattrocento period, instigated some sort of crisis for Florentine painting in the first decade of the sixteenth century. It was recognized as 'new', however, partly in nationalistic and eulogistic terms in the wake of the deaths of some of its main protagonists. The first expressed characterizations of this period and its origins were based not so much on a freshly evolving vocabulary but on traditional Florentine criteria in celebrating and analysing much of their best art, past or present – an activity that was particularly developed in Florence. It was this very intensity of analysis that Donatello famously lamented as absent in Padua. This highly public formal criticism of the arts ultimately reflected the expectations of the professional artists themselves for a certain level of quality as well as corporality, force and elegance in their work. As much as individual formal qualities, however, the most loyal Florentine painters also shared a general attitude which was self-centered and outwardly challenging but, paradoxically, strictly and proudly grounded in local art practice. Above all, it was an approach aiming to demonstrate originality of design and particularized expression to the point of arrogance for which even minor artists would strive.

Recognition of the retrospective but also deeply rooted basis of this perception of Florence's central significance in the first decade of the century is liberating, for it forewarns of the exaggerations and distortions inherent in texts for our study of the period from about 1500 to about 1550, and permits a continued dependence on formal, stylistic analysis as the most immediate method of classification. The textual analysis that has come down to us, however useful, is too second-hand, chauvinistic and generalizing to supply all of the crucial observations, especially for the art produced in the earlier half of the period which even Vasari knew much less about than we might hope. Some of the surviving texts written by artists other than Vasari will also be brought into consideration, although in general they betray a refusal to

accept debate in literary contexts by fully recognizing the special problems of using language to interpret visual art, which compromises their ultimate worth.

The origins of the historical 'High Renaissance' can be traced, therefore, to a particular set of formal qualities and practical concerns valued by many artists in Florence, as much as to the chronological point of around 1500, but this approximate date should nevertheless still be taken as a watershed for the history of art, if only because it was soon thought to have been one. It was a moment when Florentine artistic practice intentionally asserted itself through the disruptive and highly inspired examples of Leonardo and Michelangelo, who had both by then returned to their native city, against the real threat of popular non-Florentine painters like Perugino in a series of incidents that now seem positively emblematic, if fleeting in tangible terms. Precisely what contribution these native artists made in terms of style, and also in attitudes towards career and patrons, and how this affected (or did not affect) other painters working in Florence until after 1550, will be explored in this book.

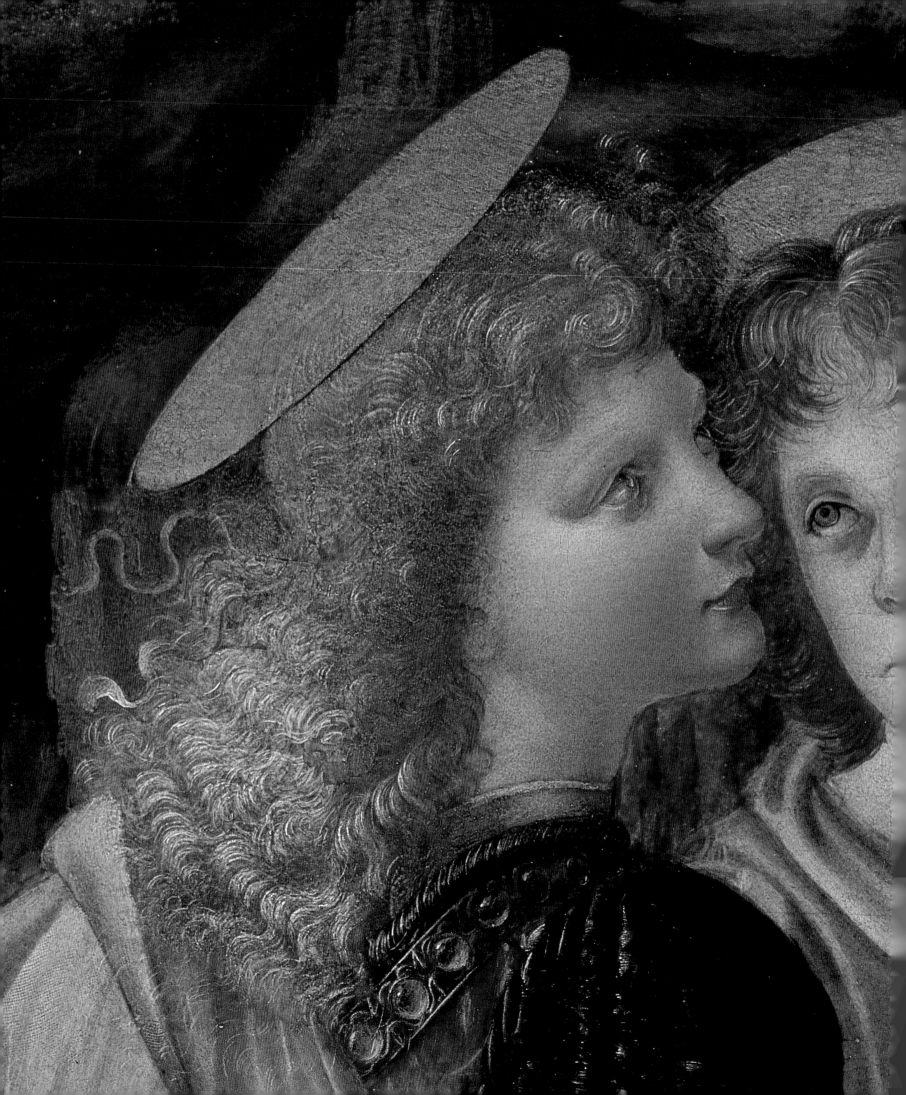

LEONARDO DA VINCI AND THE ORIGINS OF A NEW STYLE

IN THE PREFACE TO THE THIRD AND FINAL PART OF Vasari's *Lives* we read that Leonardo was unequivocally the creator of modern painting: 'Leonardo da Vinci, who, giving a beginning to that third manner, which we propose to call the modern – besides the force and boldness of his drawing, and the extreme subtlety wherewith he counterfeited all the minuteness of nature exactly as they are – with good rule, better order, right proportion, perfect drawing and divine grace.'[1] The passage was anticipated in yet more summary hyperbolic terms by Bernardo Bellincioni, a court poet of the Sforza family in Milan, who wrote as early as 1493 that both ancients and moderns need fear this master's art.[2] Such claims for Leonardo's primary importance as someone who irrevocably altered the course of the history of art have never been seriously questioned, even if the basis for them still requires some investigation. The first plate of the Pelican history of sixteenth-century painting in Italy, for instance, is a detail of an angel executed by Leonardo in the Uffizi *Baptism of Christ* otherwise in significant part produced by his teacher Andrea del Verrocchio (fig. 11 and facing page).

This mysterious altarpiece was completed, probably in the 1470s, for an undetermined patron.[3] It is presumed to have been painted for the church where it is first recorded, namely San Salvi, a Vallombrosan monastery still standing outside what were once the east walls bounding Florence, but even this apparent fact awaits documentary confirmation. It is not known whether it was executed as a high altarpiece or, as seems most likely, for a side chapel. The main figure of the Baptist in his solid, articulated pose is probably the master's responsibility, while the angel in a blue robe may even be by a third painter. The whole of the near angel was almost definitely painted by Leonardo, and possibly the figure of the Saviour, along with much of the watery landscape and foreground vegetation, but it seems not the rock forms, as a restoration of the painting has made more evident. Unlike those of the other angel, the hands of Leonardo's figure are

hidden, and he is viewed in profile rather than three-quarters, implying that Verrocchio in an uncharacteristic error of judgement may have offered him the technically easier, if the more forward, of the two angels to paint. The inclined head turning back to observe the Baptist's action seems too graceful for the stunted proportions of the body which the master doubtless dictated, quite probably from his own drawn cartoon or preliminary sketch. A *pentimento* or alteration to the left arm intended to make the body more slender could reflect Leonardo's critique of the master's finished design. Leonardo varied the conception of the other angel by painting his with longer hair, thinner lips and a proportionally smaller head, all in order to achieve a more rarefied elegance. The drapery folds are also more articulated, with deeper crevices. The young painter displayed his astonishing technical prowess by representing the head of the figure through a semi-transparent halo, as well as the jewels across his shoulder. Captured in a raking light which could almost be interpreted as part of the image's subject, the softly modelled areas Leonardo created literally foreshadow his later explorations in the handling of oil paint and its ability to imitate observed effects. They can be compared with the drier, more uniform parts that seem to distinguish Verrocchio's own handling. The profound contrast in this painting of the work of master and pupil makes such an eloquent statement that any rebuttal of the Vasarian notion is rendered superfluous, however unfair this generalization is to Verrocchio's own artistic skill – as made manifest above all in his outstanding sculptures – and to his fundamental importance for Leonardo's formation and development. The juxtaposition of the soft and ethereal of the modern painter to the hard and dry of the outmoded teacher here makes an irrefutable point.

Yet despite his pivotal role in the history of art, paradoxically Leonardo's specific achievement was, it seems, not easy for his contemporaries to isolate and characterize, and this should affect how he is ultimately situated historically. If the

pre-Vasarian sources are scanned, a consensus of what were thought the valuable aspects of the work of this artist born west of Florence in the town of Vinci in 1452 emerges rather haltingly. The observations reflect directly on works accessible in Florence compared to those in Milan and the north, and pivot either on his drawings and design ability or his naturalistic painting technique. In Florentine texts like those of the *Libro di Antonio Billi* and the Anonimo Magliabechiano, Leonardo is considered, above all, a great draughtsman and inventor,[4] while for the Milanese antiquarian Fra Sabba Castiglione (who was a relation of Baldesar Castiglione), writing in his *Ricordi* of 1562, Leonardo's principal innovation was the painting of monumental figures in a heavy chiaroscuro, reinforcing a remark by Paolo Giovio that the distinguishing aspect of his painting was the ability to model in relief.[5] In a rare visual analysis of Leonardo's work before Vasari, found in the correspondence of Isabella d'Este in a letter of 1501 from Mantua to her agent in Florence, Leonardo is described as being capable of producing a religious painting 'full of faith and sweetness'.[6] In another letter of 1505, Isabella asked Leonardo for an image of Christ aged twelve executed 'with that charm and sweetness which characterise your art to such a high degree.'[7] With adjectives like sweet and charming, Isabella understood Leonardo's style to be essentially a superior version of that practised by such artists as Perugino and Giovanni Bellini with which she was more familiar, a viewpoint, if somewhat restricted, that itself implicitly anticipates Perugino's eclipse in Florence.

From such unsystematic written comments by contemporaries and near contemporaries, it would be difficult to construct a thorough picture of Leonardo as an artist. This was as much his fault as that of commentators because it is notable how few works Leonardo brought to completion and how many fewer were openly available to the public and other artists for any extended period. If discussing private, so usually inaccessible, works becomes unavoidable in Leonardo's case, as it never even arises in Perugino's, it is because so little of his effort was made fully public and, perhaps for the first time in the history of art, the usually undisclosed practice of an artist became subject to scrutiny and discussion. This raises the murky issue of how knowledge of his art was spread. His total corpus of surviving paintings, including unfinished ones, does not appear to reach twenty examples. In Florence specifically, aside from the rather small angel in the San Salvi *Baptism*, his only exhibited work as a painter was possibly another, earlier effort of the 1470s, probably finished while he was still in Verrocchio's *bottega* – the *Annunciation* now in the Uffizi. Even this is highly debatable because its early provenance is not recorded and its horizontal shape and relatively small size might better indicate a private devotional

commission, assuming too that the attribution is wholly correct. Leonardo's major early work, the never completed *Adoration of the Magi*, also surviving in the Uffizi (fig. 12), was in the private collection of the Benci family and sometimes accessible, but was doubtless known in the period more through drawn copies after specific parts than first-hand observation. Other Leonardo paintings, generally smaller works, could be glimpsed for a period and exerted some influence but then, apparently, disappeared from view. The best-known case of this is Leonardo's *Benois Madonna* (now in the Hermitage), which profoundly affected Fra Bartolomeo and Raphael (and artists in northern Europe), but not later artists working in the sixteenth century.[8]

It appears too that Leonardo not only left many works unfinished but also continued to hold onto them for, arguably, superfluous, further execution. The *Mona Lisa* (fig. 17) is the best example of an overwrought Leonardo painting, about which it seems permissible to speculate on the loss of likeness given the rather unfeminine appearance of the sitter, who should be recognizable as a woman in her mid-twenties. As Leonardo moved around often and took already initiated works with him, so the impact of his art was reduced and a full early assessment of his style made an impossibility in practice. Indeed, he sometimes worked on paintings in one city that were intended for other destinations, further alienating him from the contexts of local taste and tradition. Likewise, because he allowed replication of his designs and possibly even retouched paintings begun by his students, as Verrocchio had done, it became controversial at times to distinguish the roles of master and workshop, as amply demonstrated by the vexed attributions of surviving versions of the *Madonna of the Yarnwinder* (fig. 14). An original Leonardo in the narrow modern sense of the word may never have existed for this particular image, as well as for analogous ones apparently conceived in Florence, such as the *Salvator Mundi* or *Annunciate Angel*.

Leonardo did not have a Florentine career that others could easily emulate. His complex and occasionally unfocused aims were impractical for the majority of painters who had to live from commission to commission; it is no surprise that he more than once sought a placement at court in order to survive more comfortably, although even in that environment he did not always have a calm existence. His lengthy moves from Florence to Milan, Rome and France were implicit admissions of the failure of his type of artist in the Florentine context. Even his willingness to take on a highly involved, major project in Florence, to produce the battle frescoes in the Palazzo della Signoria, came partly from an entirely practical need to receive a regular salary in order to

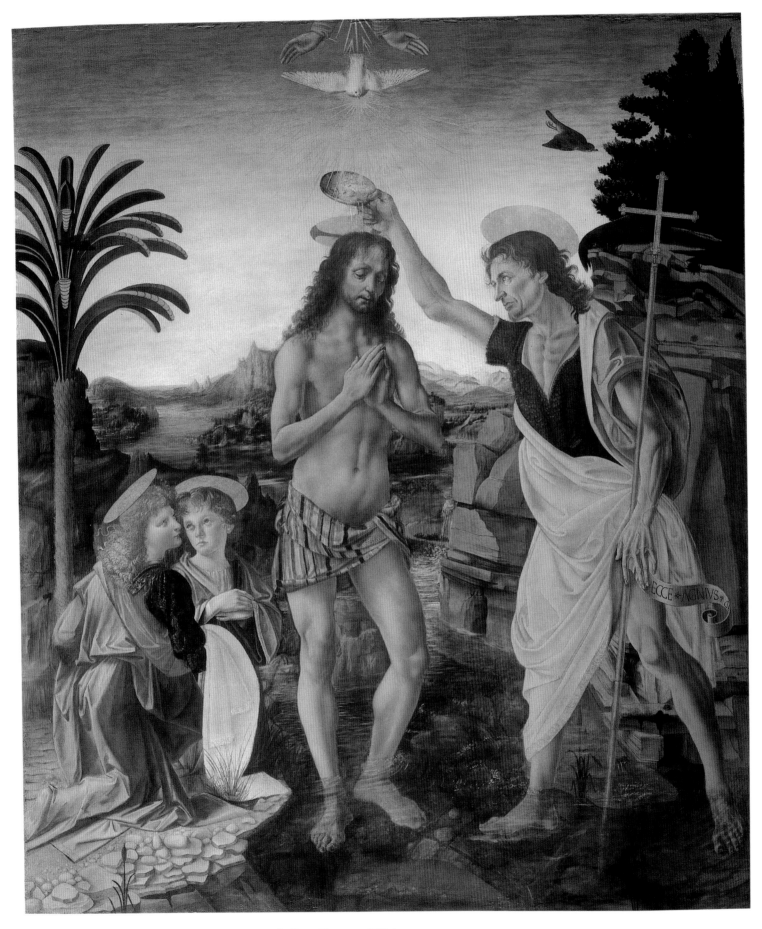

11 Verrocchio and Leonardo da Vinci, *Baptism of Christ*, Florence, Uffizi.

devote time to non-artistic pursuits, as well as to sustain his existence. Thus a vicious circle developed with the artist repeatedly abandoning the monumental commissions that, paradoxically, his reputation earned for him. So, it seems, this self-possessed artist was not especially concerned with defining a public place in the history of art.

If many difficulties present themselves for an assessment of his positive impact on the history of art, the unusual nature of his wayward career and practice was recognized during his lifetime. Leonardo's approach was an object of fascination in Milan. The young monk and novella author Matteo Bandello saw Leonardo on the scaffolding for the *Last Supper* in 1497 and wrote him into one of his stories: 'Many a time I have seen Leonardo go early in the morning to work on the platform before the Last Supper; and there he would stay from sunrise until darkness, never laying down the brush, but continuing to paint without eating or drinking. Then three or four days would pass without his touching the work, yet each day he would spend several hours examining it and criticizing the figures to himself.'[9] The role of direct inspiration and intense self-criticism for a painter were extraordinary to Bandello and doubtless to those who later had the opportunity to witness Leonardo labouring over the *Battle of Anghiari* in Florence. Ugolino Verino wrote in that period around 1503 that 'Leonardo possibly surpasses everyone, but he is incapable of removing his hand from the panel and so, like Protogenes, takes many years to finish one.'[10]

These themes were taken up immediately after the artist's death. Paolo Giovio wrote in the 1520s that Leonardo was so distracted by his search for novel means that he could not finish work already commenced – a tendency that appeared all the more lamentable just after his passing.[11] This favouring of invention over execution was accentuated as Leonardo aged and his so-called fine art interests increasingly receded: he was simply less occupied with actual painting than others of his stature, as his personal view of what an artist should be expanded beyond all recognition. A related compulsion to execute what originally must have been an unprecedentedly large number of preparatory drawings before approaching anything resembling a resolved design also inevitably affected how much finished work he could produce. While they are important for our fuller understanding of his talents, the range of Leonardo's interests cannot readily be paralleled with any major Florentine painter of the first half of the sixteenth century; it is difficult to imagine that even the few partial exceptions, like the writing desk made for Duke Cosimo de' Medici which included images of birds and rare plants by Bachiacca, would have been of comparable sophistication.[12] In retrospect, for some artists Leonardo's extramural efforts might have seemed merely fascinating, if unconducive

to picture making, and possibly a rather old-fashioned tendency in the spirit of artists like Piero della Francesca and Francesco di Giorgio, which did not lead to any particular result. Giovio perceived that Leonardo was simply too fastidious in his technique and character to be able to complete anything, and the poor condition of his paintings both in fresco and on panel is not solely attributable to natural deterioration and later abuse.[13] Castiglione, writing in *The Book of the Courtier* of an artist who was certainly Leonardo, described how 'one of the world's finest painters, despises the art for which he has so rare a talent and has set himself to study philosophy; and in this he has strange notions and fanciful revelations that, if he tried to paint them, for all his skill he could not.'[14] Such statements indicate that contemporary viewers (including doubtless other artists) were not as impressed as modern ones by unfinished work and seemingly purposeless experimentation, and the hard feelings alluded to by Vasari over Leonardo's squandering funds received for the disastrous *Battle of Anghiari* can be understood in this context.[15]

Somewhat later, Simone Fornari, who apparently knew Vasari's book in manuscript form, in his commentary to Ariosto's *Orlando Furioso* of 1549 emphasized, more forgivingly than some earlier writers had done, that Leonardo's ideas were too marvellous to be literally realized.[16] Another pre-Vasarian writer, the Venetian doctor Michelangelo Biondo, whose treatise on painting was published in Venice in 1549, attributed the Milan *Last Supper* to Mantegna and rather bizarrely appended a mention of Leonardo to his discussion of the Raphael follower Polidoro da Caravaggio.[17] While accepting that Leonardo was unique, Biondo could specify only that he had written a book of anatomy, and he was unable to present Leonardo as a particularly significant painter. Even Vasari, writing with the benefit of more hindsight, did not explain in detail why Leonardo merited such respect some thirty years after his death, aside from the nobility of his patrons. It is noteworthy that the terms of praise used in relation to Leonardo in the passage quoted from Vasari's preface at the beginning of this chapter – namely rule, order, proportion, design and grace – were not in the end particularly relevant for Vasari's judgements about the artist (for reasons that will become clear in the final chapter of this book). It is a further irony that the writer who was so instrumental in fixing Leonardo in the history of art was also strongly critical of him, in remarks that might not have been at all revised with deeper knowledge of the artist's activity.

Vasari disapproved unreservedly of Leonardo's general lack of productivity and his inability to bring works to completion. The waste of his talent through over-experimentation

was a related issue that could not be ignored, and for Vasari this contributed to an overall lack of perfection. The contrast with Vasari's own prolific output could hardly be more obvious, and points up how success was measured by many in the period by quality, certainly, but in conjunction with quantity. Without finished work, Leonardo implicitly undermined artist–client relations and so jeopardized the status and prestige of his profession. Vasari's prejudiced criticisms are somewhat stronger than those made by any modern art historian and are only starting to be addressed.[18] While with his own multifarious researches Leonardo aimed for nothing less than a total comprehension of all facets of nature, such a universal pursuit could never be undertaken without compromises and he was, not surprisingly, frustrated by such myriad investigations as recorded in his notebooks, particularly when he tried to condense them for pictorial representation. Leonardo basically operated on a different plane from any of his contemporaries in sixteenth-century Florence, though for a perceptive few his searching for discoveries of different kinds and a sense of relative spontaneity opened up many new paths, which, nevertheless, could be explored only in an equally personalized way.

Any early recognition of Leonardo's importance for art history was, therefore, both perceptive and generous. Certainly Vasari in the *Lives* was prompted by general chronological concerns, as Giovio had been in his short laudatory life of Leonardo, in placing him first in a presentation of the modern age. We may thus expand the context for appreciating the partly imposed and emblematic nature of the comments of Giovio and Vasari regarding his surpassing of Perugino at SS. Annunziata after 1500. Even the not disinterested Vasari apparently had only limited if any access to the writings containing many of Leonardo's brilliant ideas, and so failed to mention his discoveries for military engineering, among other areas. The same is partially true of our position: it has been surmised that the 6000 or so surviving folios of notes constitute perhaps only a third of the original number.[19] It was Giovio who set down Leonardo's hyperbolic claim that a painter should have a knowledge of both science and the liberal arts – an opinion that sums up how the artist's pivotal place in art criticism became fixed despite ignorance about his work, because it so appealed to intellectuals with overriding humanistic interests.[20] Authors like Giovio then sought ways to justify their predisposition to praising this already enigmatic painter: the myth of Leonardo as the originator of a new creative age thus arose a decade after his death on the shifting foundations the artist himself had laid.

There is a more banal but insurmountable factor that would have made Leonardo's contribution to Florentine art difficult to appreciate for contemporaries – his long absence

Detail of fig. 12.

from the city from about 1482 to 1500, after the first thirty years of his life. He was simply not present to clarify ideas, and to the degree that his earlier production was rather frozen in the past, this must have amplified the conceptual, disembodied nature of his surviving, frequently incomplete efforts, not to mention the mysterious dimension of his person. All of this is relevant for what followed him. The only contracted painting of his first Florentine period that he began work on, the *Adoration of the Magi* (fig. 12), can be seen to summarize a relatively early style which remained so pregnant with possibilities that it continued to occupy and affect artists even after his death in France in 1519.

Leonardo's *Adoration* was formally ordered by the Benedictine monks of San Donato a Scopeto for their high altar in March 1481.[21] Appropriately enough, given the themes already stressed, it is unfinished. The panel was abandoned and the commission eventually defaulted by Leonardo, who went to Milan the year after signing the contract. The surviving painting is more a chiaroscuro sketch in light and dark washes with few contours indicated. It is a huge wash drawing, and it needs stressing just how unfinished it is with thick, in places quite unspecific, strokes leaving an impression of mutability and rapidity. Despite the searching quality of the lines, however, some individual strokes such as the lengthy one defining the right side of the Virgin's neck are confident and direct. Clearly, no one dared attempt to complete or paint over Leonardo's panel after he left Florence (Filippino Lippi's replacement of 1496 surviving in the Uffizi was produced on a new second panel), nor did he touch it upon returning to the city in 1500, and this very neglect of the picture attests simultaneously to the unique complexity of his technique, its lack of resolution and the artist's early fame.[22]

From the signing of the contract, Leonardo had as much as half a year before his departure for Milan in which to proceed with this task. That he took so long merely to prime and block in the support proves what is known from other sources, that he was a painfully slow producer. The discarded panel also provides evidence for how Leonardo, even after having prepared a complete design through drawings, continued to change his mind on the actual support. This was a critical example in the history of painting for it demonstrates how he helped liberate artists from the restraints imposed by conventional solutions that for someone like Perugino could be literally stencilled onto a support, and to inspire experimentation in the very act of execution, even on a large scale.

In the *Adoration of the Magi*, Leonardo subjugated the involved narrative to an approximate scheme based on what have been described, anachronistically, as abstract shapes like the pyramid and semi-circle, and gave it a pronounced, if slightly recessed central focus. Such an imposed arrangement was appropriate to a painting intended to function as a high altarpiece approached from the front at a certain distance. The almost chilling analytical structure is relieved by the animated movements and gestures of the preciously scaled, under life-size figures, who now seem spectral on the large panel, so that, while specifically balanced, the composition is neither serene nor completely controlled and coherent. At least in this ambiguous state, how much we can recreate the artist's final intentions for the image is a genuine issue. This point accentuates how Leonardo's contribution to the history of painting in Florence was often transmitted through this type of unresolved, conjectural image and so bound to be of a predominantly stylistic kind.

According to some of his notebook writings, Leonardo hoped that the physical movement of represented figures would suggest inner states of mind and the singular passions of the soul.[23] Yet although such phrases contain an internal theoretical and literary plausibility, in practice it is not always clear what part his characters – often very agitated and in close proximity – play or precisely what feelings they are meant to display. In spite of his detailed research into specific emotional states, in creating facial expressions and gestures in his work Leonardo introduced an incalculable, paradoxical aspect, from which his figures draw so much of their unforgettable, uneasy power – as if he saw ambiguity and inscrutability as the best means for demonstrating artistic objectivity, as well as for getting the viewer's attention. And so we have to distinguish between what might be interpretable in a fairly literal way and a less explicable sentiment of portentous and uncanny significance, evident in his faces above all. It is perhaps easy to forget how personal and heterodox Leonardo's development of morphologies is in these works. By concentrating so much effort on the meticulous enquiry into facial expressions, he set impossible goals for himself in terms of visual representation, which other artists had to reconcile with a naturally more practical outlook. Leonardo's ambitious attitude towards individual expression also affected his treatment of subject matter, which was equally developed through his impulse to accentuate visual effects. The basic problem of identifying Leonardo's characters as in the Uffizi *Adoration* reveals the decisive role knowledge of precedent can play in the reading of images, particularly religious ones of the type supplied, again, by the utilitarian Perugino, and further emphasizes how unsettling was the Florentine's approach, especially for the altarpiece genre. It also widens the gap that could exist between artistic theory, as expressed in Leonardo's notebook writings, and the more pragmatic reality of practice, not to mention the difficulties other painters had in reconstructing his intentions from the images alone.

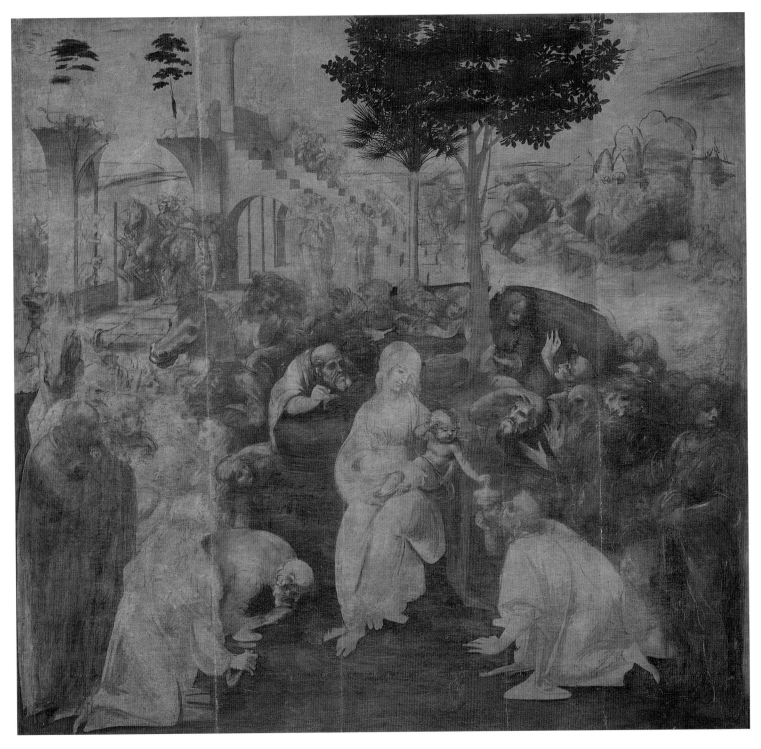

12 Leonardo da Vinci, *Adoration of the Magi*, Florence, Uffizi.

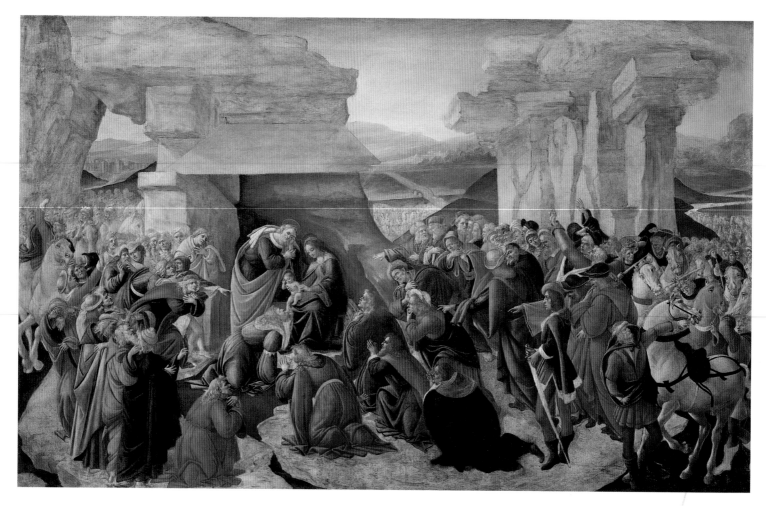

13 Sandro Botticelli, *Adoration of the Magi*, Florence, Uffizi.

The overall arrangement of the Uffizi *Adoration* seems especially contrived, since the subject naturally lent itself to a composition with some lateral emphasis. Leonardo's partial solution had major if somewhat diffused ramifications for painters in the next century, although it hardly influenced Perugino, who remained quaint and limited as a designer on a large scale. Relatively true to the spirit of Leonardo's design is Botticelli's late painting from after 1500 of the same subject (fig. 13).[24] In the asymmetry and sweeping quality of this impassioned work, appropriately left unfinished, it appears that Botticelli was the only Florentine artist older than Leonardo to appreciate the potential force of his example and attempt with some effort to equal it.

At the beginning of the new century, Leonardo returned to Florence, now under republican rule six years after the Medici expulsion. Here he worked on what Vasari later isolated as three of his four greatest efforts, the fresco of the *Battle of Anghiari*, the *Mona Lisa* portrait and the *Saint Anne* cartoon, the fourth being the Milan *Last Supper*. The first

major event recorded following his return by April 1500 was the display of his cartoon at the Servite church of SS. Annunziata in Florence, perhaps in March 1501 (see fig. 10), discussed previously. Leonardo almost immediately undertook a second picture celebrating the Virgin and Child in which natural symbolism inspired the design – the so-called *Madonna of the Yarnwinder*.[25] A letter dated 14 April 1501 written by the agent of Isabella d'Este in Florence, Fra Pietro da Novellara, concentrates on the image's meaning: 'The little picture which he is doing is of a Madonna seated as if she were about to spin yarn. The child has placed his foot on the basket of yarns and has grasped the yarnwinder and gazes attentively at the four spokes that are in the form of a cross. As if desirous of the cross he smiles and holds it firm, and is unwilling to yield it to his mother who seems to want to take it away from him.'[26] This subtle text provides important evidence that layered interpretations accepting the use of genre elements for symbolic meanings were valid in this period, though it might be added that as the Carmelite

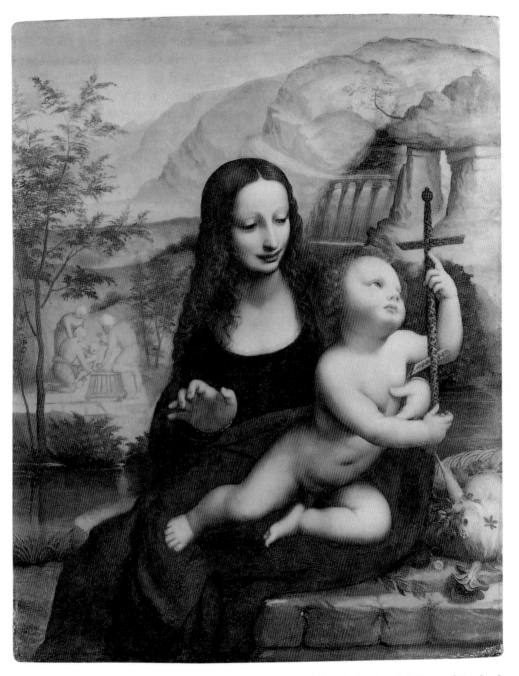

14 Leonardo da Vinci (after), *Madonna of the Yarnwinder*, Edinburgh, National Gallery of Scotland.

General in Florence Novellara was hardly a typical viewer, and even Vasari's descriptions of Leonardo's pictures of the Holy Family can seem generic by comparison.

As with the *Saint Anne* cartoon at the Annunziata, it does not appear that Novellara had seen a completed picture, though he specifically described the scale as small. Indeed, there is no evidence of a finished Leonardo painting of this subject having ever existed. The frustrated patron in this case was not a Florentine but the important French diplomat and secretary to a succession of kings, Florimond Robertet, who

may have finally received a work in France as late as 1507. In terms of quality, the relatively superior surviving versions are considered to be two in private collections. Neither corresponds to Novellara's description, however, as certain key elements are omitted. Indeed, they must have been developed following an earlier redaction that is closer to apparent copies like the one surviving in the National Gallery of Scotland (fig. 14). This, nevertheless, also lacks the detail of the Child placing his foot in a basket of bobbins, assuming the correspondent did not mistakenly recall this motif in his report

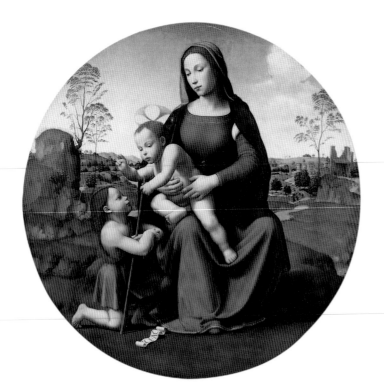

15 Giuliano Bugiardini, *Virgin and Child with the Young Saint John the Baptist*, The Nelson-Atkins Museum of Art, Kansas City, Missouri (Purchase: Nelson Trust).

to Isabella d'Este.[27] Characteristic of Leonardo's style are the foreshortened right hand of the Virgin, the forcefully disposed figures, the naturalistic rock and plant forms in the foreground and the distant primordial landscape and mountain range. A certain cramped quality to the Virgin's posture in these better replicas betrays a pupil's incoherence in translating the design to a fresh support, perhaps providing evidence for a layered, complex workshop procedure, possibly with some supervision and intervention by the master, as has been suggested.[28] It is quite probable that Leonardo took all the examples of this painting away to Milan with him, but the basic poses of the main figures at least had some influence in Florence even if no original was ever known there. The core of the design can easily be perceived in reverse, for example, in Giuliano Bugiardini's tondo of the *Virgin and Child with the Young Saint John the Baptist* (fig. 15), which like so many derivations from Leonardo becomes less anatomical, massive and monumental in its overall treatment of form, not to mention less subtle, as befits here a perpetually uninspired artist.[29] So while the celebrity and authority of Leonardo's example is evoked, there is no power in the transcription.

As it survives, the image features a three-quarter length Virgin with the reclining Christ Child placed in a rather natural, outdoor setting. This basic format is common to devotional paintings attributed to Verrocchio, and so its

relationship to the motives Leonardo absorbed as a young painter can be investigated fairly and concretely. The enormous Christ Child, as well as the division of moods between mother and son, are typically present in paintings by artists who trained with Verrocchio, such as those by Lorenzo di Credi (fig. 16), as is the type of girlish mother with heavy-lidded eyes and past shoulder-length hair falling in corkscrew curls. The continuing partial reliance on precedents in realizing this Madonna reminds us that Leonardo's style was not based solely on observations from life but betrays a dialectic between artistic convention at its most artificial and natural observation, which blend to give a deceptively objective air to the image. Leonardo's declared intention may have been to imitate nature, but like any artist he was never able to emancipate himself totally from the bonds of tradition. Indeed, repeating the more conventional facets of his style, Credi, who though only about five years younger than Leonardo died as late as 1536, was able to derive considerable success over the course of a long career in part from the production of recognizably Leonardesque religious art in a superficially highly polished technique for the Florentine market (he also supplied altarpieces to Montepulciano and Pistoia).[30] He certainly benefited tangibly from Leonardo's absences and basic unwillingness to take on the usual number of local commissions in all formats. Credi's desire for suffocating extremes of technical refinement, carefully graduated modelling and his restricted output came in for criticism from Vasari, however, even if a Life of the artist was reflexively included in the final section of his book. The high, enamel finish, distinguishing Credi's style as that of a Verrocchio-trained painter, was not one of the qualities that artists in Florence themselves extrapolated from Leonardo's practice at a greater historical distance.

But what then separates the work of these Verrocchio pupils? In formal terms, even in copies it is clear that Leonardo was simply more adept in the technical act of drawing in his development of a more subtle compositional arrangement. Drama is implied, for example, by the unusual, slightly low viewpoint and placement of the figures in closer proximity to the picture plane. There is also a more original treatment of the subject enacted through the agitated poses of the figures, indicating a deeper emotional engagement with the narrative possibilities, an ability to enliven the most conventional of themes, as well as the dynamically integrated symbols used for formal and mental effect, which is the most significant of the novelties evident from a study of this 'lost' painting. All of this demonstrates how stylistic innovation in this period is to be sought in what is intrinsic to process more than in the sometimes superficial and degenerate elements of a finished work.

The interest in stimulating a response in the viewer through representation leads to a consideration of Leonardo's developments in the portrait genre. Portraits had frequently occupied him before his return to Florence in 1500, but in his second Florentine period only one appears to have been commenced with any purpose – the so-called *Mona Lisa* (fig. 17). It seems inevitable that such a famous image should be embroiled in controversy. The most plausible suggestion is that it depicts Lisa Gherardini, who was the third wife of Francesco di Bartolomeo Giocondo (they married in 1495).[31] This private work was probably started around the summer of 1503, when Lisa was twenty-four, and the commission may have been prompted by Francesco's purchase of a new residence in the Via della Stufa in April of that year and the need for some appropriate new decorations. The patron had connections with SS. Annunziata, where he later commissioned a chapel, and he probably encountered the artist when he was staying there to work on the *Saint Anne* cartoon; equally, on the wife's side there were Gherardini merchants in Milan with whom Leonardo could have come into contact earlier. The portrait was not necessarily far advanced before Leonardo left Florence for Milan in 1506, as elements of its pictorial style and technique correspond more to his French period and so, like the *Madonna of the Yarnwinder*, only its basic design as transmitted through an underpainting perhaps could have any impact in Florence. Indeed, it cannot be absolutely ruled out that works like these two existed only as a cartoon or a series of preparatory drawings before Leonardo left Tuscany. These pictures provide examples of a relatively new phenomenon for art history of a small private painting having an influence before it was finished. Leonardo probably kept the panel on the promise of completing it when time permitted, but the patrons were never to receive a finished object.

Leonardo's odd behaviour over the portrait suggests that for him it was a special work – even a personal touchstone for his goals as an easel painter. It is curious that Leonardo's portraits were almost exclusively of women as this is against the trend of surviving portraits in the period. This might imply that they were all individuals of extraordinary character, who also had more time to sit for a particularly slow-working painter. What he eventually created, however, is not a typical portrait or straightforward likeness of a relatively affluent Florentine noblewoman. In this context, it is less surprising that the image was transformed in the workshop probably after the artist moved to France, in a way the original sitter would doubtless have been appalled by, into a version with the sitter represented nude and with more idealized features.[32] That the resulting image may represent Alexander's mistress Campaspe as painted by Apelles only

16 Lorenzo di Credi, *Virgin and Child*, London, National Gallery.

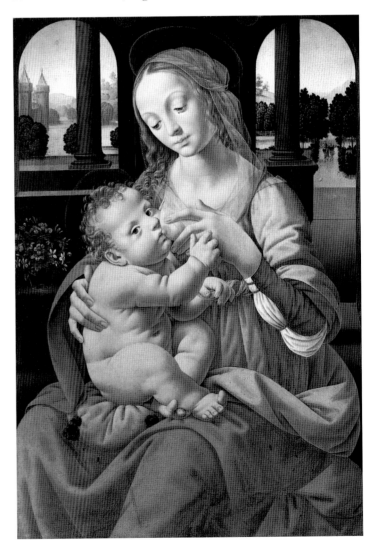

accentuates Leonardo's lack of concern for naturalism in the original portrait. So obscured and muted is the Louvre panel with dirt and discoloured varnishes that it is still difficult to make sense of its appearance, though the distinctive formal elements of Leonardo's portraiture are all present and can be catalogued: the interest in textures, the long hair falling in tightly curled strands, the sallow, silvery toned flesh and the vulnerable expression. But this image contains an additional quality that can more easily be defined by scanning his entire production, for Leonardo's development of portraiture is analogous to that traced with his religious pictures. He went beyond the delineation of a likeness and inclusion of attributes relating to virtue and morality of the type prevalent in Quattrocento portraiture: instead he sought to intimate with an intense frankness a complex inner state for his sitter that is disconcerting for the spectator. Generally speaking, this addition of the dimension of apparent thought, and with it personality, to the painted portrait constitutes one of the greatest discoveries for the history of art – Michelangelo brought the equivalent to sculpture.

The sitter here was originally not set in the open but in a loggia, which has been drastically reduced with the trimming of the panel at the sides, but is more evident in copies. The dark profiling of the head encourages the face to stand out in relief and also to be treated most subtly and gracefully against the subdued backdrop. The basic conception of the portrait is larger and broader, and less linear and distinct, than that found in any contemporary example. Yet the body is also surprisingly immobile for what might be expected of Leonardo, and the treatment of the sitter is more generalized than in even his own earlier examples. The burden of the expression comes instead through the searing look, enlarged features and the now infamous smile on an otherwise immutable and otherwordly face. The result seems surprisingly ponderous, uneasily relentless and even cloying in certain of its aspects and, again, was less widely imitated in Florentine art than the novel arrangement of the portrait sitter in a particular, localized setting.

The difficult, halting progress Leonardo made in Florence on the portrait of Lisa Gherardini is emblematic of his second Florentine period as a whole. It provides further evidence for how the city of his youth did not receive his complete attention even during the period from 1500 to 1506, and suggests that he may have considered leaving more often than he was able. In addition to continuing his scientific studies, there were physical absences, such as the sojourn of nine months starting in the summer of 1502 to work for Cesare Borgia. In 1504 he also travelled on two occasions, as a consultant on engineering tasks, to near Pisa and Piombino. What ultimately held him in Florence was the order from the repub-

lican government to fresco the *Battle of Anghiari* in the Sala del Maggior Consiglio of the Palazzo della Signoria: this was the main pursuit of his second Florentine period.[33]

It was not the first time that Leonardo was commissioned to decorate the seat of local government: in 1478 he had been contracted to produce the altarpiece for the chapel in the audience chamber of the Signoria, which Filippino Lippi eventually supplied after Leonardo had left for Milan.[34] The Lippi altarpiece survives in the Uffizi and has slight but unmistakable recollections of the conception and style of the work Leonardo may have begun to conceive for that project. The battle fresco was also abandoned in an incomplete state, and only copies after fragments of the design remain (figs 18–19), including a seemingly early painted copy on deposit in the Palazzo Vecchio and an engraving of 1558 by Lorenzo Zacchia possibly made after a *modello* by Leonardo himself. He may also have commenced in Florence the design for a painting of the Salvator Mundi in a half-length format, intended perhaps either for Isabella d'Este or, again, for the Florentine government, but, typically, there is no reason to believe that the master himself ever produced a finished version in paint and the image must be reconstructed from copies and derivations (fig. 20).[35] The compact, monolithic presentation of the young Saviour holding the globe contrasts markedly with the reactive vigour of the *Battle of Anghiari* designs and appealed to a different strand of taste in Florence, one on which Andrea del Sarto capitalized with his equally transfixing head of Christ for the tabernacle door on the altar of the miracle-working shrine of the Annunciation at SS. Annunziata.

The communal patron may originally have expected Leonardo to complete the whole projected work but he eventually shared the order for two large history paintings intended for the main hall of the Great Council (see fig. 192) with Michelangelo, who was probably commissioned in 1504, as will be discussed. They were very different in formal style and approach, with Leonardo demonstrating the variety of his fuller range in exploring details of costume and hairstyle, and Michelangelo his narrower concentration on the activated male nude. If the two designs helped alter attitudes towards narrative art in Florence for the new century, despite the fact that neither was finished and only Leonardo actually began any painting, their influence was not especially long-lived. Certainly it is of greatest significance that Vasari depended as much on the art executed in Rome by Raphael and his followers as models for lively and coherent narrative. The impact of the design by Leonardo tends to be transmitted through recalled individual poses and motives, or smaller groups of dynamic figures and, more conceptually, in the importance of a rigorous preparation. Yet because of the

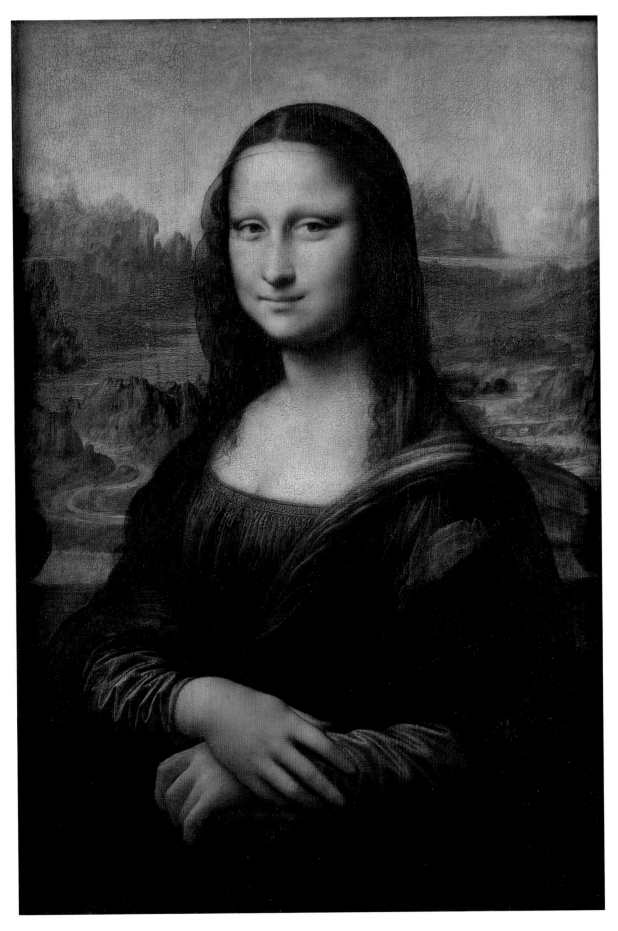

17　Leonardo da Vinci, *Mona Lisa*, Paris, Louvre.

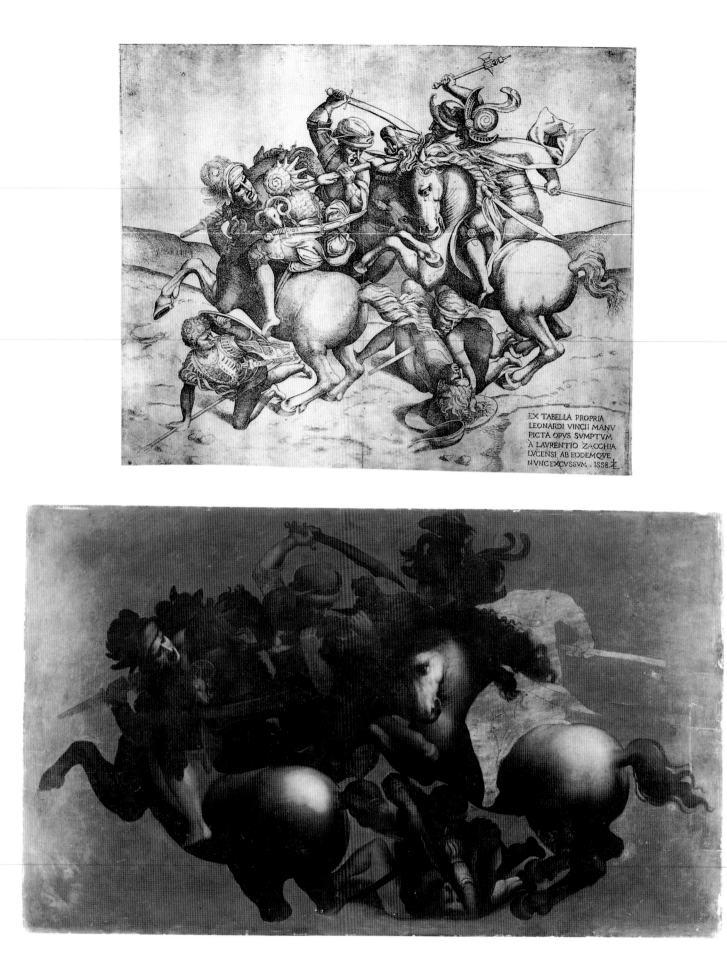

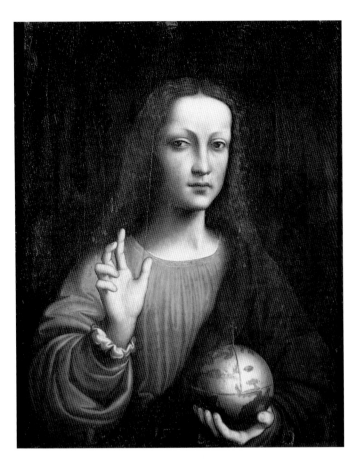

particular nature of the subject matter and placement, the formal possibilities suggested by Leonardo's *Battle of Anghiari* were not universally of the greatest relevance to painters in Florence, who rarely had cause to paint such violent themes on a monumental scale. One partial exception is provided by Pontormo's *Martyrdom of the 10,000* (fig. 21) which, while containing an uncompromising extrapolation of the force of both battle cartoons, including their episodic arrangement of different narratives, is on a limited scale (Vasari described it as containing 'figure piccole').[36] Painted during the siege of Florence around 1529 just before the final Republic was crushed by pro-Medici forces, Pontormo's work provides evidence for the deformation of a celebrated model in the later period through one of the few artists who understood some of its general stylistic implications. Not surprisingly perhaps, it was owned by Vasari's mentor Vincenzo Borghini, the Benedictine director of the Innocenti hospital and official of the Accademia del Disegno in Florence. Old Testament subjects even better allowed for the sort of liberty painters needed in order to inject some of their observations from the Palazzo della Signoria projects. Where artists perhaps most often did treat such heightened subject matter, however – on ephemeral scenery and triumphal entry decorations – it is now not easy to appreciate because of losses.

20 (*above left*) Attr. Giampetrino (after Leonardo), *Salvator Mundi*, Nancy, Musée des Beaux-Arts.

18 (*facing page top*) Lorenzo Zacchia (after Leonardo), *Battle for the Standard*, Vienna, Albertina.

19 (*facing page bottom*) Leonardo da Vinci (after), *Battle for the Standard*, Florence, Palazzo della Signoria.

21 (*left*) Pontormo, *Martyrdom of the 10,000*, Florence, Palazzo Pitti.

It is generally accepted that the frescoes by Leonardo and Michelangelo were meant for the long east wall, with the *Battle of Anghiari* on the right and the *Battle of Cascina* on the left. How they would have been framed is not known, though one would assume there to have been large areas of non-representational grotesque painting operating as a frame around these fields too. The subject of Leonardo's fresco was the military skirmish on the plain before Anghiari that had taken place in 1440 on the feast day of Saints Peter and Paul, when the Florentine coalition led by Pier Giampaolo Orsini defeated the Milanese Filippo Maria Visconti's men under the command of Niccolò Piccinino. The section generally recorded in copies is apparently that of the so-called 'battle for the standard' which formed the main section of the image. The chronology of Leonardo's participation is intricate.[37] On 24 October 1503 he was given the keys to a large room in the Sala del Papa on the premises of Santa Maria Novella where he could begin work on his drawings, though he may not have started work until January or February 1504 when the *cartolaio* was paid for the paper to be used in making the actual cartoons. A supplementary contract for the work was signed on 4 May 1504, replacing one signed not long before, in which he promised his remarkably patient and concessionary patrons to complete the preliminary cartoon by the end of February 1505. An unusual contractual clause, potentially rescinding the government's right to have another artist complete the work from Leonardo's cartoon in the master's absence (presumably insisted upon by the painter himself), stresses the fundamental importance of creative invention over original execution in this period in Florence, which may have been receiving new emphasis. Painting could not have commenced until after 31 December 1504 when the father of Benvenuto Cellini was paid for scaffolding erected in the council hall. Leonardo's progress with two minor assistants, Raffaello d'Antonio di Biagio and the so-called 'Ferrando spagnuolo', is intimated by the payments made from 30 April 1505 through to December of that year, but work was finally interrupted on 30 May 1506 when Leonardo was given permission to go to Milan for three months. Despite brief return visits to Florence in the following two years, work was never resumed. It seems that Leonardo spent about a year overall on the fresco and probably started only a relatively small central section featuring the symbolic struggle for possession of the cavalry flag.

In this commission Leonardo continued to experiment with a fresco medium modified with oil, but with tragic results. He seems here to have ill-advisedly pushed this technique even further than he had in the Milan *Last Supper*, for he could not fully complete any part of the Florentine fresco.

Francesco Albertini in 1510 wrote simply that Leonardo had produced 'li cavalli' in the Palazzo Vecchio, and presumably only some horses and perhaps their horsemen were discernible in a restricted area of the field.[38] As Giovio explained, the plaster rejected the colours ground in walnut oil, to which he added the remarkably cynical comment: 'However, it seems that the regret which was caused by the unexpected damage greatly increased the fascination of this unfinished work.'[39] Albertini mentioned that there were then still drawings by Leonardo in the Sala del Papa in Santa Maria Novella, although this room could only briefly have been opened for copying as any remaining sheets had already been shredded into talismanic pieces by the 1510s. The young polymath Anton Francesco Doni in 1549 mentioned that at one of the Medici villas 'un pezzo di battaglia di Lionardo' was still visible containing horses and men 'which will seem astounding to you' ('che vi parrà una cosa miracolosa'), which was presumably another cartoon fragment.[40] And so Leonardo's spoiled and peeling fragment remained exposed for a time in the hall – a bizarre testament to the artist's technical failure at this critical moment for Florentine painting while Perugino laboured at SS. Annunziata. As the prominent historian and literary figure Benedetto Varchi stated in 1564 during Michelangelo's funeral oration, Leonardo's by then destroyed horse group alone was 'so fierce, and in such a new manner that until then nothing so beautiful had been seen, and no object could ever compare to it.'[41] There was nothing left to salvage even to the historically curious when, in 1563, Vasari obliterated any remaining fresco in preparation for his own large-scale decorations in the hall (whose roof had also by then been raised), and his *Battle of Scannagallo* probably covered any remains of Leonardo's catastrophe. The de facto ruler of Florence, Cosimo de' Medici, no doubt also preferred to have this latent republican image in his Palazzo Ducale unceremoniously destroyed.

It emerges from the evidence of copies that Leonardo attempted to paint only the central section of the field concentrating on the fight for the standard during the Battle of Anghiari proper. If the painted copy is to scale, the figures in this area would have been, amazingly enough considering the impression they generate, under life size. The artist brought a level of expressive violence and kinetic force to narrative painting never before seen, even if the battle scenes here had a Florentine precedent in some of Verrocchio's powerful sculptural reliefs. Leonardo's belief that a painter could evoke a battle better than a poet, because the medium allowed for more vivid directness in revealing the almost centrifugal degree of violence and pathos of conflict in a single moment, is evident in his conception of this fresco and, indeed, would

22 Giovan Francesco Rustici, *Conversion of Saint Paul*, London, Victoria and Albert Museum.

have been accentuated by its very indistinctness, but only for those who managed to see his rapidly perishing final attempt.

Just how Leonardo's image was perceived in the period immediately following his death is suggested by a painting attributed to his close follower and collaborator Giovan Francesco Rustici.[42] Dating perhaps from around 1525, the unusual picture (fig. 22) is the only painting by Rustici cited by Vasari that can be identified.[43] Given as a gift by the artist to Pietro Martelli, the nominal subject of this large horizontal panel is the Conversion of Saint Paul, though no halo is visible on the main figure (there is, however, a yellow glow in the sky indicating a divine appearance). The principal event of the religious narrative is subsumed by the distracting, disintegrated formalism of the interpretation which owes so much to Leonardo's battle cartoon. The sweeping landscape, including the superimposed ruin of a temple at the left, is attractive but the main interest of the painting is the bracing activity displayed for maximum effect in the first plane, where the horses and soldiers do not even seem fixed to the ground. The painting captures the indulgent activity and fully

sculptural potential of the *Anghiari* designs better than any other surviving work of the period, while sacrificing its intense emotionality and frenzied vigour. It is significant – in demonstrating how scholars have restrained themselves somewhat when situating Leonardo in the history of art – that the Victoria and Albert Museum panel has been classed an 'eccentricity' (it has been attributed to the 'Master of the Kress Landscapes', for example) when, in fact, it may closely reflect his general intentions for his art in this period, given Rustici's unparallelled proximity in Florence to the older master with whom he sometimes collaborated.

A design developed in Florence around the same time as the *Battle of Anghiari*, the *Leda and the Swan*, is a more explicit demonstration of Leonardo's ultimate attitude towards the antique. The subject of the major mythological painting of his entire career allowed him to meditate on one of his preferred themes as frequently voiced in his religious art, that of a human figure interacting with an animal. The *Leda* was not cited by Vasari, but a document of 1525 recording the possessions of Leonardo's companion and follower Salaì, indicates

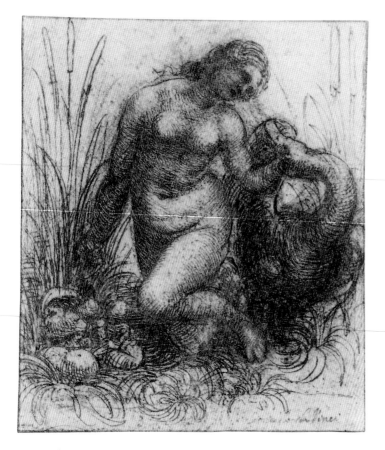

23 Bachiacca, *Leda and the Swan*, Rotterdam, Boymans-van Beuningen Museum.

versions of the composition known through preparatory sketches, which probably only included more or less the main pair of figures, were accessible to Florentines and, typically, some of the design ideas at least had a schematic influence.

A copy on canvas after Leonardo's *Leda* (fig. 25) of the painted redactions reflects partially the earlier version of the standing designs available in Florence. The version with Leda kneeling was reflected almost immediately in a painting by Piero di Cosimo, as will be discussed, while the one in a standing posture was copied in numerous paintings. The principal copy in terms of formal quality remains the one by Sarto (fig. 24), from his richest period of the 1510s, in which the head of the main standing figure turns in the other direction. It is most probable that Leonardo's development of this image led to a vogue in Florence for pictures of the subject by artists like Sarto and also Bachiacca (Baccio Bandinelli too attempted to produce a seated version for one of his rare paintings, apparently without a proper commission). Leonardo's design also satisfied a need for painters by

24 Andrea del Sarto, *Leda and the Swan*, Brussels, Musées Royaux des Beaux-Arts de Belgique.

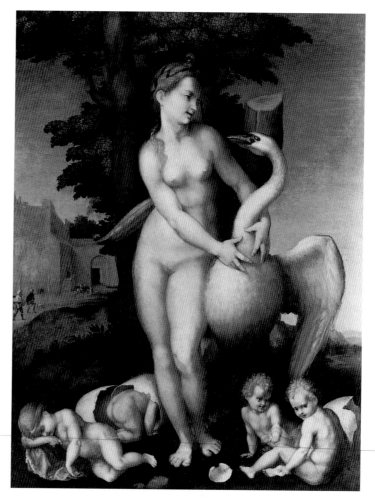

an autograph painting of the Leda was considered to have existed at a moment not long after the artist's death (the example apparently entered the collection of Francis I of France and presumably perished in the humid atmosphere of the Appartements des Bains at Fontainebleau).[44] To complicate matters, there are different versions of the design known from copies and drawings, especially a more daring and almost suffocatingly erotic one with the Leda figure in a kneeling pose recorded in related studies in Rotterdam (fig. 23) and Chatsworth. Sketches for this initial version of the subject appear on the same sheet as studies for the *Battle of Anghiari*, so Leonardo probably began work on this mythological picture towards the end of his second Florentine period, perhaps about 1505. However, it is not known for whom the *Leda* was intended, though it may well have been for a Milanese or French export patron. It does seem reasonably certain that it was not meant for the Florentine market, and that the commission possibly predated his return to Florence in 1500, if not the first serious attempts at a design. Characteristically, Leonardo created a more definitive, final version of the theme only much later, possibly during his Roman sojourn starting in about 1513.[45] But both basic

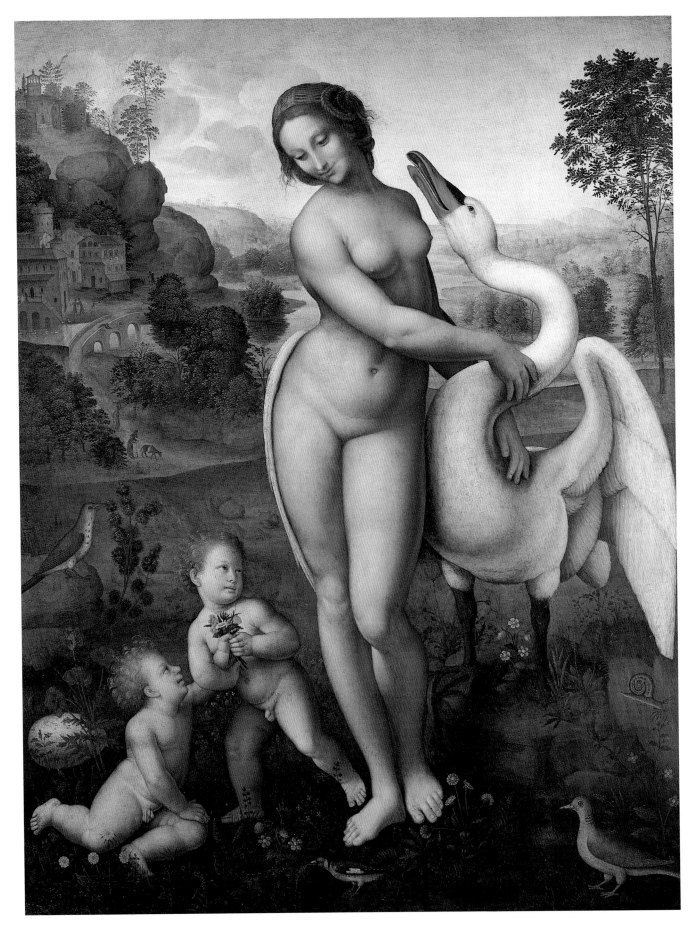

25 Leonardo da Vinci (after), *Leda and the Swan*, Rome, Galleria Borghese.

allowing them to demonstrate their interest in antique art but through a modern design, well distributed in drawn form. Overall, this listing is remarkable for illustrating how even an unfinished Leonardo could generate a huge interest in artists and, presumably, potential collectors alike, in a place excited about any visual trace of his style. Whether these painters thought they were merely copying Leonardo's invention or, more positively, giving finished form to an exciting idea unrealized by its inventor in a collaborative sense is an intriguing question. Equally, it represents a phenomenon whereby a given subject for the history of art became widely popular not so much for what significance it had for any given patron, but simply because it had been treated by a celebrated artist.

The image is based on the Greek myth, recorded in Ovid and elsewhere, of the Aetolian princess Leda to whom Zeus made love disguised as a swan, which led to the birth of some famous offspring including, in one version of the myth, Helen of Troy. Although the formal inspiration for the painting was the antique, in small-scale works such as gems and cameos more than any monumental marble, the activation and provocative sensuality of the nude, as well as the rich, fertile landscape of Leonardo's conception surpass any surviving classical model (a similar transformation is traceable in Michelangelo's sculpture *Bacchus*, or his own later painting of Leda for Alfonso d'Este). The actual narrative is handled in disengaged, even emblematic terms with the figures taking separately conceived poses, and this gives the image in part the appearance of an aggregate demonstration piece of a highly elitist type, as does the decorous, under life-size scale of the main character. The naturalistic rendering of the swan and openly erotic gesture of the almost quizzical Leda contribute, however, more disturbing aspects to the picture.

In the *Leda*, Leonardo invented a dynamic new canon of the female nude for the sixteenth century consisting of a standing pose, loosely based on an s-curve, with the upper body, lower body and head simultaneously flexed, twisted and thrust in different directions and the feet placed close together but angled outwards. The rather robust, ample nude with a relatively small head represents his ideal female type. If Verrocchio provided a direct and revered model for Leonardo's interest in the elaborately braided but partly loosened coiffure of the *Leda* with its fluidly weaving and intertwining sinuous lines that betray a deeply personal aesthetic pleasure and sense of artistic virtuosity, there were now no precedents for his development here of the female pose. This belongs fully to the new century. Thus it emerges that Leonardo undermined his immediate artistic inheritance as well as that of the antique because he did not need a classical precedent to lend authority to his nude, as Lorenzo di

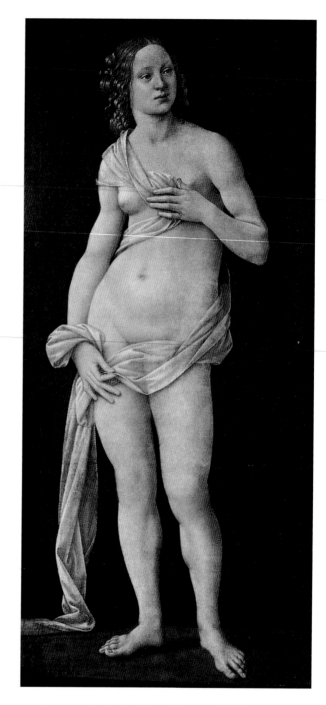

26 Lorenzo di Credi, *Venus*, Florence, Uffizi.

Credi did for his *Venus*, probably from the 1490s (fig. 26). No other work by Leonardo better encapsulates Vasari's axiomatic remark about modern artists of the third age attempting to equal and surpass antique art. Indeed, if any painting is literally anti-classical art in its antagonism to antique models and ideals, it is Leonardo's *Leda and the Swan*. This anti-classicism qualified the general importance the antique might have had for Florentine painters in the period leading up to 1550: if there was healthy respect for classical forms among the most

deeply committed artists, there was no far-reaching slavish revival, as there was in Rome.

In sum, there is no doubt that the extraordinary quality of Leonardo's art attracted considerable attention in Florence in the first half of the sixteenth century, even if what it suggested was perhaps ultimately more potent than what it literally demonstrated. The atmospheric quality of his pictures contributed an aspect of subtle naturalism and evocative, shifting meanings to these works that contrasts with the crystalline clarity of much Quattrocento painting. His exploration of an elaborate type of modelling, to which the verb *sfumare* was much later attached, allowed him to insinuate a subtle, literally unfathomable dimension to his painting.[46] The overwhelming force of other completed efforts, however, like Michelangelo's Doni Tondo, ensured that there would be up-to-date local alternatives to Leonardo's technical model, which was, ultimately, of more universal importance for the history of painting in Milan than in Florence. Nevertheless, Leonardo's inability to complete his work, as well as the inherent complexity of his drawing and painting techniques, probably led to confusion in the minds of imitators as to how to produce paintings with such effects. So while his development of different formats and of dynamic, dramatic narrative and all its implications for variety of gesture, expression, setting and paint handling was his single most important contribution for the new century, some of the developments from his work were based on misunderstandings of his intentions. Leonardo's elaboration of a new emotional force of representation was an uneasy one fostering the production of unavoidably disunified images, with a mental tension and uncanny ambiguity. The appeal to other painters is easily documented, but one is driven to wonder whether his few designs were too subtle to have the inflexible, unequivocal and permanent messages that clients and patrons would generally have expected, particularly in the case of altarpieces. So in terms of outward style, Leonardo was arguably a more elusive and uneven artist than definitions of the High Renaissance allow. Accepting this creates a different sense of a period in which experimentation and novelty were at the heart of artistic practice – this very difficulty and obsession with

inventiveness in all of its aspects, formal and iconographic, respecting a Florentine artistic tradition, as outlined in the first chapter. Contrary to his example, Vasari felt compelled to develop a more coherent alternative.

Leonardo simply transformed the attitude of the most perceptive artists in Florence towards the nature of the creative process, inevitably delaying and even devaluing final execution, such that he could create images with considerable effort which he never intended to produce on his own. In career terms, this complicated the artist's relationships with his patrons and could lead only to their neglect, since his main concern was to satisfy his own judgement and the potential criticism of other artists. The unfinished works, the refusal to deliver basically finished paintings, the experimental techniques, the increased number of preparatory drawings undertaken and his itinerant lifestyle all support this view. At the same time, with Michelangelo, Leonardo helped establish a new way of collecting, as works became desirable to possess, even if displaced from their original context. The very rarity of his art contributed to its preciousness and fame, in contrast to Perugino whose merit was established more by the general availability of finished examples of his imprint. Leonardo's relentless attitude towards invention also transformed the ways a workshop could function and seemed to inspire artists either to develop a more sophisticated system of collaboration and dissemination of motifs, as in the case of Sarto, or to reduce the role of the shop altogether and concentrate on design in conjunction with a looser final execution, as in the case of Rosso Fiorentino. Broadly speaking, despite their strangeness and incoherence, and in part because of the very insecurity of such efforts, Leonardo's explorations lie somewhere behind many of the innovations produced later in the sixteenth century by so-called Mannerist painters such as Rosso and, especially it seems, Pontormo. In Florence, the polymorphous Leonardo presented artists with a series of original questions, but ones even he himself could not fully or adequately answer. This left a diverse group of local artists with the dilemma of whether to ignore him as a curiosity or to attempt to imitate him at their peril.

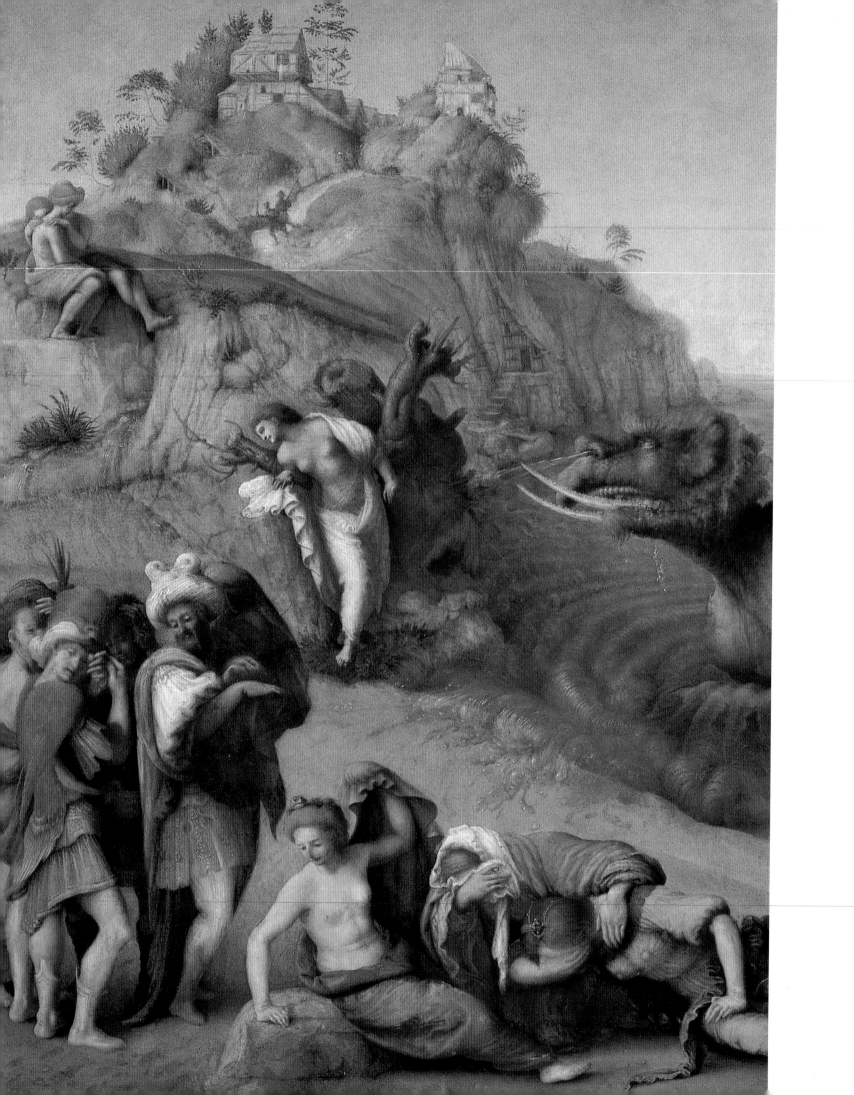

PIERO DI COSIMO: A RENAISSANCE 'ECCENTRIC'?

B Y IMPOSING BOUNDARIES ON THE HISTORY OF ART, it is easy to overlook how the innovators of earlier generations lived on to witness and sometimes facilitate the rise of yet younger innovators. In Florence a group of painters established in the Quattrocento continued to practise well into the sixteenth century, in particular Filippino Lippi, Sandro Botticelli and Piero di Cosimo. Some of the earliest memories of the artists born in the mid-1490s, such as Pontormo, Rosso and Baccio Bandinelli, would have been of public work by these liminal figures, and it must have considerably attracted them. All are distinguished towards the end of their careers by an apparent eccentricity, which is more properly classified as an aspect of fantastic inventiveness evolving directly out of widespread Quattrocento concerns. It was not, therefore, an especially new artistic quality when young painters like Rosso, Pontormo and a number of others, immediately developed it in their own startling earlier productions. While older artists such as Lippi and Botticelli have generally been suppressed in chronologically driven accounts of art of the High Renaissance period because they are assumed somehow to have lost their creative edge, this can misrepresent both their historical importance and some of the principal stylistic tendencies of the later period.

It was above all Piero di Cosimo, the first Tuscan painter following Leonardo to be given a Life by Vasari, who proved the most consistently and directly relevant of the celebrated artists for the younger talents emerging in Florence after 1500. Indeed, of those ageing masters he is the ideal test case for our understanding of what importance the fifteenth century could have for the next in terms of specific influence as well as general approach, since he lived further into the new century than either Lippi or Botticelli and was more active overall. Indeed, more than any Florentine of his generation Piero provided a living model in finished paintings for a high degree of pictorial charm and iconographical inventiveness, often personal and extravagant, that was a major stimulus for the development of the so-called Mannerists. Yet even this far-reaching statement is too restricted, for Piero's impact is felt on almost every early sixteenth-century Tuscan artist, including the naturally talented characters who seem to have passed directly through his workshop like Andrea del Sarto and Pontormo, but also those practising apparently conservative and dour styles such as Ridolfo Ghirlandaio, Giuliano Bugiardini, Fra Bartolomeo and Mariotto Albertinelli. The very range of his influence should itself warn against over-generalizing about stylistic trend in this complex and heterogeneous period in Florence.

Piero di Lorenzo di Piero, called Piero di Cosimo after his master Cosimo Rosselli, was born in 1462 to a craftsman father and died in 1522.[1] He was therefore about a decade younger than Leonardo, though he outlived him by only two years. While he showed a thoughtful interest in the more accessible aspects of Leonardo's example, Piero's style was never derivative of the older master's: the former provided rather a benchmark of anticipated creativity of which the painter was constantly aware. Had Leonardo based his entire career in Tuscany and been of a relatively more disciplined and conservative character, Piero would be a model for the sort of career he might have had, and so a closer study of the younger artist is of additional conceptual importance. An examination of Piero's work also helps relieve the impression that the history of painting in Florence around 1500 can simply be approached as a contrast between the opposing styles and methods of Perugino and Leonardo, when the reality was much more fluid. While he may have been ambivalent about Perugino, Piero was one of the first Florentines to deal successfully with the problem of how to accommodate the brilliant but frequently impractical innovations and explorations of Leonardo by navigating an independent and conscious middle course through which he explored his own priorities. While Vasari gives the misleading impression that younger artists in Florence could have learned everything about the new art from study of the Anghiari battle cartoons, an equally respected, high-calibre and multifarious artist like Piero helped to make a bridge between generations through his example of professionalism.

In terms of consistent patronage from a group of sophisticated local patrons, he certainly never had any serious competition from either Leonardo or Michelangelo. Like them, he created an innovative style that was at the root hard to imitate, if not emulate.

From a factual point of view, Piero is a mysterious figure, probably more than any other major Tuscan painter of this period, and if this creates confusion in dealing with his stylistic development and patronage, it does explain why he remains somewhat difficult and elusive to place. The lack of primary documentation accounts in part for the tendency to limit his significance, by dating major works like the Innocenti and SS. Annunziata altarpieces too late on stylistic grounds, despite the fact that Piero produced some fifty finished paintings over a lengthy career based almost exclusively in Florence. The earliest surviving work to which archival documentation has been directly applied is the *Visitation with Saints Nicholas of Bari and Anthony Abbot* (in the National Gallery in Washington), which was probably completed just after 1489 when the frame in the chapel of the Capponi family in Santo Spirito was finished.[2] Previous to this, there is evidence that he belonged to the painters' confraternity of Saint Luke by 1482.[3] The completion date of the artist's Innocenti altarpiece, surviving in the museum of the Ospedale in Florence, has been confirmed as 1493 at the latest in reference to a set of documents for its installation and the fitting out of its altar controlled by the Pugliese family.[4] The bacchanals painted for Giovanni Vespucci were probably not produced earlier than 1499 when the family palazzo opposite the church of San Michele Visdomini in the Via dei Servi was constructed.[5] Two paintings definitely from this series, featuring the wasps that make a pun on the patron's surname, are the *Discovery of Honey* (in the Art Museum in Worcester, Massachusetts) and the *Misfortunes of Silenus* (in the Fogg Museum at Harvard). In 1504 Piero is finally cited for the first time in the records of the painter's guild of the Arte dei Medici e Speziali, though this apparently late record indicates more about the survival of the source than the painter's practice. An as yet unidentified panel painting of the Virgin ordered by Federico Gondi is documented as having been sent to Naples around 1505,[6] while the date of the *Incarnation* altarpiece (now in the Uffizi but painted for SS. Annunziata) has been circumstantially established as 1505 from the evidence of the will made by the chapel's patron Pierozzo Tedaldi, though it was probably executed closer to 1500 to judge by its style.[7] Piero was also a member of the confraternity attached to the church of the Annunziata, where he would be buried. The Uffizi *Liberation of Andromeda* has been plausibly associated with a payment of 1510 from Filippo Strozzi the Younger for a *spalliera* panel, even though on

iconographic and stylistic grounds this has been unconvincingly contested in favour of a date following the restoration of the Medici family in Florence in 1512.[8] Even with Vasari's Life of the artist to supplement knowledge of Piero's career, with only these few fixed chronological points, it must necessarily be considered in the broadest terms at this stage.

The *Immaculate Conception with Saints* in S. Francesco in Fiesole (fig. 27) appears to be Piero's only signed and dated picture. The signature and date written on the base of the panel ('Pier di Cosimo 1480') must both be additions, however, because its style points to the last years of his life, sometime in the 1510s.[9] Nevertheless, despite the apocryphal signature, this work can still introduce the artist, as it displays and concentrates many of his most outstanding qualities. The squarish panel is no longer in its original location, but has apparently been moved to the right nave from the roodscreen or transept of the church referred to by Vasari, where it was presumably on the left-hand side for a viewer facing the high altar, to judge by the viewing angle.[10] Its patronage remains a complete mystery. The design is unusual, predicated on the slanting block on which Francis and Jerome kneel, dominating the lower middle of the panel. By virtue of the intrusion of this platform, which is to be understood as an extension of the real altar, the other four saints, identified as Augustine, Bernard, Thomas Aquinas and Bonaventure, appear as three-quarter lengths. The truncation of these figures and the altar-like extension create the powerful illusion that the real space of the church co-exists with the fictive divine realm in the painting to give it greater illusionistic power. While this inclusion of three-quarter length figures had implications for pricing because a painter would traditionally charge more for full-length saints, the result is nevertheless startlingly original for Florence, and only Sarto in his late Sarzana altarpiece (formerly in Berlin, now destroyed) attempted anything like it in design.

Despite the spatial drama accentuated by the empty, sun-parched landscape, this magical altarpiece is hauntingly gentle and taciturn in expression, perhaps even elegiac – partly a result of the intrinsically visionary, abstract subject matter – a much debated one not directly sanctioned by the Gospels that had been traditionally promoted by the Franciscan Order.[11] In Piero's altarpiece only Francis and Jerome concern themselves with debating the doctrine of the Immaculate Conception, alluded to by inscriptions placed in nearly all areas of the picture. The upper part includes an unusually ancient and benign-looking God the Father selecting the Virgin with a rod (an allusion to the apocryphal story of King Ahasuerus and Esther) to indicate the Immaculate Conception, while he courteously turns a tablet towards her. The figure of the young Virgin, ethereal in form despite being the focus of

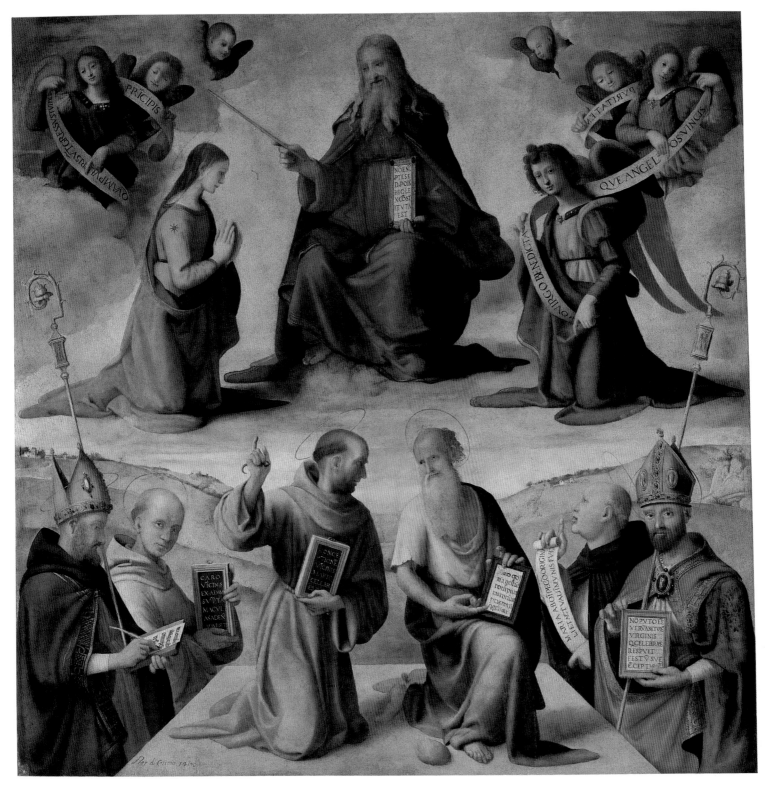

27 Piero di Cosimo, *Immaculate Conception with Saints*, Fiesole, S. Francesco.

iconographic attention, is paired with an extra, full-length angel, who with outward gaze and frontalized placement appears more physically solid than does the Saviour's mother.

Individual figures are rather stiff and fragile, seemingly nostalgic of a Trecento taste: Vasari praised it as a 'cosetta', so emphasizing the precious sense of scale. Structuring this exquisiteness, however, the saints exude a definite sculptural power with their square shoulders and large, articulate hands. The broadly moulded draperies contribute to this impression of malleability and bulk. Even the painting technique reflects this contrast between elegant delicacy and flexible solidity. The work is illuminated evenly in a filtered, granular light, but it is heavily impastoed too, approaching in finish a painting by Sarto rather than one by Piero's closer contemporary Fra Bartolomeo. The laying in of colour with few shadows might well be compared instead to the effect generated in Pontormo's later altarpiece of the *Pietà* in Sta Felicita in Florence. Piero's distinctive interest in uncanny observation is evident as in the mitre of the saint at the left edge that bends his ear, while he is caught in the act of reinforcing a letter on his tablet rather than writing one. The awkwardly repaired sleeve of Saint Jerome, who is dressed in a soft blue instead of his canonical red, is also typical of the painter's acute visual sensitivity, as is his heterodox insistence on leaving the bent nails of Francis's stigmata in his hands.

Rather than church altarpieces, however, Piero di Cosimo's mythological paintings are his most characteristic surviving works. These present separate problems of patronage, dating and interpretation from the religious ones. It is through these strictly private images, above all, that issues relating to Piero's capricious originality can be addressed with more purpose, and they should be examined first. Some of the interpretative difficulties can be encapsulated through a painting neutrally titled in the National Gallery, London, as *Satyr mourning a Nymph* (fig. 28), but usually known as the *Death of Procris*. Probably painted around 1500 for a still unknown client (this domestic work has a Guicciardini family provenance), it is not part of a *cassone* chest but an inset *spalliera* panel – the low viewpoint is evidence for its original installation relatively high up on a wall above the dado level. This enchanting image naturally calls to mind the story of Procris and Cephalus recounted in Ovid's *Metamorphosis* and would therefore be an appropriate decoration for the marriage bedroom by warning of the perils of jealousy between husband and wife. But the nymph should have been murdered with a spear after spying on Cephalus, whereas there is no spear in the painting, and there seem to be more than one wound. Nor is a satyr kneeling by the body pushing away the girl's hair from her face mentioned in the primary text, even if a faun does appear. This makes interpreting such an image problematic, without resorting to intricate theories regarding source material that deny the artist his unique creative power. It could be argued that such a text, which might have been a corrupt one, has merely eluded scholars.[12] Similarly, the painter may have taken so much license in interpreting any sources that they can no longer be identified, even though Piero was perfectly capable of illustrating a source when called for by circumstances. To give Piero fuller credit, however, it is possible that he attempted to create a visual analogy for a piece of writing, as if to compete with and challenge the written word instead of merely illustrating

28 Piero di Cosimo, *Satyr mourning a Nymph (Death of Procris)*, London, National Gallery.

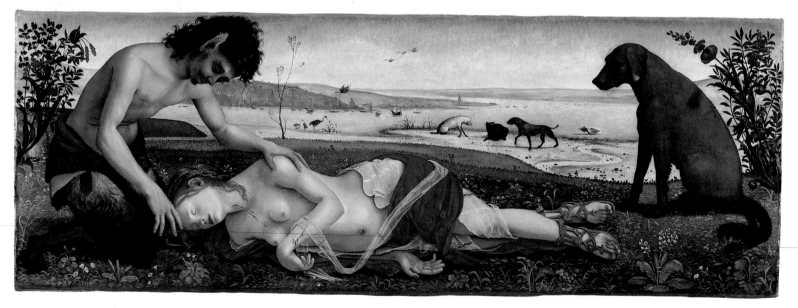

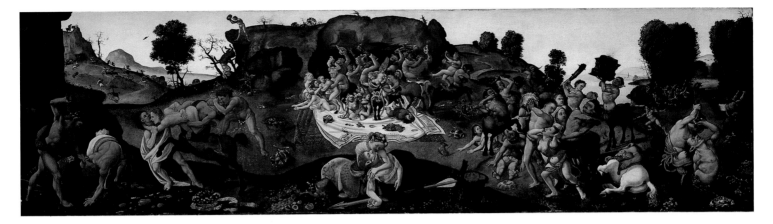

29 Piero di Cosimo, *Battle of Lapiths and Centaurs*, London, National Gallery.

it – a view that undermines the modern scholarly approach to his mythologies, obsessed as it is with the mining of fairly obscure literary sources. Given that writing and painting in the Renaissance were recognized as autonomous and incompatible expressions, one is driven to wonder how far a knowledge of learned writings was considered even relevant to an artist's constitution in this period. Perhaps the London panel is primarily a beautifully still and openly presented painting of merely evocative subject matter featuring a dead nymph with a small, delicate body – her blood-stained hand providing eloquent proof of a violent death as she must have held one of her wounds before expiring. Artistic devices are certainly on full display in Piero's picture, such as the foreshortened face used here as metaphor for physical pain, or the drapery wrapped around her body, which is coloured red for obvious symbolic reasons. Whatever its exact subject, the painting also demonstrates that Piero had a lyrical sensitivity and sensibility when justified, and that the 'primitive' subjects he is commonly associated with were only one part of his repertoire. This contrast is well exemplified in his *Battle of Lapiths and Centaurs* (fig. 29) by the sensitive portrayal of the central pair of heroes isolated from the incredibly tumultuous action around them (fig. 30), a motif that would have appealed to Leonardo, assuming he knew the work.

The hypnotic profile *Cleopatra* (fig. 31) demonstrates, on the other hand, the more flagrantly luxuriant aspect to Piero as a painter of secular themes. This time he treated a securely identifiable subject from Roman history, though his interpretation of the image is still far from straightforward or purely illustrative. Dating perhaps to the 1480s, the painting represents the death of Cleopatra which belongs to the category of celebrated women of antiquity who committed suicide, such as more virtuous names like Lucretia. The moralizing found in some of the written accounts of Cleopatra's passing is not hinted at in the ambiguity of the painted image.

Piero may evoke a specific moment before she was mortally wounded by the asp, represented like a living necklace, though his handling of the theme is distinctly non-narrative to the point that the subject might itself be open to reinterpretation. The picture primarily celebrates the exotic beauty of the Queen of Egypt, as evidenced by the long neck and fancifully elaborate coiffure. The snake can be better understood more as an attribute than a narrative device. The inscription identifies her as Simonetta Cattaneo Vespucci, the famous beauty who died young in 1476, and who may be the Flora in Botticelli's *Primavera* of about 1478, according to the wishes of Lorenzo de' Medici. But this has sensibly been

30 Detail of fig. 29.

and more episodic treatment of the narrative. The Oxford *Forest Fire* (fig. 34) might reasonably be viewed as an independent work of art, perhaps the latest of this grouping to have been executed to judge by its formal style, and as such is somewhat emblematic of the artist's achievement in Florence around 1500 in treating this more characteristic theme of the savagery and ignobility of nature and 'early man'. On a general level, the Oxford picture, like many others by Piero, visualizes the entertaining degree of tension one feels in reading about 'primitive' history as in Lucretius' *De Rerum Natura* – a text that was, nevertheless, explicitly critical of belief in the sort of fantastic creatures that Piero often represented. The *Forest Fire* contains no familiar subject but a disjunctive narrative with animals fleeing the fires. Human figures either flee also or concentrate on bringing water to the fire. The composition is not firmly set. Instead, Piero loosely divided the picture by the placement of trees. Technical examination reveals that, in spite of this loose arrangement the painting was carefully planned and contains few *pentimenti*.[21] The birds, for example, were clearly studied separately and the finished studies from these sessions applied directly to the panel, not always smoothly. Piero commonly used this aggregate approach. The result is not wholly literal or analytical, however. The artist gave the animals plausible expressions, such as the mother bear, who panting in exhaustion leads her cubs over a crest in the foreground. As conservation of the panel has revealed, the two human faces added over those of real animals do imply, however, a certain improvisation in the treatment of the iconography, probably of the artist's own initiative who would not, therefore, have been trying to follow rigidly a literary source. Whatever their precise meaning, these odd creatures are doubtless intended to evoke a vicarious sense of doom in the viewer. The decorative richness of the work and the transparent beauty of the glowing distances in the forest and rich, coral colours can now be appreciated after a recent cleaning. Piero's other mythological paintings may also reveal similar surprises beneath their paint surfaces.

Broadly speaking, to put Piero's mythological paintings into context is an exercise complicated by the realization that it is the artist himself and not his individual patrons who provides the common denominator in their production through the repetition of favoured themes in his secular subject matter. It seems that prospective patrons in Florence were attracted to an artist who had developed the market in particular subjects, in Piero's case narratives relating to nature and 'primitive man'. Accepting this, it becomes doubtful whether paintings of this cognate theme were always executed for the same commission, or that individual patrons implored him to illustrate texts they had coincidentally troubled to

Detail of fig. 34.

select, when he was the specialist. Indeed, in part because of the highly personal circumstances in which they were produced and displayed, although they were occasionally copied Piero's secular works did not have much of a definite legacy in the sixteenth century in terms of his acutely personal and elaborate approach to narrative, as distinct from formal style and the model of independent invention promoted. To this extent, his sophisticated explorations in secular imagery can be seen as not just the climax but the apotheosis of an illustrious tradition of Florentine domestic secular painting, to be mined more for stylistic qualities than their relatively hermetic iconographic sources, just as artists concerned themselves more with the formal clues of Leonardo's work than any of its theoretical underpinnings. The greatest private decorations of the early sixteenth century in Florence, such as those for the Borgherini and Benintendi, were of religious subject matter, generally derived from the Old Testament. Presumably, the very subjects of Piero's paintings that we find so difficult to identify were forgotten relatively soon after their delivery. It seems doubtful that Vasari and his contemporaries would have had any more success than modern scholars in reconstructing the late artist's intentions.

This recognition also casts light on the question of Piero's 'eccentricity'. It must first be admitted that identifying such bizarre aspects in a Renaissance painter is not straightforward. In the case of Piero di Cosimo, Vasari is our sole literary source for his misanthropic and brutish character, even if, as seems likely, he based his account in part on conversations with younger artists such as Sarto who knew Piero in old age. While overlooking the untroubled social facts of the artist's life, Vasari's biography of Piero is replete with anecdotal records such as the one about the artist who would eat only boiled eggs, which are so colourful in literary content that they must be in part fictional.[22] It is possible that Vasari constructed an image of an otherwordly savage based on the artist's preference for 'primitive man' themes, as well as on his predilection for recording unusual details and for northern European art – extrapolating an image of the man from his characteristic imagery.

Certainly Vasari had his own personal, even didactic motives in publishing a book in 1550 that accentuated the negative aspects of anti-social character through an artist who died in Florence when the writer was just ten. The ever obsequious Vasari felt driven to attack, and make a special example of, what he described as the artist's wild character because this lack of self-control harmed the type of prospects for international patronage that the Aretine valued and for which he saw little evidence from his knowledge of Piero's career, based as it was almost exclusively in Tuscany and a relatively small circle of patrons. Vasari harboured the same prejudice

against Leonardo, but because the latter artist was of a more divine stature as the leading painter of a new age, he suffered less than Piero from this type of critique. Given the calorific tone of some of Piero's modern historiography, it needs to be stressed that there is also straightforward praise for his art in the biography, and not just admonishings over a lifestyle. Vasari isolated his excellent technique producing soft, richly coloured paintings, as well as the spirituality and delightful inventiveness of his art – loaded terms that could easily be used to characterize the style of Rosso. Central to Vasari's more positive appreciation of Piero's work is a notion of *fantasia* or pure imagination, to which the misleading and inadequate later charge of eccentricity has an indirect link.[23] The combination of exotic fantasy and verisimilitude in his style generated a kind of fantastical hyper-reality that was more awesome for seeming real, and this aspect of Vasari's analysis of Piero's style retains its potency. Yet pointing out conventional literary elements in the biography and its overall purpose in warning artists working in the mid-sixteenth century about excessive behaviour tends to distance Vasari from his primary subject and by extension normalizes an undoubtedly sensitive painter like Piero. The difficult question of his personality and its relationship to his work is thus neatly but unsatisfactorily sidestepped.

The case of Piero, and in the same way Pontormo later in the sixteenth century, illustrates the perils of equating the construct of a personality found in a written text like Vasari's directly with an artist's work. So his account must be temporarily suppressed in an attempt to reveal the artist in a more generous spirit. Certainly, Piero's art is neither uninhibited nor ineloquent. The esoteric subjects represented in his mythological paintings themselves allow for an elevated, fertile and receptive mind. Unexpectedly perhaps, one recent historian has claimed for Piero over Botticelli a superior intellectual position, far removed from Vasari's picture of a wild recluse, for in his words the artist's historical paintings can be readily paralleled with the most history-conscious humanists.[24] Disquieting eccentricity could itself be an intellectual stance in the Renaissance both for artists and writers. Similarly, a preoccupation with the grotesque, such as the depiction of human heads on animals in the *Forest Fire*, might be interpreted as an interest in one of the few surviving forms of ancient art, and so a sophisticated one. If we deem acceptable a proposed interpretation of the 'primitive' subjects Piero painted for Francesco del Pugliese as anti-Medici and signalling the rise of a Borghese movement in Florence, we may have to admit another aspect to the artist's personality, that of a self-consciously political creature, whose occasionally brutal imagery had a subtle contemporary edge.[25] If Piero perhaps most often cultivated the more uncompromising side

carefully structured in its layout and is compact with short, stocky bodies and overlapping forms. The work is basically symmetrical and controlled, but in an attempt to enliven the iconic altarpiece the image is predicated on the narrative of a double mystic marriage between the Christ Child and Saint Catherine, who receives a ring, and Saint Dorothy, from whom he appears to take rosebuds. Piero's figures are seen close up giving them a force and monumentality, evidence of his desire for a vibrant, immediate impact – the type of qualities that modern painting was expected to contain in the written opinions of Giovio and Vasari. The palette has shifted notably towards solemn darks, as Piero moved away from the angular contours and wide areas of colour found in his earlier production, such as the other Pugliese altarpiece now in Saint Louis, to a more tonally aware painting style of the sort only hinted at previously. If not atmospheric, the effect is intense, as he introduced a darker, more harmonized selection of saturated colours combined with a polished surface, which influenced sixteenth-century painters as much as the examples of Leonardo or Michelangelo. And so Piero explored in fully completed works such as this one of the 1490s some of the problems Leonardo had posed in his often unfinished production left behind in Florence at his departure around 1482. Indeed, the dilemma all painters faced if attempting to acknowledge and absorb something of Leonardo's difficult and rather fleeting invention is well evidenced by this example. Piero investigated light and shade in his own simpler, less empirical way, seeking instead brilliant effect rather than closely graded modelling, and if the results are less sophisticated or extreme than those promised by Leonardo, they had the virtue of being finished and often publicly accessible in Florence, not to mention attractive.

More distinctly personal to Piero in the Innocenti altarpiece are the exacting effects, the cold light revealing details and the shimmering surfaces. More typical of his interest in playful, witty and quixotic visual tricks is the juxtaposition of the white marble head of a putto on top of the arch who acts as a support for the rope holding up the red baldachin, and the two living angels who climb up to hold the fictive canvas. In a comparable way the candles burning down to indicate the passage of time in this fictive world have a sensitive immediacy that looks forward, conceptually, to the fleeting clouds of incense in Sarto's Uffizi *Madonna of the Harpies* of 1517.

The *Incarnation* with the added Saints Catherine, Margaret, John the Evangelist, Peter, Philip Benizi and Antoninus, painted as an altarpiece for SS. Annunziata itself (fig. 36), reveals more of Piero's distinctive abilities, namely in spatial construction and the placement of powerful, sturdy figures. It is usually thought to have been painted some time around

1505 for the altar of Pierozzo Tedaldi dedicated to the Evangelist in SS. Annunziata but may have been painted earlier, around the time Leonardo returned to Florence and was active in the same church. When constructing space and placing figures Piero seems to have fluctuated between extremes of clarity and almost arbitrary casualness, as is especially evident too in his more ambitious mythological paintings. Here, the standing saints are disposed with the relatively precarious and free sense of rhythm that would have been liberating for the likes of Sarto, Rosso, Pontormo and other more marginalized painters. It is worth stressing the constant value of asymmetry in Florentine design that Piero kept alive for younger artists, and that provided an alternative to the cerebral degree of control displayed in Leonardo's altarpieces, such as the unfinished *Adoration of the Magi*. The figures in Piero's *Incarnation* are arranged in a planar fashion and in symmetrical triads, and the poses of the two females in the foreground are even mischievously echoed by those in the grisaille Annunciation on the Virgin's platform. They are, nevertheless, varied as much as possible within that typical imposed structure.

The two female saints seem almost to be twins, but the four males are especially odd and unidealized – witness Antoninus with his straining, turtle-like neck. The other *beato* in the altarpiece, Filippo Benizi, appears to be a portrait, and while Peter's face may be based on an antique sculpture, John the Evangelist with his strangely remote expression (fig. 37) reflects Piero's attempt to bring an up-to-date Leonardo type into the public forum, recalling specifically Leonardo's design for an Annunciate angel from his second Florentine period (fig. 38).[29] The version of this image recorded in a drawing by Leonardo now at Windsor shows some similarities in the position of the left hand on the breast, for example, though it is worth emphasizing too how freely Piero reworked Leonardo's invention as recorded in the copy at Basel: among other alterations, the angle from which the body is seen is completely different and the head position reversed. This analysis of the heads in the painting attests to the range and premeditation in Piero's approach to physiognomies – which was not lost on the young Rosso especially when he painted the lively row of apostles in his *Assumption of the Virgin* less than a decade later in the atrium of the same church. The introduction of a range of facial types in the altarpiece also concentrates the deliberate, complex use of hand gestures, an example of Piero's visual eloquence – a quality of yet greater importance for him when presenting individual characters in his mythological subject paintings. The facial expressions, at the same time, remain fairly subdued and so the unease of the image is found principally in its organization and irregular patterning of drapery folds. The panel contains even

36 Piero di Cosimo, *Incarnation with Saints*, Florence, Uffizi.

more meticulous and fantastical aspects than are present in the Innocenti work, not least because of its still more dominant landscape, as well as startling surface effects treated in the painter's detailed, seamless technique.

The Tedaldi altarpiece for SS. Annunziata was a particularly important and prominent commission for Piero, exhibited along with the Innocenti altarpiece at the focal point for artistic innovation in this period in Florence, not far from the Cathedral. It fell at a critical stage in the first decade of the sixteenth century, when Piero came to assume the mantle of dominant older painter in Florence, with the withdrawal of Fra Bartolomeo into the Dominican Order, the death of

Filippino Lippi and the impending departures of Leonardo, Michelangelo, Raphael and Perugino. It was around this time too that Piero produced altarpieces for export from Florence, for Borgo San Lorenzo and for Norcia in Umbria – always a good indicator of general fame.

Issues surrounding Piero's place in the history of Florentine art in this period of the so-called High Renaissance are coherently demonstrated in his devotional panel the *Virgin and Child with Two Angels* (fig. 39), of about 1505. As has been recognized, Leonardo's design for the kneeling *Leda and the Swan*, invented in Florence as early as 1503, was reinterpreted by Piero for the serpentine pose of his musician angel.[30] If

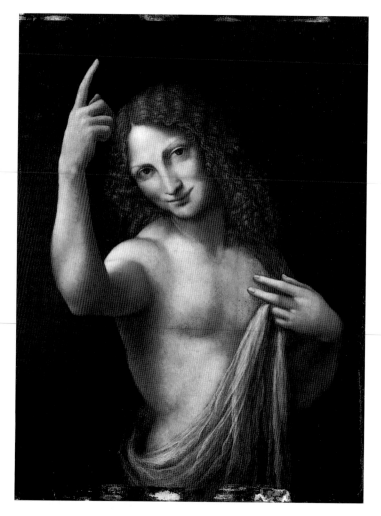

37 Detail of fig. 36.

38 Leonardo da Vinci (after), *Annunciate Angel*, Basel, Öffentliche Kunstsammlung.

somewhat stiffer when executed by Piero, a juxtaposition with either of the two surviving drawings by Leonardo (fig. 40 and see fig. 23) clearly reveals the influence, as the younger Tuscan painter engaged directly with the more extreme and uneasy formal aspects of poses developed by the older master. The Umbrian Raphael in the same period in Florence filtered these out of his comparable private devotional works. Piero's work is equally manipulated by comparison to Raphael's religious paintings from this date, but he sought a more animated and rhythmical narrative, in terms of both pose and facial expression. He also created a more forceful effect with the sharp lighting, the *di sotto in su* viewpoint and the compressed figures placed towards the immediate picture plane. The fastening on a pose in an erotic, classical subject for a sacred character demonstrates the fluidity of Piero's imagination, though he may just have been aware that Leonardo had also experimented with this pose for a Marian figure in a drawing. In this context of a critical direct engage-

ment with Leonardo, it seems even more distortive for the history of Florentine painting to have Piero suffer against a model that makes Leonardo alone the pinnacle of achievement at the start of the sixteenth century. Idiosyncratic flourishes like the Virgin's headdress or her frontally posed left hand attest to Piero's more intense and abrupt artistic sensibility, and provide glimpses of his personal invention, but it is precisely such passages that make his art so innovative in Florentine terms and attractive to younger painters, especially his sometime pupil Sarto.

The quality of Piero's later pictures tends to be uneven, and for the first time in his career the presence of a workshop hand can be detected when making certain attributions. This observation allows that the ageing painter was not so isolated or marginalized as Vasari would lead us to believe, but continued to live in his native city practising a critically accepted style that could be replicated and imitated by other artists, and was still in demand with Florentine

patrons and collectors, even the Aretine biographer himself. Vasari is little help on the complex question of Piero's workshop and immediate followers, mentioning that he had several students though only Sarto is cited by name. Piero's late impact can be seen in a mysterious but powerful altarpiece, the *Virgin and Child with Saints Francis, Jerome, John the Evangelist and the Baptist* by another still anonymous master surviving in a right transept chapel in San Salvatore al Monte in Florence (fig. 41).[31] Executed perhaps around 1520, the strange types and especially the angular sense of rhythm and intensity are deeply indebted to Piero's altarpieces. He was, however, imitated most extensively by the equally fantastic Serumido Master, who like the San Salvatore Master may well have passed through Piero's studio.

This Master of Serumido (unlike Giovanni Larciani who will be treated later) remains hard to place as an artist because in the absence of an archival breakthrough we still lack a proper name for him. His alias derives from the current location of an attributed altarpiece, the *Virgin and Child with*

Saints Peter, Paul, Francis and James (fig. 42) in the church in Florence popularly known as that of the Serumido after the architect of the rebuilt church, or more correctly as S. Pier Gattolini. The anomalous nature of this label is reinforced when we recognize that the painting was, in fact, originally produced for the church of S. Jacopo tra' Fossi for a still undetermined patron. Suggestions that this artist might be either Ruberto Lippi or Bastiano da Sangallo, who was the author of the Holkham Hall copy of the *Battle of Cascina*, both have drawbacks and remain to be confirmed.[32] Bastiano, called Aristotile, was a Vasari informant in Rome, so it is unlikely that he did not discuss and promote his public work in Florence, while the stylistic links with Filippino are not sufficiently strong to provide a firm conclusion. Even in reconstructing this painter for the first time in the 1960s, Federico Zeri classed him a 'petit-maître', and so the tendency to disregard him was immediately fixed.

The expressive physiognomics and dramatically manipulated forms especially evident in the more intimate works of

39 Piero di Cosimo, *Virgin and Child with Two Angels*, Venice, Palazzo Cini.

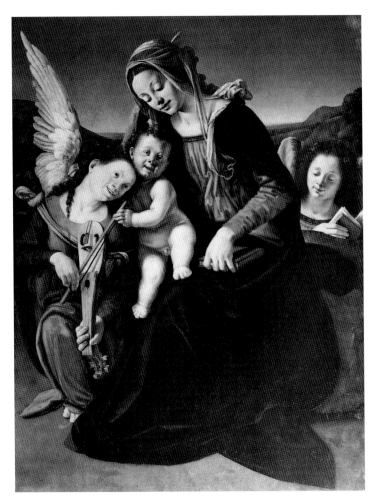

40 Leonardo, *Leda and the Swan*, Chatsworth, Devonshire Collection.

the Serumido Master, many of which are untraced, have generated the scholarly label 'eccentric' for this painter as it has for Piero di Cosimo, but he was not marginal. He was actually reasonably prolific (his ever expanding oeuvre now comprises more than fifteen paintings) in supplying several public altarpieces for churches in Florence and its outskirts, but he was clearly also successful with private patrons since he produced a number of unmistakable Virgin and Childs, and horizontal panels with historical and mythological subjects. In these ways, he might be considered the most notable heir to Piero, and it is perhaps no coincidence that he adapted Piero's *Liberation of Andromeda* (fig. 43), as part of a series dedicated to Ovid's tale. He is sometimes thought to have been active for only about a decade from the mid-1510s onwards, but the example of Giovanni Larciani suggests that such parameters are too constrained. The only certain date relates to an altarpiece, *Annunciation and Saints Sebastian and Anthony Abbot* in S. Giuseppe in Florence, that must be later than 1523, when, according to his unpublished testament, Alessandro Perini proposed an altar painting at a not insignificant cost of sixty florins for his chapel dedicated to Saints Anthony and Sebastian in that church behind Santa Croce.

Stylistically, the Serumido Master has been classified as an unlikely mixture of impulses from Piero, Filippino

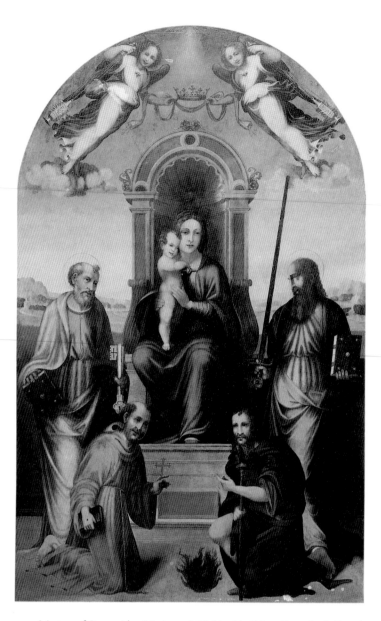

42 Master of Serumido, *Virgin and Child with Saints Peter, Paul, Francis and James*, Florence, S. Pier Gattolini.

41 Anonymous, *Virgin and Child with Four Saints*, Florence, S. Salvatore al Monte.

Lippi, Francesco Granacci, Fra Bartolomeo and Ridolfo Ghirlandaio, by which it is meant that his style combines an inventive sense associated with the late Quattrocento, with a more sober reductiveness in creating monumental compositions featuring statuesque figures that places him firmly in the sixteenth century. These divergent qualities are apparent in his signature altarpiece in S. Piero Gattolini. An anachronistic, naive quality to his style, uncertainty over figure scale, bulbous forms, an unreal acidity of colour and plodding technique do not disguise the lively intellectual character transmitted by his designs, especially visible in the prominent architecture found in most of his paintings. Considering that Vasari may well not have mentioned this painter even in

43 Master of Serumido, *Liberation of Andromeda*, Florence, Uffizi (deposit).

44 Piero di Cosimo, *Liberation of Andromeda*, Florence, Uffizi.

passing, it can be concluded either that this style did not attract the biographer's interest or that he did not judge it worthy of celebration in the *Lives* – an antipathy evident sometimes in his account of Piero. Yet this oversight is unfortunate, for the contingent Serumido Master is a distinctly Florentine phenomenon in this period and a more original one, at least in his religious expression, than the above description might imply. Although suffocatingly restrictive in design, such works have an intensity that reveals an ambitiousness and relentless focus in the painter's general attitude. What is significant too is how this inventiveness and flair for a painter working in Florence after 1500 would derive as much from an initial study of the works by an artist like Piero as from that of Leonardo, Michelangelo or Perugino. This realization brings Piero back to his rightful position as a key painter in Florence around 1500.

Piero di Cosimo's most seemingly confident and outstanding later work to survive is, appropriately enough, a secular one – the *Liberation of Andromeda* (fig. 44), probably painted around 1510 for the Strozzi family. It manifests all the qualities that kept his style attractive and relevant until his death in 1522, and which were seen in a public forum in the Fiesole altarpiece. This private mythological picture drawn from the Greek myth retold in Ovid's *Metamorphoses* fully displays the inventive power of his art and his ability to paint landscape in softer, more carefully blended and modulated colours than is evident in earlier efforts. It is read in sequence from the upper right to the horrific scene at the left and finishing in the lower right with the marriage between Perseus and the Ethiopian Andromeda, with the murder of the beast reserved for the dramatic centre. Piero's panel is replete with unusual and striking harmonies of glimmering colour, as well as nude form and complex drapery folds, betraying an intensive technique. Through a finished painting like this one Piero might finally be said to have become Leonardo's equal in Florence for exotic invention and detailed observation, as evidenced by the swirling water effects, not to mention his portrayal of reactive emotional states. When faced with this sparkling image it is apparent – and appropriate given his particular mythological and private skills – that Piero is the artist who best represents a formal bridge between the late Quattrocento and what has been termed the early Mannerist period in Florence. It seems that the very capriciousness of his work came to be sanctioned towards the end of his life by the elaborately refined and somewhat eclectic and hedonistic taste that re-emerged in Florence with the return of the Medici from exile in 1512. And as Vasari had to admit, Piero deliberately sought difficulties to execute in his painting and nothing could be more typical of the greatest artists working within a particularly vibrant strand of the Florentine artistic tradition.

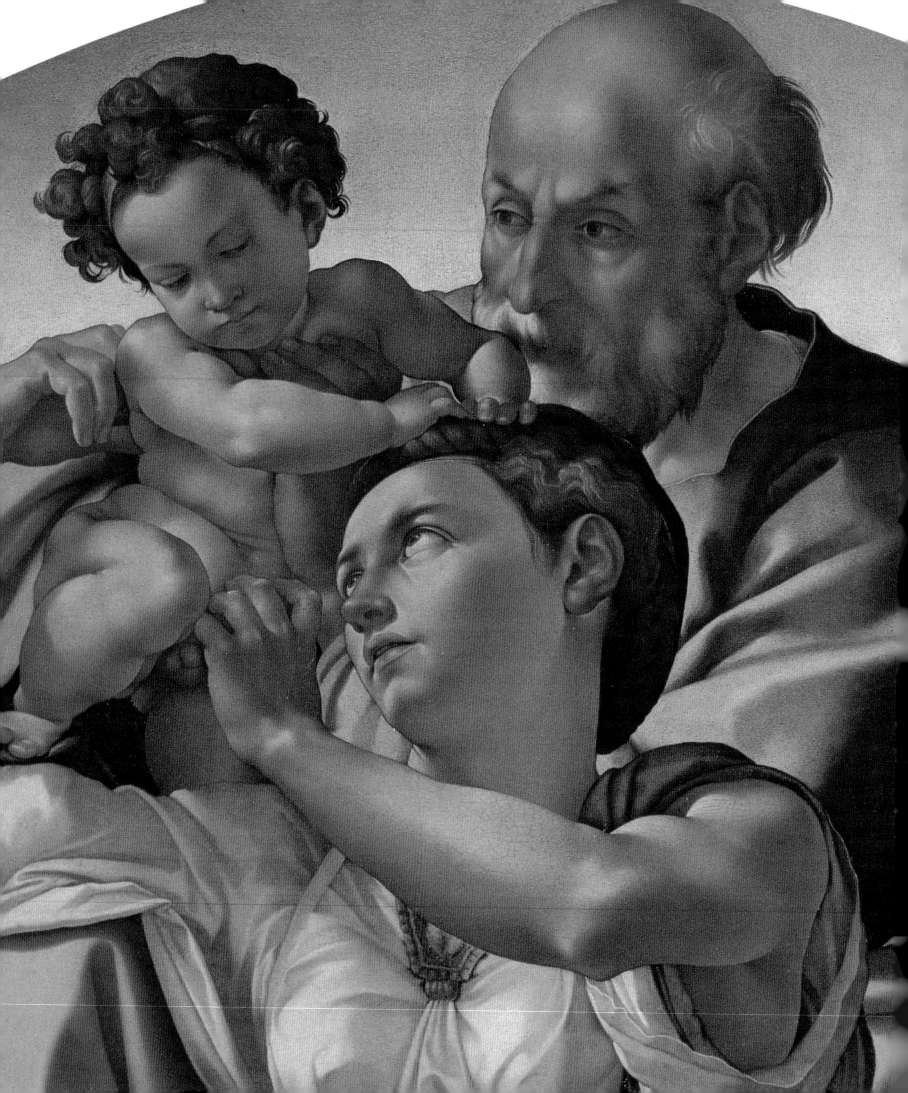

MICHELANGELO THE FLORENTINE PAINTER

IT IS A COMMONPLACE THAT Michelangelo Buonarroti was an innovator in three arts – sculpture, architecture and painting.[1] Yet as a visual artist he concentrated less on any particular medium than on one overriding pursuit – the male nude or, more specifically, the male nude in action. Michelangelo himself is quoted in 1553 by his authorized, first biographer, Ascanio Condivi, as having criticized the German artist Dürer's interest in proportion and physiognomy because the study of the movement and gesture of the male body alone were enough for a lifetime's work.[2] This sharp insistence on the primacy of the nude belongs to one strain of Tuscan visual tradition in its categorical bias: one has only to recall Masaccio's *Saint Peter healing with his Shadow* from the Brancacci Chapel in the Carmine church, where the human form itself relates the story, to evoke its potency. Not everyone was so favourable about the restrictive nature of Michelangelo's enterprise. The Venetian Lodovico Dolce, for example, in his *Aretino* dialogue of 1557 expounded that 'in the nude Michelangelo is superb and truly miraculous, and unparalleled by any man; but in one aspect [*maniera*] only, which is to say the drawing of a muscular and elaborated body, with foreshortenings and lively movements, which display the difficulties of this art down to the last detail; and each individual part of the body, and the overall effect of the parts together, are so supremely excellent that nothing can be imagined or made more outstanding and more perfect.'[3] With the likes of Raphael and his fellow Venetian Titian in mind, Dolce continued to suggest that there was something indecent about this exclusive art of relentlessly aggressive and highly evolved nude poses. Dolce's critique indirectly touches upon a central issue of Michelangelo's production, that despite its supremacy, it was intrinsically perilous to imitate. Vasari's deeper appreciation of this dilemma is fundamental for how he assessed art of the modern period, and it ultimately qualified his opinion of Michelangelo's place in the history of art. Perhaps in earlier ridiculing Michelangelo for his boorish manners, Paolo Giovio had in mind the issue of the decorum of his visual art too.[4]

For Michelangelo this exclusive attitude towards the male nude differed little from painting to sculpture. In his letter of 1547 solicited by Benedetto Varchi on the much debated issue of the *paragone* – that is, the relative merits of painting versus sculpture – he wrote disingenuously that painting and sculpture were virtually the same thing.[5] This is, incidentally, one of his very few direct expressions about the nature of artistic practice. Its bluntness reveals his distaste for what we would call theory, as well as his reluctance to enter more esoteric critical debates, and implies that his creativity was not underpinned by language; but even without written statements, the basic principles of his art are obvious. Painting and sculpture were united in the common ideal of the male nude and in believing that an artist should practise both disciplines, Michelangelo was defensively wary of those who only painted. Few in Florence respected his example by working in both media, however, with the not entirely sustained or successful exceptions of Giovan Francesco Rustici and Baccio Bandinelli. Even Leonardo might be accused of stretching the truth when he claimed to practise sculpture to the same degree as painting.[6]

Michelangelo is, therefore, almost alone among Tuscan painters of the later Renaissance as being also an outstanding sculptor. This is significant not only for the outward appearance of his few pictures but for how others approached them. Even by 1501, when he returned to Florence after a long sojourn in Rome begun in 1496, Michelangelo was too independent and exalted perhaps to have been a real competitor for the established painters there. This also seems likely when we consider that the doomed *Battle of Cascina* fresco commission of 1504 for the Palazzo della Signoria was the last public one in Florence from an artist who died in Rome sixty years later, even if he had some revenge by outliving almost everyone he directly influenced. He was only ever an intermittent painter and so developed some *ad hoc* methods – especially when beginning new work – that would not have had much technical relevance to those for whom painting was their regular profession. In other words, he was not a part of

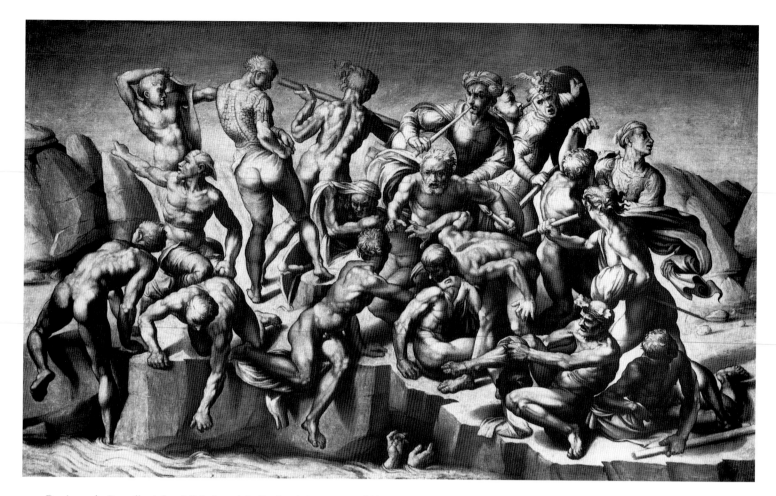

45 Bastiano da Sangallo (after Michelangelo), *Battle of Cascina*, Norfolk, Holkham Hall, Earl of Leicester.

painter are more securely known than as a sculptor. Ghirlandaio, who died in 1494, had one of the purest fresco techniques of the type that Michelangelo passionately favoured and so the link between them can be traced, just as it can for certain aspects of Michelangelo's pen and ink drawing style. In terms of panel painting, even without primary evidence, it would also be deduced from the technique of his earlier attributed pictures, namely the *Virgin and Child with Angels* and an *Entombment* (both unfinished and in the London National Gallery and probably produced not in Florence but in Rome), that he had close contact with Ghirlandaio.[12] Equally telling is the fact that Michelangelo later associated with painters from the Ghirlandaio shop such as Granacci and Jacopo Torni (called L'Indaco il Vecchio) when needing assistants for the Sistine Chapel commission: the former was Michelangelo's main recruiter in Florence for artists to help him in executing the ceiling.[13]

The first major painting commission for Michelangelo in Florence was to fresco a Florentine victory over the Pisans in 1364 on the feast day of Saint Victor, the so-called *Battle of Cascina*, as we have seen. This was apparently also his ini-

tial fresco commission of any significance. He received the charge, therefore, based more on his general fame than practical experience, though this proved not to be a real liability because he did not execute any painting. It was ordered in the late summer of 1504, following the republican government's earlier request for the large *Battle of Anghiari* from Leonardo in October 1503, probably for the left-hand side of the east wall of the Hall of the Great Council in the recently remodelled Palazzo della Signoria (see fig. 192). Michelangelo was by then already 29 years old. Like Leonardo, he was presumably chosen at the request of the Standardbearer of Justice, Piero Soderini – though an intermediary role for his chancellor, Marcello Adriani, in providing the texts and any necessary translation for the programmes has recently been proposed.[14] Benedetto Varchi in his oration delivered at Michelangelo's funeral in 1564 actually claimed that there had been a general competition for the other half of the wall in the room, as did Cellini in his autobiography, but this is otherwise unconfirmed.[15] Whatever motivated it, the selection of Michelangelo attests his high reputation in Florence by 1503, based mainly on the exposure of the marble *David* on the

Cathedral work site on the important feast day of the Baptist.[16] He had also gained the equally ill-fated commission to produce twelve statues of the Apostles for the Cathedral in this year. On 22 September 1504, while Leonardo was working on his cartoon in a room at Santa Maria Novella, Michelangelo was appointed premises in the hospital of the Tintori at Sant' Onofrio, not far from Santa Croce, and paper was supplied for his cartoon on 31 October 1504.[17] By March 1505, however, he had left Florence for Rome to take on the Julius II tomb, so he did not have enough time to begin painting, unlike Leonardo who had made a start, if a disastrous one, on his half of the mural.

Michelangelo's treatment of his assigned subject was contrary to Leonardo's, to judge by the surviving preparatory drawings and copies, and reflects his prejudice in favour of the active male nude. A now seminal copy in monochrome on panel of the preparatory cartoon for the central section survives (fig. 45). Done at Vasari's personal urging by Bastiano da Sangallo in Rome in 1542, this replica was composed from drawn copies made by the young Sangallo in Florence from the original cartoon.[18] It is the most faithful extant replica of the lost cartoon (which was not, however, cited again until the mid-nineteenth century), but it should be emphasized that Bastiano was not a talented painter, as details of the image make clear (fig. 46); compared with the autograph drawings there is a clear loss of characterization and a simplifying of details. It is because of what the panel records rather than its intrinsic content that it was so valued as an object – no less a person than Paolo Giovio arranged to have it presented to Francis I, according to Vasari.

It has been argued first that the painted copy contains not the battle proper but an emergency call to arms sounded by the captain Manno Donati on the day preceding it, which was meant to maintain the soldiers' readiness, and second that it includes all that Michelangelo brought to the finished cartoon stage.[19] This is the only episode Vasari and other writers like Varchi and Simone Fornari describe in any detail when discussing the project.[20] If intended for the central section this would make sense of the way in which figures look laterally out of the field in both directions. It seems a distinctly odd choice for a major scene, but one entirely consonant with Michelangelo's singular artistic tastes. Iconographically, it might be thought that the lack of armour on the figures emphasizes their plain courage, and so accentuates again that it is form, above all, that generates meaning for Michelangelo, more than exterior attributes. However, he certainly planned to depict more than these bathing soldiers rushing to prepare for fighting, as indicated by drawings such as a copy in the British Museum (fig. 47), which includes military activity behind and to the right of the central figures;

46 Detail of fig. 45.

47 Michelangelo (copy), *Battle of Cascina*, London, British Museum.

48 Michelangelo, *Battle Scene*, Oxford, Ashmolean Museum.

49 Michelangelo, *Male Nude*, Florence, Casa Buonarroti.

50 Michelangelo, *Male Nude*, Haarlem, Teylers Museum.

another sketch (fig. 48) shows a horse skirmish clearly intended for a different part of the image – the artist's only formal concession to Leonardo's spirited design relegated to the deep background.

The principal and most influential part of the *Cascina* fresco design reflects an approach that is essentially modular, as opposed to one underpinned by narrative. Based on a group of activated male nudes who are isolated while balanced and pivoting like freestanding sculptures on individual pedestals, the over life-size figures alone created the design of the work, merely set on a flat inclined plane without any significant spatial demarcation. Respecting this principle, Michelangelo organized the figures as if climbing up the picture space like a sculpted low relief – a stacking device completely at odds with Leonardo's method in the *Battle of Anghiari* where the figures were intended to be set more

in depth and also interact in a way that did not hold any interest for Michelangelo. He was mainly concerned with the individualized figural units of male bodies – many even turn their backs on the spectator. The motivation for the sculptor in him was the difficult challenge to create so many complex nude poses expressing various degrees of surprise at having been woken by the alarm. The earlier pairs of *ignudi* by the *Drunkenness of Noah* on the Sistine ceiling, with their smooth and exquisite forms, indicate a reconstruction of how the *Cascina* nudes might have appeared.

Although he never saw the actual cartoon, Cellini praised the drawings for the *Cascina* fresco as the best and most powerful work Michelangelo ever created ('he never surpassed the force of those first studies').[21] The impact of the whole design was unsustained except through copies, however, because the cartoon was shredded into pieces on

developed a typically restless and heterodox solution in which the young Baptist is set half-length inside a stone foundation in the background. The tondo features the passing forward of the Christ Child by Joseph over the shoulder of the Virgin, who has just been disturbed while reading a prayer book now closed and visible in her lap. To help his transfer the child rests a hand on the head of his mother. In stretching upwards the Virgin appears to expend the effort required to carry a piece of stone rather than a small child, and so it is appropriate that Christ is twisted into a pose recalling an architectural keystone. In the main action, through which the artist was able to elevate the child Saviour symbolically in the pictorial field, there is a compelling tension between an intense effort already completed and controlled ease, which creates a distinctive sensation in Michelangelo's art of a dynamic movement perpetually unresolved. The focus on a specific narrative action and the elimination of almost all extraneous symbols is especially significant because these were a format and subject which traditionally suggested stasis and reflection, as in many examples by Perugino, Fra Bartolomeo and also Raphael, who was in Florence during the period it was created. Indeed, the central movement could be described as the main subject of the painting, and so the viewer is not invited to reflect on the ideal beauty of the Virgin, or to be charmed by the quaint domesticity of the family group, but primarily to admire the force of the artist's conception and to rationalize the oddly balanced poses. The ambitious nature of the solution for a domestic subject had major implications for later artists, as did the subjective hint of soporific, pensive, perhaps even troubled melancholy in the features, which provides a premonition of Christ's death, seeming all the more poignant in such massive persons.

Set before the most perfunctory of landscapes betraying a conventional prejudice shared by many Florentine artists (though not, it should be stressed, by two olders painters, Leonardo or Piero di Cosimo), the closely knit three-figure group presses forward to the picture plane. The trio is conceived like a marble block, as has often been pointed out, but it is much deeper than it is wide and so perhaps more like a section of architecture, to alter the metaphor. In formal terms, the intertwined figures create a circulatory impression echoing the rhythm of the frame. The telescoped space and the general density can easily be parallelled with Domenico Ghirlandaio's paintings, though Michelangelo accentuated these effects which thus obviated the need for a rational perspective.

The main foreground figures are distinguished, above all, by their monumentality. The body of Joseph is segmented but unavoidably massive, alert and compellingly off-balance. Mary is proportionally rather slim as well as muscular, but the way in which her legs are turned parallel to the picture plane makes her appear yet grander. The foreshortening of her face could well have been considered indecorous by some viewers in that it denies a clear experience of her beautiful features: this type of pose is more familiar from other contexts and it soon appeared at frequent intervals on the Sistine Chapel vault. Similarly, the drapery round Mary's taut, muscular left arm falls open to reveal the total limb and the lower part of the shoulder. This may be the only Madonna with a bared arm in the history of painting up to this date (though the studio model for it was certainly that of a male),[29] and again this type of partial nudity was more appropriate in relation to pre-New Testament women, such as for the Cumean Sibyl on the Sistine ceiling. Although it can be hazardous to make presumptions about possible contemporary reactions to the seemingly indecorous in art, the Doni Tondo does not appear to display a piety consonant with a painting by Perugino or Fra Bartolomeo. Instead, the image is centered round a movement that is neither absolutely legible nor automatically comprehensible: Vasari even interpreted it as the Virgin passing the child to her husband but this seems highly doubtful. The subject matter was certainly evolved to a degree for which Agnolo Doni, who had earlier commissioned an altarpiece for the Badia Fiorentina from the stylistically limited and orthodox Francesco Botticini, cannot have been fully prepared.[30]

The lapidary, gem-like quality in the Doni Tondo evokes a different sort of marriage in the picture, that of painting and sculpture, but it also marries the high-pitched clarity expected of a fresco to a panel painting. There is as yet little of the *cangiante* modelling in colour, however, that was later so crucial to the execution of the Sistine vault murals. Instead, the modelling in Michelangelo's picture is traditional in that he used a range of attractive local colours either saturated to subdue them or lightened with a great deal of white, rather than through a series of closely graded values in the method of oil painting pioneered by Leonardo. The younger artist, somewhat paradoxically, favoured the brilliant surface hardness which had earlier been possible with an old-fashioned egg tempera technique, though it seems likely that he achieved such effects with pure oil – the tondo is so nearly perfectly preserved, however, that its medium cannot be scientifically tested and so its nature must be guessed at.[31] This slow, patient handling was quite orthodox: Michelangelo's innovation is his uniquely obsessive refinement of it, compared to which Domenico Ghirlandaio's paintings seem almost hastily executed. There is correspondingly no atmosphere or tonal unity; it is light, colour and form that generate relief. The source of illumination is a strong and singular one from the direction of the Virgin's upward glance, while

the shadows are impenetrable, even though the action takes place out of doors on a bright day, as in any Domenico Ghirlandaio picture.

So the tondo is not painterly in any extrinsic sense. No brushwork or textures can be detected in the perfectly enamelled and opalescent surfaces. Grass is treated, for example, with the same degree of selective naturalism as the decoration on the Virgin's brooch. The traces of gilding on this clasp or in her headdress and belt constitute isolated disturbances of the otherwise absolutely fused paint surface. In the circumstances it is not surprising that technical examination has revealed few changes or *pentimenti*: only the nose, right hand and right elbow of the Virgin were altered during the course of execution. With a similar exactitude, the defining contours are carefully and incisively indicated by thin, brown lines of the finest precision. A study of the Doni Tondo as an object thus provides an oblique insight into Michelangelo's unfinished sculptures and the issue of *non-finito*, where claw marks often remain but which the artist would have preferred to do away with, to judge from his fully finished marbles. In parallel to this, Michelangelo largely obliterated individual strokes in the very few panel paintings he managed to complete.

A comparison of the Doni Tondo with work by Francesco Granacci, another Florentine-born painter with strong links to Domenico Ghirlandaio and who also prospered in the first part of the sixteenth century, clarifies some issues of sylistic classification for this so-called High Renaissance period, particularly as the artists were known to have been intimate (Granacci was six years Michelangelo's senior).[32] Vasari claimed that the Saint Thomas in Granacci's *Assumption of the Virgin* was so vigorous that it might be taken for one by Michelangelo ('che pare il mano di Michelagnolo') and it therefore provides a good test case.[33] The altarpiece made for a Medici chapel in S. Pier Maggiore (fig. 53) must date to the late 1510s. Even a cursory glance at this picture reveals Granacci as closer than any other Florentine to Michelangelo's panel-painting style – a telling relationship that can be parallelled by that of Raphael in Florence and Ridolfo Ghirlandaio. The opaque, obdurate surfaces and rather bleached highlights present in Granacci's work specifically match what is seen in the Doni Tondo. Similarly, the predilection for an unfussy drapery style and designs of powerful three-dimensionality featuring monumental, sculptural figures are shared by both painters. However, the greater stability, symmetrical balance and blander emotional quality of Granacci's style tie it to the more homogeneous ideals representable by Fra Bartolomeo and Ridolfo Ghirlandaio, as will be discussed, in contrast to Michelangelo's more profoundly difficult style. The same point has been made through the juxtaposition of some Florentine work of Leonardo with his close but relatively uninspired imitator, Lorenzo di Credi.

This conclusion is worth stressing despite the fact that Granacci imported to Florence as directly and rapidly as any Florentine painter (with the partial exception of Fra Bartolomeo) various lessons of the Sistine Chapel frescoes in his panel paintings. The results can be seen in the altarpiece of the *Virgin and Child with Saints Francis and Zenobius* of about 1515, originally in the Girolami chapel in S. Gallo (fig. 52). In the details, the two putti pulling on a drape repeat motifs present in the Sistine vault fresco, as do the sharpened perspective and the gravity of the expressions, but the approach is ultimately regularized and rather linear in principal compared to Michelangelo's example, even if the work is attractive overall. It was difficult for some older Florentine artists, including Granacci, not to be subsumed by Michelangelo's monolithic model and to behave in some cases as unofficial pupils of the master, thereby placing limitations on what they could personally achieve.

The history of Michelangelo as a painter in Florence following his two major earlier efforts can be related surprisingly quickly. He seems to have produced only one other

52 Francesco Granacci, *Virgin and Child with Saints Francis and Zenobius*, Florence, Accademia.

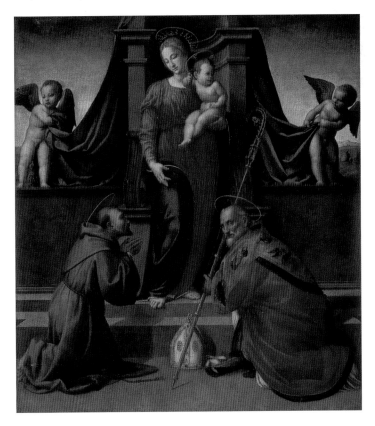

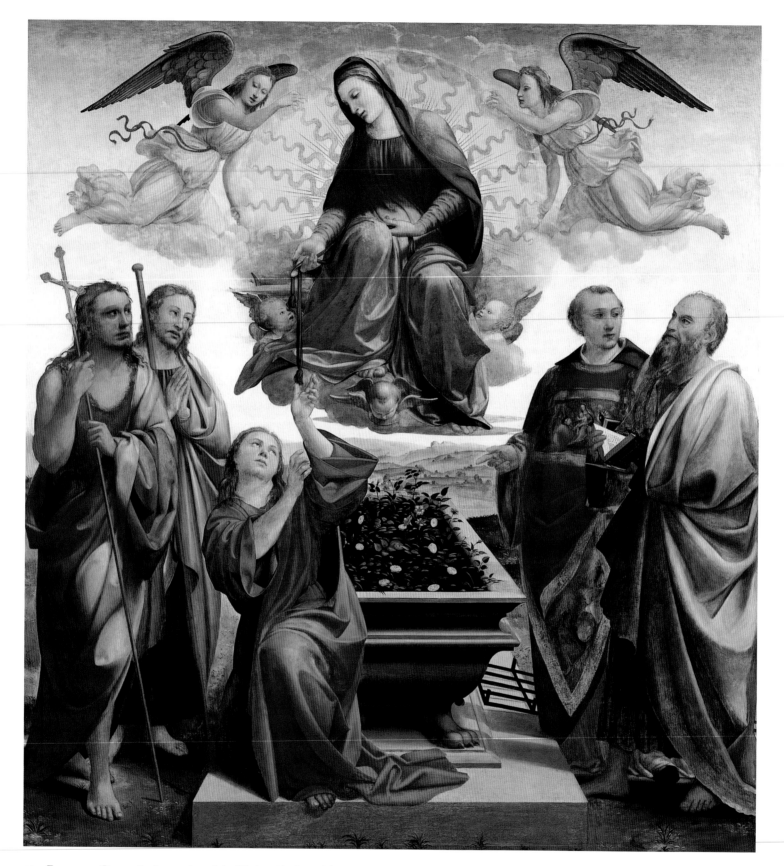

53 Francesco Granacci, *Assumption of the Virgin with Saints Thomas, John the Baptist, James, Lawrence and Bartholomew*, Sarasota, The John and Mabel Ringling Museum of Art, the State Art Museum of Florida; Bequest of John Ringling.

finished example there before his more or less final departure from his native city about 1530 and this was for export – the *Leda and the Swan*. Few local artists would have seen the original, though no less a figure than Vasari made a copy for his patron Ottaviano de' Medici and the design seems to have been fairly well known in Florence.[34] Professional pressures ensured that Michelangelo could not cease painting completely, although it is clear that he would have preferred to concentrate on sculpture and architecture. In fact, in Florence he was more a supplier of designs than actually a painter – it was friends and colleagues who transformed his designs into pictures. There is at least one curious instance when he himself may have drawn the contours of some figures directly on the support for Giuliano Bugiardini's understudied altarpiece the *Martyrdom of Saint Catherine* of around 1540 for the Rucellai chapel in Sta Maria Novella (fig. 54).[35] The activated foreground figures seen from all different angles in this huge but rather depressing and laboured panel – which Vasari claimed in a comic passage in the *Lives* took twelve years to conclude – in individual cases might still be compared profitably to the *Cascina* cartoon designs, if in a very general sense.[36] Born about the same year as Michelangelo, the amiable Bugiardini was, somewhat surprisingly considering his fairly mediocre talent, one of his longest and closest friends (they had been formed as artists together in the S. Marco sculpture garden and the Domenico Ghirlandaio workshop). Vasari devoted a whole Life to this minor painter (who died as late as 1554), although he chastized him none the less for being too much in love with his own work – a textbook case of pride and arrogance unrelated to objective skill in a Florentine painter as fostered by a prejudiced belief in tradition. Bugiardini is relatively stronger as a portraitist, as in the example of the so-called *La Monaca* (fig. 55), where his studious control and dry elegance have their most sustained effect.

A still mysterious passage in Vasari also leads one to believe that Michelangelo made drawn designs for the high altar of the church of Sant'Apollonia, where one of the sculptor's nieces was resident, which Granacci eventually painted.[37] Yet while some of Granacci's own small panels for this project of about 1520 survive in the Accademia, the works Michelangelo collaborated on are no longer identifiable, and those that do exist are painted in a thin and delicate style with a nacreous finish, distinctive to Granacci alone. Of greater importance are the two works Pontormo executed from Michelangelo's designs, a collaboration leaving what are undoubtedly the paintings of highest quality by a Tuscan-born artist after Michelangelo inventions. The works in question are *Venus and Cupid* (just possibly the badly discoloured horizontal panel now in the Accademia, Florence) and *Noli*

54 Giuliano Bugiardini, *Martyrdom of Saint Catherine*, Florence, Sta Maria Novella.

Me Tangere (fig. 56; it is Bronzino's replica that survives in the Casa Buonarroti). These were produced from the now lost cartoons Michelangelo executed in Florence in the early 1530s. The one of the reclining Venus and Cupid was ordered by Bartolomeo Bettini as part of a sophisticated ensemble, with subsidiary decorations by Bronzino, and is in need of further study.[38] The much better-documented *Noli Me Tangere* was obtained through an intermediary by a general of Charles V, Alfonso d'Avalos, Marquis of Vasto, but the finished panel was intended for the private collection of the artist's close friend Vittoria Colonna, who was particularly devoted to the penitent Magdalen.[39] Primary sources inform us that the latter cartoon was executed rather quickly in 1531 and, in typical fashion, not to the artist's satisfaction.

The choice of subjects betray Michelangelo's long-term fascination with the theme of two interlocking or interrelated figures. Here the narrative is interpreted basically like a Doubting Thomas in reverse with Christ's finger overlapping the Magdalen's breast. The characters are monumental yet just under life-size in actual scale. Perhaps because of the way the work was developed from a drawn cartoon, the figures stand independent of the landscape and very close to the picture plane. They themselves relate in a rather compartmentalized and rigid configuration with the more frontally disposed Christ swaying away from the Magdalen, even while appearing to restrain her. He is a placidly benign protagonist in Pontormo's redaction. By way of contrast, the Magdalen is tense, treated unusually in a standing pose and seeming to twist suddenly towards Christ, with the curving stairs in the middleground mimicking the torsion of her body. One of her outstretched arms disappears behind Christ, as if to accentuate with a physical metaphor her desire to touch the resurrected body, on which no wounds are visible because of his divine state. The lack of haloes intensifies the rapport. The high horizon line also puts the viewer in the picture in quite an intimate position. Presumably, Pontormo had to add his own landscape with its steep incline, which one cannot imagine Michelangelo having any interest in developing. This case is useful for demonstrating how the relative rarity of Michelangelo's work meant that even sophisticated patrons were increasingly satisfied with some trace of the artist's hand. In other words, a surrogate Michelangelo was better than no Michelangelo at all.

In contrast to the two designs utilized by Pontormo, the *Leda and the Swan* was painted by Michelangelo himself for Alfonso d'Este of Ferrara. The technique was old-fashioned tempera, according to Vasari, but this may have been simply a supposition based on the tight surface quality of the finished work (assuming it looked like the Doni Tondo in this regard).[40] The entire design is now known solely from a

55 Giuliano Bugiardini, *La Monaca*, Florence, Uffizi.

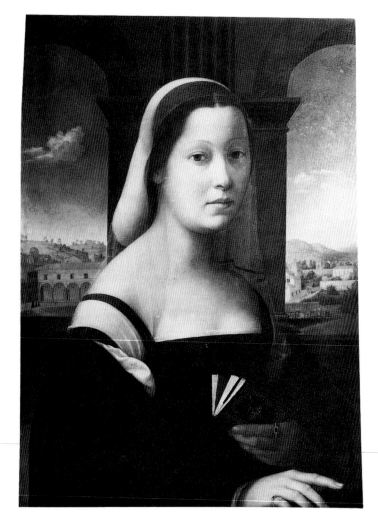

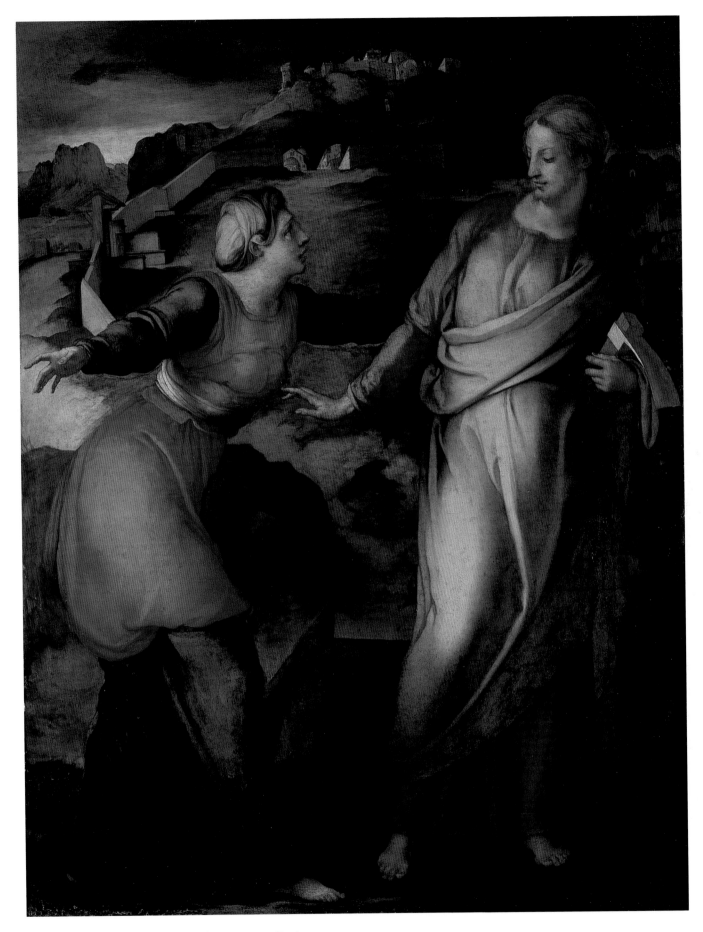

56 Pontormo, *Noli Me Tangere*, Milan, private collection.

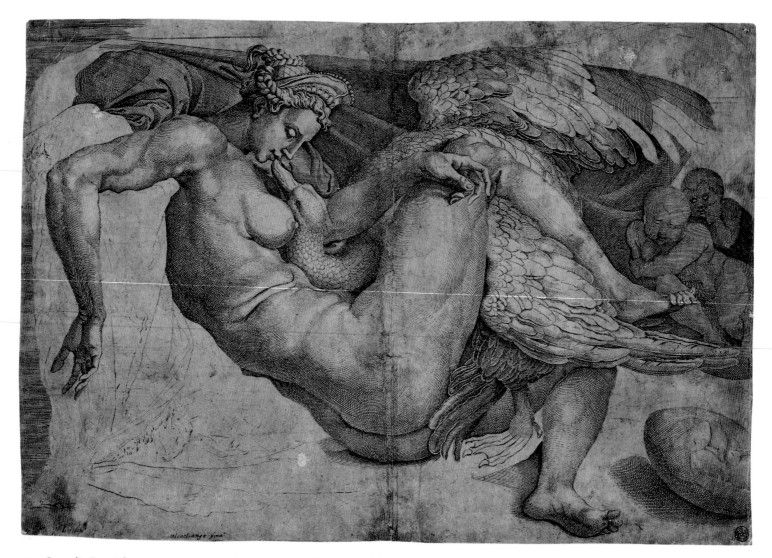

57 Cornelis Bos (after Michelangelo), *Leda and the Swan*, London, British Museum.

Cornelius Bos engraving after the panel (in reverse; fig. 57). It is assumed to be accurate, although it cannot be ruled out that he made additions to create the background, which would make a more attractive print. This easel painting was produced in Florence, rather quickly for Michelangelo, in the defined period from November 1529 to October 1530, just before Pontormo painted the *Venus and Cupid*. Through a combination of events, including a spontaneous insult to Michelangelo's finished painting by the Duke's philistine agent and the restoration of the Medici in Florence, the artist's *garzone* Antonio Mini received the panel with some drawings as a gift in lieu of dowries for his sisters, and soon took it to France, presumably in order to sell it to Francis I, where it was eventually lost.[41] As the subject and scale were apparently of the artist's own choosing, the *Leda* was possibly intended in part as an implicit critique of Leonardo's redaction on this theme from earlier in the century (see fig.

23). The later work is dominated by the massive androgynous nude, which turned out to be one of the last 'female' nudes Michelangelo ever created, intertwined with the animal. The main figures overlap each other and appear in profile, fused to the ground as in a sculptural relief. It is a powerful but disturbing image, rather more suffocating and uneasily explicit than Leonardo's, which seems gentle and allusive by comparison. This juxtaposition reveals the essentially incommensurable artistic values and visions of these artists, who in their different ways in the first decade of the century suggested possible advances in the history of Florentine painting, by establishing a set of brilliant challenges to later artists that they themselves had not always concretely demonstrated.

As exemplified once again by the *Leda*, Michelangelo's contribution to the history of painting in Florence followed from a revelation about the masculine form that is a constant in his art. He concentrated more than was naturally required

on the nude to indicate to others that he had a unique and personal style and that he was not a simple craftsman producing all the different categories of object. The almost miraculously refined sense of finish evident from those works he was able to complete, such as the *Doni Tondo*, is consonant with the disciplined superiority of his technique. That specifically would have been difficult to emulate and was only sought by those who had also passed through Domenico Ghirlandaio's workshop, such as Granacci and Bugiardini. It is rather in terms of general invention dominated by the nude that his major impact may be sought.

If Michelangelo's invention was rooted in drawing and observation, it was fundamentally conceptual to the degree that he sought to surpass the restrictions of given models either of the antique or of nature. In attempting to express the perfect style, Michelangelo worked with what was for him the most beautiful raw material in nature – even if in practice this was a highly selective and specific notion, particularly for Michelangelo who concentrated so exclusively on the male form. While respecting this ideal, he did not merely re-adapt formulaic gestures and expressions but tried to communicate something novel using the nude in an original figurative repertoire. Not for him a series of formal arabesques of the male body; instead, he selectively returned to and re-used earlier poses that clearly held a great deal of personal meaning for him, regardless of the public acclaim any particular work might have received. Condivi refered in 1553 to Michelangelo as a model and standard ('essempio e norma'), an inimitable exemplar of perfection, an absolute, and this sentiment is expressed less exuberantly by many writers about art at the time.[42] The academician Giambattista Gelli, for example, wrote at midcentury of Michelangelo as a Florentine who brought painting 'to such a degree of perfection that it seems as though it cannot be improved any further.'[43] This is a sentiment Vasari shared, but other more innovative artists like Pontormo took Michelangelo's singular achievement in the expression of the male nude as an acceptable challenge, with sometimes halting results.

So far from representing a universal, it is evident that Michelangelo's art was often unrealized, inaccessible and, above all, restrictive at its core. The monolithic nature of his pursuit led to the production of some wrought, emotionally profound figures, as each gesture and pose was repeatedly investigated over an extended period of time and in a variety of contexts and media. This very obsessiveness posed an ultimately insoluble problem for his close admirers among painters in Florence like Pontormo and Jacone. They strove to create even more highly convoluted work than their exemplar based on the same active nude, as displayed especially in Pontormo's late drawings for the choir frescoes in San Lorenzo. Indeed, it was Pontormo who in the medium of painting most fully grasped and pushed to a natural extreme the potential of Michelangelo's model as already established in the first decade of the sixteenth century, which has nothing to do with the kind of mannered painting isolated by Vasari and others in their writings about Perugino. Pontormo, more than anyone else, appreciated from Michelangelo's example how a concern for the creative process to the potential detriment of everything else was the key message of his life and work.

Concentrated on the male nude in movement, Michelangelo's art pursued with an almost debilitating integrity a search for original perfection that could not be easily emulated (as the case of Pontormo will best demonstrate), though because of the range of his own attempts as a painter, it was relevant to private devotional paintings, as well as altarpieces and monumental narrative frescoes. The beginning of the sixteenth century can arguably be presented as a stranger, more obsessive stylistic moment in Florence, if Michelangelo and Leonardo are taken as emblematic. That the art produced in their wake could be so formally diverse and emotionally compelling, however, was in no small part due to the inability of Michelangelo and Leonardo to establish comprehensive finished and public solutions to the myriad problems they had set themselves.

In the final analysis, Vasari's perception that it was better for the painters of later generations to model their style on Raphael's varied art was thus especially astute, as well as sound practical advice. This critical discrepancy reveals that even in outlining qualities modern artists should admire, Vasari strove for something quite different – a realization that will be returned to in the final chapter. It remains one of the deeper ironies of this period that he still chose to give Michelangelo ultimate praise in the *Lives of the Artists*.

FRA BARTOLOMEO, THE SCHOOL OF SAN MARCO AND THE DOMINICAN MANNER

THE MOST PROBLEMATIC INCLUSION on conventional lists of crucial Florentine 'High Renaissance' painters would be Fra Bartolomeo, for the reason that the modest and devout quality of his artistic expression, circumscribed by his status as a Dominican friar, belongs to a different strand of the history of painting in Florence.[1] To place him among the forerunners of innovation in this period without some significant qualification is misleading when compared to the historical record. Respectful of his religious calling, Fra Bartolomeo did not engage very deeply with antique art or subjects, humanist texts or the nude form. The absence of their impact on his painting somewhat marginalizes his role and importance for the sixteenth century and highlights the problem inherent in describing him as a 'classicist' – a by now over-familiar term that needs to be re-expressed for it to retain any validity in relation to his work. Although his interest in representing landscape was as original and wide-ranging as that of any Florentine, the Frate's strictly pious and anti-secular art is actually rather unusual among that of Renaissance painters. More than the other protagonists of this period, his aim was not so much to seek novelty as it was to satisfy select viewers with well-defined preconceptions and a unified, serial experience of art objects. In a related way, his personal expression was filtered through a static, reductive approach to design, as he apparently sought to instigate a homogeneous group style based on his models, now known somewhat anachronistically as the 'School of San Marco'. Thus, like that of Raphael, Fra Bartolomeo's contribution to Florentine painting after 1500 was arguably more restricted in scope, or at least different in nature – especially as his stylistic influence was mainly limited to a close circle of initiated followers like Fra Paolino and Giovanni Antonio Sogliani, who produced work of a comparably institutional, formulaic type that stressed continuity and authority rather than innovation.

As if admitting his essential difference after 1500, when he entered the Dominican Order, discreet signatures begin to appear on his work declaring his friar status, almost like a public statement that his talent came from God. The fact that the epigones – though not Fra Paolino, his most dedicated one – sometimes used the same form of signature ('Orate Pro Pictore') demonstrates the existence of a unified Dominican style. This patent lack of distinguishing individualism contrasts markedly with the attitudes of other, contemporary artists, particularly Leonardo. As a Dominican, Fra Bartolomeo was also guaranteed a steady flow of patronage through the Order and their sympathizers both in and outside Florence, primarily because he was a friar painter. This was a situation that cannot have been conducive to creativity in the most innovative branch of the Florentine artistic tradition, fostered as it was by competition and critical debate. Subservience to the Order likewise gave him in return a basic level of personal and material security in the cloister, which such painters as Pontormo and Rosso Fiorentino seem also to have craved at different points in their careers. Like Ridolfo Ghirlandaio, as will be seen, Fra Bartolomeo's fleeting primacy in Florence around 1510 was based as much on his ability to earn prominent public commissions through wide, institutional contacts as it was on his reliable formal style. The consistency of his patronage and the preferential treatment he received accounts too for the relatively narrow range of subjects he was asked to execute. Not surprisingly perhaps, he painted very few portraits, with the particular exception of a characteristically severe one of Savonarola, in strict profile against a black background – he simply repeated the likeness in an even more gripping posthumous image of the preacher in the guise of *Saint Peter Martyr* (both in the Museo di San Marco, Florence). When Fra Bartolomeo's work is seen in its Dominican context, both visually and career-wise, this tends to marginalize him from the ideals of Leonardo and Michelangelo

which he and many of his patrons, fundamentally, did not share. In its deliberate simplicity, moderation and unrelenting seriousness his art inevitably lacks nuance and attractive ambiguity compared with the sometimes internally contradictory paintings by Leonardo and later Rosso. Evidence for rather cold responses to his work can be found in the period itself. Fra Giovanni da Fiesole may have been given the epithet 'angelic' not long after his death, but Fra Bartolomeo never received such spiritual glorification, even from his own Order. More pointedly, the beautiful altarpiece of God the Father and Saints Mary Magdalen and Catherine of Siena, which he initially produced for the Dominicans of S. Pietro Martire on the Venetian island of Murano, was never delivered as the friars apparently balked at the price following the death of the prior-patron (they settled for a cheaper and iconographically much more pedestrian altarpiece by Francesco Bissolo).[2] This incident accounts for the fact that Fra Bartolomeo's altarpiece, dated 1509, was instead donated by him and installed in the Dominican church of S. Romano in Lucca.

This introduction seems to contradict rather startlingly the inherited view of this artist. In the past, Fra Bartolomeo, together with his frequent collaborator Mariotto Albertinelli, was omnipresent in accounts of Florentine painting after 1500, where he is generally singled out for his contact with Raphael, and celebrated for his presumed achievements as an academic and classicist painter and prescient Christian reformer before the Counter Reformation age. The general consensus is that Fra Bartolomeo and his followers practised above all a devout classicism – something of an oxymoron that has been used without elaboration or admission of irony. The motivation to make him a privotal figure in the period may in part be found in the continuing historiographical need of scholars to identify a High Renaissance from which Mannerist artists subsequently rebelled. According to this model, Fra Bartolomeo is generally treated like the Florentine equivalent of Raphael of the Vatican Stanza della Segnatura, following the preface to the third part of Vasari's Lives where he is artifically placed in a direct relationship with Raphael because of their shared search for relief, sweetness and grace. Through such hyperbole, however, Vasari forged a link that helped him to appropriate Raphael as a token Florentine artist. Ironically, this is the reverse side of the equally questionable motivation for modern scholars to create ties between the two to help elevate Fra Bartolomeo by virtue of his relation to Raphael, even if their work had major fundamental differences.

Born in Florence in 1473, Fra Bartolomeo was originally known as Baccio della Porta, from Baccio which is Tuscan dialect for Bartolomeo and after the Porta di S. Pier Gattolini which had been the site of one his early workshops. Before

22 April 1499 when he signed a contract with Gerozzo Dini to paint the fresco of the Last Judgement for Sta Maria Nuova (now in a ruined state in the Museo di San Marco), he is still quite a mysterious figure.[3] Vasari dates the Pugliese tabernacle now in the Uffizi earlier than that fresco, and some paintings of the Virgin and Child which are no longer identifiable.[4] The Annunciation altarpiece in Volterra Cathedral carries a date of 1497, but nothing else is certain. There is evidence that he entered Cosimo Rosselli's workshop by 1485, but Rosselli was too pedestrian a painter to have had much of an impact on the young and gifted Bartolomeo. Instead, the more varied Piero di Cosimo, who was about ten years his senior, has been plausibly suggested as a major early influence.[5] It has also been argued that Lorenzo di Credi made a decisive impact on the artist's early style, given that Credi took control of Verrochio's important workshop after the latter left Florence for Venice in April 1486. Any influence of Leonardo – who was absent from Florence in Milan while Fra Bartolomeo and artists of his generation were forming – came indirectly, primarily through the impure filter of the less talented Credi, as in the desire for graduated modelling. Fra Bartolomeo appears to have maintained a lifelong contact with Credi, who was equally attached to the Savonarolan movement though he responded artistically to his contact with the preacher's followers by becoming even more archaic than the Frate, who in contrast was capable of profound spiritual depth. His typically peripatetic training was apparently completed in the workshop of Domenico Ghirlandaio around the time of the master's death in 1494, with his participation in Florence in the production of the Saint Vincent Ferrer altarpiece sent to Rimini, where it still survives. The pattern of Fra Bartolomeo's earlier career demonstrates a certain duality in his taste for traditional and more radical styles. In terms of his connoisseurship, it helps to account for a rather inconsistent body of early work.

Not unexpectedly perhaps, the only surviving examples of secular subject matter in Fra Bartolomeo's painted oeuvre appeared before he became a Dominican, and there was only one important exception from late in his career. The early works are the Minerva (fig. 58) and the Uffizi Porcia – the latter in much worse condition. They date from the 1490s and were presumably supplied together as part of the private decorations for a Florentine palace, perhaps on the theme of female characters from literature and history. The figures stand fully clothed and frontally in niches like saints with attributes; they even take the artist's Marian facial type. He was not, apparently, inspired by the antique in developing the poses of these classical characters, as is especially evident in the Porcia with its outmoded planar, Gothic sway. In no way does his conception parallel the original sublimation and

almost disrespectful recreation in modern form of an antique theme evident in Leonardo's *Leda and the Swan* or Michelangelo's sculpture the *Bacchus*. Indeed, Bartolomeo's most evolved secular design, a very late work, for a never executed painting of the Adoration of Venus, was commissioned by order of a particularly sophisticated foreign prince, Alfonso d'Este, who may himself have had Savonarolan sympathies.

Given the almost relentlessly serious expression evident in his earlier work, the crucial event in the life of this artist may seem to have been predestined. Inspired by the popular and influential Ferrarese preacher Girolamo Savonarola, who was executed in the Piazza della Signoria in 1498, he became a Dominican on 26 July 1500, according to a document directly cited by Vasari, when he started his year-long novitiate at S. Domenico in Prato, and so withdrew from an active life.[6] He was known thereafter as Fra Bartolomeo. There is irony here in the context of received definitions of the sixteenth century, in that Fra Bartolomeo is one major artist known to have had a definite spiritual crisis, though he practised an even more restrained and equanimous style afterwards.

Between the summer of 1500 and 1504, the Frate produced no public work in Florence – a period of self-enforced retirement that would have affected his response to the most important contemporary innovations of Leonardo and Michelangelo, especially their battle cartoons for the frescoes in the Palazzo della Signoria, which were not at all easy to monitor without some determination. It is Fra Bartolomeo's relationship to Savonarola rather than to another artist that provides the key to understanding the rest of his career. Although Savonarola never expressed a cohesive theory of art, and it should be stressed that his references to art are often intended only metaphorically, it is possible to compile an ideal reconstruction of the stylistic qualities he preferred from a reading of his sermons and spiritual tracts, leaving to one side the issue of the validity of using such forms of expression as a source for visual art.[7] This formulation can then be juxtaposed to the work of Fra Bartolomeo and of the major group of artists trained and influenced by him – the School of San Marco, or *pittori savonaroliani* – to reveal how far they match up. Art for Savonarola should be pure, idealized, uncomplex and lacking in formal artifice or distracting ornament of any kind. In his anti-visual, anti-sensual stance, the preacher appears to have been strictly against the whole possibility of formalism in art – the relatively crude and diagrammatic woodcut images published with his writings seem apposite in this context too (fig. 59). Above all, Savonarola approved of art (and every aspect of life, for that matter) that was simple. He believed that good art could be produced only by artists who were pure and faithful too, and their works would naturally give away the truth of what was in their

58 Fra Bartolomeo, *Minerva*, Paris, Louvre.

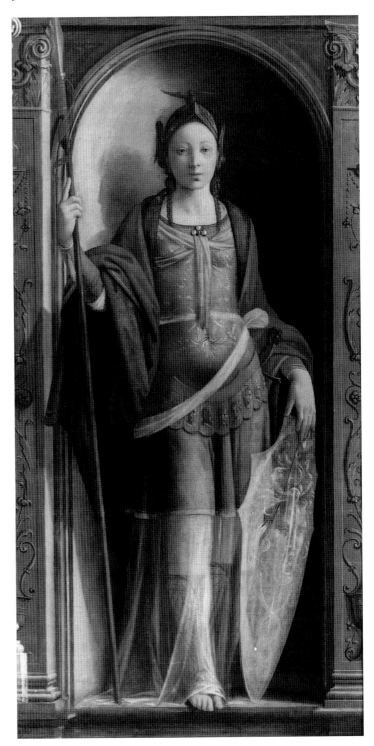

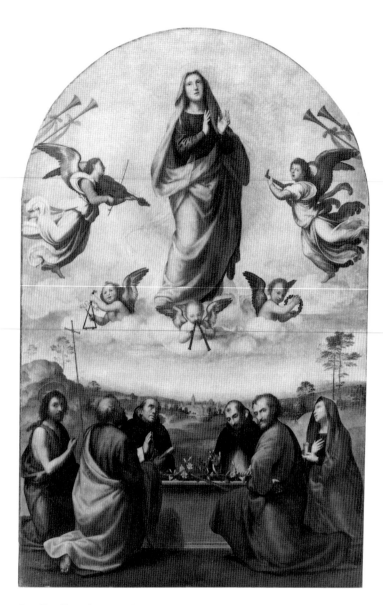

60 Fra Bartolomeo, *Assumption of the Virgin with Six Saints,* formerly Berlin, Kaiser Friedrich Museum (destroyed).

1508 by the confraternity of the Contemplanti.[12] And again, the catalyst for new development in Fra Bartolomeo's art in this period was provided by another non-Florentine, the Venetian, Giovanni Bellini. The Frate went to Venice in 1508 where it was his experience of Bellini paintings such as the S. Zaccaria altarpiece that propelled his art into the new century. This incident is doubly ironic given that Vasari presented Bellini in the Lives as the forerunner of Giorgione, who for him was the true creator of the modern age in Venice. Certainly it was atypical for a Florentine painter to have such a significant Venetian influence as Fra Bartolomeo did through his entirely justifiable admiration for Bellini, and this perhaps would have been perceived with some disdain by the more prejudiced of his Tuscan contemporaries. At

the same time, the interchange reveals how Fra Bartolomeo looked outside the rich Florentine tradition to satisfy certain artistic needs at a critical moment and so set himself partially at odds with that very tradition.

The general spaciousness, use of *all'antica* architecture and softer textures and atmospheres inspired by Bellini appear in the major altarpiece the *Virgin and Child with Saints Stephen and John the Baptist,* signed and dated 1509, for the cathedral in Lucca (fig. 62). Although not painted specifically for the Florentine market, this particular work is crucial for making a general point about Fra Bartolomeo scholarship. Indeed, it is directly relevant for our continued understanding of the painter's historiography that the panel in Lucca has not been cleaned very recently, for in this state it contains the subtle tonalities and resonant colours in a balanced palette associated by modern scholars with all of Fra Bartolomeo's painting. Here the sense of volume, equilibrium and luminosity of his art seem still to merge in apparent perfection. A comparable private image is supplied by the tondo *Virgin and Child with Saint Joseph* (now in the Poldi Pezzoli Museum, Milan), which does have a Florentine provenance. This too has not been recently restored and so shares with the Lucca altarpiece a beautifully soft, crepuscular light that seems to solidify form – which may not be precisely true to the artist's intentions.

The design of the Lucca altarpiece is predicated on a typical basic arrangement with the enthroned, seated Virgin holding the Christ Child in her lap, flanked by the two under-life-size saints, one of whom faces into the centre, while the other looks out to catch the viewer's attention. Many passages indicate that it is, above all, a decorous, hierarchical image: the attributes are clearly displayed, one in front and the other at chest height, the heads of the saints placed at the same level as that of Christ, and the Virgin's leg kept on the central axis. The emotional content is correspondingly somewhat timid and aloof. The artist's acute sensitivity in evoking a specific time of day – early evening with smoke rising from a chimney in the background – was also inspired by Venetian painting. Fra Bartolomeo's excellence at representing landscape, especially evident from his drawings, should again be stressed – though in this tendency he was little followed by other sixteenth-century Florentine artists, with the exception of such artists as Ridolfo Ghirlandaio and Antonio di Donnino.

Following his brief Venetian period, Fra Bartolomeo worked consistently during what became his most productive period for public works in this increasingly economical style with designs distinguished by a basic clarity and emotional reticence. The most characteristic and fully realized of this series of altarpieces produced in conjunction with Albertinelli is the *Mystic Marriage of Saint Catherine,* also

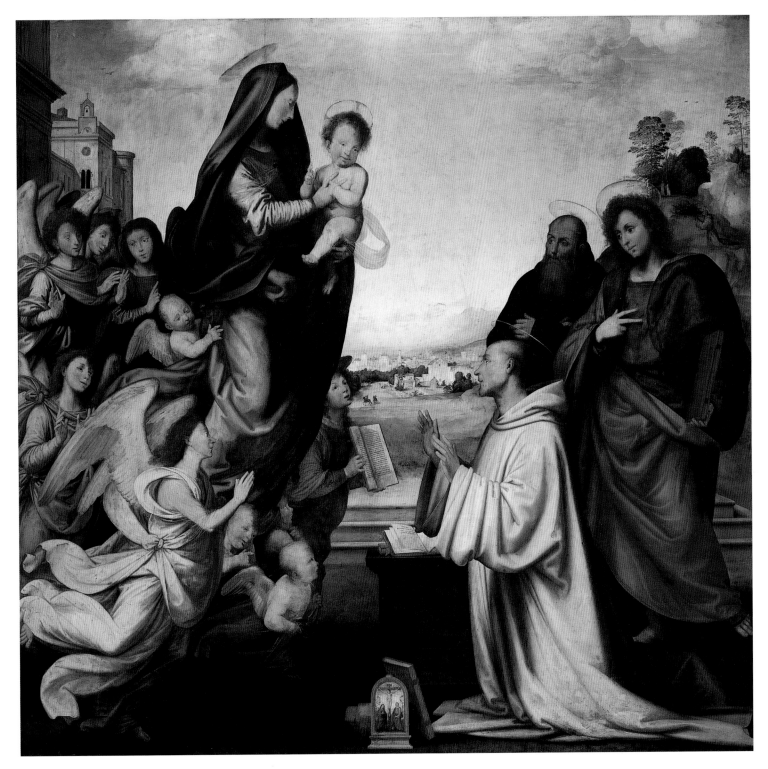

61 Fra Bartolomeo, *Vision of Saint Bernard with Saints Benedict and John the Evangelist*, Florence, Uffizi.

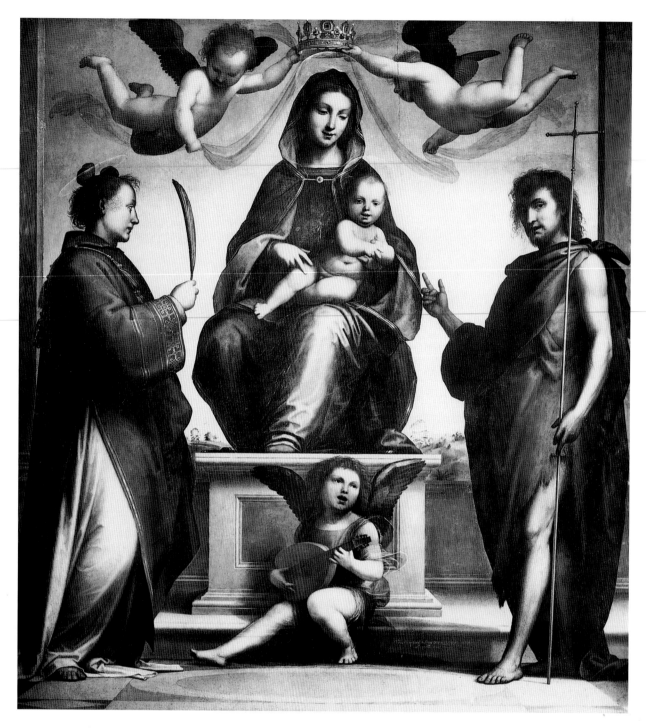

62 Fra Bartolomeo, *Virgin and Child with Saints Stephen and John the Baptist*, Lucca, Cathedral.

known as the Pala Pitti, signed and dated 1512 (fig. 63). Commissioned to replace a Fra Bartolomeo altarpiece sent to France in 1512 (now in the Louvre) it was painted for a side altar dedicated to Saint Catherine in the left nave of S. Marco where a copy remains.[13] The central narrative is expanded by the addition of some thirteen laterally displaced saints in the sort of crowded design for which Fra Bartolomeo is so well known. The regular, coherent placement of the large number of figures is made possible by the inherently clarifying properties of the perspective and enveloping architecture. Here the artist aimed to produce a simplified and disciplined construction within an enclosed, hermetic space to aid contemplation. Yet despite the huge scale of the support the figures still seem to be under life-size and are treated more like forms manipulated by the painter than naturalistic bodies – an impression reinforced for the viewer by the generalized,

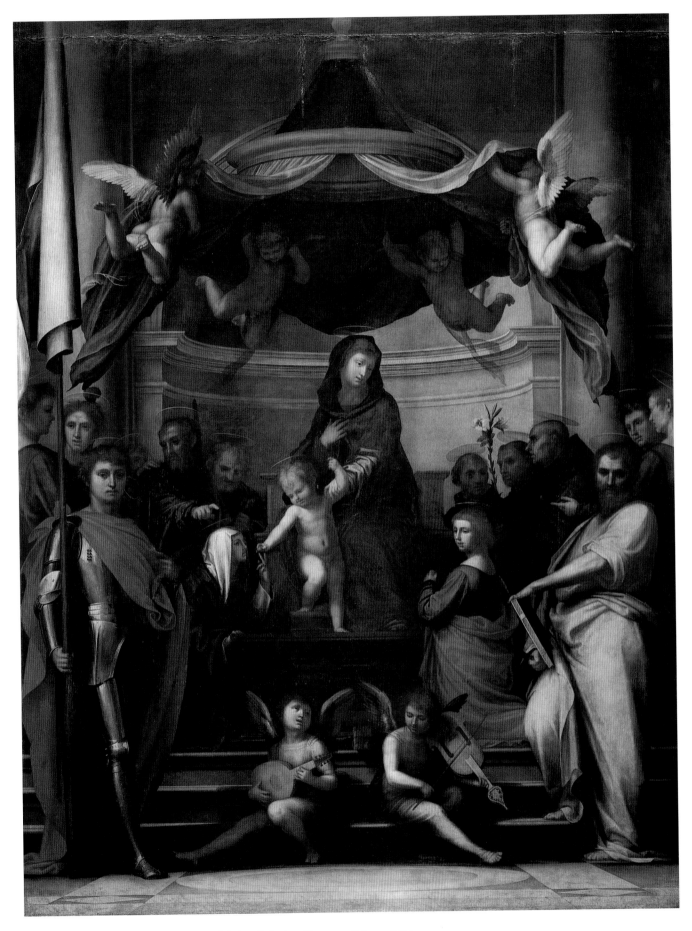

63 Fra Bartolomeo, *Mystic Marriage of Saint Catherine*, Florence, Palazzo Pitti.

undemonstrative features and rather wistful expressions. Any detail is basically sacrificed for an overall abstract effect that is solid and superficially logical. Individual figures are demonstrative but not engaging or interrelated except in small groups. The desire for bilateral symmetry and a concentrated, untroubled balance is equally obsessive in its regularity and self-denying restraint: the artist awkwardly echoes Saint Dominic's lily with Saint Paul's sword. The Frate was so willing to sacrifice attributes that would distract from the absolute clarity of presentation of the enthroned Virgin and Child that four of the male saints are no longer identifiable. The straightforward presentation of these saints around the Virgin respects a general, overriding Dominican prescription to preserve simplicity and so the meditative value of an image, rather than following the more traditionally Florentine tendency to seek variety counter to conventional usage.

The compositions of Fra Bartolomeo's mature altarpieces, including the Pala Pitti, are limited by their schematic coherence: they are almost all based on the same frontally disposed, pyramidal core design, persistently lacking in intensity or disharmonious accenting. The serial nature of his approach meant that, like Perugino, Fra Bartolomeo did not consider it necessary to rethink his designs or presentation of facial types, even when working for different patrons: perfection was reached by revisiting and reworking the same formulae, not by discovering new ones – an ideal shared by Ridolfo Ghirlandaio. To a significant degree the two artists worked to equal standards that were exposed as limited and old-fashioned after the return of Leonardo and Michelangelo to Florence around 1500. The ability to represent relief through the use of emphasized shadow was the single most noteworthy quality of Fra Bartolomeo's painting style according to Vasari (who, however, also pointed out in the same passage that the artist's works had already darkened by his time of writing).[14] This brooding quality is most evident in the mature altarpieces. Despite the pervading muted atmosphere, the *Mystic Marriage* contains crisp outlines and unified smooth surfaces that also allowed the artist to create strongly lit areas, contrasting sharply with the solid dark ones, rather than to develop subtle gradations. It appears that Fra Bartolomeo equated dispassionate technical clarity with a type of dour naturalism, in contrast to Michelangelo for whom complexity and ideality satisfied the same end.

The figures in the altarpiece are sculptural to the degree that they tend to be clearly separated and retain a stasis and solidity, but they lack the torsion of Michelangelo's more individualized creations. For Fra Bartolomeo such poses were achieved through artificial means and not from the direct study of the living model: he used wooden models to take different poses – evidence of a certain lack of engagement

in the creative process compared with many other Florentine artists of the period. Vasari himself owned the mannequin that Fra Bartolomeo's workshop used.[15] Inevitably, a certain inorganic crudity results from this practice of creating figural poses. The general meaning of these rather rhetorical figures was clearly as important to the artist as their tactility and organicity. Throughout his working life, Fra Bartolomeo implicitly validated Perugino's procedure at a time when it was being undermined in Florence. The shortcut manner in which he replicated his figures with ease reveals a certain lack of invention that, while understandable in the context of workshop practice, is not consonant with the more fully creative attitudes of Leonardo, Michelangelo and others, and would have isolated the artist as rather uncritical, perhaps old-fashioned even in this mature phase of his career. To be fair, the unorthodox nature of their examples made it easier for artists like Fra Bartolomeo to ignore them for a while without harming their own reputations, at least in the first decade of the century.

In his search for tonal relief Fra Bartolomeo here left the monochrome underpainting visible in the light areas, as well as in the shadows. It seems that he was still generally imitating what he thought Leonardo had attempted by favouring brownish coloured underpaintings in this period, though he was less interested or able to follow Leonardo's intentions for colour and the result is reductive by comparison. The general approaches of the two painters were ultimately incompatible: where Leonardo used effects of light and shade to make his work seem more palpably real, Fra Bartolomeo used them as further outward indicators of a less palpable mysticism, which suited the initiated majority of his audience. Ultimately, the Frate sought to recover nature and to give it coherence in a resolved system, whereas Leonardo hoped to reveal through his explorations its deeper, infinite possibilities. In Fra Bartolomeo colour is added to the outlined forms and is not especially integral to the overall effect, while the surface is smooth and densely opaque. At times his attempts to create daring contrast and a varied dissonance seem faintly absurd, as in the powerful Saint Bartholomew who is dressed in violet and pink. Above all, there is no ornament and this is one reason why younger artists like Rosso and Pontormo were more attracted to the earlier work of Andrea del Sarto.

Along with the issue of Savonarola and art, the problem of Fra Bartolomeo's relationship to the collaborator with whom he had long and repeated close contacts, Mariotto Albertinelli, is the other controversial area in accounts of his work.[16] Vasari claimed that it was difficult at times to tell their contributions apart, and from an examination of one export work they signed together, the *Annunciation* of 1511 (now in the Musée d'Art et d'Histoire in Geneva), it is pos-

sible to confirm his claim.[17] Recognition of their proximity is important because the reliance on assistance and close exchange rather goes against the grain of the more defiant and isolationist attitudes projected by artists like Leonardo and Michelangelo, not to mention Rosso later on. At the same time, their closeness demonstrates how in general Fra Bartolomeo's so-called Savonarolan manner was transmitted to non-Dominican painters without any feeling of compromise or unease. Indeed, there are cases when Albertinelli's position in this team may have been underestimated: the major group of large altarpieces by the Frate on which his modern reputation rests fall in the period 1508–13 when they again shared a workshop. Albertinelli was not an artist devoid of ideas, and a positive exchange must have occurred.

An example of an early Albertinelli is the tondo that can be dated on the basis of style to the late 1490s (fig. 64). Featuring the Virgin adoring the Child with the help of an angel who hands him some of the instruments of the Passion, it is formally rather weak in its awkward spatial and figural relationships. The divine characters are placed in front of a landscape as if imposed on the background rather than integrated within the overall picture. There is likewise a lack of relief in the large, simplified areas of drapery with folds in dissonant, unrelated patterns. The inset chorus of angels in the upper part of the painting on a gilt background reflects his training as a goldbeater, but destroys the integrity of the fictive space. As this example already makes apparent, Albertinelli could be more sensual than the Frate and took a more cerebral approach to pictorial effect.

The importance of Albertinelli for Fra Bartolomeo can best be demonstrated through what is perhaps his most fully realized major work and one that seems indisputably to be by him – the Uffizi *Visitation* (fig. 65), which carries the date 1503 on a pilaster. The painting provided a compositional standard of equal weight and stability to Fra Bartolomeo's brand of monumentality, famously based on pyramidal constructions, to judge by the popularity of this concentrated image. It is always possible that he depended here on Fra Bartolomeo drawings for the design, but this would not account for impressive scale and grandiose stasis of the painted image.[18] Ordered by the Congregazione dei Preti by Orsanmichele in Florence, not for their church but for the altar in the oratory of the Confraternity of the Visitation, it features the two mothers meeting before an open arcade without any other setting. There are marked differences from Fra Bartolomeo's practice at this date: Albertinelli preferred darker overall tonalities, and a distinctly more viscous paint handling and broader areas of saturated colour, while his forms are more rounded and tubular with a duller sense of rhythm than in the Frate's work. His characters are sweeter

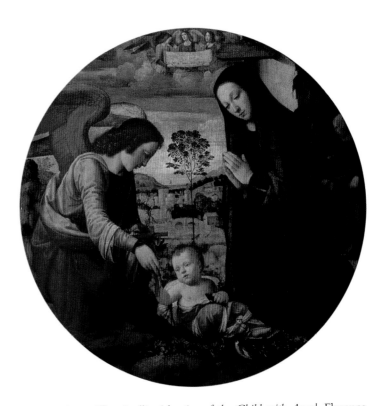

64 Mariotto Albertinelli, *Adoration of the Child with Angel*, Florence, Palazzo Pitti.

too in their facial expressions. Even if there is some truth to Vasari's puzzling statement that Albertinelli disapproved of Savonarola – curious, that is, given his rapport with Fra Bartolomeo[19] – this particular work influenced the School of San Marco, as exemplified by Giovanni Antonio Sogliani's derivation of the *Visitation* produced for the Confraternity of S. Niccolò del Ceppo in Florence, where it remains.[20]

Albertinelli's interest in technical experimentation, as evident in the *Annunciation* of 1510 (fig. 66), was of greater daring than anything on a comparable scale by the Frate from the same period. Although he felt bound to criticize it, even Vasari recognized that this altarpiece held the key to Albertinelli – the work into which he put maximum thought – and it is certainly his most ostentatious.[21] He laboured so long over it that a dispute with the patron arose and eventually it had to be evaluated for the final fee. The principal development was in experimenting with darker surfaces and more forceful lighting in the wake of the excitement generated by Leonardo's second Florentine period. In fact, the panel is so huge that it needed two lighting systems: the illumination in the upper part has a divine source, while in the lower part it rakes across the picture plane from left to right. Contradicting this further is the prominent use of gilding on, for example, the wings, the lily, the rays and garlands of the lower angels. The reduced palette with much use of black and

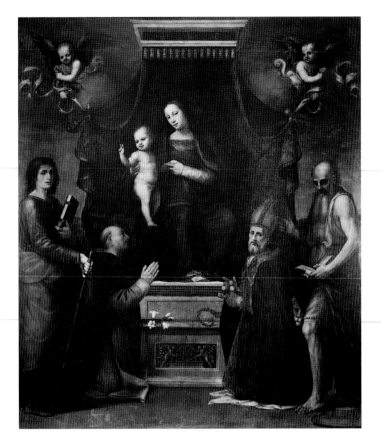

67 Mariotto Albertinelli, *Virgin and Child with Saints Julian, Dominic, Nicholas of Bari and Jerome*, Florence, Accademia.

white is notable, as is the soft, incandescent atmosphere; the Virgin is dressed all in blue to facilitate greater control of the overall tonality. Albertinelli's technical intentions are clarified in another contemporary altarpiece, the *Saint Julian* (fig. 67), now a near-wreck. Its frayed, glutinous surface and heavy application of paint obviously betray an experiment with oil painting that has to be seen as a partial failure, though it may also indicate a late interest, not sustained, in attempting a practice inspired by Leonardo's example. Compared to that found in Fra Bartolomeo's altarpiece of the previous year in Lucca Cathedral, Albertinelli's handling is more abrupt, turgid and broad with a warmer, more deeply luminous paint surface. His technique allowed him to try to paint thicker textures, as in the brocades, than Fra Bartolomeo who favoured a more restrained approach and enamelled surfaces.

The treatment of the architectural space with a barrel vault in the *Annunciation* would rival Bellini's S. Giobbe altarpiece (now in the Venice Accademia) in its literal depiction of an image supposedly viewed from a church floor. But in this strict attitude it surpasses any painting by Fra Bartolomeo, who never tolerated such a visually indeterminate floorplan. In creating the desired atmospheric effect Albertinelli reduced the amount of landscape represented as if to seal off the space for greater control. The figures seem rather small in relation to this pictorial field and are not particularly legible, and it is perhaps here that Albertinelli diverged most from the characteristics of the School of San Marco, though other aspects are relevant for this unofficial group: the slowly paced movements, the features idealized through replication. Vasari wrote that not long afterwards Albertinelli gave up painting to run a tavern because he could not tolerate the new critical climate in Florence, and it certainly is true that there are relatively few late works attributed to him in the years before his death in 1515 – so providing further evidence for the School of San Marco's losing a dominant position in the city with the rise of Sarto.

The Frate's career was itself linked to the fate of the Florentine Republic and after 1512 when the Medici returned, his flow of commissions in the city came to a halt. The master travelled in that period to places including Ferrara and Rome, where he came into close contact with Raphael. But despite his institutional religious status and connections, the Frate was apparently unable to establish himself successfully in Rome, and his stay there may have been something of a disappointment. It can be no coincidence that his style also began to reach a natural limit in the last years of his life up to his death in 1517, as is apparent in overblown works like the Lucca *Madonna della Misericordia*, just when Michelangelo again returned to Florence for a long period, and also when Pontormo and Rosso emerged as independent artists.

What contemporary evidence is there for opinions about Fra Bartolomeo's mature work from which to consider his historical worth, particularly in relation to his Dominican status? One surprisingly frank judgement of a mature Fra Bartolomeo is recorded in a letter of 1509 written by Alamanno Salviati. It discusses a painting of the Virgin and Child ordered from him by Alamanno's brother, Averardo. The style is described as very ordinary and displeasing because, in his words, new art is always more and more beautiful – a rather damning aside for those who wish to put the Frate at the forefront of Florentine art in this period ('perché le cose nuove son sempre mai più belle'). Alamanno Salviati instructs his brother to return the painting and pay off the framemaker, saying that he will undertake to get him another one.[22] The implication is that the picture will be rejected at any material cost to the patron.

There was clearly a trap in the style Fra Bartolomeo did so much to create and promote for the Dominican Order, which could lock artists into compositional forms that were unchallenging and unprovocative, as the life and work of Fra Paolino makes apparent. Born in Pistoia in 1488, Fra Paolino was the fortunate artist appointed to inherit, that is, super-

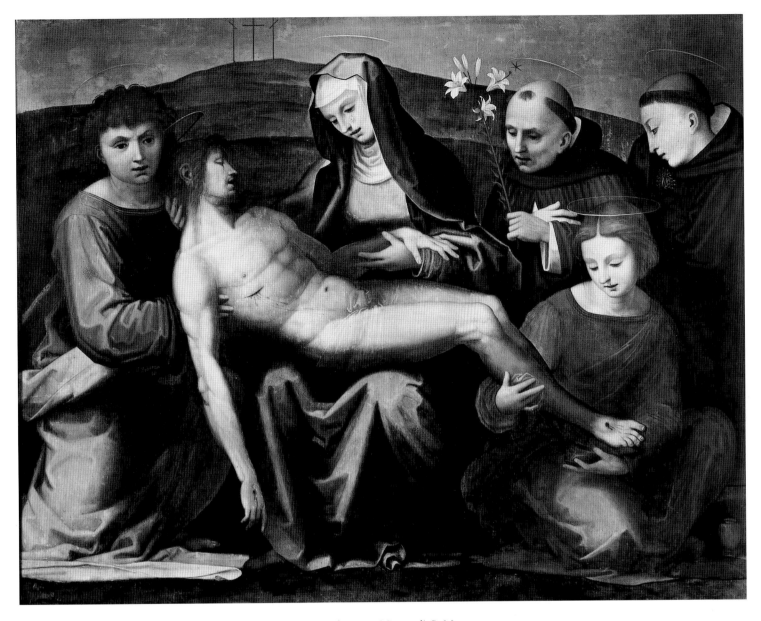

68 Fra Paolino, *Pietà with Saints Dominic and Thomas Aquinas*, Florence, Museo di S. Marco.

intend, the master's workshop effects by the Dominicans, thereby giving him the chance to make a career out of unreflectively repeating Fra Bartolomeo's inventions in a highly simplified manner, often for altars in Dominican churches (fig. 68), though nearly always away from Florence itself.[23] The case of Giovanni Antonio Sogliani's later fresco commission from the mid-1530s for the large refectory of San Marco, now part of its museum, is yet more representative as it involves the work of a major loyal follower with greater talent than Fra Paolino and one who frequently worked for the Florentine market. Vasari wrote that Sogliani produced a design on his own accord of the Multiplication of the Loaves and Fishes to which the friars objected, preferring instead

things 'positive, ordinarie e semplici'.[24] That this was quite a common subject for refectories only emphasizes their rather limited attitude to patronage. Despite the maturity of an established artist born in 1492, Sogliani had neither the will nor the prestige to fight them and gave in (how differently would Michelangelo or Rosso have reacted in similar circumstances). His squared *modello* (fig. 69) proves the truth of Vasari's anecdote. The image Sogliani finally produced in 1536 on a more pedantic and restrained subject, entitled *Saint Dominic and his Friars fed by Angels*, contains added portraits and saints, as well as a Crucifixion (fig. 71), and these subdue the narrative impulses of his original design. In comparison with the drawing it is static and disunified. The fact that

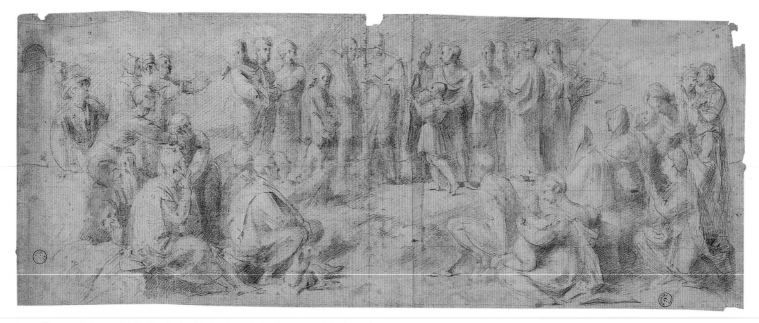

69 Giovanni Antonio Sogliani, *Multiplication of the Loaves and Fishes*, Florence, Uffizi.

Sogliani's composition was influenced by Rosso's *Betrothal of the Virgin* in S. Lorenzo (fig. 148) must have played a part in its rejection on the grounds that it was too modern, not just iconographically but stylistically.

Vasari's almost sarcastic characterization of the misanthropic Sogliani as a kind of religious populist who did not engage professionally with other artists is also relevant when considering his distance from contemporary Florentine activities: 'his manner had been much in favour, since he gives an air of piety to his figures, in such a fashion as pleases those who, delighting little in the highest and most difficult flights of art, love things that are seemly, simple, gracious and sweet.'[25] These words cannot help but evoke the condemnations of Perugino's art at the start of the sixteenth century. And so it seems especially appropriate that Vasari himself later took over an altarpiece commission for Pisa Cathedral from Sogliani at the request of the patron because he had been too plodding over it. The *Saint Brigitta* altarpiece by Sogliani of 1522 (fig. 70) provides an example of his style at its most institutional and relentlessly sober and mystical. It is clear, subdued and perfunctory, and the emotional content is decidedly serious. Indeed, the very notion of formal style is itself somewhat irrelevant compared to the elaborate preordained message encapsulated by this religious image. Appropriately, it carries the signature used earlier by Fra Bartolomeo: 'Orate Pro Pictore'. This type of stereotypical painting comes perilously close to fulfilling the definitions of 'mannerism' as outlined in the period by Paolo Giovio and Vasari.

There are further reasons to believe that Fra Bartolomeo, like some of these other artists, was detached and even mar-ginalized from certain innovations in this later period in Florence. Respecting his religious calling, he did not dedicate much effort to absorbing the vigour and surface naturalism of antique art, with the partial exception of a few isolated drawings, which tend, in any case, to be among his least dynamic. Vasari affirmed that Fra Bartolomeo was so

70 Giovanni Antonio Sogliani, *Saint Brigitta distributes the Rule*, Florence, Museo di S. Marco.

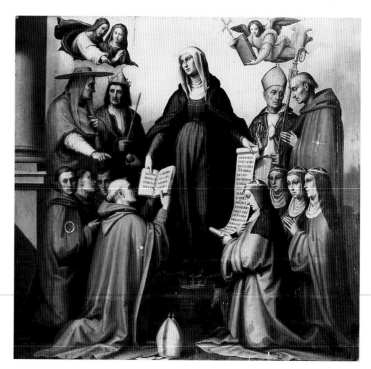

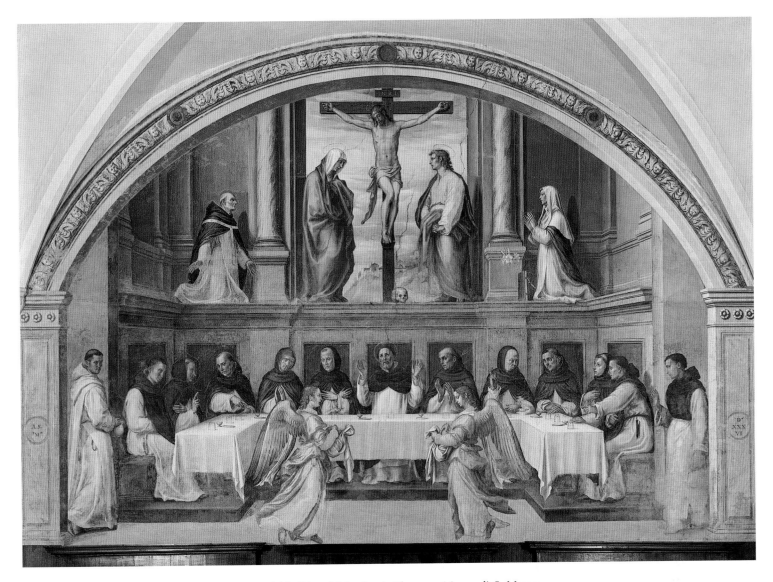

71 Giovanni Antonio Sogliani, *Saint Dominic and his Friars fed by Angels*, Florence, Museo di S. Marco.

repeatedly taunted in Florence for his inability to depict either nudes or monumental figures that he painted works which deliberately attempted to counter such criticism.[26] The existence of these works would support Vasari's statements published almost forty years after the events. It may be relevant to recall here how chronologically close these attacks came to Perugino's controversial eclipse, and the terms used against Fra Bartolomeo are precisely those analysed in the first chapter from the writings of Vasari and Giovio. The response over his inability to represent the nude was the *Saint Sebastian* installed for a time at S. Marco. Even if it was a demonstration piece, the claim of the Anonimo Magliabechiano that his best work was the nude *Saint Sebastian*, now known through copies and derivations of a lost original that was sent to France, can be taken as an implicit criticism

of the artist by exposing its uncharacteristic nature in his oeuvre – but one closer to the heart of more secularized Florentine artistic traditions.[27]

In response to the second taunt about the lack of monumentality in his style, Fra Bartolomeo produced the *Saint Mark* (fig. 72). Here, as with other later works, Fra Bartolomeo lost direction somewhat even as he matured – a notion borne out by an indisputably autograph painting like this, as the painter attempted to graft his familiar manner to the more energetic and powerfully monumental art of Rome after viewing the Vatican frescoes of Michelangelo and Raphael. As an example of his limitation, despite the vast actual size, the paint handling of the *Saint Mark* is still relatively tight: the artist equated mere physical scale with monumentality, which is more properly generated by formal

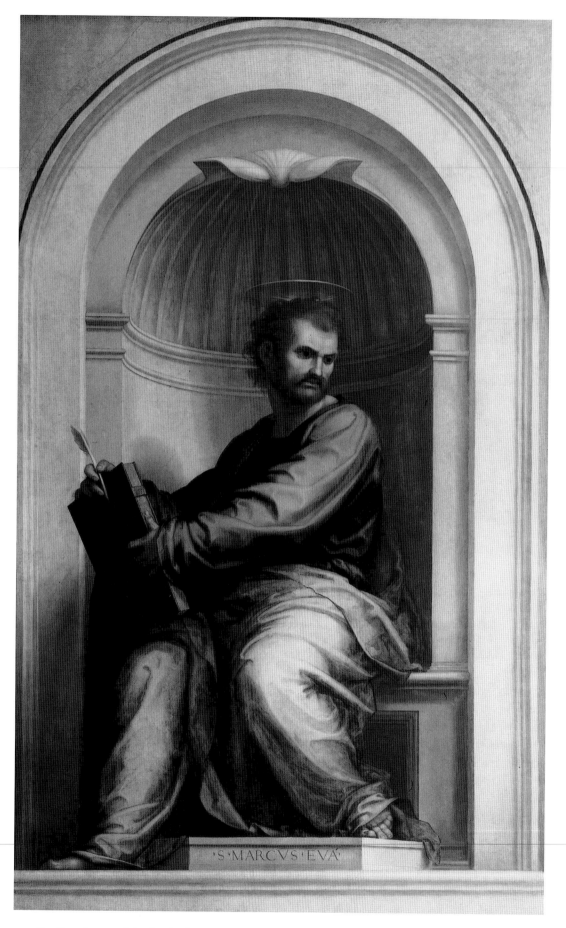

'S·MARCVS·EVA·

72 Fra Bartolomeo, *Saint Mark*, Florence, Accademia.

means. The figure's enormous height (more than 3.5 metres) betrays the ambitiousness of an artist exposed to the Sistine ceiling and Michelangelo's sculptures in Rome, especially the *Moses*. The veneer of aggression in the features, selectively accentuated by the single bulging vein on the temple, may also be derived from another Michelangelo, his marble *David*. The form is over-inflated and strangely inorganic, as if manufactured from disparate modular elements of the art of Michelangelo and of the Roman Raphael – literally a mannerist image according to the period sense of the term. Similarly, it is monstrous in scale but still lacks a certain degree of power, grandeur or tension. And so the saint swivels rather than turns on his axis, while the placement of the knees and arms on the same plane and the repeating folds tend to flatten out the figure.

The change in appearance of Fra Bartolomeo's painted work brought about by the large number of recent cleanings is not as dramatic as in the case of Michelangelo's, but it too is significant for the history of Renaissance art. The familiar Fra Bartolomeo painting, with its subdued, unified surface that seems to exemplify the qualities of restraint and formal unity celebrated by Wölfflin, has been modified to a more forced, disjunctive and stark appearance with restoration. The best example of this dramatic transformation is the *Salvator Mundi* tryptych painted in 1516 for the Billi altar in SS. Annunziata (now in the Accademia).[28] Like the artist's *Saint Mark* it was later transferred to canvas. The palette is less sober and more richly glowing than in his earlier efforts. Although quite thinly painted, both picture surfaces are partially activated by some striated brushstrokes and coloured shadows, but compared with Sarto's experiments by the middle of the 1510s, they did not attract as many younger artists in Florence. The cleaning of these works has revealed on the one hand more originality in the context of Fra Bartolomeo's range of personal development from early to late, but on the other ultimately a limited and circumscribed one because of the controlling influences of Michelangelo, Raphael and, by this date (around 1515), Sarto. Even the young Rosso and Pontormo were more liberated from such direct influences by then. More than their intrinsic value, perhaps the celebrity of Fra Bartolomeo paintings of this period like the *Saint Mark* rested on their transporting up-to-date Roman stylistic motifs to Florence. Possibly, they thus saved the less intrepid native artists a journey south – it is a significant record given the number of important Florentine artists who are not documented as having travelled to Rome.

This is not to imply that Fra Bartolomeo's late work was without serious merit: painted in the church of San Marco, a familiar location for the painter, the *Saint Vincent Ferrer* (fig. 73) is a challenging example, using a more monochromatic palette and exuding a pervasive if effete directness. It features Saint Vincent Ferrer making his characteristic right-arm gesture heavenwards as he preaches about the Last Judgement and is a good example of the artist's continuing interest in illusionism: the figure is viewed from below and placed in a restrictive niche the boundaries of which his hands seem to break, although it has acquired some power unintentionally by having been trimmed to a three-quarter length. The poor condition of the painting has also given it greater emotional power than would have been present in the original. Vasari saw the work already in an extremely damaged state, and he claimed that the artist used a technique reminiscent of Perugino by applying his colours directly on a ground mixed with wet glue which led to rapid deterioration.[29] While such technical experimentation is typical of the period in Florence, it is telling that even for one of his last paintings the Frate's closest model remained Perugino and not Leonardo, an artist for whom he seems never to have lost respect – less surprising, however, when one recalls that, for a painter maturing in the 1490s, it was Perugino who was the really dominant painter in Florence. Equally significant in terms of technique is the fact that the retrograde follower of Domenico Ghirlandaio, Giuliano Bugiardini, was called upon by Albertinelli at the age of 42 to finish the Frate's *Pietà*

73 Fra Bartolomeo, *Saint Vincent Ferrer*, Florence, Museo di S. Marco.

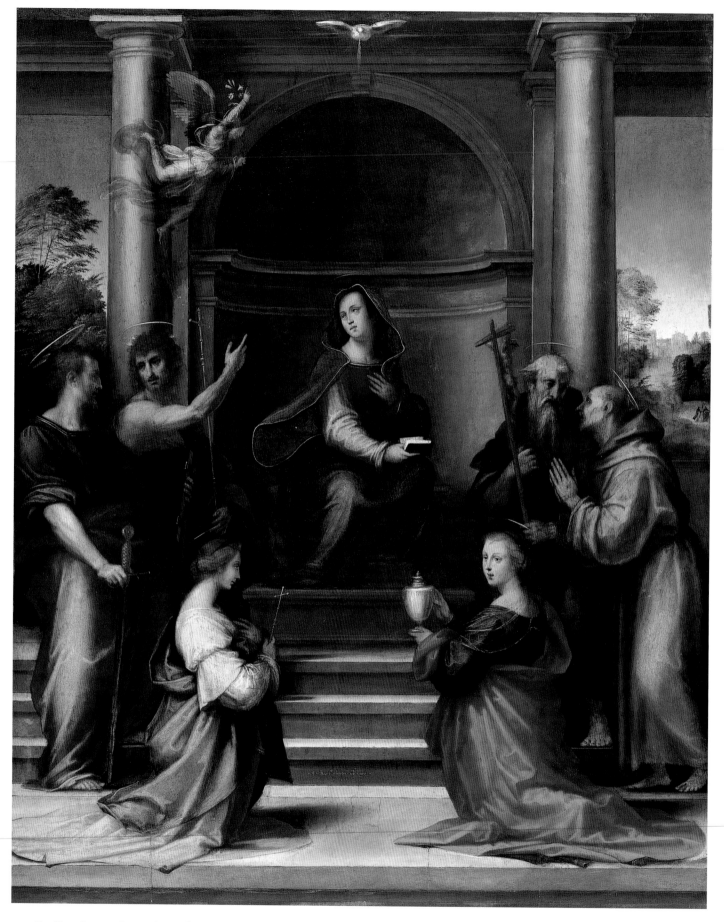

74 Fra Bartolomeo, *Incarnation with Six Saints*, Paris, Louvre.

altarpiece for S. Gallo following his death.[30] Bugiardini was also responsible for completing for Cristofano Rinieri – and making an export copy for France – Fra Bartolomeo's composition the *Rape of Dinah* – an episode from Genesis.[31]

In describing some of the later paintings Fra Bartolomeo and Albertinelli produced in Rome as in a 'delicate style', Vasari was subtly undermining their work at that stylistic moment in the papal city around 1512 in the wake of the completion of the vault of the Sistine chapel.[32] Nevertheless, efforts in this moderate, precious manner are among the Frate's most enthralling, such as the *Incarnation with Six Saints*, signed and dated 1515 (fig. 74) and, not surprisingly, a non-Dominican work, possibly painted for export to Francis I. Conceived in the format of an altarpiece, only the motif of Jerome and Francis sharing a cross is a concession to the reduced pictorial field, though the technique is much more vibrant than that found on his large panels. It is very daring and premeditated colouristically, with the surface correspondingly more detailed and active than usual. The angel is especially stunning in its transparency which contrasts with the heavy, opaque surfaces the artist normally favoured, as if curbing a latent ability. At one point Vasari did compliment the vigour of his art when discussing a grisaille of *Saint George* done for the Pugliese family (already mentioned in the context of Piero di Cosimo's patrons), which was then in the palace of Matteo Botti, but such a modern term of unconditional praise is exceptional in this Life.[33]

To conclude: it seems appropriate that in contrast to his more intensively creative, younger contemporary Andrea del Sarto – who left a cycle of sophisticated monumental narratives in the cloister of the Scalzo confraternity, perhaps uneasily close to S. Marco, through which his stylistic development from early to late can be traced – Fra Bartolomeo depicted over time a sequence of intimate saints' heads (fig. 75), most for a Dominican-run hospice near Fiesole. Executed in some cases on the unusual, modest supports of terracotta and roof tile, the frescoes reveal the Frate at his most relaxed and technically unrestrained. In their translucent colouring and tender, if detached emotional quality these hallucinatory works reveal an artist who could rival and surpass Perugino – an already eclipsed force in Florence by the end of the first decade of the sixteenth century – but who would never trouble Michelangelo who, it might be recalled in the interests of chronology, was actually younger than Fra Bartolomeo. So while he and Sarto have been given relatively equal treatments in recent accounts of Florentine painting,

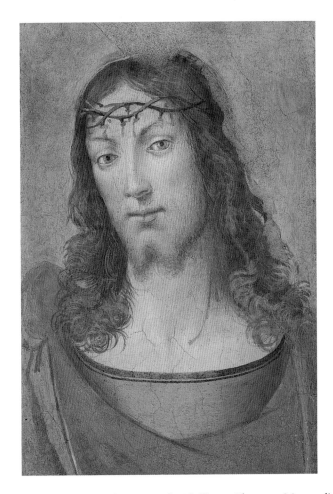

75 Fra Bartolomeo, *Christ crowned with Thorns*, Florence, Museo di S. Marco.

such a relative placement would probably not have struck many contemporaries. Francesco Sansovino's notice on Tuscan art, added to his edition of Landino's edition of Dante's *Divine Comedy*, published in 1564, is particularly emblematic because as Florentines they were judged according to the same criteria.[34] Fra Bartolomeo is given a brief mention along with rather more glowing citations of Filippino Lippi and even the mediocre Bugiardini, with whom the friar was closely associated, but Sarto is considered to be on a different plane – among the first of his age ('tra primi dell'età sua'). If it is true to say that there is no reason why artists should necessarily continue to be judged according to the opinions of their own times, the pointed severity of such comments in relation to Fra Bartolomeo and his followers have, none the less, been too long ignored in studies of the so-called High Renaissance.

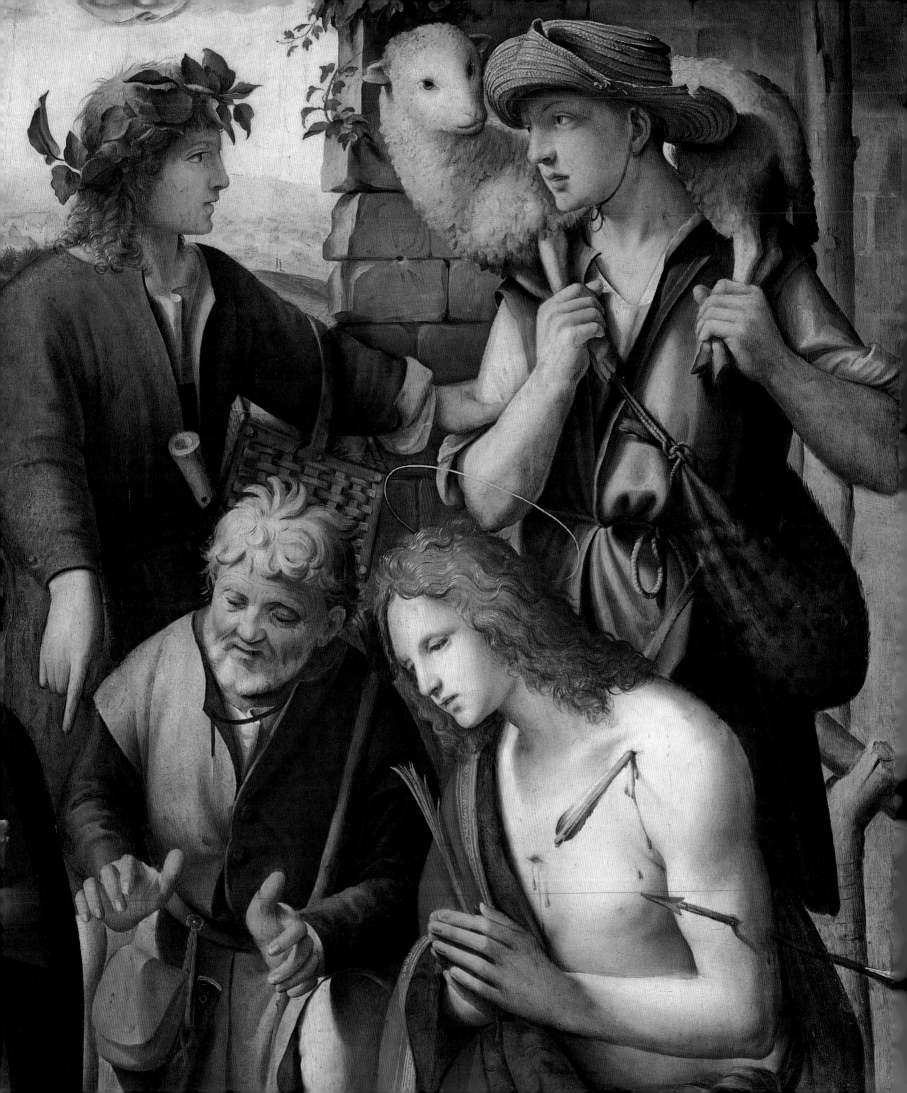

6

RIDOLFO GHIRLANDAIO AND THE RETROSPECTIVE TRADITION IN PAINTING

THERE IS A NATURAL TENDENCY IN ACCOUNTS OF any period to separate the primary painters from those assumed to be more secondary. For the High Renaissance this division is generally based on stylistic analysis, so it is not surprising that the group of apparently regressive contemporaries includes a long list of names who explored tangents away from the nominated mainstream, such as Piero di Cosimo, or those who followed more conservative styles that accentuated formal links to the illustrious art of the past. Yet this classification has proved problematic if only because it implies that every artist active in Florence in the first part of the sixteenth century should be considered solely in relation to their comprehension of Leonardo and Michelangelo, even though the concerns of those two artists could be mutually exclusive. Inevitably, some younger painters especially have been judged retrograde for not respecting the achievements of those two masters despite there being few points of contact, either career-wise or stylistically, between those innovators and those who followed a more traditional career path, such as Ridolfo Ghirlandaio, or others like Fra Bartolomeo, who operated under different conditions subservient to the Dominican order. Even for those artists who might have sometimes been interested in absorbing and rivalling innovations, like Piero di Cosimo or Filippino Lippi, this understanding was never more than partial because of the frequently disparate and dispersed models in Leonardo and Michelangelo's work. Indeed, a safe traditional artist like Ridolfo was successful in part because of the sometimes unresolved and so, at times, negative nature of the contribution of such pioneers. In other words, it was possible for a major artist in Florence like Ridolfo to make occasional reference to their efforts and still achieve a wide success precisely because he could fully realize his personal aims without conflict or procrastination. At the same time, Ridolfo's case demonstrates how the emphasis in Leonardo and Michelangelo's example on process and experimentation did not affect all painters even in Florence. Above all, it needs to be appreciated that a model based on innovation is not relevant to the practice of every artist to the same degree, just as the work's financial value, which it seems for Ridolfo's work was as elevated as any contemporary painter, was not assessed on the grounds of originality alone. If his contribution has been largely overlooked this is certainly in part because its stylistic roots were so deep in the Quattrocento, and so occupied with the perfection of already tested models in every case. But that is to devalue the wide impact of this dominant painter.

Ridolfo di Domenico Ghirlandaio, who was born in 1483 and died in 1561, is in particular need of rehabilitation against such strictly progressive models, as a painter who was naturally included in Vasari's most modern age.[1] This reassessment has been long in coming given his close friendship in Florence with Raphael, to be discussed later in the chapter. If Ridolfo's imagination had its limitations he still practised a distinctive and consistent style, not to be explained as simply following the work of more innovative figures such as Leonardo or Raphael. Few painters of the Florentine Renaissance better exemplify the dictum that what was valued in their time may not correspond to what is valued in ours, and the imposing of a particular canon on the period has even distorted approaches to Ridolfo's style, leading to frequent underplaying and outright misunderstanding of his extremely successful career. In particular, there has been a marked tendency to date his paintings, whether documented or not, too late on the basis of questionable stylistic assessments, and also to view them with insufficient evidence as having been executed in collaboration with one or more of his numerous students, many of whom exist solely as names. There is still an open problem in dealing with the emergence of the most prolific Ridolfo pupil, and the one most commonly evoked wrongly in relation to this type of later painting, namely Michele di Jacopo Tosini, called Michele di Ridolfo

(Vasari wrote that this painter loved Ridolfo like a father and took his name).[2] Advanced datings of Ridolfo paintings are wilful to the degree that his work was thought to have followed, *a priori*, artists we now consider more innovative. Although he probably always had overlapping commissions, Ridolfo was not inefficient and long execution spans for his paintings seem out of the question.

Ironically, the earlier datings have made it possible to suggest for him a somewhat livelier place in the development of Tuscan painting. In stylistic terms Ridolfo absorbed some of the formal principles of the High Renaissance as it has been traditionally defined more rapidly than is generally appreciated. His work has a noble and restrained clarity and balance, as well as an emotional sincerity; its decorous, ruminative calm combined with a monumental scale represents his own contribution to one distinctly orthodox branch of Florentine painting at the start of the sixteenth century. What has been defined as a universal style in Florence around 1500 is more accurately approached as a more limited set of fundamentally atavistic values shared by conservative painters like Ridolfo, whose work, none the less, has a breadth and vigour greater than anything Perugino could manage at the end of his stay in Florence.

Unlike Michelangelo, Ridolfo could never have disguised his roots in the Ghirlandaio workshop (his father was Domenico Ghirlandaio), nor would he have tried. The family *bottega* tradition was still, after all, a common route for painters to become established in Florence: other less well-known artists with familiar surnames like Ruberto Lippi, Giovanbattista Verrocchio and Bastiano da San Gallo, practised in this period too. Ridolfo's case can be taken as emblematic of the fate of this type of rooted painter in the sixteenth century. Certainly, the importance of Ridolfo's association with the art of Domenico is primary for all aspects of his career, not just his style which took its charge from the noble tradition and authority of artistic lineage, the weight of the past imposed on the present. In some instances, he even worked for the descendants of Domenico's patrons, just as the same patrons later employed his workshop after he himself ceased to be the single dominant hand. In one case, at San Jacopo a Ripoli, an institution traditionally sponsored by the Antinori, it is possible that he replaced one of his own first altarpieces, the *Mystic Marriage of Saint Catherine*, with a new panel perhaps some three decades later, assisted by Michele Tosini.[3]

Unavoidably, there was an intensely politicized element to Ridolfo's patronage as his style automatically associated a given commission with the prestige of his Florentine ancestry. His example serves as proof that Renaissance patrons looked as much to the past as to the future. The pattern of his career also provides a reminder that patronage in this period was as much a social activity as one based on objective taste, and Ridolfo's family contacts were often the reason for his selection by potential patrons and clients. From his father, Ridolfo inherited not only his stylistic tendencies towards a precise, linear if still modulated style, but also his commercial acumen and desire for material success that were far more organized and business-like than that of a typical artisan, despite the fact that many of the commissions he undertook were modest. Even these artistically rather limited projects could be quite strategic in nature, however, such as the commission of 1515 to paint a modest predella featuring the Madonna della Misericordia, for the decoration of a group of Trecento sculptures found in the Bigallo. This was the oratory of an important confraternity adjacent to the Baptistery and Cathedral of Florence, thus a location of enormous strategic potential for any artist's career, and a place where only a respected artist would be offered work.[4]

Technically, Ridolfo's production is commonly of high quality, depending on the destination, and this indicates that most people who ordered works of art would have expected finish and legible iconography more than unbridled innovation. If he was not overly preoccupied with the creative process, it is perhaps because he was born into a family with a successful and long-settled basic style. Because he did not travel far from his native city either, his style, legion of students and very presence provided a notional common denominator for Florentine art throughout the sixteenth century. His very success and ability to earn a constant and plentiful number of commissions meant that he attracted large numbers of students to his studio. These pupils were well enough trained to establish careers not just in Tuscany but also abroad in some cases. There is evidence too that, through repetition of his father's compositional models and a wide distribution, Ridolfo was able to establish a pattern for certain important subjects in Florence and Tuscany, especially for the Annunciation – a feast day of crucial significance in the Florentine calendar.[5]

With regard to his general status, it is relevant that Ridolfo was the first Florentine painter to create what appears to have been his own private chapel outside the family's villa (now Agostini) at Colleramole, near Galluzzo, just south of Florence, in their ancestral area. It contains donor portraits of himself, his immediate family and father in a frescoed tabernacle (fig. 76), with an altar featuring a recessed *Virgin and Child with Saints Joseph and Benedict* flanked by exquisitely rendered grisaille Virtues, *Faith* and *Hope*, in niches.[6] That this seems to date from relatively early in his career, perhaps in the 1510s, only reinforces the cohesion of this most prominent and entrenched family of Florentine artists. Although

Vasari did not dwell on Ridolfo's social standing, the tone of his Life of the painter is, nevertheless, perfectly neutral and uncritical, and one could be forgiven for supposing that he preferred Ridolfo to, for example, his greatly superior but more varied and difficult Florentine contemporary Pontormo.

In one of the most remarkable of all instances of Renaissance patronage, it emerges that Ridolfo's altarpieces were also systematically exported by one patron to a number of regional churches in Tuscany. This was facilitated through his life-long friend, the director of the Hospital of Santa Maria Nuova and later bishop of Cortona, Leonardo Buonafede.[7] The altarpieces may have been understood as the painted equivalent of Della Robbia and Buglione family sculptures in polychrome terracotta that were also dispatched from Florence in great numbers. In the case of Sta Maria Nuova alone, there is evidence for the production of as many as eight panel altarpieces by Ridolfo having been placed in churches belonging to the hospital's patrimony between about 1500 and 1528 during Buonafede's reign, mainly with the subject matter of the Virgin and Child enthroned with lateral saints appropriate to the particular location. Through these commissions, which seem to have been ordered in a remarkably casual and trusting procedure, Ridolfo's work was used to create a unity of function and taste in decoration over a broad geographical range. Working for very different types of patrons, he also sent altarpieces of higher quality to satellite towns outside Florence, such as Prato, Pistoia, Colle Val d'Elsa and Monte San Savino.

The elevated patronage Ridolfo received from the Medici and other prominent Florentine corporations and families, such as the Antinori, Ricasoli and others, should alone justify serious interest in his work. But the consistent quality of his portraiture and his enormous influence propagated through his numerous pupils (among the earlier still identifiable ones, Antonio Ceraiuolo, Baccio Ghetti, Domenico Puligo and Mariano da Pescia), also merit more investigation. He produced, for example, the first major painted likeness of Cosimo de' Medici in a neglected, because lately unexhibited, portrait dated 1531. Considering that the dignity of artists was a major theme of the *Lives*, it seems curious that Vasari did not make more of this aspect of Ridolfo's biography, even if his familial tie to Domenico was naturally emphasised. Ridolfo is a rare figure who came close to fulfilling that misleading modern view of the Florentine Renaissance as a time when artists moved in the same circles as their patrons. Through his marriage in 1510 to Contessina Deti, he attained a level of social standing approaching that of his patrician patrons.[8] In 1525 he married secondly the daughter of the important Florentine notary Bartolomeo

76 Ridolfo Ghirlandaio, *Virgin and Child with Saints Joseph and Benedict* flanked by grisailles of *Faith* and *Hope*, Colleramole, Galluzzo (now Agostini).

Mei. Ridolfo belonged to the prestigious confraternities of the Tempio and of S. Paolo, whose membership included dignitaries who became his patrons – such as Giulio de' Medici and later Duke Cosimo de' Medici – and, traditionally, artists of the Ghirlandaio family. Ridolfo was later made *de collegio* under the Medici principate, so becoming eligible for political office, even if it is not known if he ever accepted the responsibility. He was, however, chosen by the confraternity of the Tempio to be captain, with a member of the Albizzi family, of the Quarter of S. Giovanni in Florence in 1535. For an artist he was considered of sufficient social and

intellectual standing to have a small part in the fourth *ragionamento* of Anton Francesco Doni's dialogue *I Marmi*, published in Venice in 1552.[9] Clearly, there is a need for more research on this facet of his cultural life, just as the consistent devotional links between Ridolfo's family and the Camaldolese Order still have to be fully traced.

Especially revealing for how we classify the period in Florence after 1500 is an analysis of Ridolfo's earlier style. If there was a classical tradition in Florence in the sense of a venerable, passive yet high-quality conservativism against which painters like Rosso and Pontormo directly rebelled, this did not emanate from Leonardo and Michelangelo but from the Ghirlandaio family and extended circle of artists. Without some understanding of their output it is impossible to appreciate the context for the deeply radical nature of the contributions of the likes of Rosso and Pontormo. The basically submissive and pedantic aspect of Ridolfo's style thus provides evidence for the entrenched outlook of some Florentine artists after 1500, including first Perugino but more importantly Fra Bartolomeo and also others such as Giuliano Bugiardini and the Botticini family of painters. These Zeri has astutely grouped together and memorably characterized as practising 'una sorta di parlata classicistica' that, nevertheless, had nothing to do with the antique.[10] Like many of these figures, Ridolfo's approach to art was essentially prescriptive, rhetorical and simplifying and which lost some tactility and incisiveness over the course of his career. As with that of Fra Bartolomeo, who was ten years older, Ridolfo's work has to be viewed with specific preconceptions for its full meaning to be admired and appreciated, the former in Dominican traditions and the latter in conservative Florentine ones. This juxtaposition of names is not random: Vasari claimed that Ridolfo had been in Fra Bartolomeo's studio in Florence, which reinforces the conceptual if not stylistic link between the two artists.[11]

The curiously modest, almost anonymous character of Ridolfo's style is exemplified by an incident involving his completion of an altarpiece begun by a former pupil and assistant of Domenico Ghirlandaio, Sebastiano Mainardi, for San Gimignano. Following Mainardi's death in 1513, the procurator of the patron turned to Ridolfo, no longer a young painter by this date, to finish the panel. The result is so seamless that the collaboration would never be suspected without the survival of the second contract.[12] After all, Leonardo simply leaving his *Adoration of the Magi* panel incomplete on his departure from Florence was not typical practice for every unfinished work. In this context it is appropriate too that only one surviving painting by Ridolfo is both signed and dated. This is the *Adoration of the Shepherds with Saints Roch and Sebastian* panel (fig. 77), which is inscribed on a cartello strip at the lower center RIDOLFUS GRILLANDAIUS FLORENTINUS FACIEBAT / INSTANTE IOHANNE ITALIANO PETRI MDX. The unusual use of the word 'italiano' to indicate the patron's nationality suggests that it was produced for export. The signature implies too that Ridolfo felt unusual pride in this single painting and his Florentine birth, which can be taken as a sort of demonstration piece of his talents.

Nothing is yet directly known of the patron or intended location of this altarpiece. The presence of the two plague saints kneeling in the first plane before the Christ Child is possibly relevant for unravelling the circumstances of its commissioning since they are anachronistic to the principal mystery of the Adoration. The picture is distinguished above all by a tendency towards stylistic purity and restraint out of which any dramatic narrative has been carefully filtered. The adult figures form a loose circle around the Christ Child, so that the design is enclosed and concentrated with the bodies found towards the margins shown in near profiles, while the poses are basically still and the expressions are calmly modest and inwardly abstracted. Colour selection is straightforward, based on alternating combinations of green, red and blue. The work could not be described as emotionally insincere or dispassionate, however, as is obvious from the treatment of the arrows in the androgynous nude Saint Sebastian with one open wound dripping blood. The strong Northern European character of the background architecture was engrained in Ridolfo's style from the example of his father, although the figures are treated less descriptively than in Domenico's work. Certainly, the work is deeply indebted to exemplary Quattrocento precedents, but the style in general is still more simplified and less ornamental. The interest in textures and surface detail is more like Piero di Cosimo, as is apparent in *tour-de-force* details like the hat of the shepherd at the upper right. Such references demonstrate how difficult it can be to characterize seemingly contrary styles in this period, with aspects of an inventive artist's approach seamlessly affecting that of a conservative and sentimental one.

The work that made Ridolfo's reputation in Florence, specifically for the quality of its portraits according to Vasari, was the slightly earlier *Way to Calvary* (fig. 79), painted for the church of S. Gallo, located outside the walls of Florence but destroyed in a scorched earth policy of 1529.[13] This altarpiece was brutally transferred to canvas at some point in its history and is almost a wreck. It can be dated on stylistic grounds to perhaps 1505–10. The design is treated in a continuous, frieze-like strip of attenuated, statuesque figures, with the cut-off headboard for the cross at left, suggesting illusionistically a continuity beyond the picture space. Drama is further created by the marked fall of light from the left producing strong shadows. It is again not a facile image:

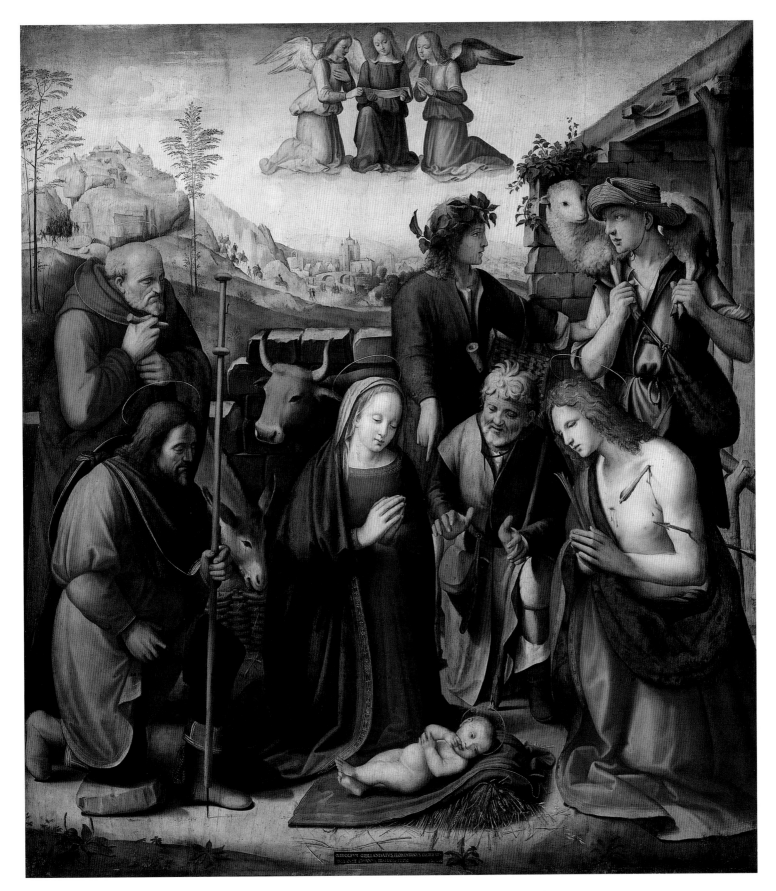

77 Ridolfo Ghirlandaio, *Adoration of the Shepherds with Saints Roch and Sebastian*, Budapest, Museum of Fine Arts.

expressively it is direct and even brutal in certain passages, as in the blood on Veronica's veil, or especially the image of Christ all in red with his head bowed in sorrow and eyes closed. The troubled sky full of churning clouds seems unusual and particularly effective.

Altogether, the *Way to Calvary* is not exactly retrograde, but abounds with references to contemporary art and, as much as any painting from this period, betrays a genuine excitement about the developments in Florentine art at the start of the new century – a feeling that was not always sustained in Ridolfo's painted efforts, which tend to rework the same models. It is replete with obvious quotations, particularly from Leonardo's art as in the caricatured head of a soldier, demonstrating the younger Ridolfo's direct engagement with the cartoons produced for the *Battle of Anghiari* frescoes. Such references are rarely again evident in his surviving work, though they may have been exhibited in the temporary arches with elaborate narrative subjects that he produced throughout his career, like so many other artists during various Florentine celebrations. That Vasari was able to credit Ridolfo as one of the superior draughtsmen to study directly from the cartoons cannot be taken as mere hyperbole given the importance of the model to which he referred, and this has implications that have only recently been taken up through the study of his few identifiable drawings.[14] In addition to the allusions to the battle cartoons, the transparent and luminous quality of the better preserved parts of the surface recalls Flemish painting, but again through an intermediary like Piero di Cosimo.

With the portraits in mind too, the combination of cautious naturalism and docile ideality is perhaps what most distinguishes Ridolfo's essentially retroactive style, and is further evident in the independent portraits attributed with any security to the artist. Surprisingly perhaps, given the amount of work lavished on the art of Florence, there are many attributional and dating problems in this genre of Florentine sixteenth-century painting, but an earlier portrait of a man (fig. 78) represents what might be accepted as a benchmark for Ridolfo's portrait style.[15] It probably dates from the first decade of the sixteenth century, so about contemporary with the *Adoration* altarpiece. Here the figure is crisply rendered in a dignified and neutral fashion with a suggestion of intensity in the face, parallelled by the composed gesture of the right hand. The hint of interaction set up between the sitter and spectator would allow that Ridolfo was cognizant of Leonardo's developments in portraiture in Florence at this time, and helps to account for the fact that more than one portrait now accepted as Ridolfo's was formerly attributed to Piero di Cosimo. There is some superficial interest in the strong lighting, handling of certain textures and broad

78 Ridolfo Ghirlandaio, *Portrait of a Man*, The Art Institute of Chicago, Mr. and Mrs. Martin A. Ryerson Collection, 1933.1009.

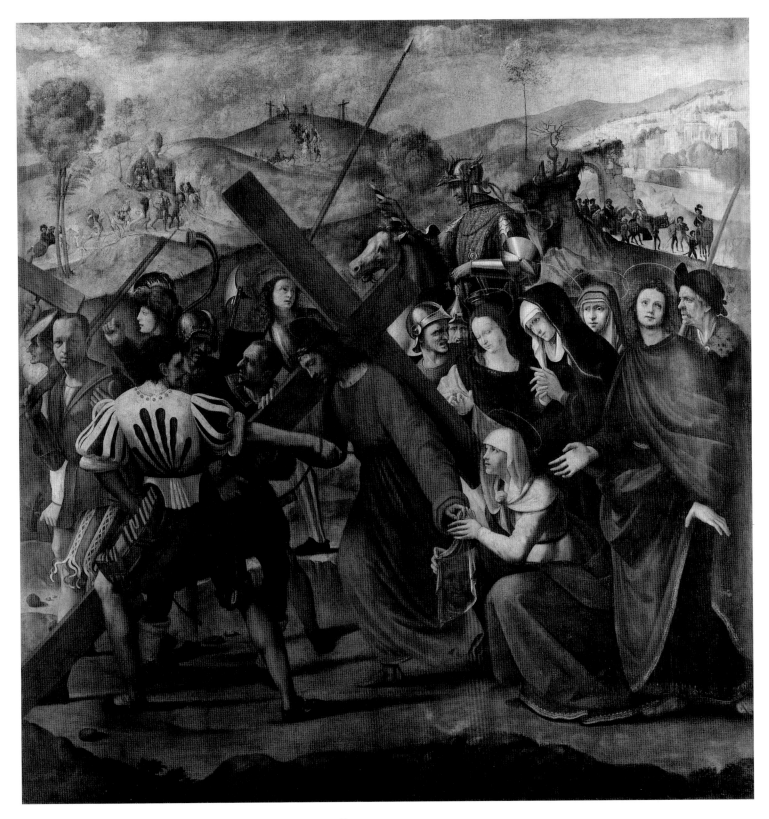

79 Ridolfo Ghirlandaio, *Way to Calvary*, London, National Gallery.

rhythms carried, as in the opening of the cloak. The use of the ledge to truncate the length (added apparently at a late stage by the painter) and the open, unarticulated window are perfectly traditional; it is in such references to the past, both Florentine and Northern European, that Ridolfo made his career as a portraitist in Florence. Such was his hold on the market that he was able to develop portrait specialists in his workshop. It is appropriate, therefore, that one of the longest general discussions about portraiture made by Vasari occurs in the Life of Domenico Puligo in relation to an especially faithful Ridolfo pupil, Antonio Ceraiuolo.[16] In addition to the Cosimo de' Medici portrait of 1531, only one other portrait attributed to Ridolfo with some confidence, that of a woman (surviving in the Pitti), carries a date of 1509 on the support, and this intensely Raphaelesque image compares easily to that of the man in Chicago.

The full extent of Ridolfo's early relationship with Raphael is still to be traced but it is critical for classifying art of this period because it casts light on the nature of the style of both painters. How the styles available then in Florence are now characterized must take into account the fact that Ridolfo was as close to Raphael as any artist on the latter's visit to Florence in the first decade of the sixteenth century.[17] After asking Ridolfo to complete an unfinished painting of the Virgin and Child to be dispatched to Siena, Raphael even wanted the Florentine to join him in Rome around 1508 in order to assist presumably in painting the Stanza della Segnatura in the Vatican – an indication of a most trusting relationship.[18] The sort of Ridolfo painting that might have attracted Raphael to his workshop is well represented by a pair of panels each containing three angels, some holding gigantic lilies (fig. 80), with a provenance from the church of S. Baldassare in Maiano where they probably framed a tabernacle or icon. Close in style to the *Way to Calvary* altarpiece and so datable to around 1505, they are pure examples of the bewitching charm of Ridolfo's earlier work. With tender and confident expressions of reverent joy, the figures are delicate but firm as is evident in their conspicuously long arms and large hands, all exquisitely drawn. They are captured in a fine light with bright, ringing colours arranged according to a symmetrical scheme. Details like the draperies gathered in the middle and the broad lapels on the collars are completely anachronistic by this date and evoke Trecento sculpture, but Ridolfo could not resist such charming touches and probably felt no contradiction or pretension in including this type of motif in his work.

Raphael worked intermittently in Florence between 1504 and 1508, when still in his mid-twenties, and he did not refuse commissions from Perugia. In Florence he produced almost exclusively private works featuring the Holy Family

80 Ridolfo Ghirlandaio, *Three Angels*, Florence, Accademia.

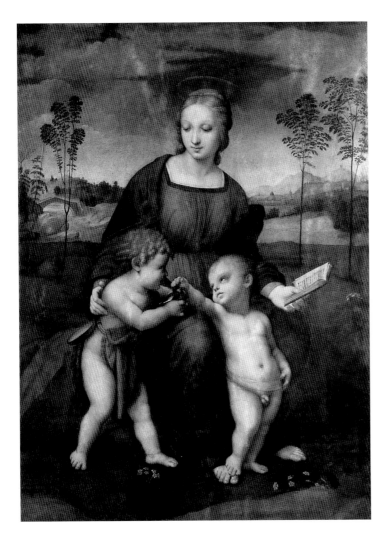

82 Raphael, *La Madonna del Baldacchino*, Florence, Palazzo Pitti.

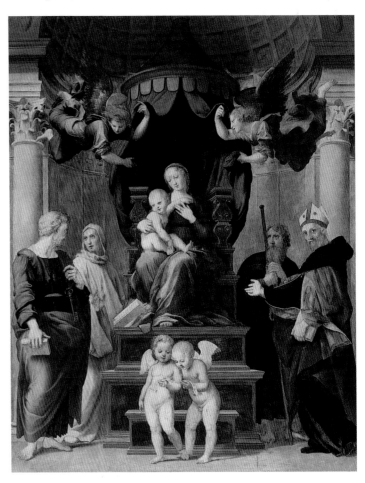

(fig. 81) – intimate images retaining the qualities of tranquillity, harmony and balance that still owe much to the Quattrocento painters he studied in his youth such as Piero della Francesca, Luca Signorelli and Perugino, not to mention his own father Giovanni Santi, while just starting to reflect the influences of more recent Florentine art. The broader significance of Raphael for the indigenous art scene in Florence has been overstated because of his only slowly waning stylistic rapport with a Peruginesque mode, not to mention the private and transitional nature of his work there. His only public work, the *Madonna del Baldacchino* (fig. 82) started for the Dei chapel in the Augustinian church of Santo Spirito, was left unfinished, and although it had some immediate influence in Florence, the precise whereabouts of the panel prior to the artist's death in 1520, when it was acquired by his executor Baldassare Turini and sent to Pescia, are not known.[19] His genuinely influential production was in the future in Rome, where his acquired Florentine habits and motifs were duly passed on to his workshop and so engendered a long legacy. It is arguable that Florence had more to

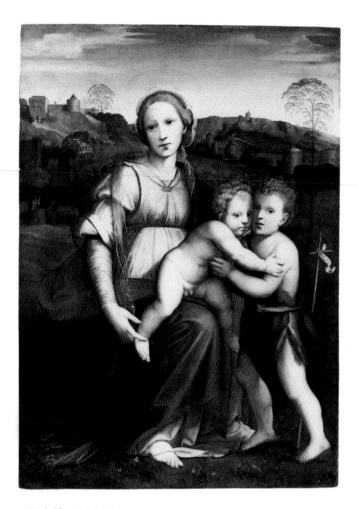

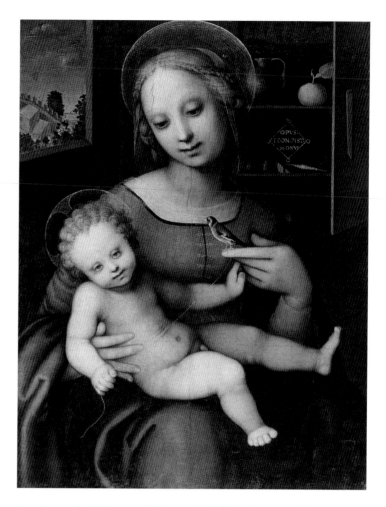

83 Ridolfo Ghirlandaio, *Virgin and Child with the Young Saint John the Baptist*, whereabouts unknown.

84 Leonardo Malatesta, *Virgin and Child*, Berlin, Staatliche Museen, Gemäldegalerie.

teach Raphael than he had to offer its artists in return (and it is a common and misleading tendency in modern scholarship to credit Raphael with inspiring contemporary Florentine artists when they simply shared influences from the same local traditions), with the important exception of Ridolfo in the first decade of the sixteenth century.

Given Ridolfo's stylistic predilections, this is in itself telling about the nature of Raphael's thinking at this point. But even Ridolfo's absorption of his friend's art was frozen at the moment of their contact in Florence, though he was able at this time to replicate Raphael's style of about 1505 to a highly convincing degree. Indeed, more than any major painter working in this period, Ridolfo can claim to be the immediate heir of the Florentine Raphael, as evidenced by private domestic paintings of this period featuring the Virgin and Child (fig. 83). The other artists most directly influenced by the relatively modest number of works Raphael produced or initiated in Florence can be very minor indeed, including the likes of Leonardo Malatesta da Pistoia, who signed and dated

an altarpiece in 1516, among other works of this style (fig. 84).[20] These parasitic artists may even have been exploiting the fame of Raphael in Rome by timelessly reproducing his earlier pretty and restrained works in a manner and level of quality that he himself would doubtless not have tolerated from his own studio. It does not appear either that many of their derivative paintings were produced directly for Florence itself.

In contrast to Raphael in his Florentine period, Ridolfo in the first decade of the sixteenth century received a large number of public commissions, some of considerable prominence such as the *Way to Calvary*. An altarpiece for the church of Sant'Andrea at Mosciano near Scandicci (now in the Accademia, Florence) is his earliest, dated 1503 on the panel, while another of the Coronation of the Virgin and Saints supplied to the Dominican nuns at Ripoli (now exhibited at Avignon) is dated 1504. One of his early datable paintings is a large tondo (fig. 85), documented to 1503.[21] Payments for this picture, as on other early occasions, were made to Davide,

Ridolfo's uncle and protector after the death of his father in 1494, but there seems no doubt the style is that of the young nephew, and so ostensibly represents one of his first dated works. The elevated patronage through the bloodline of this artist barely in his twentieth year should be noted, as should the apparently enduring ties to his uncle, who was an expert mosaicist more than a painter. The Pitti tondo was executed for the private rooms of Piero Soderini who, as we have seen, had been elected Gonfaloniere in the previous year and was instrumental in awarding the commissions for the battle cartoons to Leonardo and Michelangelo. In this context, Ridolfo's painting takes on a broader, more public dimension in this period. Featuring Saints Peter and Paul depicted about half life-size, it is an imposing image, displaying an uncharacteristic if symmetrical movement. This may be evidence of a certain ambitiousness on the part of the younger artist that was not long sustained, particularly in his smaller scale domestic works which eventually became derivative and were executed with abundant workshop participation. The sky appears to open up to inspire the startled figures. Like the histrionic gestures and vivid expressions, the flat landscape with tufted forms at the right recalls Piero di Cosimo's work, as does the odd detail of Paul's attribute of the sword resting on the book open at the folio numbered 18. The gesture of Peter pulling up his drapery like a skirt, however, may have a source in antique sculpture, as could his deeply set features.

This early republican commission highlights the crucial aspect of patronage in Ridolfo's career, and his ability to gain (and complete) commissions from some of the elevated civic bodies and patricians in Florence, whatever their political allegiances. A contrasting example is provided by the recently constructed Cappella dei Priori in the Palazzo della Signoria for which he received payments from 1511 that continued as late as 1515, by order at least in part of Lorenzo de' Medici the Younger, who headed the newly installed regime in Florence.[22] It has been suggested that Lorenzo at a moment of personal political crisis in Florence turned to Ridolfo to show his respect and allegiance to his grandfather through artistic patronage – Domenico Ghirlandaio having painted a fresco in the Palazzo in the previous century.[23] This supplies another important example of how Ridolfo could be used as much for the general connotation of a venerable style as for its intrinsic beauty. As with Fra Bartolomeo and his Dominican patrons, it is arguable that Ridolfo's cultivated public determined the appearance of his art to a serious extent because of their firm expectations. The decorative scheme of this low-vaulted chapel (fig. 86) is traditional with the *Vision of Saint Bernard* at the altar end in a lunette, divided by a round window, facing another fresco of the Annunciation at the opposite end of the room, transversed by doors. It is

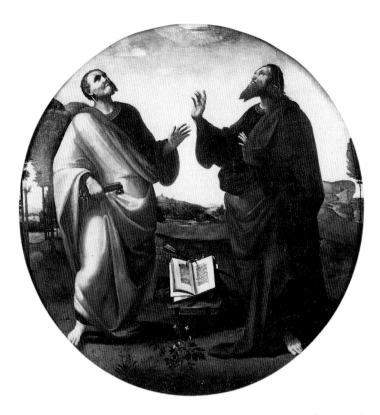

85 Ridolfo Ghirlandaio, *Saints Peter and Paul*, Florence, Palazzo Pitti.

richly gilded and replete with *all'antica* grotesque decorations in an elaborate organization predicated on a combination of real and fictive architecture that recalls aspects of Raphael's Stanza della Segnatura. Despite their superficially luxurious appearance, subsidiary images appearing with the decorative suprastructure in the chapel are orthodox, including the patron saint of Florence (John the Baptist), a Trinity, putti holding instruments of the Passion and the Four Evangelists, along with some thirty-two inscriptions with neutral, moralizing messages – the Medici patrons avoided any provocative anti-republican jibes. Likewise, the rather ponderous and schematic altarpiece by his pupil Mariano Graziadei da Pescia (who died young in 1520) of the Holy Family with Saint Elizabeth is conciliatory compared to Fra Bartolomeo's Pala di Signoria that includes Saint Anne and the other civic protectors of Florence and was ordered by the republicans for the altar of the council hall. Paradoxically, Ridolfo's neutral painting style seems to have been well suited for potentially controversial commissions such as this one – a possibly inflammatory project became in his hands an ornate jewel box.

Ridolfo also produced a notable altarpiece for the official church of the Signoria located next to the Palazzo Vecchio, S. Pier Scheraggio. Cited by Vasari as a collaborative work, the *Virgin and Child in Glory with Saints Julian and Sebastian*

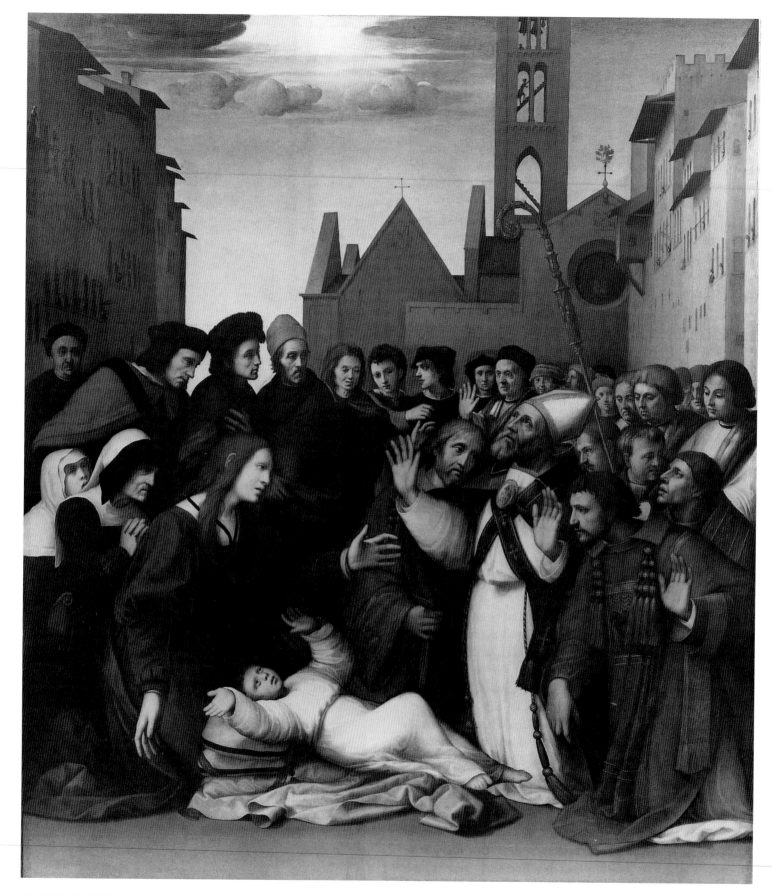

88 Ridolfo Ghirlandaio, *Miraculous Raising of the Child by Saint Zenobius*, Florence, Museo di S. Salvi.

earlier Ridolfo, Perugino and Granacci had assessed his work for payment after the patron expressed some doubts about its full worth. Incidentally, this raises another role of Ridolfo's, as a frequent arbitrator in artistic disputes in Florence. When a replacement was needed for Rosso's difficult altarpiece finished for Sta Maria Nuova in 1518, Ridolfo was the artist to whom the Hospital's director Leonardo Buonafede turned.

Extremely carefully finished and presented, both paintings show the figures concentrated in the foreground with the background closed off by architecture. The designs are consequently characterized by a certain density, especially in the case of the *Raising of the Child* in which the right-hand side is particularly crowded as if to indicate that the people have just emerged from the church of S. Pier Maggiore (now destroyed) depicted in the background. The figures recall the mythological paintings of Piero di Cosimo in their charmingly stumpy proportions and especially in the sharp characterization of some of the background heads, not to mention odd details like the tiny figures climbing up the campanile. There is a certain naive quality evoked by the under life-size characters that distinguishes the work as Ridolfo's, however, as do the saturated colours that give the whole panel a cold and dark atmosphere as if the painter was representing the scene in winter, further indicated by the number of fur hats worn by the bystanders. Here there is real pathos in the expression of the mother of the child who reaches dramatically across towards the kneeling saint, just as there is an almost Baroque moodiness in one of the acolytes carrying the saint's body in the other painting. But there is also a quality of backward-looking quaintness evident elsewhere: a Domenico Ghirlandaio fresco at Sta Trinità, for example, provided the source for the raised child. The large number of portraits, presumably of confraternity members, in both panels also link these images of the son to those of his father, and even further back to those of Masaccio and Masolino at the Carmine. This reference to art of the Florentine past can be supplemented first by Vasari's notice that Ridolfo owned a painting executed by Masaccio featuring Christ healing the lunatic, with a building in perspective, which has been identified with one partly by the artist now in the Johnson Collection in Philadelphia. Secondly, Ridolfo was the artist commissioned by Battista della Palla, the mercenary art dealer to Francis I, to replicate Pollaiuolo's *Three Labours of Hercules* in the Palazzo della Signoria to be sent to Francis I, possibly around 1515.[26]

To examine Ridolfo and his later workshop, as far as this is possible from the few documented examples produced for the local market, yields few surprises over the general appearance of the product, but career-wise he was far from mori-

bund. One major Florentine altarpiece almost definitely completed in the 1520s, at least in its present form, is the *Assumption of the Virgin with Saint John the Baptist* (fig. 89).[27] This vast panel can be identified with one described by Vasari as executed by Ridolfo before his collaboration with Michele Tosini. The context of this passage tells us that the altarpiece must have been executed before 1529 when it was damaged in storage during the siege of Florence, after which Ridolfo himself restored the panel and added his self-portrait, clearly detectable at the lower left. Despite some alterations in the arrangement of the costume and the position of the bust, it is this image that appears to have served as the source for the oval woodcut portrait of Ridolfo in Vasari's 1568 Life of the painter.

This huge altarpiece was painted for the high altar of Sta Maria Assunta dei Battilani, formerly in the Via delle Ruote on the corner with Via Santa Reparata. Through the inclusion of more figures the design expands on those earlier altarpieces by Ridolfo with the cognate subject of the Madonna della Cintola, such as that for Prato Cathedral, a fully documented work of 1507–9.[28] The general symmetry and regularity of composition and figure style on display in the Berlin picture are to be expected in a religious painting emanating from the Ghirlandaio workshop, though there is a superficial naturalism too in the differentiated faces of the apostles. The equally stable upper part is dominated by a static, Nazarene-like Virgin being assumed into heaven, flanked by a choir of twelve standing and kneeling angels. In her upright, frontalized pose and thin frame, the Mother of God still recalls the example of Fra Bartolomeo, who had died not long before in 1517. It is entirely characteristic that for a subject with some narrative possibilities Ridolfo still returned to his own earlier templates for compositional models rather than attempting a more daring treatment of the subject, as one might expect of a progressive Florentine painter in this decade. In its more apparently suave and otherwordly elements, the altarpiece also seems transitional to a style that has been associated, sometimes prematurely, with that of Michele Tosini.

Difficult questions surrounding his workshop activities by 1530 or so come to the fore as Ridolfo was eventually driven by age (and unwavering success) to allow his younger followers to take over. The most important problem is to distinguish the roles of Ridolfo and Michele di Ridolfo Tosini. Of course, it is necessary to depend exclusively in such a reconstruction on public altarpieces for which documentation can be found, rather than the mass of private domestic paintings and portraits which present particular, in some cases currently insoluble, questions of connoisseurship. Their collaboration was closer even than that of Albertinelli and Fra

90 (*facing page*) Ridolfo Ghirlandaio and Michele Tosini, *Saint Anne, the Virgin and the Christ Child with Saints Peter Martyr, Augustine, Thomas Aquinas, Vincent Ferrer, Mary Magdalen and Catherine*, Florence, S. Spirito.

89 Ridolfo Ghirlandaio, *Assumption of the Virgin with Saint John the Baptist*, Berlin, Staatliche Museen, Gemäldegalerie.

Bartolomeo, and their attributed paintings dating from the mid-1520s onwards have always been labelled as the work of both, in equal, indistinguishable parts, owing to the natural difficulty in separating out hands.

The most secure earlier painting with which to monitor the changeover in the workshop is provided by the Segni altarpiece, still found *in situ* in its original frame in the left nave of S. Spirito in Florence, which can be dated by documents to about 1528–30 (fig. 90).[29] It features Saint Anne with the Virgin and Christ Child enthroned in the centre of

the picture, with the standing saints Peter Martyr, Augustine, Thomas Aquinas and Vincent Ferrer and the two kneeling female saints Mary Magdalen and Catherine. The preponderance of Dominicans in an altarpiece painted for an Augustinian church has yet to be explained. It may be significant, however, that some members of the Segni family had displayed strong Savonarolan loyalties, which raises the intriguing possibility that the painting was ordered during the siege of Florence when such tendencies carried renewed political weight. This is probably the sort of commission that would

have gone to Fra Bartolomeo while he lived, but for which Ridolfo Ghirlandaio was an acceptable surrogate in the late 1520s.

The design of the Segni altarpiece is not without force but it is deliberately archaizing – a general quality of religious art of the 1520s, as demonstrated by Pontormo's *Saint Anne Altarpiece* (now in the Louvre) painted for the Florentine government at that time. Ridolfo would almost certainly have seen Leonardo's cartoon featuring Saint Anne exhibited temporarily at SS. Annunziata in Florence at the start of the sixteenth

century, but he made no reference to it in this painting of the same core subject: his sense of what was appropriate to his art had shifted from an earlier moment in his career when he would have been attracted by newer experiments. Ridolfo's placement of Saint Anne above and separate from the Virgin is formally uninspired as well as undynamic, recalling Masaccio more than Leonardo. The Virgin's look heavenward similarly defuses any potential power that might have been explored in their relationship. Ridolfo and Tosini were more comfortable with Andrea del Sarto than Leonardo as a

91 Ridolfo Ghirlandaio, Michele Tosini and workshop, *Assumption of the Virgin with Saints John the Baptist, Sebastian and Romuald and a Bishop Saint*, Florence, S. Martino alla Palma.

formal source, but only with the former's relatively static later pictures, produced in abundance in the 1520s for Florence and its environs. Indeed, Ridolfo and his workshop unabashedly produced at the Angeli monastery in Florence copies in fresco of Sarto's S. Salvi *Last Supper* – their replica is dated 1543. They turned to his *Disputation* of perhaps about 1517 and also his more recent Gambassi altarpiece from the later 1520s (both now in the Palazzo Pitti) for the basic compositional models with the four standing and two foreground saints kneeling with their legs folded under. Owing to the aggregate handling of the traditional design shape and the rigid deployment of the poses, the figures in the Segni altarpiece are sedate and clearly characterized, but also have a strangely remote quality. With this type of conceptualization and purification of physiognomies, the saints in the picture especially recall aspects of Sarto's final manner of the late 1520s, as opposed to his more excited and visually stimulating earliest work that was so important for the young Rosso and Pontormo.

The Segni altarpiece would never be mistaken for one by Sarto, however. It is starker and more focused, with broad areas of hard colour and sculpted flesh, and any distracting ornament is reserved for the dress and coiffures of the two female saints in the foreground. If any fresh contribution from Tosini can be detected, and it should be stressed that there is no marked change in style from the earlier works, it may be found in the suaver and more rarefied treatment of the expressions which seem just slightly more unreal and detached than in any earlier Ridolfo workshop painting, as is especially evident in the female saints at the base of the panel. It has to be admitted, however, that Tosini appears to have been absorbed quite seamlessly into the studio, without a dramatic impact – a tribute to the almost suffocating power of the Ghirlandaio *bottega*.

It can probably be assumed that by the 1540s, as Ridolfo approached his sixties, Michele Tosini played an increasingly crucial part in the execution of Ghirlandaio workshop paintings. Some of the issues in defining the divisions in the workshop seem insoluble, however. Take, for example, the *Assumption of the Virgin* altarpiece at S. Martino alla Palma (fig. 91), which could be the one listed by Vasari as a collaborative work between Ridolfo and Tosini, but which is so primitive as to make any stylistic dating impossibly difficult and perhaps largely irrelevant.[30] It seems doubtful too whether Vasari, had he himself known such a crude picture, would have bothered to cite it in the *Lives*, and presumably his list of joint works by the two painters was based on their information and not his own research. Similarly, dating on stylistic grounds alone undocumented altarpieces listed by Vasari is an exercise fraught with difficulty and may be sensibly put off in the current state of knowledge about the two artists.

Fortunately, there are some secure monumental works surviving from those years by which to judge the stylistic progress of Ridolfo and Tosini up to the middle of the sixteenth century. In particular, an altarpiece commissioned by the ageing Leonardo Buonafede and painted in the years just before his death in 1545, aged 95, provides a secure example of the group style in that later period. Painted for the high altar of the church of S. Jacopo in the Via Ghibellina, the *Virgin and Child with Saints James, Francis, Clare and Lawrence* (fig. 92) can be documented as completed by about 1544.[31]

This securely documented altarpiece best exemplifies the Ghirlandaio deflationary house style in the first half of the 1540s – an observation reinforcable by a glance at another lost work from this period produced for Buonafede, the *Meeting at the Golden Gate with Saints Joseph and Leonard* (formerly in the Galli Tassi collection). The design of the S. Salvi picture (fig. 92) is impressive but predictably regular, subdued and

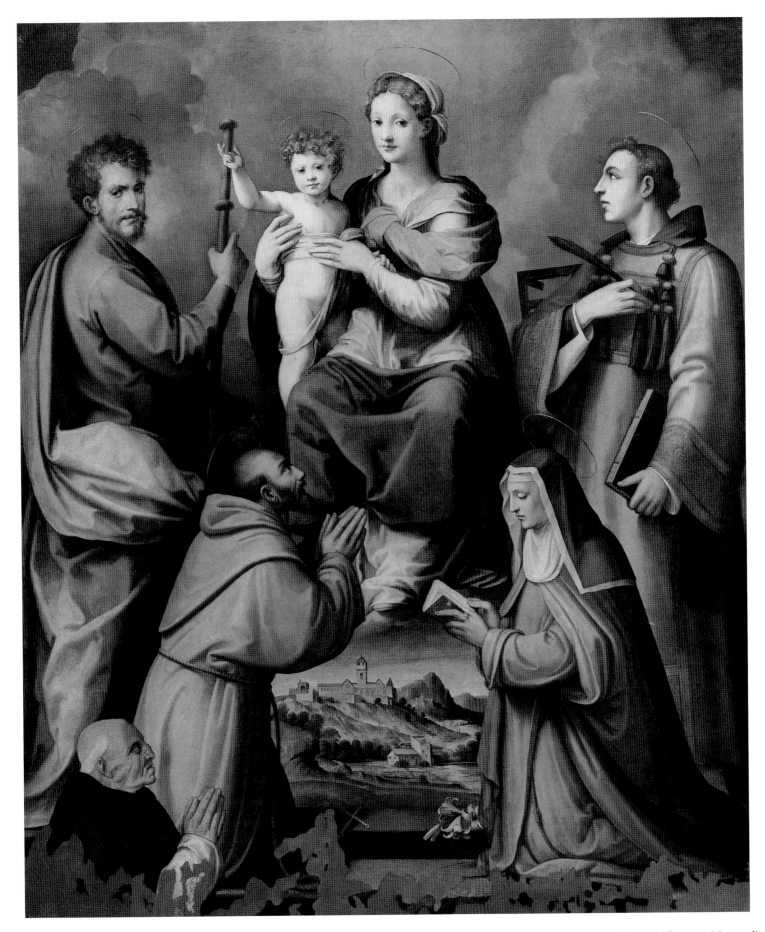

92 Ridolfo Ghirlandaio and Michele Tosini, *Virgin and Child in Glory with Saints James, Francis, Clare and Lawrence and Donor*, Florence, Museo di S. Salvi.

stabilized with monumental, volumetric forms near the first plane, and no abrupt accents. It is confident but not overly analytical. The characters are treated in a generalized manner in familiar monumental poses with eloquent bearings and not completely dispassionate expressions. The Saint Francis even displays a certain intensity and vivacity in his worship of the floating Virgin and Child. The technique is appropriately smooth and polished, just as the drapery folds are columnar, tending to swirl instead of puckering into deep crevices. In its nobility, restraint and strength of line the continuity with earlier paintings by Ridolfo is obvious, and this was a patron well known for a definite, unchanging taste. Likewise, Sarto, so dominant in Florence during the 1520s, again provided the basic model for the Virgin and Child grouping in works like the Gambassi altarpiece or the Borgo Pinti tabernacle, both mature productions by the painter of the 1520s. However, in the increasingly unnatural treatment of the physiognomies and ornamental quality of the draperies and the colour, Tosini may now be seen to have impressed himself stylistically on the workshop, somewhat independently of Ridolfo. The altarpiece was painted for a Poor Clares convent and this explains the presence of the two Franciscans and the Saint Clare depicted in the act of reading. The identifiable view in the background below the Virgin and Child, that of the Carthusian monastery the Certosa di Galluzzo to which Buonafede was devoted, is an aspect of landscape painting in which the Ghirlandaio workshop had consummate skill. Vasari relates that he employed Ridolfo as a landscape specialist in the *camera verde* of the Palazzo della Signoria for which a payment of 1542 is known, but little of the original fresco.[33]

In outlining the slow stylistic development of Ridolfo and Tosini from the 1520s to the 1540s (and beyond), it is apparent that the conservative, relatively restrained style of the Ghirlandaio family remained popular with patrons in this period. Their works, not surprisingly, are closer to the Perugino-type mannerism of uninspired repetition isolated by Giovio and Vasari, than any style defined in relation to progress made by younger painters in Rome in the 1520s. None the less, there is perhaps a danger in pushing this formulation too far given that Ridolfo's workshop was also a focal point in the first half of the sixteenth century for a surprising range of quite different talents who grafted themselves onto his stable and still fertile root. While an artist of old-fashioned sensibility like Antonio Ceraiuolo always remained fairly close to the master's formulations, as in his relentlessly hieratic *Saint Michael* from SS. Annunziata (now in the Museo di S. Salvi), one of the more intriguing cases among Ridolfo's followers is Baccio Ghetti, who is first recorded in 1503.[34] Mentioned as a pupil along with Domenico Puligo in the Life of Puligo itself, Vasari knew no

93 Baccio Ghetti, *Virgin and Child with Saints John the Baptist, Mark, Andrew and Peter*, surmounted by the *Baptism of Christ*, Fucecchio, Collegiata.

works by this painter mysterious to Florence, only that he went to France after his training. The recent identification of the so-called 'Master of the Copenhagen Charity' with this Ghetti, based on comparison to a documented fresco, is most significant considering that the painter has been commonly classed as another of the minor Florentine *eccentrici*.[35] This historiographic episode is an important object lesson for demonstrating how easy it was for Ridolfo's stylistic model to be degraded and adapted to the sort of decorative flair, sentimental expression and reductiveness prevalent in Ghetti's few surviving paintings. How much he produced for Florence itself remains open to question; his main altarpiece survives in Fucecchio, near Pisa (fig. 93), so he may have developed as a provincial (and presumably less costly) alternative to Ridolfo himself.

Without Vasari's Life of Puligo it would also not be self-evident that the painter had been a pupil of Ridolfo, but a document of 1513 linking the two painters provides an approximate date for the apprenticeship.[36] Born in 1492,

94 Domenico Puligo, *Portrait of a Man*, Firle, Gage Collection.

95 Domenico Puligo, *Virgin and Child with Six Saints*, Florence, Sta Maria Maddalena de' Pazzi.

Puligo is more usually discussed in relation to Sarto and Rosso among others because of the consistently attractive and pungent atmosphere and the rich colouring of his paintings. Puligo's distinctive portraits are of especially high quality and worthy of deeper study (fig. 94), as is the narrative impulse he brought to devotional formats, for example in his altarpiece for the Romena chapel in Sta Maddalena dei Pazzi featuring the Virgin and Child and an assortment of saints (fig. 95), definitely completed just before his death in 1527. Yet with knowledge of his training it is also possible to appreciate how the glimmering veneer in Puligo's art is applied to a solid repertoire of arrangements and poses often deriving from Ridolfo's corpus. That the main influences on Puligo's work – from the bland orthodoxy of Ridolfo to the incandescent color and narrative impulses inspired by Sarto and the florid refinement of the better travelled Rosso – are seemingly incompatible has implications for how we might divide up the period in general. Puligo and to the same extent Baccio Ghetti are hybrid artists falling fluently between superficially contrasting styles. Over-restrictive applications of general style terms therefore underestimate the ability of painters trained in Florence to distinguish between not just a range of individuals, but also facets of particular

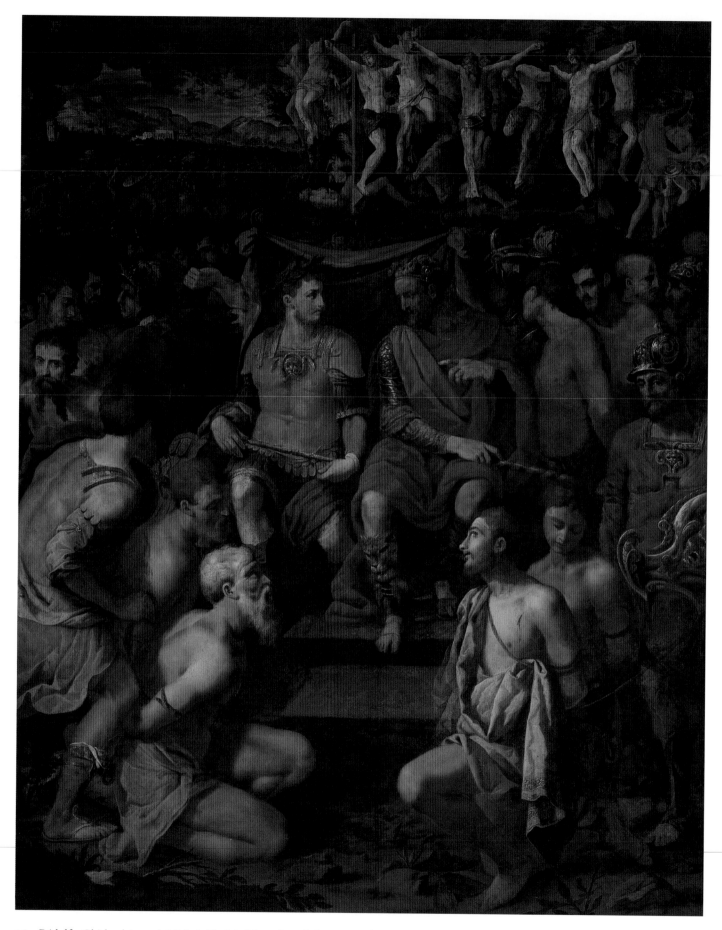

96 Ridolfo Ghirlandaio and Michele Tosini, *Martyrdom of the 10,000*, Florence, Museo di S. Salvi.

styles, such that even Ridolfo provided fertile ground for development. Looking forward to the 1540s, Carlo Portelli provides another example of a pupil of Ridolfo and Tosini seemingly more indebted to the likes of Sarto, Rosso and especially Francesco Salviati, but who actually represents a hybrid of different influences.

This consideration of Ridolfo Ghirlandaio's later stylistic development serves, finally, to bring out the conservative artistic strand developing in ducal Florence towards the middle of the sixteenth century in which Vasari and Bronzino most dominated, when their seemingly unfashionable art nevertheless remained in high demand. Vasari himself was careful to employ these two painters in selected situations for his own commissions, as if to appropriate their intrinsically venerable style to his own purpose in attempting to dominate the Florentine artistic scene at mid-century. In general, it seems that Ridolfo's retrospective, tempered and blandly naturalistic style sustained itself, presumably as a comfortable and agreeably familiar local alternative to the more Roman-influenced styles of Salviati and Vasari. Its close links to the distant past of the Ghirlandaio family workshop were considered a positive virtue for many. Blending his fairly neutral art with the constituent elements of the mature style Sarto refined in the 1520s, Ridolfo with Tosini (and yet later followers like Francesco Brina) could provide clients and artists alike with a path out of the rather excessive, intellectualizing art favoured by many of their adventurous contemporaries. The continuing practice of Ridolfo and his workshop, with their familiar, legible, definitive style of unmistakable force and charm, in many later altarpieces produced after 1550, like the *Martyrdom of the 10,000* (fig. 96), was the key to their success and ensured the unwavering popularity of this fundamentally predictable but proven style almost to the end of the century.

ANDREA DEL SARTO:
THE ARTIST 'WITHOUT ERRORS'

As a major Florentine painter working in the first decades of the sixteenth century, Andrea del Sarto has generally been classified as a seminal High Renaissance artist, though his career and style overlapped equally with what is called the Mannerist period. Yet it is arguable that he developed in reverse to the sequence implied by these terms, with his more stable, classical phase following his more experimental and irrational one – a contradiction undermining the very validity of such terms. Significantly, both phases of Sarto's career were influential, though at different times and for different artists. His early work of the 1510s was immediately important for the more advanced of the younger painters – Rosso Fiorentino and Pontormo who, broadly speaking, had something approaching a shared outlook for a brief moment around 1513. The impact of Sarto's more dignified and restrained later style of the 1520s was somewhat delayed in making itself fully felt, precisely because of the influence of the palpable and impetuous styles developed by the likes of Rosso and Pontormo; and even some of his imitators, such as Domenico Puligo and Jacone, could come as close to those artists as to Sarto in the 1520s. Yet Sarto's legacy arguably had more longevity than any Florentine painter of the first half of the sixteenth century. It became a substantial part of the formal basis for later sixteenth-century painters in Tuscany, working in very different religious climates, for whom Sarto provided a model of clarity and refined decorum.

Born in 1486 to a family of tailors (hence his nickname 'Sarto'), Andrea d'Agnolo is another example of the type of artist who was most comfortable working in Florence and for Florentines.[1] He established there a *bottega* that became the most active and important prior to Vasari's later in the century, if perhaps less multivalent than that of Ridolfo Ghirlandaio. So, in a working life lasting little more than two decades, Sarto was able to produce well over a hundred paintings and numerous sanctioned replicas and derivations through his workshop, in a way that Leonardo anticipated in practice but never approached in quantity. Even by native standards, Sarto was not especially well travelled and felt deep loyalty to his artisan roots – which Michelangelo would certainly have suppressed in public. Like Franciabigio, Sarto did not shirk from supplying objects of supreme quality to friends of his own social class: he produced, for example, a *Virgin and Child* for a woodworker and arguably his finest portrait (now in the National Gallery of Scotland in Edinburgh) for a glassmaker known as Becuccio *bicchieraio*, who was also involved in commissioning one of Sarto's last altarpieces. At the height of his early success, in 1520, Sarto purchased land for a house in the parish of S. Michele Visdomini, which happened to be a few paces from SS. Annunziata, the site of his first major fresco commission.[2] Like most Florentine painters, he joined the sort of confraternity he frequently worked for as an artist, in his case that of Saint Sebastian, also based at the Annunziata.[3] For them he created late in his career as an unofficial artistic testament a striking half-length image of the saint clutching an arrow, now known through copies (fig. 97). He may also have been an adopted member of the Confraternity of the Scalzo for whom he produced throughout his career a cycle including ten monumental narratives in grisaille with stories from the Life of John the Baptist: the Confraternity buried Sarto in their communal tomb located in SS. Annunziata.

If Sarto immediately recognized the value of a healthy export market for his paintings, he seems also to have been professionally somewhat complacent, and he was not an artist like Michelangelo or Rosso who felt driven to construct a career on a more international stage. The major exception was his visit to France to work for Francis I, where, despite his apparently immediate success with the large and resplendent *Charity* (now in the Louvre, signed and dated 1518), he lasted a relatively short time and when back in Florence refused to return. His vocal rejection of printmaking after one

97 Andrea del Sarto (copy), *Saint Sebastian*, whereabouts unknown.

than to anything Raphael produced in the Vatican Stanze with his workshop in the 1510s.[6] No less than the other frescoes in the main hall at Poggio a Caiano, this is brilliantly sensitive to its setting, which accounts for the angle and height of viewing and the open lighting. The content of the painting alludes to events of purely local import, such as the return of Cosimo de' Medici from exile in 1434 or the donation from the Sultan of Egypt to the Florentines in 1487 of a menagerie of exotic animals. Any desire to account for its monumentality betrays a critical imperative which may well not have been present in the artist's mind (or those of his contemporaries), and to that extent it would be misleading. An artist did not need to see Rome to appreciate formal grandeur in modern art for fresco painting: this quality was equally, if not more, entrenched in the Florentine tradition.

Despite his central importance there is little external evidence about Sarto's level of culture in the broader sense: it is necessary to speak mainly in negatives. He apparently had no sustained ambitions to compose poetry like Bronzino or attempt to learn Latin like Leonardo and Rosso. His *Portrait of an Unidentified Lady* holding open a volume of Petrarch (in the Uffizi) suggests one possible intellectual contact, though it is difficult to interpret its depth since the image naturally tells us more about the sitter than the artist. Aside from several portraits, he supplied probably only one non-religious panel painting for the Florentine market – the Brussels *Leda and the Swan* (the *Charities* in Paris and Washington were produced to satisfy French taste). There is some graphic evidence that he designed a *Perseus and Andromeda*, but for an uncertain patron. His major monumental historical painting was the Cicero fresco for the *gran salone* at Poggio a Caiano, although his splendidly relaxed and uninhibited interpretation of the subject, supplied according to a programme of Paolo Giovio's, contrasts markedly with Pontormo's rather hermetic treatment of *Vertumnus and Pomona* in a lunette above the main hall (whose precise meaning has generated more scholarly debate than Sarto's seemingly more straightforward, epicurean vision of the ancient world). In looking at this brand of secular subject matter, it is easier to value the unusually advanced intellectual stature of Piero di Cosimo – a painter who none the less had considerable formal impact on Sarto as one of his masters, as well evidenced by the painting at Poggio a Caiano.

negative experience with Agostino Veneziano reflects Sarto's brand of professionalism, but also a certain modesty over the wider dissemination of his ideas.[4] The portrait of a Pisan canon, now identified with that in the Metropolitan Museum in New York (painted late in his career when he was better connected), is evidence for one of Sarto's few certain personal links with a high-ranking ecclesiastic, particularly if, as has been suggested, this individual helped him earn the commission for his late Sant'Agnese polyptych in Pisa.[5] While working at Poggio a Caiano the artist probably encountered Paolo Giovio, someone unusually deeply preoccupied with understanding advances in the history of art, as well as collaborating with painters.

If Sarto ever visited Rome in person there is no direct evidence for it, and his one work usually discussed in relation to Roman art, the *Triumph of Caesar* fresco of about 1520 (fig. 98), is more indebted in its surprising asymmetry, colourful content, indulgent naturalism and relaxed confidence to his own *Journey of the Magi* of 1511 in the SS. Annunziata atrium (particularly when Alessandro Allori's additions of 1582 to the right-hand part of the field are imagined away),

To be fair to Sarto, this general profile could be repeated for many Florentine sixteenth-century painters and was probably as much the result of accidents of patronage as of particular temperament. Obviously, there were more facets to his character than that of the popular view of the timid, browbeaten husband of Lucrezia del Fede. Vasari's circumstantial account of Sarto's students driving Pontormo from the

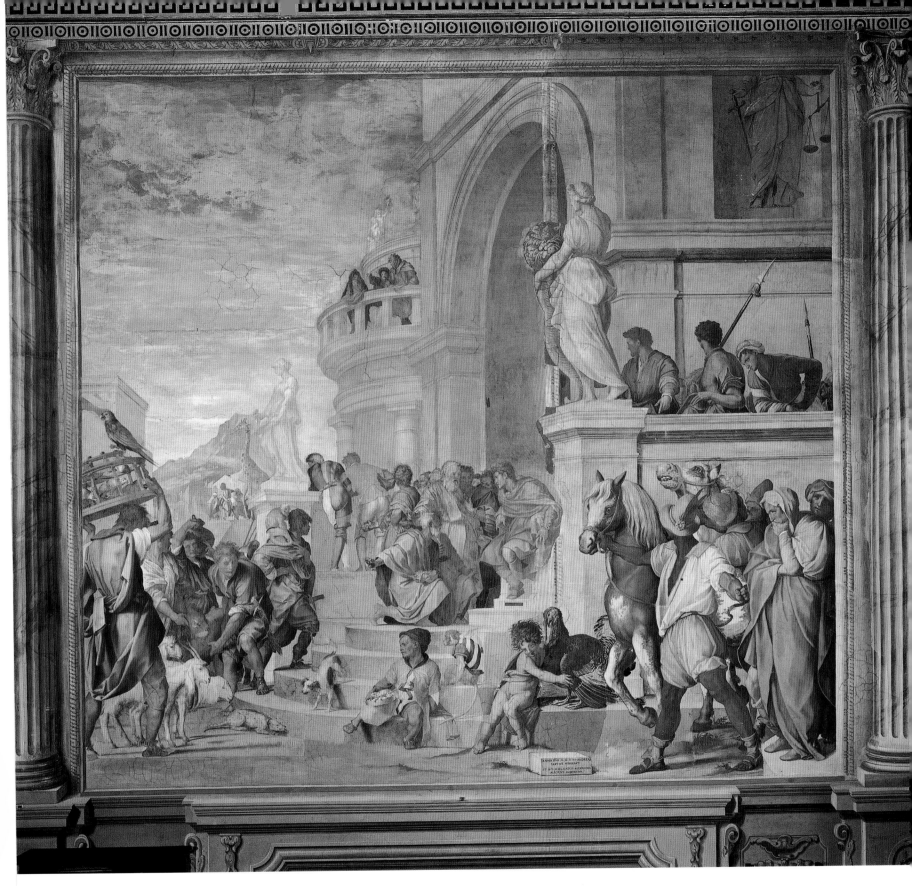

98 Andrea del Sarto (with additions by Alessandro Allori), *Triumph of Caesar*, Poggio a Caiano, Villa Medici.

Sarto's full but open design is based on a wedge of figures travelling in procession from the back right to the left foreground towards the entrance of the real church. The lack of strong narrative purpose and the absence of a direct precedent on this scale allowed for a surprisingly relaxed treatment of the scene. The three Magi actually face and address the viewer, as if acknowledging our shared notional role in the journey towards the Virgin and Christ, a gesture that dignified the real pilgrims moving into the church of SS. Annunziata. It is one of the most casual and self-confident works Sarto ever produced, both for its fluent design and also for its fractured colouristic effects, and it can stand as a summation of his achievement in this group of especially public frescoes.

In terms of his place in the Florentine art scene at this moment, however, the most critical early work on panel by Sarto may be the *Mystic Marriage of Saint Catherine* (fig. 100), which has been dated on the basis of style to around 1512–13, that is at a moment when the painter was most closely associated in his workshop with Pontormo and Rosso.[17] The style has much in common with the earlier SS. Annunziata frescoes by the artist. Yet its precise date must remain a matter of not insignificant conjecture because the work is mysterious as regards facts. It is not documented, nor is its original patron or early history known. It carries Sarto's monogram on the front of the bottom step, so its authorship is not in doubt, but it is not dated on the panel support. Quite possibly, it served as an altarpiece not in Florence but in some regional church in Tuscany and it is difficult to be certain how much of a sustained impact it could have had in Florence itself, except on those like Rosso and Pontormo who may have seen it in progress. The relatively private nature of the early interchange among these three artists is not without significance for how they were later perceived by Vasari, to the unfair detriment of Sarto.

The Dresden altarpiece features a centrally enthroned Virgin with the mystic marriage of Saint Catherine to the Christ Child acted out with her apparent urging in front of her. It was fortuitous for Sarto's stylistic development that there was a narrative intrinsic to this sacred subject, as it provided him with the justification for enlivening the traditionally iconic altarpiece category. Another female saint, Margaret, is placed on the other side to balance the left half of the composition, kneeling frontally to provide the maximum contrast with the other female saint, who has her back largely turned on the viewer, while a young John the Baptist embracing his attribute of the lamb of God sits on a step at the base of the panel.

This medium-sized altarpiece represents Sarto at his most premeditated and capriciously inventive, particularly in the memorable episodes of the two angels who playfully hide half their faces from the spectator, and Margaret's attribute of the dragon attempting but conspicuously failing to frighten John and his lamb. Such details remind us that Sarto spent time as a youth in the workshop of the Florentine painter most celebrated for his eccentric behaviour and peculiar style, Piero di Cosimo. The under life-size saints themselves are delicate and elegantly refined in their child-like proportions. The muted atmosphere, recalling Leonardo, adds mystery to the scene, as do the vividly incandescent and unusual sparkling colours.

It is at this earlier moment in his career that Sarto could be thought closest to Leonardo, when he would have been attracted to the few partially finished paintings, especially portraits, that could still be seen in Florence after the artist's departure around 1508. But it was the high-pitched and more superficial elements of Leonardo's art that interested Sarto as a working painter at this stage, as much as his complex and beguiling emotional characterization, which was somewhat more difficult to imitate. Over the long term, however, Leonardo's experiments in producing a tonally coherent type of painting with an enveloping atmosphere inspired Sarto more. None the less, Sarto's individualistic handling adopted from a skilled fresco technique tended to be more open and direct than Leonardo would probably have tolerated. If Sarto was driven towards this freer type of technique on panel by Leonardo or Michelangelo, it can have been only by misunderstanding their true intentions, as neither openly sponsored such a method.

The actual design of the *Mystic Marriage* can be interpreted in several ways, all calligraphic in principle. So while the painting features soft forms and charming and peculiar detail, it is most traditionally Florentine in its emphasis on underlying structure. The three adult saints alone, for example, can be analysed to form a triangular shape, but together with the young Baptist they can be superimposed by a diamond form. More intriguingly, with the two angels holding open the drapes of the baldachin it is possible to discover a number of x shapes in the sharp, linear construction – a configuration echoed whimsically by the shape of the metal cross held by Margaret and, more importantly, by Sarto's monogram of the two interlocked As (standing for his first names Andrea d'Agnolo).[18] Given Sarto's first name, his interesting type of signature may perhaps hide a reference to the cross of Saint Andrew, known in heraldry as the saltire cross. This quite conceptual approach to disciplining a design had a huge influence on the young Pontormo and is best shown in his S. Michele Visdomini altarpiece of 1518.

Given the existence of works like the *Mystic Marriage* it is conventional to view Sarto as the most inventive and

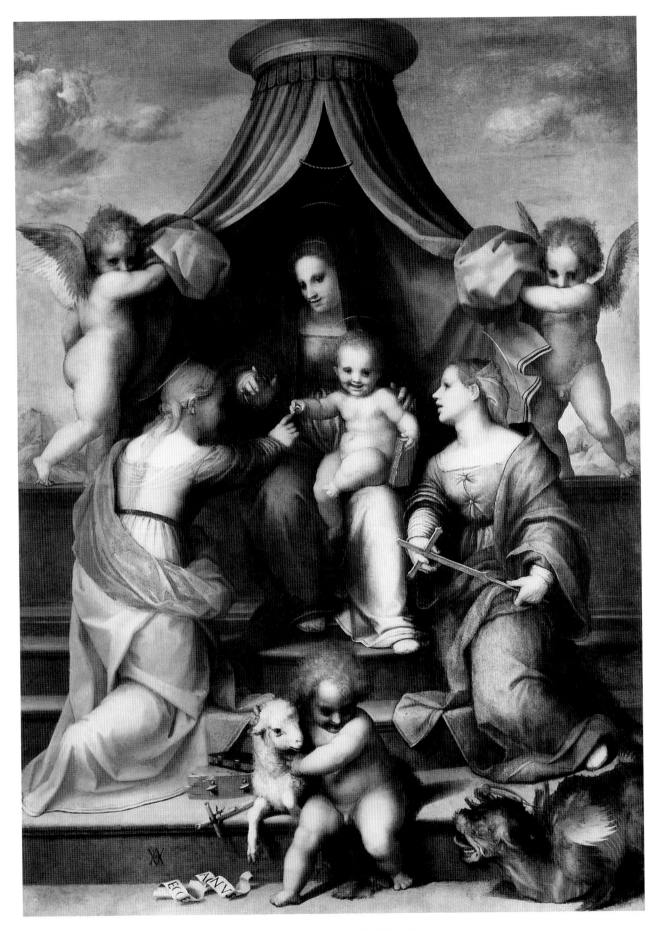

100 Andrea del Sarto, *Mystic Marriage of Saint Catherine*, Dresden, Gemäldegalerie.

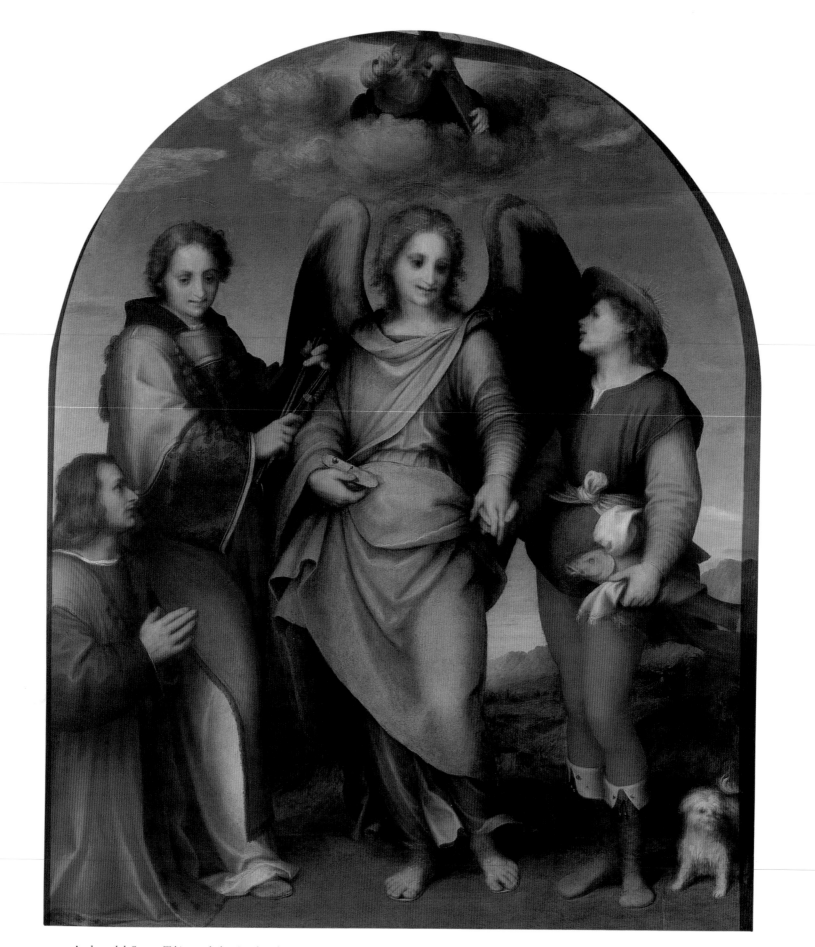

101 Andrea del Sarto, *Tobias and the Angel with Saint Leonard and Donor*, Vienna, Kunsthistorisches Museum.

intensely exciting painter practising in Florence in the early 1510s. But, as mentioned above, there is an open problem with dating and other examples must be presented before this view can be accepted. One is provided by the precisely datable *Tobias* altarpiece (fig. 101). The medium-sized altarpiece on panel was painted for the church of Sta Lucia a Settimello, outside Florence, for the family altar of Leonardo Morelli; documents survive proving that Sarto was paid for the work between March and October 1512.[19]

Saint Tobias holds the hand of the Archangel Raphael at the right with the donor, richly dressed in a red cloak with fur trim, and his namesaint Leonard at the left. Tobias's little dog looks out at the viewer and wags his tail to add a sense of delightful immediacy to the work and seduce the viewer into forgetting the integrity of the picture plane. The deacon saint Leonard holds his attribute of prison fetters on top of a book rested on the arm of Tobias. His body is angled towards the centre but his head turns back to acknowledge his charge – the patron of the work. The arrangement of the altarpiece is informally straightforward with the four youthful figures set in a row on a grey platform before an empty landscape treated in broad planes opening up on one side and a uniform blue sky, all surmounted by a small, blessing Christ in Glory holding a Cross, identified in the documents as a *maestà*.

Rather than the overall design, the innovative and vibrant aspects of the work are the treatment of colour and atmosphere. Individual colours are gem-like, scintillating and saturated in a magnetically attractive way, while the choices are often complex and surprising. This is especially true of the draperies of Tobias and the angel, whose colours were bound to be less canonical than most saints, as their cult developed relatively late. Indeed, in other representations of this subject their clothing is an indulgence for artists seeking to explore the possibilities of colour, as is most immediately obvious in the Tobias who wears purple boots that turn red in the shadows and have yellow tops. His stockings are red and his suit slate blue with a white belt, red sleeves and yellow-green highlights, and his hat is red with a purple underside. The rather shrill and daring juxtapositions of rich colour applied often with a roughened impasto brushwork, as in this picture, were an inspiration for younger painters emerging in Florence around 1512–13, particularly Rosso. Sarto's independent experiments with the oil painting technique, more consistently and fully realized than Leonardo's ever had been, were absolutely critical at this point for the development of Florentine art practice.

Sarto's characteristic treatment of morphologies also immediately attracted young artists. The smiles and half-

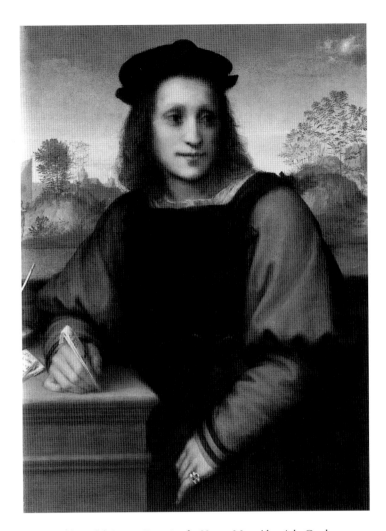

102 Andrea del Sarto, *Portrait of a Young Man*, Alnwick Castle.

closed, blackened eyes, which give the faces their delicate, unreal spirituality, are distinctive to his work of this earlier period and were profoundly influential. In the case of Puligo, they provided the basis for the entire expressive quality of his work, not just for his portraits. In portraiture, Sarto's young man (fig. 102) has the same soft, evocative dissonance found in his subject pictures. The features are notably out of focus and treated in the same broken roseate light as in the *Tobias* altarpiece. The actual surfaces of early Sarto pictures like these are more palpable and loosely treated than anything ever before seen in a finished panel painting in Florence and were equally influential in inspiring local painters to attempt this destabilising, seemingly momentary impression in their finished work. The fact that Florentine painters traditionally received a solid training in fresco painting, the ultimate source of this direct and free technique, would have made it easier for them to absorb Sarto's example. The figures in the *Tobias* piece even have incised contours, as Sarto relied on his fresco

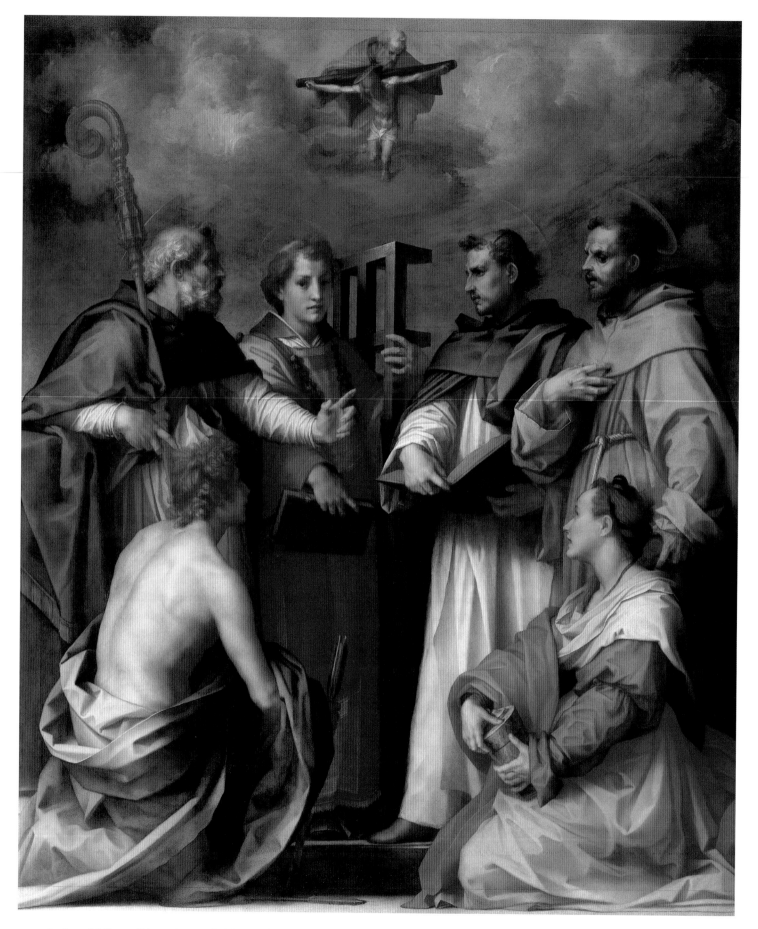

105 Andrea del Sarto, *Disputation on the Trinity*, Florence, Palazzo Pitti.

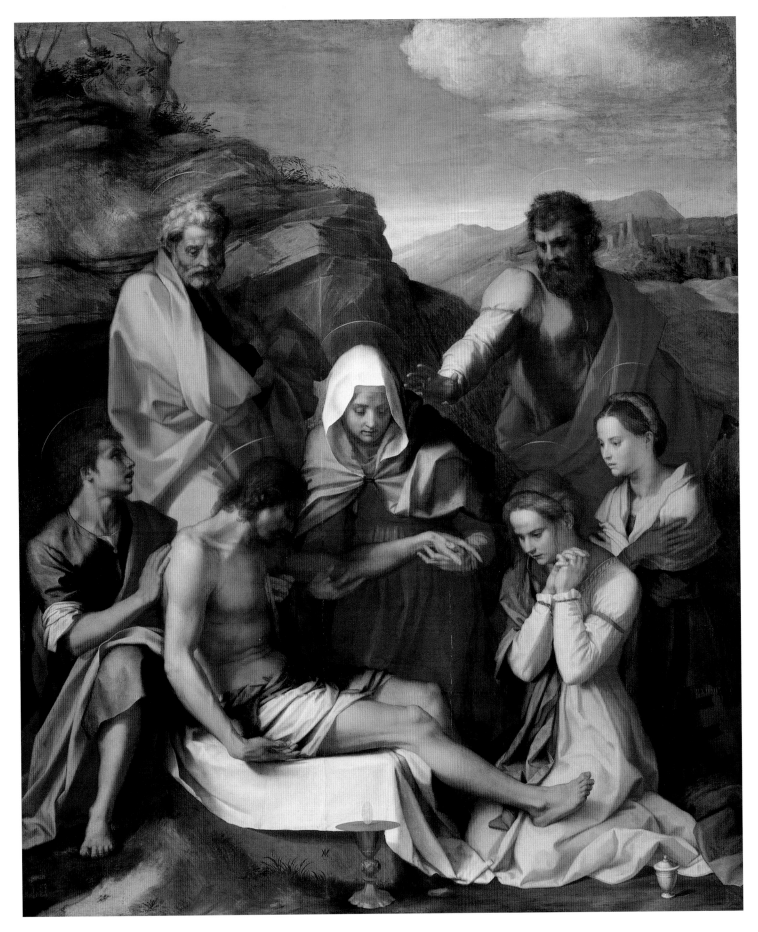

106 Andrea del Sarto, *Pietà with Saints*, Florence, Palazzo Pitti.

of his senior status. The remarkably refined, sensitive but still richly extravagant character of these paintings, some of which may have been affected by the Italian works the artist would have seen at Fontainebleau, was not sustained much past this period in his career, at the end of the second decade of the sixteenth century. They none the less provide us by analogy with the best example of the sort of decorative pictorial mode Sarto would have used in any public temporary decorations he would have been involved with, such as those for the Entry of Leo X in 1515.

The *sacra conversazione* format of the *Disputation* lends itself naturally to a balanced treatment, but on examining a Sarto painting from around the same date with a nominally narrative subject it is easier to perceive his greater clarity of presentation, in his general movement towards a more restrained, sculptural style. A major work fitting such criteria is the Luco *Pietà* (fig. 106). It was produced in the period after Sarto fled Florence during the plague of 1523, when he took refuge through the kindness of his friend Antonio Brancacci at the Camaldolese convent of Luco in the Mugello east of Florence (it was in this period that Pontormo went to the Certosa di Galluzzo). At that time the abbess of the house, Caterina della Casa, ordered him to paint the high altarpiece for their church dedicated to Saint Peter, who duly appears in the upper left. Although it was painted for a provincial location outside Florence, it is one of the most important works for understanding Sarto's development; as happened with Rosso practising in Umbria and Tuscany after the Sack of Rome, literally working away from Florence did not lead to any compromise for Sarto – though it would later when making something directly for export.

The composition of the *Pietà* is predicated on the monumental figures set directly at the picture plane. The painter again imposed his preferred x-shape on the design through the interlocking characters. Yet because of the strength of individual gestures, and the insertion of the female donor portrait in the guise of Saint Catherine at the right edge, the design seems loosely additive, even slackened and awkwardly jarring compared with a tightly knit early work like the *Mystic Marriage* (see fig. 100). Individual poses and gestures are forceful and unambiguous in their intention, especially that of Saint Paul who, standing almost sideways, extends his right arm diagonally into the centre and his left one back into space. The variegated colour scheme enhances the visual impact of each broad section of the figural composition at the expense of overall unity and any superficial pleasure. The taut precision of Sarto's earliest design solutions has thus been sacrificed for a much grander, static and more generalized effect, than even in the *Disputation*. The lightening of the

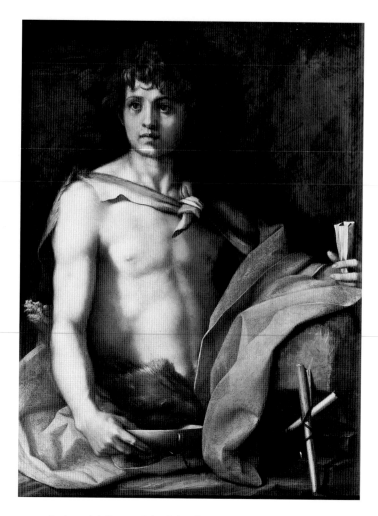

107 Andrea del Sarto, *Saint John the Baptist*, Florence, Palazzo Pitti.

background and insertion of a deep landscape particularly contribute to this impression.

While the general trend in the treatment of religious imagery in the first half of the sixteenth century was definitely away from stable, iconic images towards purer narrative, in the Luco *Pietà*, Sarto reversed this principle by producing a distinctly formalized, conceptual image – a move all the more surprising given the integral narrative impulses present in his earlier altarpieces. The figures are arranged somewhat haphazardly around Christ in a self-consciously organized group outside the tomb. The inclusion of the eucharistic wafer and chalice in the immediate foreground add to this strong sense of artificiality, which tends to distance the viewer from the specific moment represented. Instead, the spectator is positioned to witness and share in the undistracted reflection on the body of the Saviour laid on the stone of unction and the winding sheet arranged like a cloth on an altar. Emotionally, compared with Sarto's earlier work, the Luco *Pietà* seems more controlled and reflective,

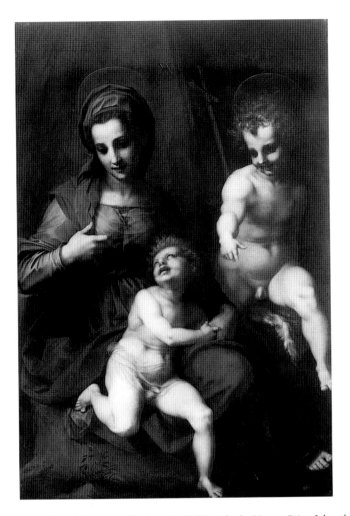

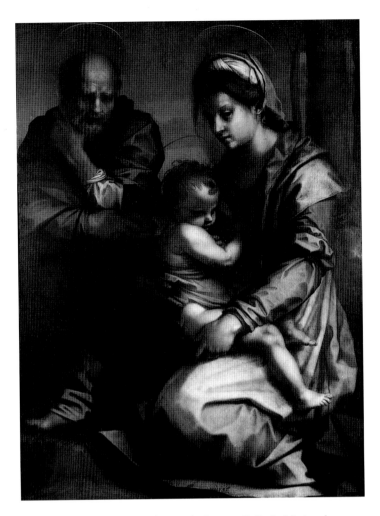

108 Andrea del Sarto, *Virgin and Child with the Young Saint John the Baptist*, Rome, Galleria Borghese.

109 Andrea del Sarto, *Holy Family*, Rome, Galleria Nazionale.

just as the design has lost the aggressive tightness of the *Mystic Marriage* for example. Along with the formal elements of the painting, its subject matter supplies evidence for a move away from intensity and apparent spontaneity towards breadth and calm in Sarto's stylistic development from the 1510s to the 1520s. The *Saint John the Baptist* (fig. 107), which formed part of the Benintendi cycle of domestic paintings probably around 1523, provides an intimate example of this formal relaxation combined with a greater sense of dignified, almost sculptural restraint (as does the so-called *Madonna del Sacco*, signed and dated 1525, in a monumental fresco).[24] In many ways, such paintings might seem a supreme fulfilment of the 'High Renaissance' as a style favouring a stable unity and clear expression of a fairly elaborate content. But it arrived here somewhat later than commonly ascertained, and after an evolution out of a more agitated and positively enthusiastic stylistic mode that could not be accounted for by that anomalous definition. Yet these retrograde qualities are pre-

cisely the ones that appealed most strongly to religious sensibilities in Florence after the decrees of the Council of Trent of 1545 and, at the same time, ultimately lowered Sarto in Vasari's estimation.

The change in Sarto's work from a livelier, spirited, narrative-based art to a more muted, diffuse and stable one can be more easily demonstrated in smaller scale devotional paintings. A slightly wider chronological span allows comparison between two such works (figs 108–9). The Borghese *Virgin and Child with the Young Saint John the Baptist* probably dates to the mid-1510s and may be the painting that Vasari says was painted in Florence for Giovanni Gaddi.[25] The figures are presented in a rocky setting. No conventional pyramidal shape is identifiable in the design, which is conceived instead in intricate linear terms with a number of intersecting diagonal forms. Again, Sarto's monogram of the two As is prominently placed next to John's cross, apparently to provide a sly clue to following the arrangement of the

diagonals. The composition is thus created by the manipulated bodies, overriding any concerns for naturalism or narrative logic. It might be wondered, for example, why the Virgin's right elbow has been set on a convenient rock and raised in a diagonal across her body? The approximate parallel posing of the lower halves of the bodies of Christ and the Baptist adds a further somewhat obsessive aspect to the artist's structuring of the design. The mood of the painting is frankly excited with rapid movements held seemingly temporarily in the grid-like construction, captured in the gloomy setting in a shaft of icy white light. The smiling Christ is almost ecstatic as he looks back suddenly at his mother. In foreshortening his head Sarto focused on the strange effect created by the rolling eyes and curly hair.

By way of contrast, the Barberini *Holy Family* can be taken as an example of a more outrightly stabilized Sarto in this genre of the small devotional painting. Dating probably from about a decade later, in the mid-1520s, the work is associated with one described by Vasari as painted by Sarto for another Florentine, Zanobi Bracci.[26] The painting is dominated by the Virgin seated sideways on the ground with one leg up on a rock form. The enclosed, corporeal pyramid of mother and child establishes an immutable design – a balance that contrasts sharply with the Borghese *Holy Family*. The forms are also more monumental, though not overpoweringly so on this scale. The surface, patiently and suggestively built up, has the appearance of polished white marble, as is apparent also in the *Disputation* (see fig. 105), and contrasts with the distinctly unreal metallic texture and more precise disposition of the draperies in Sarto's earliest works. Dirt now covering the painting gives an unrealistic impression of chiaroscuro that is not true to the artist's intentions. It was almost certainly once brighter and clearer, more like the *Disputation*.

The simplification of the surface in the Barberini *Holy Family* is reinforced by the muted emotional content. There is a pressing narrative element in this devotional image given that the Holy Family appears in a wilderness as if they were resting on the Flight into Egypt, but this is not much explored. All three figures look abstractedly out of the picture space, and do not respond to one another like the characters in the Borghese painting. Emotionally the image is not uncompelling, but it is as if the message takes longer to reach us than in the painter's earlier creations. Joseph in particular with his frown seems possessed by a slowly dawning and perhaps restless awareness and also has a dignified presence not always attributed to him in art. It is telling that the Virgin is more heavy-set and mature in years than her counterpart in the Borghese picture, as the artist's attitude towards expression matured and solidified in the intervening years.

This increasing downplaying or even suppression of external content in Sarto's work is traceable even where a purer narration was required by the format and subject, as in the *Last Supper* (fig. 110) decorating the refectory at the Vallombrosan monastery of S. Salvi outside Florence (where the Verrocchio and Leonardo *Baptism of Christ* was visible in the church; see fig. 11). Sarto favoured a similar approach. This vast fresco was probably executed about 1526–7. Its composition is lucid and spacious. Perhaps no local artist since Masaccio made such interesting use of empty space as Sarto did with the wall and loggia above the main scene through which we glimpse the light of a setting sun. The pedantic, almost textbook way in which the figures are set in the box-like space opening up onto the real room is strikingly reminiscent of Quattrocento Florentine representations of the same subject, such as the one at Ognissanti by Domenico Ghirlandaio, and this revival of older formulae is obvious proof of an increasingly apparent conservative strand in Sarto's style. There seems to be little in Sarto's *Last Supper* to suggest that he was aware of a more sophisticated precedent in Leonardo's *Last Supper* for a Dominican refectory in Milan of the 1490s (different images of this had been printed before the end of the fifteenth century) in which the artist somehow unified through figural triads a potentially static subject for art. Compared with Leonardo's image, Sarto's so lacks urgency that it could be argued that he depicted an earlier, more reflective moment of the story, when Christ hands the bread to Judas to identify him as his betrayer.[27] If he knew of Leonardo's work, he avoided his intelligent grouping of the apostles into threes: consequently, his figures are rather upright and generally not overlapping, and so more remote from the spectator in the refectory. The rigid, staccato effect thus produced accentuates the plasticity of each figure and, in terms of message, their individual responsibility and destiny. This approach contrasts markedly with Leonardo's image which is based, famously, on an overall analytical compactness. Naturally, this comparison with one of the originators of a new style of painting in Florence raises questions about how Sarto's later work can be classified stylistically in relation to Leonardo, not least because the style encapsulated by Sarto's highly polished fresco was by far the more influential of the two for Florence and was completed in a medium that always attracted attention in the city.

The technical ease of this work is perhaps what Vasari was observing when he praised the fresco as the most 'fluent' ('la più facile') work Sarto ever did.[28] It could not be convincingly argued that this dignified sobriety was required by the ecclesiastical setting with its restricted access, because the roundels with the small saints in the arch framing the fresco were executed (in about 1511, when the commission was first allotted) in Sarto's livelier, first manner with bright, sorbet

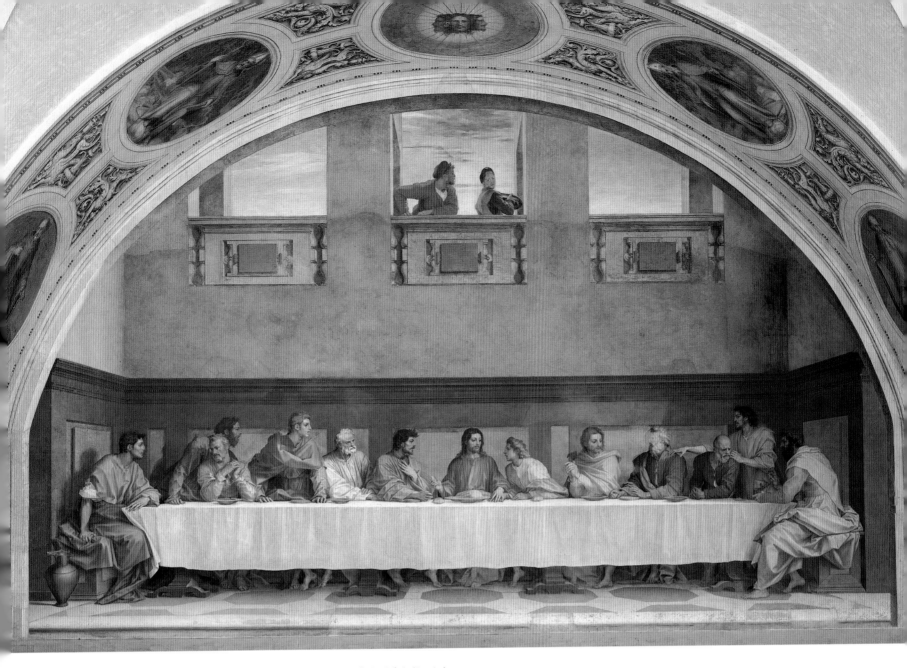

110 Andrea del Sarto, *Last Supper*, Florence, Museo di S. Salvi (*in situ*).

colours, alert poses and linear folds. The introduction of contrasts and in two cases of unexpected colours over the sober habits of these Vallombrosan saints plays with the viewer's expectations and brings an element of delight to the viewing of the fresco. This juxtaposition demonstrates as well as any other the marked shift that had occurred in Sarto's style. As far as we know, the S. Salvi *Last Supper* was not negatively compared in the sixteenth century with Leonardo's ill-fated fresco, or any other for that matter. On the contrary, it was considered by Borghini writing in 1584 (the year he took the Benedictine habit) to be the finest work Sarto ever painted.[29] It was produced in Florence within a venerable tradition of refectory images of the subject, and Sarto was satisfied at this later stage in his career with evoking that tradition to

strengthen his own authority rather than seeking a powerfully novel invention alone, such as Leonardo so relentlessly attempted. Success also allowed Sarto to isolate himself from the local competition from artists like Rosso and Pontormo which had inspired him to extremes in the earlier 1510s.

Sarto was content to repeat the tenets of his mature style until his death, in 1530 aged 54, in most of his final major works, nearly all of which were painted for a presumably more lucrative export market from the artist's busy studio in Florence itself. One example from this group is the Gambassi altarpiece featuring the Virgin and Child in Glory with Saints Lawrence, Onophrius, John the Baptist, Mary Magdalen, Sebastian and Roch (fig. 111). It was commissioned by Sarto's friend Becuccio *bicchieraio* for the town of his birth, to be

143

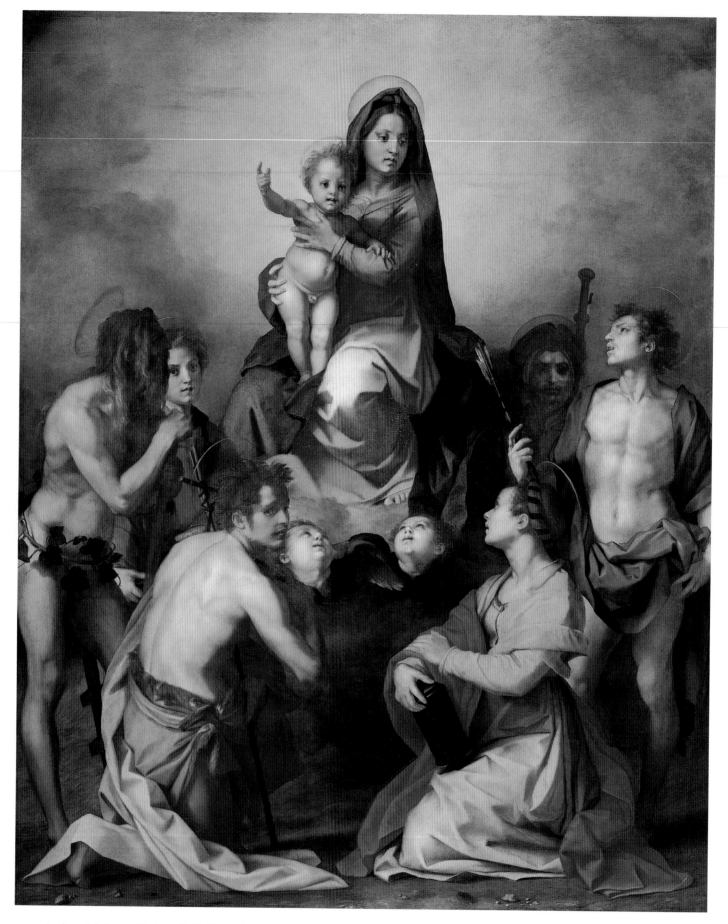

111 Andrea del Sarto, *Virgin and Child in Glory with Six Saints*, Florence, Palazzo Pitti.

placed on the high altar of the female monastery of the Eremite Benedictines, the Pieve di Sta Maria a Chianni a Gambassi. The altar was dedicated to the hermit saints Onophrius and Lawrence, and they are identifiable in the altarpiece as those standing at the left. The frame originally contained two circular donor portraits (now in Chicago). Given the presence of Onophrius, John the Baptist and the Magdalen, Sarto had the Virgin and Child appear in glory in a symbolic wilderness.

The design is again symmetrical, forming a three-dimensional pyramid with the saints here circled round the raised divine centre, with those in front kneeling down to admit the viewer's eye past them to the Virgin located further back in the space. It is not startling or energetic compositionally, since the goal of the painter was to create an object of noble, restful, static contemplation of a meaning that is cumulative and not unified with the fiction of a narrative, as in the *Tobias* altarpiece. The religious sentiment in this altarpiece seems more straightforward and powerfully abstracted than even in the Luco *Pietà*, and also more mystical in the dependence on supernatural elements that tend to distance the viewer, like the clouds and the golden glow behind the Virgin and Child. The loss of power is apparent in the reduced scale of the figures which lack monumentality, even though certain details like the torso of Sebastian suggest a residual sculptural influence in the muscular form spreading across the picture plane. The compositional stasis and lack of *frisson* and engagement in the Gambassi altarpiece isolates it from the painter's earlier output. Individual poses are also rather stiff and less organic mainly because most of them are re-used from previous works by the artist. As a compilation, this export picture probably contains some workshop participation in its execution. The importance of landscape is reduced and indeed in this case eliminated, for this would have added the sort of visual interest that Sarto by then found distracting and too time-consuming to instruct his assistants how to produce. Colours are also unnatural but not metallic compared to his earlier works, treated in a cold, rather suffused and enclosing light. It has the subtle, pearly tonality distinctive to Sarto's late work. The overall appearance is faded because of the force of the divine, white light striking the figures. There is a distinct loss of the inherently pictorial and decorative impact of Sarto's earlier altarpieces, but a gain in the still vibrant profundity of emotional expression.

The period of stylistic devolution represented by the painting sent to Gambassi corresponds to the achievement of an increasingly canonical status of Sarto's work in Florence – which was perhaps greater even than Perugino's had been at the turn of the century – after the permanent departure of Rosso from the city early in 1524, Pontormo's decreasing

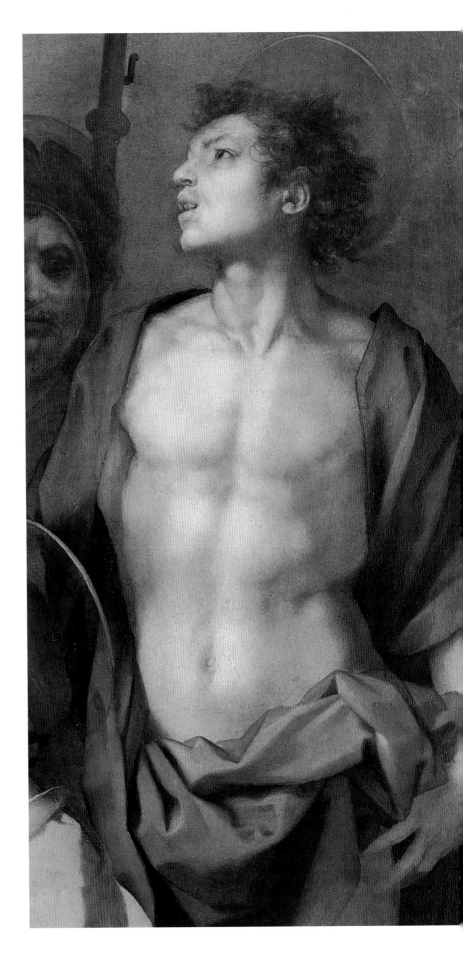

Detail of fig. 111.

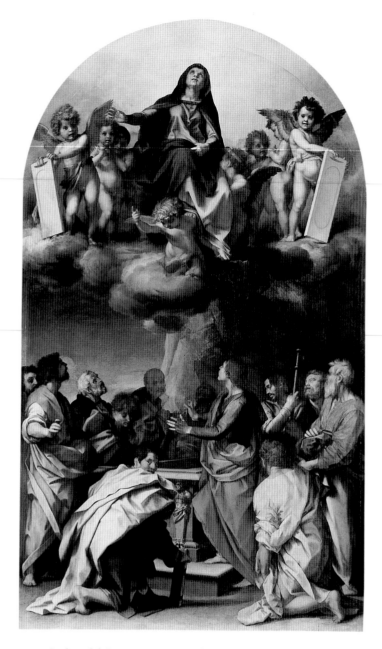

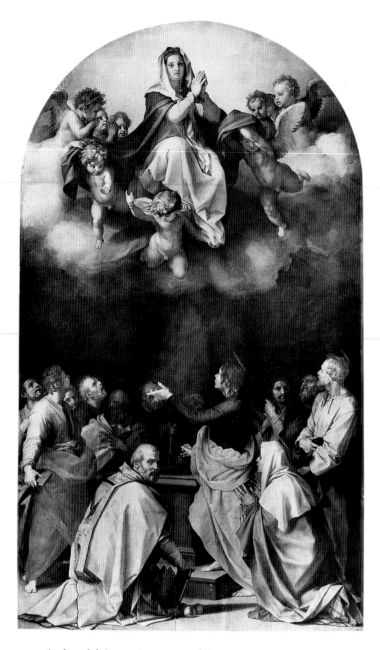

112 Andrea del Sarto, *Assumption of the Virgin*, Florence, Palazzo Pitti.

113 Andrea del Sarto, *Assumption of the Virgin*, Florence, Palazzo Pitti.

activity as a painter towards the late 1520s and the deaths of Franciabigio in 1525 and Puligo in 1527. Sarto freely exploited this situation through his workshop, and perhaps also a certain slackening or at least settling of patronage in Florence due to serious political and military turmoil there at the time of the final Republic. He produced a number of major exported altarpieces like the Gambassi one, but also others such as the polyptych for Sant'Agnese in Pisa and the altarpieces for Vallombrosa, Sarzana, S. Godenzo and Poppi, works that would all teach approximately the same stylistic lessons. In this later period of his career he produced also

designs for Silvio Passerini (who became a Vasari patron) that were intended for a lavish embroidered altar frontal for Cortona Cathedral. The final altarpiece in this group in the Pitti, which carries the date 1540, was completed after the artist's death but still bears his full imprint. His style and reputation in the wake of his passing affected the art of Ridolfo Ghirlandaio, that most implacably consistent of Florentine masters after about 1530, which itself attests how fundamentally schematic and calm are Sarto's last paintings.

The loss of competitive pressure and interchange with all of these events of the mid-1520s was another factor in the

146

slowing of Sarto's stylistic progress in the last part of his career. As was the case with Perugino, success itself contributed to a certain atrophying or hardening of style into a diminutive form of mannerism and led to the production of the two monumental altarpieces of the *Assumption of the Virgin* (both of which conveniently survive in the same room in the Palazzo Pitti; figs 112–13), based on essentially the same composition.[30] If the overall results can still be very impressive and provocative in the late 1520s, this is a tribute to the sheer depth of his talent and the consummate beauty and fullness of his technique, drawing and use of colour. All these may explain why there was no backlash in Florence against his later style until Vasari, as there had been for Perugino against the achievement of Leonardo and Michelangelo.

The universally high quality and fertility of Sarto's final production (and here a contrast with the general levelling off of Fra Bartolomeo's later output arises) is due also to the number of competent and ambitious young painters that Sarto continually attracted to his *bottega*. These include Francesco Salviati and Vasari himself, and a host of intriguing lesser-known figures like Solosmeo, Andrea's brother known by his alias Spillo,[31] Pier Francesco Foschi and Jacopino del Conte. The last named seems to have been active predominantly in Rome where he spread a style based closely at times on Sarto's mainly through private devotional works and portraits, such that his name is commonly associated with later workshop pictures of dubious status in relation to Sarto himself.[32] Conte may have spent no more than the first half of the 1530s in Florence, but through undoubtedly earlier paintings like the *Virgin and Child with the Young Baptist in Glory* (fig. 114) he expanded a late Sartesque manner of painting with the addition of an abstract remoteness and unreality inspired by his study of Michelangelo's latest marble sculptures for the New Sacristy of San Lorenzo, to a degree that his master would never have countenanced, at least in his own public production.

Through their work this large group of artists of varying degrees of natural talent multiplied the possibilities of the master's style and technique, and ensured that his contribution did not remain static even with his death. It is worth stressing, however, that they tended to develop from Sarto's more cool and restrained figure of the 1520s, and so contributed to the misleading impression that his style was basically unified over the entire course of his career. An early example of this reliance, independent even of direct workshop productions, is represented by Foschi's *Pietà with Saints*, painted as part of the Bini altar in S. Felice in Piazza in Florence around 1525 (fig. 115).[33] The calm and simplified presentation of these two saints in bare niches, respecting principles of gentle asymmetry and expressive strength, is true

114 Jacopino del Conte, *Virgin and Child with the Young Saint John the Baptist in Glory*, Berlin, Staatliche Museen, Gemäldegalerie.

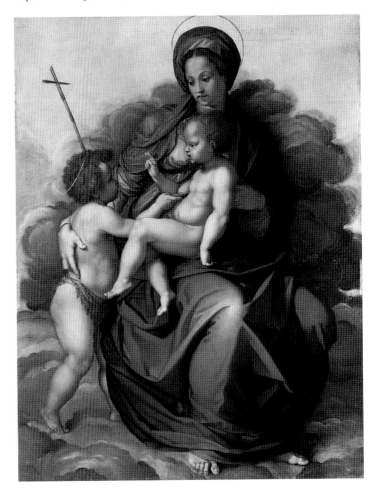

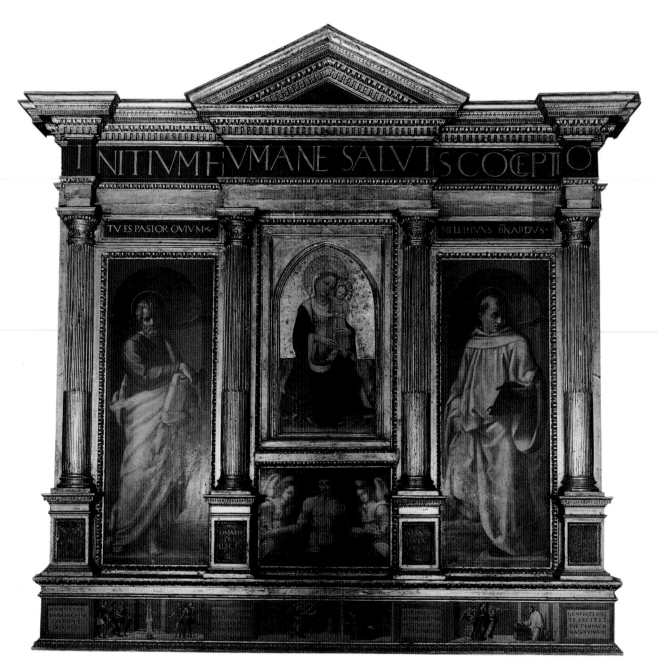

115 Pier Francesco Foschi and Master of Serumido, *Pietà with Saints* and predella, Florence, S. Felice in Piazza.

to the spirit of Sarto's work of this decade. Combined with a skilled painting technique which it is perhaps possible to underrate, Foschi exploited these qualities as the basis for a long career in Florence (he died as late as 1567). Even before 1550 he produced a number of other public altarpieces for Florentine churches, such as the signed *Immaculate Conception* (fig. 116), securely datable to about 1545, for a Torrigiani chapel in S. Spirito (one of three for this church), which reflect his distinctive style containing fixed, heavily moulded but elongated and spiky forms. Foschi was arguably also the

most able portraitist among Sarto's later students. The recent convincing attribution to Foschi of the *Portrait of a Musician* in the Uffizi, long accepted as a Pontormo, attests to a practically hidden element of his talent. Vasari did not make much of Foschi's career, though he perhaps painted more altarpieces in Florence in the 1540s than anyone except the Ghirlandaio workshop – evidence for Vasari's generally lukewarm reaction to Sarto's broad legacy up to 1550.

The repetition and self-referencing of Sarto's public work was encouraged by his gaining an increasing number of com-

missions for sites outside Florence, which allowed him to duplicate the examples of his most moderate manner, and to tolerate more and more workshop intervention in order to get paintings delivered on schedule. At times, he more or less replicated the same designs, as with the three late *Sacrifice of Isaac* paintings (divided among Madrid, Dresden and Cleveland), or took a previous picture not delivered in his lifetime as a starting point, as with the second Pitti *Assumption of the Virgin* done for the Passerini (see fig. 113), or more often he simply reworked old poses. Broadly speaking, one suspects that his patrons equally became correspondingly more conservative in their expectations of Sarto, and his relationship to them must have gradually altered to one of increasing respect which he willingly accepted, in contrast to Rosso whose enhanced status only inspired him to be more independent. Perhaps it is not over-speculative to conclude that in the decade following the deaths of Leonardo and Raphael, Sarto through his relative conservatism had become increasingly conscious of defining a stable place for himself for posterity.

The articulate if somewhat blandly heroic character of Sarto's final works, while indicative of his fame and acceptance by his contemporaries as a canonical painter (as already discussed, his art was the major influence on the Ghirlandaio house style from the 1520s onwards), was not without its repercussions for his critical fortunes. Vasari was generally complimentary about Sarto's art but stopped short of giving him the divine stature of a Michelangelo mainly because he was felt to lack a necessary boldness and daring of spirit – a timidity that the biographer had personally witnessed when studying in his workshop in the mid-1520s. Here it is worth stressing that Sarto's favoured sculptor was not Michelangelo but the more versatile and fundamentally pictorial Jacopo Sansovino. The question of personality is an opportune one because it may be possible to see the gradual normalizing of Sarto's style in terms of his settling into a more instinctive mode as he matured rather than as a true weakening, encouraged in part by the loss of competition from younger artists and inevitable workshop input. Vasari disapproved also of the general lack of adornment and capriciousness in Sarto's style, and paintings like Pontormo's Borgherini bed panels of about 1518 and Rosso's S. Lorenzo *Betrothal of the Virgin* altarpiece of 1522–3 (fig. 148) supplied him with more accessible, approved models of this type in Florence, which seemed to anticipate the sort of loose and fantastical conceptualization also indulged by Francesco Salviati. In other words, Sarto's most characteristic later style was not what Vasari wished to promote at mid-century. Sarto's lack of desire to compete with the achievements of Roman art or to absorb up-to-date

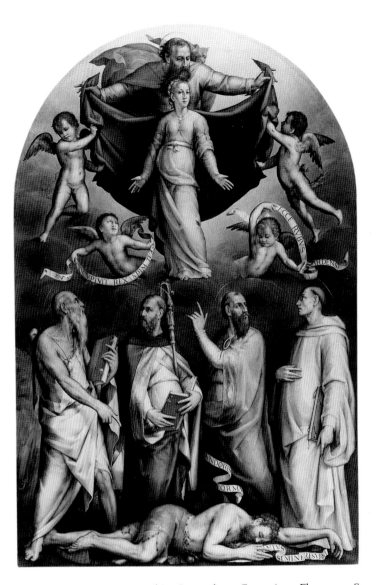

116 Pier Francesco Foschi, *Immaculate Conception*, Florence, S. Spirito.

Roman influences was also for Vasari inexcusable, however slanted his viewpoint (he makes similar criticisms of Franciabigio, later Pontormo and other Tuscans of the period). Yet it remains true that Vasari's few disparaging remarks about Sarto are most suited to the artist's very late paintings with their somewhat bland articulacy and quietitude, rather than his more vivid, earliest efforts like the *Tobias* and *Mystic Marriage* altarpieces (see figs 101, 100) that seem to have been unknown in Florence later in the sixteenth century, but which, ironically, had been studied by the younger Rosso and Pontormo. Similarly, it is notable that the most influential earlier altarpiece by Sarto on Vasari's own painting was the highly reductive one for Sant'Ambrogio of 1515 rather than a more challenging example from the same period. Its

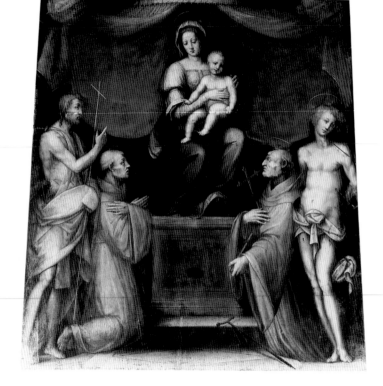

118 Antonio Solosmeo, *Virgin and Child with Saints John the Baptist, Francis, Giovanni Gualberto and Sebastian*, Poppi, S. Fedele.

117 Jacopo da Empoli, *Trinity with Saints Michael and John the Evangelist*, Florence, S. Giovanni Battista della Calza.

dominant impact is also reflected in the only secure painting by a rather limited follower who was more active as a sculptor, Antonio Solosmeo – a fairly crude tryptych of the Virgin and Child with saints (fig. 118), signed and dated 1527 on the central panel.[34]

There is a further irony here because it was precisely such qualities of formal purity, formulaic naturalism and static clarity in the last works Sarto produced that so attracted later sixteenth-century artists in Florence, such as Jacopo da Empoli (fig. 117), Santi di Tito and Mirabello Cavalori. Although it is beyond the scope of this book to trace their careers, it is important to recognize that to them Sarto, and not the obscure and experimental Leonardo or the single-minded and superhuman Michelangelo, was the epitome of Florentine Old Master painters of recent history. These artists working under the moderating pressures of reform in the church positively revered the Sarto they knew best, that of the 1520s, as represented by the S. Salvi *Last Supper* or the *Madonna del Sacco* – the latter representing almost a mental image of the Rest on the Flight into Egypt with the narrative trappings stripped to mere attributes of the subject. Sarto's work of this more decorous later period provided a path out of the excesses and abstractions of the style represented by Vasari and his team of faithful followers, much as Raphael had provided Vasari and others with a model for bypassing Michelangelo's achievement. Vasari thus had good reason in the *Lives* of 1550 to downplay the contribution of

Sarto's work of the 1520s, which seriously rivalled his attempts to dominate the Florentine artistic scene at mid-century. Yet through copies and imitations (fig. 119) these later artists literally echoed the sentiments of the staunch republican Piero Capponi as recorded by Doni in his *Il Cancelliere* of 1562: Capponi had the responsibility of destroying Sarto's celebrated Borgo Pinti tabernacle as part of the scorched earth preparations in 1529 for the siege of Florence but ordered his men to leave it standing 'because the fame of such an illustrious man, brings much honour to the city, which is more useful than to level it.'[35]

119 Andrea del Sarto (copy), *Virgin and Child with the Young John the Baptist* (copy of the Borgo Pinti tabernacle), Birmingham, Barber Institute of Fine Arts.

THE CRITICAL MISFORTUNES OF FRANCIABIGIO

LIKE ANDREA DEL SARTO, Franciabigio is another Florentine painter whose career overlapped with both the periods now known as High Renaissance and Mannerist.[1] That appreciation of Franciabigio has not been enhanced by such classifications is best revealed by the mistaken linking, since Vasari, of his style to that of Raphael – an artist who in truth had negligible impact on his life and work. Born in 1484, Francesco di Cristofano di Francesco, known as Franciabigio, cannot be grouped with artists such as Ridolfo Ghirlandaio or Francesco Granacci because his ties to the Quattrocento were generally much weaker. Similarly, it would be misleading to extrapolate from his fundamentally sober style that he was the unofficial heir to the Mariotto Albertinelli and Fra Bartolomeo partnership that had been dissipated by the mid-1510s. His active participation in many schemes with now much more discussed painters such as Sarto, Rosso and Pontormo – the SS. Annunziata atrium decorations, those for the *gran salone* at Poggio a Caiano and the Benintendi bedroom panels – put his career in close rapport with the most innovative of the younger figures. Indeed, his relationship to those talents has perhaps received insufficient attention, even though there is some contemporary evidence for his own fame and prominence being equal to theirs. Overall, among Florentine sixteenth-century painters he remains somewhat difficult to place, but he was no less wedded to local artistic traditions.

Never peripheral to artistic events in Florence or lacking opportunities, Franciabigio rarely left the city, dying there in 1525 aged only 41. He is another of the large, heterogeneous group of artists ranging from Ridolfo to Pontormo who found enough challenge, stimulus and patronage in Florence to remain satisfied there. Consequently, his career, which was apparently uneventful and quietly successful – with the unexpected exception of one public controversy with the Servite friars of SS. Annunziata who angered him so much over a commission that he defaced his own fresco – can be traced without much difficulty, although the fifty or so paintings he produced are not particularly well documented overall. He supplied his Florentine patrons with a range of small-scale and public works, in fresco and on panel (and in one unusual instance at least of a portrait, on canvas), and his frequent tendency to sign his pictures with a personalized monogram, not unlike Sarto's, implies public pride in his efforts.

Over the course of two decades Franciabigio worked for a variety of patrons from all levels of society. This lack of pretension helped to foster his critical downfall. Vasari first implies in an aside to his not always sympathetic and rather short Life of the painter that he was too retiring and easily satisfied with his modest success. The inadequate biography of Franciabigio is largely responsible for our rather vague understanding of him. Although his legacy was sustained by a small following of former pupils, it appears that Vasari had little direct knowledge of the painter himself, who died before the young Giorgio reached Florence. Along with that of Piero di Cosimo, Vasari's Life of Franciabigio is the least informed of those biographies devoted to the older major Florentine painters active into the 1520s. The lack of direct contact with Piero and Franciabigio made it easier for Vasari to treat them in rather caricatural and emblematic terms. An antidote to his bland image of Franciabigio is partially provided by the extraordinary poem written by the so-called Padre Stradino, composed while the artist was still alive, in which he is described not only as a master of all the arts of painting and sculpture, but also as 'unique: as well as being a good improviser of tunes on musical instruments, a composer, and also a great actor, able to play many characters of different ages and social positions, always able to use the most appropriate language, a man gifted by nature and not by learning, so much so that he is unique'.[2] The extended reference in this text to Franciabigio as an experienced sculptor is particularly intriguing since, although there is no direct evidence for his work in any three-dimensional medium, to judge from his painting style it does not seem out of the question. It is an instructive text for forming the basis of a possible biography of the artist contrary to that composed by Vasari.

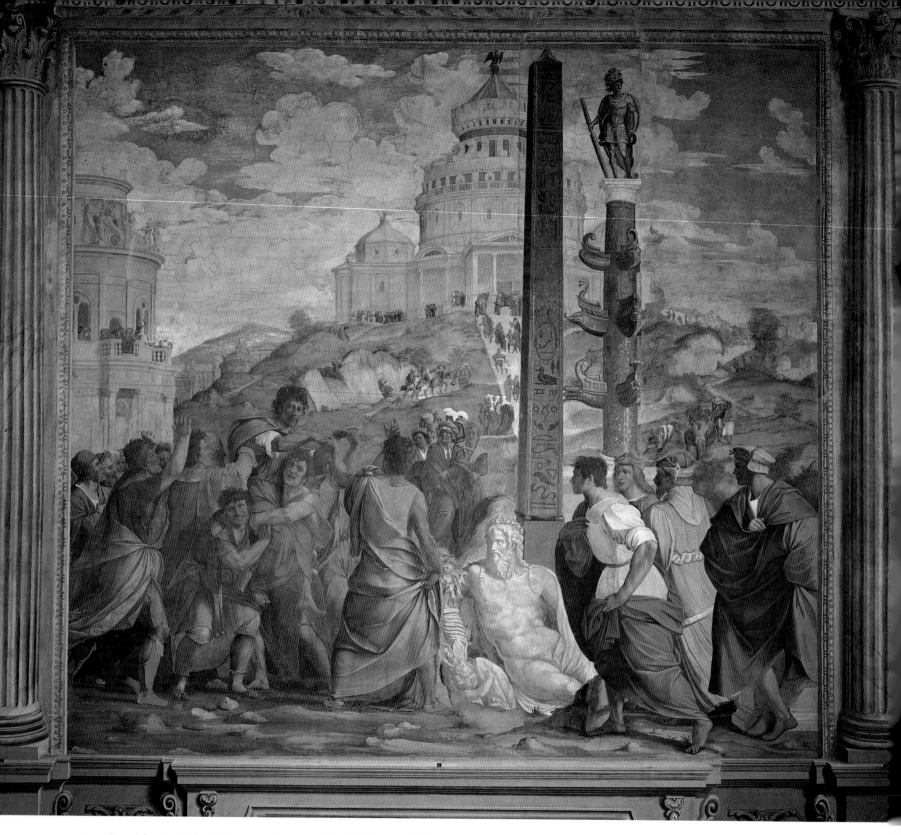

120 Franciabigio (with additions by Alessandro Allori), *Triumph of Cicero*, Poggio a Caiano, Villa Medici.

If Franciabigio worked for humble patrons of the type Vasari emphasized, he moved equally in the upper echelons of Florentine society, especially of the Medici with whom he enjoyed a close relationship. He was the artist given the commission about 1520 by Giulio de' Medici for the entire cycle of frescoes at Poggio a Caiano, which he was expected to divide with Sarto and Pontormo, so attesting to the respect he earned from the most important of Florentine patrons.[3] Like Sarto, he frescoed one of the larger and more prominent lower fields in the room. His *Triumph of Cicero* (fig. 120)

is based on Plutarch in which the 'Pater Patriae', following a period of exile, is carried by a vigorous frieze of figures to the Capitoline reconstructed above in the background – an apparent allusion to Cosimo il Vecchio's return from Milan from his own exile. The fresco takes its place comfortably alongside what are now the more celebrated images by Sarto and Pontormo, which together evoke the notion of a Medici Golden Age in an impressive private setting outside Florence. The inclusion of what are clearly portraits of contemporaries shows that the fresco addresses the present as much the antiquarian past. Like Sarto's, it has lateral additions by Alessandro Allori in the right half which must be mentally eliminated, but Franciabigio's massive forms, fairly ponderous narrative sense and uncompromising approach to physiognomies are all unmistakable – though the desire to create a lively and emotionally compelling narrative should not be missed. This is accomplished primarily through the jarring figural rhythms and specific motifs such as the interlocking hands in the centre of the field.

In stylistic terms, Franciabigio was decidely not eclectic. He is an artist who can be said to have done one thing consistently at the highest level in a mainstream Florentine tradition, namely the generation of sturdy and powerful figures in insistently monumental and taut poses such as those apparent in the Cicero fresco. The fact that he practised strictly within this unified local tradition with its particular model of synthesis makes general comparisons of his work with that of the Umbrian-trained Raphael all the more irrelevant. Although none of his few extant drawings was made directly after ancient sculptures, he must have looked as intensely and thoughtfully at surviving all'antica forms as any Florentine painter in this period in order to produce the stark solidity of his figures and the vivid, body-revealing architecture of his draperies. Like Leonardo and Michelangelo, however, his respect for the antique was not slavish. His figures in general have a liberated monumentality – also derived from the antique – that Sarto struggled to attain and learn, initially in part, from Franciabigio's model. In turn, the more luxurious aspects of painting that came so easily to Sarto seem not to have been instinctively part of Franciabigio's basic repertoire. Emotionally, his images are distinguished by an affective reticence and dignity, though he could achieve tenderness where required, and with regard to the direct piety of his figures it is not surprising to learn that his name has been associated with that of Fra Bartolomeo's partner Albertinelli in his younger years. In the consistency and always careful mediation of his work he provides a good example of an artist who believed in the basic superiority and universality of the Tuscan artistic tradition and so did not attempt any dramatic stylistic progress or change. To this extent, he was not explic-

itly affected by the developments suggested by Leonardo and Michelangelo in their Florentine efforts but, in sharing their distress over the style of Perugino, Franciabigio successfully presented through his own work from the beginning another local alternative based on well-grounded principles of design and proficient technique. Along with Sarto, he filled the critical vacuum created by the departure of Leonardo and Michelangelo from Florence in the 1510s.

Many of the most positive and characteristic qualities of Franciabigio's art are exemplified by the *Saint Job* altarpiece (fig. 121) produced for the high altar of the church of the confraternity of the same dedication to which he himself belonged by 1509 at the latest.[4] It features the Virgin and Child enthroned with Saints Job and John the Baptist and is signed with his monogram and dated 1516. This is a work from which even Sarto might have learned, with its concentrated power and the monolithic scale and weight of its figures. The altarpiece has darkened considerably but the rich paint surface is still very much in evidence. The artist's use of space and atmosphere can be judged as progressive in their simplicity, for almost half the field is left completely empty, lending the image an ambiguous sense of impending drama. The Virgin's compact pose is also forward-looking in its serpentine twist and dropped-leg position. The Christ Child grips her firmly to maintain balance. Saint Job is burly in type with correspondingly heavy and ponderous draperies that seem to cling to the body, as is so often the case with Franciabigio's figures. The head has the air of an antique sculpture but the beggar-like pose is derived from a venerated local precedent in the shivering man in Masaccio's fresco of the *Baptism of the Neophytes by Saint Peter* in the Brancacci Chapel in Sta Maria del Carmine – a tribute to the desire for continuity with the past evident in Florentine painting. In terms of Franciabigio's own mural painting, many of these same qualities of an almost clumsy, unpretentious vigor can be found in his still rarely visited *Last Supper*, signed and dated 1514 and *in situ* in the refectory of S. Giovanni della Calza in Florence. The nominal client appears to have been the Medici abbess of the Maltese sisters controlling the site – an example of the artist's occasionally elevated patronage.

The young Francesco di Cristofano joined the confraternity of Saint Job – which gave him his pseudonym (*bigio* meaning 'grey' derives from the colour of their habit) – before we even have a documented work by Sarto, providing further circumstantial evidence for his early maturity and moderate temperament. In fact, he is not referred to by his alias in any known document from his lifetime, but one made just after his death does cite him as 'el Bigio', indicating that the name was current prior to Vasari's biography.[5] His membership of

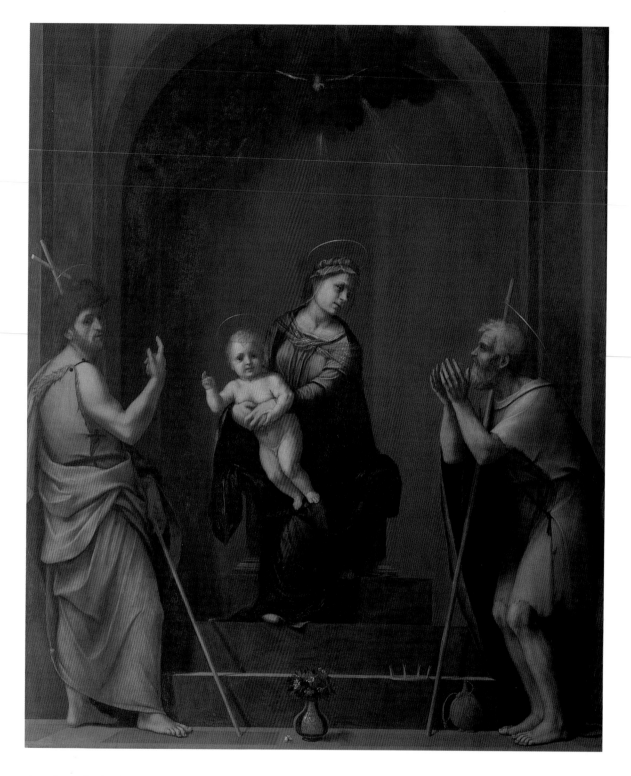

the confraternity for which this work was painted is confirmed by an act of 15 July 1509 whose membership list includes 'Francesco di Cristofano pictore'. Vasari took his likeness for the woodcut portrait in the *Lives* from the John the Baptist in the panel picture, which is assumed from this usage to have been a self-portrait. Franciabigio remained closely tied to this brotherhood, located behind SS. Annunziata: he also produced for them an outdoor *Visitation* tabernacle, now

recorded in a reproductive print, possibly before the high altarpiece of 1516.

Franciabigio's early development closely parallels Sarto's. Vasari wrote that after about 1505 Sarto befriended Franciabigio and the two decided to share a workshop on the Piazza del Grano, behind the Palazzo della Signoria, so supplying evidence for their forming some kind of team at a crucial point in their careers.[6] Perhaps they even had thoughts of

working in a partnership like that of Fra Bartolomeo and Mariotto Albertinelli in order to survive in the especially heated competitive atmosphere of Florence – around the time that Michelangelo left for Rome to begin the decorations for the Sistine Chapel. Franciabigio may have been the more precocious of the two as he was already paying dues in the painter's Company of Saint Luke by 1504; aged 20 he was expecting to take on independent commissions.[7] The same could not be said about Sarto when he reached that age in 1506, and he may have initially relied on Franciabigio's connections for work by becoming his partner. By November 1506 Franciabigio was being paid alone for some relatively minor decorative painting, including a now lost *Pietà* on a frontal for the high altar of his own parish church of S. Pancrazio in Florence, followed by work in the Rucellai Chapel in the same place.[8] Like a great many Florentine males of his social class, he was also linked to the confraternity attached to his neighbourhood church of S. Pancrazio.

One now lost work produced together, probably in 1509, was the curtain for the high altar of SS. Annunziata, including an Annunciation and a Deposition from the Cross apparently based directly on the Filippino Lippi–Perugino altarpiece that became a centre of artistic controversy in this period. It was not so prestigious to have to replicate another artist's work, but it was on a very large scale and for the high altar of one of the most popular pilgrimage churches in the city, and so a commission that could not be refused. For either or both artists, it was probably intended as a trial piece by the Servites, who must already have been thinking about initiating the fresco cycle dedicated to Filippo Benizi in their forecourt. It was around this time, Vasari relates, that the two young painters left the Piazza del Grano workshop and took a new one within the university buildings, near SS. Annunziata, following which they met the young Jacopo Sansovino, who had already been to Rome.[9] The early contact with an innovative sculptor was critical for the progress of both artists in bringing a solidity and articulacy to their figures that can only come from a deep understanding of the fundamentals of sculpture.

Another leitmotif in modern criticism of Franciabigio is that his art is compared to his detriment with that of the younger Sarto. As a result, his undocumented work has frequently been dated *a priori* too late on purely stylistic grounds, according to an obviously circular argument. But this view of him as a sort of artistic weathervane is ripe for re-assessment. At least in the first part of his career, Franciabigio was no less than Sarto a thoroughly contemporary figure. For example, a new date of 1515 was revealed in recent conservation of one of the painted side panels (fig. 122) Franciabigio contributed to frame Nanni Unghero's wooden

121 (*facing page*) Franciabigio, *Virgin and Child with Saints John the Baptist and Job*, Florence, Museo di S. Salvi.

122 Franciabigio, *Angel*, Florence, S. Spirito.

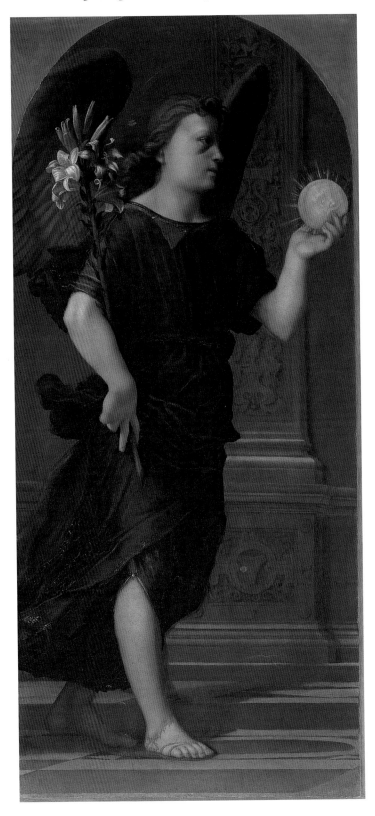

statue on the San Niccolò da Tolentino altar in S. Spirito.[10] That this date is several years earlier than that often proposed on stylistic grounds (typically it has been placed around 1518) for his part in the project highlights the tendency to misrepresent the progressive aspect of his style during this period, before Sarto had come to dominate the scene in Florence. The two flamboyant angels reveal Franciabigio's distinctive lexicon with their proto-Baroque sensibility and deep pathos painted in excited, jagged contours, combined with the strong raking light and almost smouldering atmosphere.

More specifically, considering further the critical misfortunes of these painters, the corresponding tendency in Sarto scholarship is to date his first panel paintings, such as the predella in the Borghese Gallery featuring a Pietà with Saints, slightly too early. This misleadingly implies that they were more progressive than was apparently the case and opens up the possibility that Franciabigio in this area can be given more credit for nurturing the stylistic advances of his younger colleague.[11] This seems plausible even if the basic differences in their approaches – Franciabigio aiming for sculptural simplification and Sarto for pictorial elaboration in tactile terms – are evident. Franciabigio certainly leaves the first physical traces of having been able to paint a large altarpiece on panel – that produced for export to S. Stefano a Campoli in San Casciano in Val di Pesa, between Florence and Siena.[12]

This altarpiece, the *Virgin and Child with Saints Stephen, Bartholomew, Anthony Abbot and Francis* (fig. 123), has only recently been identified as Franciabigio's work, overturning the previous attribution to Giuliano Bugiardini. The painting is undocumented and undated, but has all the hallmarks of an early work, perhaps from around 1510. It was presumably painted for the high altar of this provincial parish church dedicated to Saint Stephen. The stylistic link to Albertinelli, who had been one of Franciabigio's teachers, is clear in the simplicity of the design and firmly polished treatment of the paint surface and flesh parts, though the pupil displays a greater overall elegance and sensitivity even in this relatively youthful image. Similarly, the heterodox saintly types, such as the small and unusually young Francis and the uncouth figure of Bartholomew, are not indebted to the work of his master. Already characteristic of the painter are the slipped leg pose of the Virgin and the colour combinations in the various examples of *cangiante* modelling. However, his inexperience is betrayed by uncertain spatial relations in the design, as well as the high viewpoint and steep perspective, which suggest an urgent desire on the artist's part to bring the devotional image notionally closer to the spectator in the church than that found in altarpieces of the so-called School of San Marco. The rather different influence of the mature Piero di Cosimo is apparent in the rustic charac-

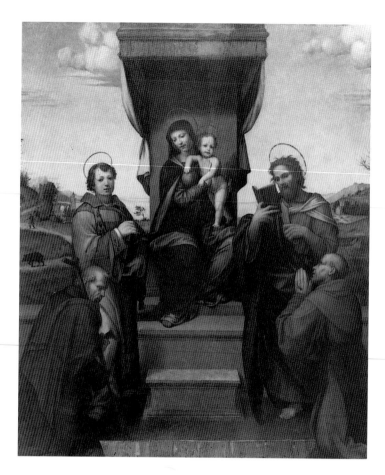

123 Franciabigio, *Virgin and Child with Saints Stephen, Bartholomew, Anthony Abbot and Francis*, San Casciano in Val di Pesa, S. Stefano a Campoli.

ter of the saints, and also in quixotic details like the single boar in profile walking alone on a background path, or the one windswept tree between Saint Stephen and the slate throne. The actual paint handling in the Campoli altarpiece is varied but not as free as that displayed in earlier pictures by Sarto – one of the main differences between the two emergent artists.

Like Sarto, however, Franciabigio was a naturally accomplished fresco painter. A relatively secure example of his early work in the medium is the *Adoration of the Shepherds* (fig. 124). Painted for the chapel in the Villa Lioni, initially Dani, near Sta Margherita a Montici in Florence, it is dated 1510 by an inscription on the now lost frame.[13] The fresco is in very poor condition. To a lesser extent than the S. Salvi *Annunciation*, and because of its different function, the *Adoration* is treated like an altarpiece complete with an inset image of the Pietà at its base. The design is loosely structured with a group of four rather rigid adult figures placed in somewhat listless rhythms across the picture plane. The sombre mood is dictated by their respectful demeanour around the sleeping

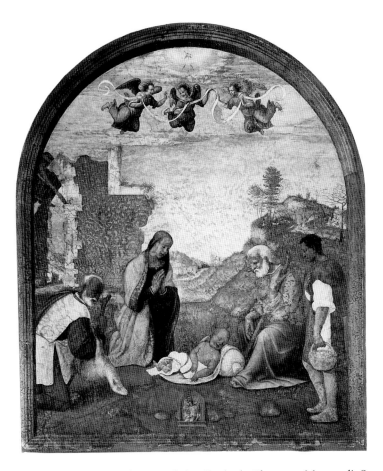

124 Franciabigio, *Adoration of the Shepherds*, Florence, Museo di S. Salvi.

Christ Child, juxtaposed with the offering of the sacrifical lamb, carried by one of the shepherds. Nothing in the fresco suggests Franciabigio had yet been able to study Leonardo's *Adoration of the Magi*, by then probably in the Benci collection in Florence. In composition it can easily be paralleled instead by examples of the cognate subject in more restrained attempts with looser arrangements, especially those by Ridolfo Ghirlandaio, as in his *Adoration of the Shepherds* altarpiece (see fig. 77) from the same year, which happens to be his only signed and dated work. This relatively open and stable treatment of the subject was the basic model followed in the period, compared to Leonardo's more ambitious and difficult partial solution to a subject which, admittedly, did tend to call for more figures.

Nevertheless, the S. Salvi *Adoration* is not only distinguished by its calmer, drier elements but also contains capricious and extravagant motifs, as in the three delightful little angels at the top of the pictorial field, who seem almost to belong to a different painting in their joyous, playful mood. With the rich and unusual colours of their costumes and tightly curled hair, they add a discordant note to the image. If Franciabigio

had developed these more surprising motifs of his early style, his work would have progressed very differently. A comparable desire for such an effect of visual immediacy, which was a distinguishing feature of the most innovative art in Florence after 1500, can be traced in Sarto's first frescoes in the SS. Annunziata atrium (see fig. 99).

Franciabigio's *Virgin and Child* (fig. 125) deepens our understanding of the development of the two artists. Inscribed 1509 on the edge of the book supported on the Virgin's thigh, this is Franciabigio's earliest independent securely dated work to survive. It may have been painted contemporaneously with Sarto's *Virgin and Child* (hanging near it in the Palazzo Corsini; fig. 126) with which it makes a critical comparison. Certainly, both paintings share the same diamond-shaped design, but Franciabigio's is more solid and laterally disposed, apart from being obviously larger and more monumental, whereas Sarto's *Virgin and Child* is painted approximately in the 'minute manner' Vasari lambasted in the stylistically comparable fresco of the *Annunciation* near Orsanmichele. Franciabigio also seems more confident with his powers at this age, as is reflected in the restrained expressive key of his painting and the wonderfully relaxed pose of the Christ Child. Technically, he was a more polished painter than Sarto at this date – the surface of his painting seems to be almost sculpted and fused, while the drapery folds have more regular patterns and are less ornamental. The motif of the book supported on the thigh may have inspired Sarto for the Evangelist figure in the *Madonna of the Harpies* (see fig. 103), so providing evidence for his admiration of Franciabigio's picture of 1509.

One of the most important aspects of this devotional effort by Franciabigio in the Corsini is the derivation in a religious painting, largely in reverse, from Leonardo's standing *Leda*, which had been started in Florence around 1503 but not yet completed when he left his native city for Milan in 1508. This is evident in the Virgin's tense, serpentine pose with the body inclined in a confident and complex movement. The sense of lumbering dynamism in the striding female figure is a characteristic of Franciabigio's art that the young Sarto could not yet reproduce. Franciabigio's interest in the *Leda* supplied a precedent for Sarto who, not long after, painted his version of the same theme (now on deposit with the Musée des Beaux-Arts in Brussels). The order of events would allow that it was Franciabigio who brought this design to Sarto's attention and first made a study of it.

A mythological painting of about this date of 1510 has been attributed to the artists working in collaboration, the *Icarus* (fig. 127), though this seems to constitute yet another injustice to Franciabigio.[14] It has also been attributed to Sarto alone with some regularity, but from its style it appears to

125 (*above left*) Franciabigio, *Virgin and Child*, Rome, Palazzo Corsini.

126 (*above right*) Andrea del Sarto, *Virgin and Child*, Rome, Palazzo Corsini.

128 (*facing page*) Franciabigio, *Calumny of Apelles*, Florence, Palazzo Pitti.

127 (*right*) Franciabigio, *Icarus*, Florence, Museo Davanzati.

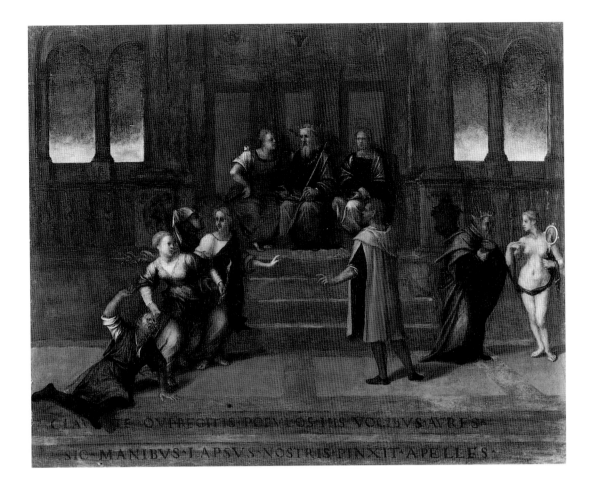

have been executed instead by Franciabigio, if at a moment when the two artists were closest. Despite the similarities to early Sarto, the general control, absolute clarity and rather stiffly posed figures belong to Franciabigio alone, even if the basic elements of the composition are derived from an antique cameo. The *Icarus* panel indicates that the still youthful artists were commissioned by patrons with cultural pretensions, for the mythological subject matter of the picture is based on Ovid, an apparently unique example in their early corpus. Given that Icarus's Athenian father Daedalus was a craftsman and inventor, it is possible that this image had some professional significance for Franciabigio and, potentially, his patron too. The female figure in the picture appears to be Pasiphaë, whom Daedalus had helped to mate with Poseidon's white bull.

The work supplies a generic precedent for Franciabigio's equally advanced if more perplexing *Calumny of Apelles*, datable towards the mid-1510s (fig. 128). This small picture has an early provenance to the Medici – a family with whom Franciabigio had several, still unexplored, contacts at many points in his career.[15] The artist's attempt in this monogrammed panel to recreate the famous example of Apelles known through a description in Greek by Lucian, and given

a glowing treatment in Alberti's treatise *De Pictura* (1435), betrays an intellectual ambitiousness that should not be disregarded when considering his standing in Florentine art of the period. His interpretation has as yet resisted a precise exegesis of all its elements: Calumny is certainly the woman at left accompanied by Treachery and Deceit who approach an enthroned king flanked by Ignorance and Suspicion. Presumably Truth is represented as the screaming man roughly held by the Calumny figure. Alberti mentions the work in the context of the close relationship painters should cultivate with literary types because of the help they can provide in developing particular subjects for art. This relatively esoteric theme became in the Renaissance a standard of excellence for the representation of narrative, and Franciabigio's willingness to translate it into paint suggests a desire to challenge both past and present. A similar sentiment can be traced on a larger scale in secular paintings by Piero di Cosimo. Certainly, in treating the invention Franciabigio accentuated the anecdotal potential of the subject over its more allegorical possibilities by presenting a dramatically unified scene.

The comparison between Franciabigio and Sarto can be sustained in the area of portraiture too (a genre, it might be recalled, that did not particularly tax the skills of Fra Bar-

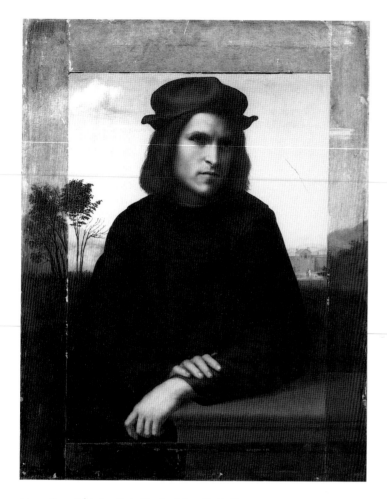

129 Franciabigio, *Portrait of a Man*, Paris, Louvre.

tolomeo, Albertinelli or their followers). For its expression, pose and use of the plinth, Sarto's *Portrait of a Young Man* (see fig. 102) is closely related to one of another youth attributed on the basis of style to Franciabigio (fig. 129). A restoration of the painting has returned the image to its original, more compressed and powerful format with the form reaching the edge of the panel. It seems probable that the Franciabigio portrait was produced earlier than the Sarto, so it deserves some stylistic primacy. But perhaps what matters most is the ease with which the two artists exchanged motifs, and the impression that Franciabigio's work does not suffer in quality when compared to Sarto's. Expressively, these early portraits share an attractive but ambivalent sense of mystery, presumed to derive from a study of Leonardo. It is not entirely certain which Leonardo portraits they would have known (one of them may have seen the then still incomplete *Mona Lisa* before it left Florence), and perhaps they became familiar with them through second-hand derivation or verbal description. Like the figure in the Sarto portrait, Franciabigio's is under life-size. He too looks away from the light source and

his eyes are consequently in shadow. Yet Franciabigio found a more potent expressive possibility in this action by turning the head further down as if the sitter were somehow burdened by thought. More than Sarto's portrait, which has a relaxed quality, Franciabigio produced a compact and planar image, with precisely defined contours for the body. Appropriate for his more simplified construction is the smoother paint surface, which contrasts with Sarto's atmospheric effects. His work is not derivative of his younger colleague's. Indeed, it may be no coincidence that the long-term direction of Sarto's portraiture was towards a more concentrated solution like that on display in the Franciabigio example.

It was around 1512–13 that both artists found themselves employed by the Servite friars of SS. Annunziata. The group of painters working in fresco in the atrium of the church are now commonly referred to as the 'School of the Annunziata', symbolically led by Sarto.[16] The formulation is anachronistic, however, as no school was ever officially created and the styles represented by this diverse group of mostly younger artists, including also Rosso Fiorentino, Pontormo, Francesco Indaco and Bandinelli, do not form a collective. They probably mostly felt themselves to be rivals competing at close quarters with very different artistic and career goals. Their rise overlapped with the demise of the Florentine Republic and the renewal of the Medici family in their native city. With regard to the artistic life of the city, political events also signalled the decline of Fra Bartolomeo's general influence on artists in Florence because of his association with the Dominicans of San Marco, who could not have been so much in favour with the returning Medici. The Servites' pro-Medici stance earnt them considerable favours from the Medici pope Leo X and they were organized in promoting their alliance in visual terms through new commissions.

Franciabigio's *Betrothal of the Virgin* (fig. 130) was discussed by Vasari as the key demonstration of his talents, and it remains his one work in the most prominent public location in Florence. This is itself of interest for his posthumous reputation, given that the damaged appearance of the finished painting must always have excited adverse comments. In Franciabigio, the friars turned to an artist who had previously worked for them in a minor capacity producing decorative work, and who also had experience in monumental fresco painting, as well as a close association with Sarto. In this fresco, first paid for in 1513, Franciabigio had a chance finally to compete directly against his former partner, though not entirely successfully – a result that seems to have done some long-term damage to his artistic ambitions.[17] Whereas for most artists working in the atrium, including Sarto and Pontormo, the frescoes were a early opportunity to establish their public careers, Franciabigio and Rosso in the same position

130 Franciabigio, *Betrothal of the Virgin*, Florence, SS. Annunziata.

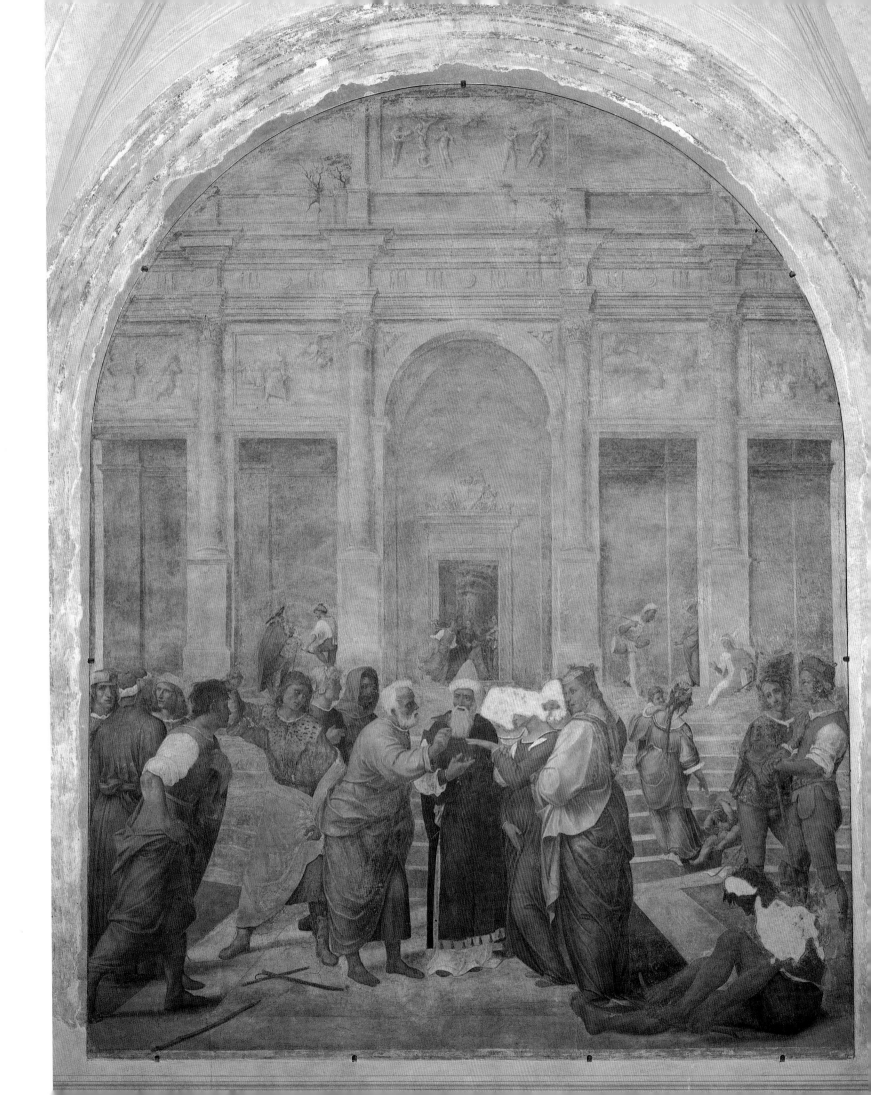

apparently compromised theirs. So, when Sarto abandoned the Scalzo fresco decorations to go to France around 1518, Franciabigio was seen as a suitable replacement for two large fields, but only a temporary one: the confraternity were clearly pleased to let Sarto resume the Saint John the Baptist cycle when he returned to Florence. Franciabigio's motivation in taking on a commission successfully initiated by his friend and rival still seems perplexing, beyond attesting to his impeccable professionalism. It is perhaps only in the larger scale of his figures and taut emotional content that he appears to make an obvious challenge to Sarto's work at the Scalzo.

The design of his *Betrothal*, with its moderately sized figures and expansive architecture, is in general keeping with the precedents created by Sarto, as well as Cosimo Rosselli in his one fresco that initiated the *Filippo Benizzi* cycle around 1475. The fictive architecture resembles a church facade with a loggia, perhaps meant as an idealized representation of the Annunziata itself. In its basic theatricality the construction provides indirect evidence for the artist's work as a designer of stage sets and ephemeral decorations of the type praised so highly by Vasari. The composition is based on a loosely unified row of rather wiry figures. It contains a great deal of anecdotal detail as befits the rich subject matter, and the artist includes superb portraits of contemporary males at the left edge, following the example of Sarto's frescoes, although the fluently rhythmical and painterly qualities of the *Filippo Benizzi* series stand out in comparison to Franciabigio's single work. Among all those in the atrium, Franciabigio's picture features the most explicit use of subsidiary Old Testament scenes to expand the iconography, including representations in fictive relief in the upper architecture of Abraham and Isaac carrying the wood up the mountain where the boy was to be sacrificed and the actual Sacrifice of Isaac in the leftmost section, the Fall of Man and the Expulsion in the upper middle and Moses receiving the Tablets and the Adoration of the Golden Calf at the right. It is difficult to relate these particular subjects directly to the Betrothal. In the most general terms, the Old Testament events were taken to prefigure or ordain that the Saviour's birth and sacrifice were required so that a new covenant between God and humanity could be established. The Marriage of the Virgin and Joseph was, of course, only part of the chain of events in which the Old Testament prophecies were fulfilled. It may be that not too much should be read into this juxtaposition of stories, and each of the Old Testament scenes is to be appreciated independently of the New Testament one, rather like a predella in relation to an altarpiece. Whatever their precise meaning, the inclusion of such images shows a significant intellectual capacity on the artist's part, which is evident by comparison with the other atrium frescoes. That these subjects would have been chosen for him by a Servite friar does not weaken this point since he was clearly seen as someone able to deal with such sophisticated input as easily as, if not more than, any artist working in the atrium.

Franciabigio's fresco is badly damaged by abrasion in the paint layers, revealing the underlying *intonaco* in several places. Vasari recorded the claim that Franciabigio smashed his own fresco after it was unveiled without his knowledge at the same time as Sarto's *Nativity of the Virgin*, dated 1514.[18] Given that he also makes the aside in this passage that Franciabigio was the most competent fresco painter in Florence at this date, the problems cannot have been related to technical inexperience with the medium of fresco, as they may well have been for the inexperienced Rosso over his *Assumption of the Virgin* of about the same date. The documentary evidence suggests, however, that Franciabigio's field was finished before that by Sarto, and Vasari's anecdote must be read with caution – though the fact remains that Franciabigio's work is damaged in the face of the Virgin and in other places, and it may well be true that the friars and building supervisors exposed the work without permission. Considering that they were not especially generous in their dealings with the painters of the atrium, it is also possible that a dispute arose between the parties over working conditions or the final payment, which did not turn out in the painter's favour, and so he simply refused to repair the fresco. A document of 16 June 1515 ordering Franciabigio to do the necessary repairs was presumably totally ignored.[19] Whatever the precise reason for this act, it implies that the friars' handling of Franciabigio was rather inconsiderate (the conflict can be seen in the context of their disputes with Filippino Lippi and Rosso), and that he had some defiant pride, or perhaps foolhardiness, not entirely expected from Vasari's character description. None the less, the defacement remains highly symbolic, for it was Sarto, not Franciabigio, who emerged from their early partnership to play the more active role in the development of Florentine art through the 1510s. For receptive artists, however, Franciabigio must have still provided a distinctly powerful model of excellence in the city, as in the *Saint Job* altarpiece of 1516. It seems safe to say that whatever importance Franciabigio had from this moment on rested on his providing a consistently serious and stable model.

It is perhaps emblematic too of his already somewhat confined place in Florentine art by this date in the mid-1510s that Franciabigio's most compelling works from the middle of the decade are private portraits, for which he had a particular talent and of which he signed an unusually large proportion. This aptitude for portraiture never weakened. A later example is the *Portrait of a Man* (fig. 131), securely signed and

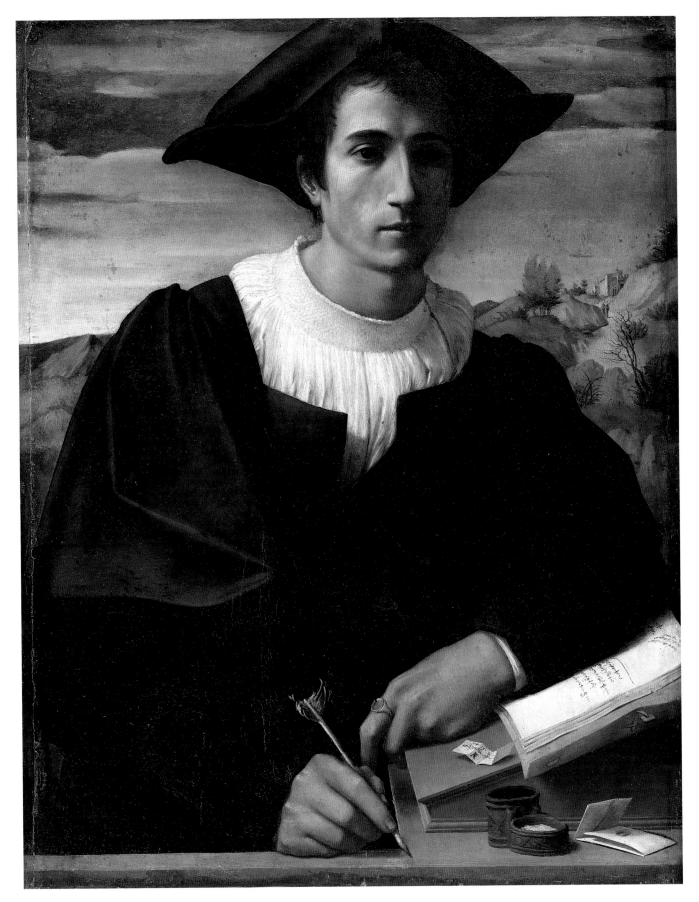

131 Franciabigio, *Portrait of a Man*, Berlin, Staatliche Museen, Gemäldegalerie.

dated 1522, which magnifies the qualities for which the mature Franciabigio was valued throughout his final years. It belongs with a particular genre of portrait featuring individuals who pause while working on their account books as if disturbed by the viewer's sudden presence. The figure here stands at a desk in front of his ledger with a certain feigned casualness before a deep landscape and stormy sky. Compared to the melancholy sitters populating Franciabigio's earlier portraits, the impassivity of this man with his head casually displaced to one side represents a stylistic intensification, in which form is simplified and moulded as if composed of volumetric units. Expressively, the work is beautifully gentle and muted, with the landscape coming close to the sitter and even seeming to dip and create a hollow for the agile form. Paradoxically, the very obduracy of the square face seems to mask profound thought and sensitivity, as in Leonardo's portraits. The close and fairly level viewpoint lends further intensity to the image, while the surface is fused and enamelled with no visible brushwork. The somewhat dry, immutable power and sculptural smoothness looks directly forward to Bronzino and Allori portraits. In this regard it is intriguing that the picture has been thought to be the one of Matteo Sofferoni mentioned by Vasari, for Bronzino was related to this family and his early *Portrait of a Lady in Green* at Hampton Court depicts Sofferoni's daughter, as has been recently argued.[20]

The Berlin portrait thus provides something of a direct model for the conception of the later image by an artist celebrated for his intractable suavity.

The more pressing question of how to judge Franciabigio's individual skills in relation to those of his contemporaries, as well as the problems Vasari had in classifying him, are more directly answerable with regard to his single contribution to the important cycle of decorative paintings for the private palazzo of the Benintendi in Florence. His *Bathsheba and David* (fig. 132) once formed part of a heterogenous cycle of somewhat perplexing significance, consisting of some five panels of different sizes with Pontormo's *Adoration of the Magi* (now in the Pitti), Bachiacca's so-called *Legend of the King's Sons* (in Dresden) and *Baptism of Christ* (in Berlin) and Sarto's solitary *John the Baptist* (also in the Pitti).[21] Dated 1523, Franciabigio's panel is the only one in the series to be inscribed and it happens to be the artist's single most outstanding later work. Ultimately inspired by the even more complex commission for the Borgherini bed panels, these pictures were painted for the antechamber in the palazzo of the banker Giovanmaria di Lorenzo Benintendi in a wooden framework designed by Baccio d'Agnolo. The patron was born in 1491 and so the commission was that of a younger man from a family traditionally loyal to the Medici. Given his loyalties, it seems likely that Benintendi was attempting

132 Franciabigio, *Bathsheba and David*, Dresden, Staatliche Kunstsammlungen.

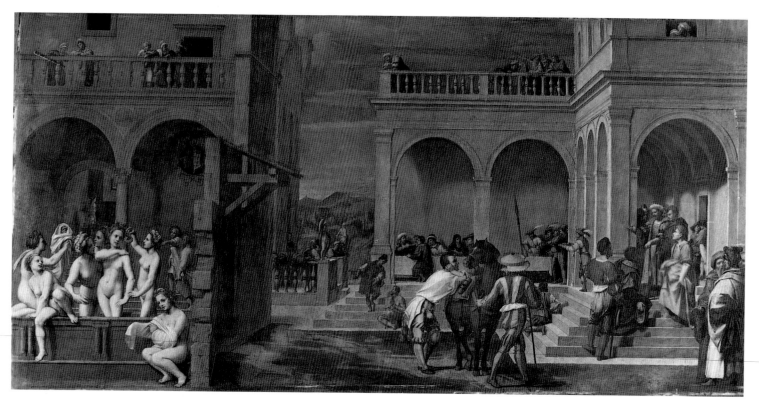

to re-unite the painters, with one exception, who had started the vast frescoes for the Medici at Poggio a Caiano – a task left incomplete with the death of Leo X in 1521. (The same patron also acquired an altarpiece by Fra Bartolomeo from San Marco, to complete his collection of modern art.) Benintendi had already married Bartolomea di Bivigliano d'Alamanno, of a collateral branch of the Medici family, in 1517, and presumably the paintings were intended for the renovation of his palazzo after his marriage and not directly related to the wedding, although it remains a mysterious project in its direct motivation, as much as in the overall programme. The general motivation for the choice of subjects is apparently provided by the Baptist, who was the patron saint of Florence. Thus in the case of the Franciabigio, Bathsheba according to typological reasoning was an antetype for the Purification of the Church that can be obliquely linked to the Baptism of Christ.[22]

Franciabigio's complex painting contains as many as five different scenes related loosely from left to right. Bathsheba with her maids in her bath in the lower left corner, watched by David from a balcony in the upper centre of the panel, is the earliest moment in the narrative, while events relating to her husband Uriah's duping at the feast and dispatch to battle occur in the right half of the panel. The result is one of Franciabigio's most idiosyncratic and extravagant images, which retains his skillful naturalism and sophistication as a narrative painter and designer of a complex scene with a force far beyond Bachiacca, and a playful humour to rival the Pontormo of the Borgherini bed panels. The painting is perhaps memorable above all for the extraordinary vignette at the left of the maidens helping the principal female character with her bathing. The iconographic requirement for Franciabigio to emphasize the Baptism-like qualities of this motif justified its dominance in the pictorial field and he rose to the challenge of the production of charming female nudity – something not much apparent in his work prior to this (only Rosso could perhaps have matched this exhibition). Vasari seems to have been critically unprepared for this area of the painting, to judge by his negative comments: 'lavorò alcune femmine troppo con leccata e saporita maniera'.[23] This reference to an over-elaborate, piquant manner is perhaps one of the most disappointing recorded in the entire *Lives* for its prudery and temporary lapse of imagination: if Vasari immortalized his artistic predecessors in the *Lives*, he also betrayed them at times. One might have expected Vasari to celebrate such surprising stylistic explorations in a work from this period but, as the example of Piero di Cosimo has shown, he was not always at ease with art that seemed to him to lack nobility and coherence. Without wishing to over-stress the point, it does seem a potential turning point for the early

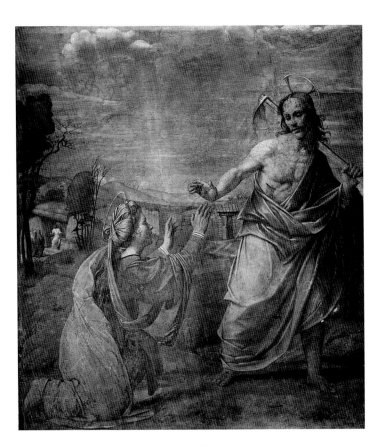

133 Franciabigio, *Noli Me Tangere*, Florence, Museo di S. Salvi.

appreciation of the painter. The tragedy for Franciabigio, perhaps, was that the private nature of this example, which was also part of a lesser genre of decoration, may have closed the work off from many younger artists, thus compromising any potential influence.

Until the end of his life Franciabigio continued in this standard mode – basically consistent but none the less undeniably impressive, especially with the introduction of a few unusual accents, as in the bath scene in the Benintendi panel. The *Noli Me Tangere* (fig. 133) provides a more expected effort by the painter near to his death in 1525. The rather laboured quality to the image displayed in the stumpy proportions and heavy draperies, residue perhaps from an intensive working method, contrasts sharply with Sarto's increasingly abstracted and facile style in this period. This is, apparently, the fresco mentioned by Vasari at the end of Franciabigio's Life as having been done for a textile worker named Arcangelo resident in the Via Porta Rossa. The commission was thus a modest one from someone who had the same position as Franciabigio's father. (Unlike in the case of Vasari, there appears no evidence from the pattern of patronage over his career of any attempts by Franciabigio at social climbing.) The painting retains the fictive frame conceived by the artist to cut off the scene for maximum dramatic effect. The free

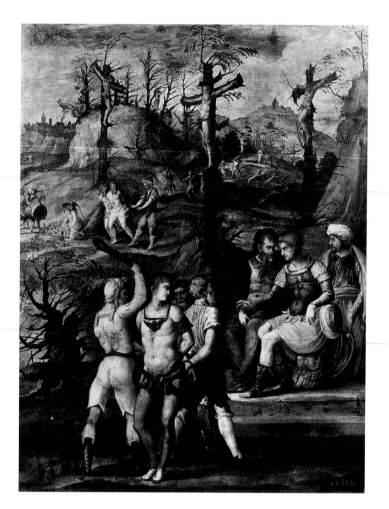

134 Antonio di Donnino Mazzieri, *Martyrdom of the 10,000*, Florence, SS. Annunziata.

handling is astonishing, just as the harmonic quality of the painting is impressive, and demonstrates how Franciabigio could open up his approach, in the appropriate situation, on a painting for an exterior setting. His panel pictures correspondingly feature much denser, harmonized surfaces. The image is conceived in clear, outdoor colours with Christ in purple and the Magdalen a veritable polychrome. Notably smaller and thinner than the Christ, she falls to one knee like a supplicant before a cult statue. The Saviour strides dynamically away, marked with prominent wounds but carrying a large hoe according to his disguise as a gardener. The adept foreshortening of his right arm and well-observed nude form are familiar parts of the repertoire of any competent Florentine painter by this period. At the same time, Franciabigio's development of a sensitive pathos on such a magnified scale finds a parallel in Florentine painting of this date perhaps only in the work of Pontormo.

Writing in conclusion, with the prejudices and concerns of the middle of the sixteenth century, Vasari could not but

fail to consider Franciabigio's style as ultimately too laborious and technically diligent (the main criticisms made of the painter), even though these aspects undoubtedly form part of his frank charm. His public paintings are certainly no more or less polished in finish than any by Fra Bartolomeo, for example. It must be remembered that Franciabigio died relatively early in the century, and that Vasari was attacking him for not possessing a characteristic of painting produced later with more frequency, and then more often by artists who had passed through Rome, like Francesco Salviati and himself. Vasari was doubtless not especially inspired to alter his opinion by any of the later surviving public work by Franciabigio's followers such as Antonio di Donnino Mazzieri, whose one Florentine altarpiece featuring Saint Anne with two saints and two Servite *beati* (still in SS. Annunziata), datable to 1543, is a fairly stilted, reductive and ponderous effort by the artist, produced four years before his death in 1547.[24] His other secure altarpiece, an *Adoration of the Shepherds*, was produced for Castiglione Fiorentino in 1538, while a rather crude attributed panel with a *Saint Sebastian* carrying a date of 1525 survives in the Museo di San Salvi in Florence. A number of much more imaginative small-scale works, usually with prominent landscape elements, have been plausibly associated with the style of this painter, such as those of the *Martyrdom of the 10,000* (fig. 134), which Vasari might just have been charmed by had he known them. Vasari was at least able to praise the artist's spirited manner of drawing, which he observed personally during the collaborative preparations for the *apparati* for the wedding of Cosimo and Eleanora de' Medici of 1539.[25] From a few securely attributable drawings, surviving mostly in the Uffizi, Vasari's opinion can be tested. Donnino was nevertheless attacked in at least one text published before Vasari's *Lives*, in Agnolo Firenzuola's *Novella* of 1548, which sarcastically condemned his hasty technique in his description of the frescoes in the Giocondo chapel of the Martiri in the choir of SS. Annunziata, now destroyed.[26] The nature of this critique echoes Leonardo Buonafede's dismissal of Rosso's Sta Maria Nuova altarpiece of 1518, as will be discussed in the next chapter, and reflects how difficult it was even for experienced observers to tolerate a more open paint handling in sixteenth-century Florence.

The critical distortions in the Life of Franciabigio arose more artificially than Firenzuola's attack based on direct observation because Vasari manipulated the biography to make a general point about the importance of Raphael and Roman art. Vasari certainly invented the story that when Franciabigio saw the works of Raphael, he thought them so superior that he refused to compete and would not leave Florence. This anecdote at the conclusion of the biography is

mere hyperbole, revealing more about Vasari than Franciabigio, for whom no compelling evidence that he visited Rome has yet been presented, and should not be taken as an epitaph for his perfectly distinctive art. A historiographical parallel can be drawn with Vasari's equally discreditable tale of Francesco Francia who died of misery in Bologna after seeing the beauty of Raphael's *Saint Cecilia* altarpiece. The supposed relationship to Raphael has even produced a notable misjudgement in the connoisseurship of Franciabigio, for a body of domestic pictures have been attributed to him on insufficient grounds. This group, which mixes the various influences of the Florentine Raphael, Piero di Cosimo, Fra Bartolomeo, Franciabigio and Sarto, includes only one well-known picture, the *Madonna del Pozzo* (fig. 135) – to be fair, this was even attributed to Franciabigio by Vasari in the second edition of the *Lives*. These generally smaller works, including an ambitious *Temple of Hercules* (fig. 136), which was presumably a private *spalliera* painting of the type Piero di Cosimo treated with such success, have recently been attributed to a little-known painter named Jacopo dell' Indaco, who being born in 1476 was older than Franciabigio.[27] They share a vigorous and pleasantly charming, but rather ungraceful, sense of style that seemed to fit a preconceived ideal of a more eclectic Franciabigio. Because this painter appears not to have created any larger public altarpieces or frescoes, that is, types of work that are more generally documented, it may prove impossible to discover his identity through archival research.

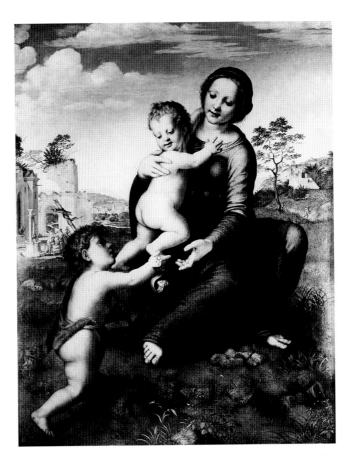

135 Jacopo dell'Indaco, *Madonna del Pozzo*, Florence, Accademia.

136 (*below*) Jacopo dell'Indaco, *Temple of Hercules*, Florence, Uffizi.

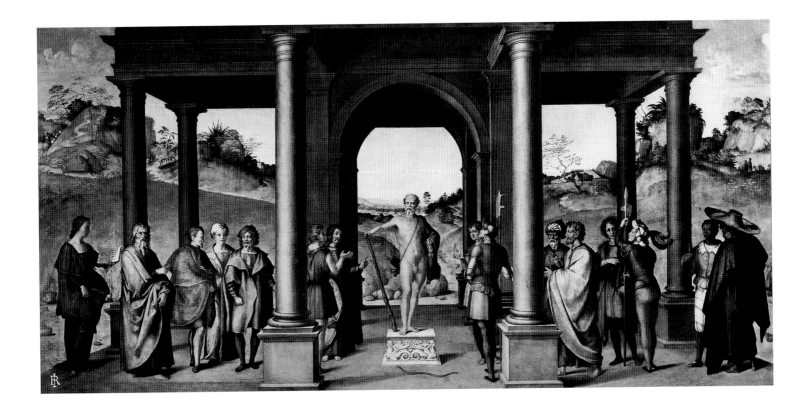

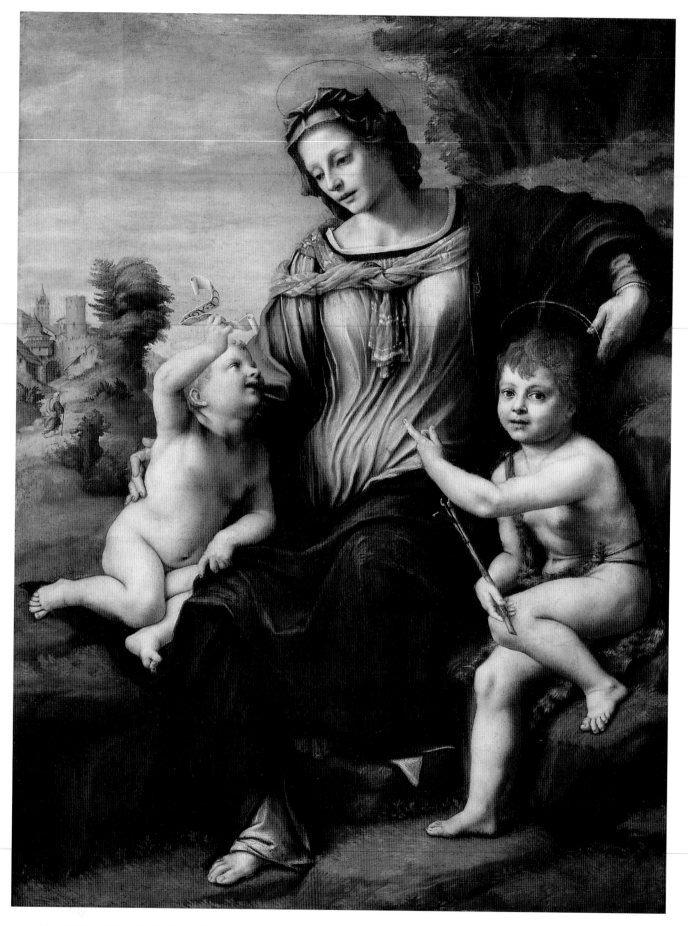

137 Franciabigio, *Holy Family*, Vaduz, Liechtenstein Collection.

The re-attribution of this body of work also raises the major problem of Raphael and the possible extent of his influence on the younger artists in Florence, touched upon elsewhere. Given the mostly private nature of his career there, it seems likely that there was something of a delayed reaction to Raphael among Florentine painters, eventually encouraged by the sheer fame of his later Roman work rather than the quality of his earlier production in Florence. The style of the few paintings Raphael left behind became cherished by a group of highly conservative artists for whom its lessons related to Perugino's idiom had continued relevance. Jacopo dell' Indaco seems to have abandoned Italy for Spain around 1520 and, if by him, there seems no reason to doubt that some of the ascribed paintings could have been produced in the 1510s.

Even Franciabigio's one work displaying a knowledge of a Raphael invention – the Vaduz *Holy Family* (fig. 137) – was produced at the very end of his career and for a private patron.[28] The composition here competes not with an earlier Florentine Raphael but with his *Madonna dell'Impannata* (now in the Pitti) that came to Florence from Rome around 1514 and entered the Bindo Altoviti collection. It equally brings to mind Pontormo's Pucci altarpiece of 1518, in S. Michele Visdomini, although Franciabigio significantly altered any such sources to suit his own definite tastes. The paint surface too is confidently and crisply treated with great personal sensitivity and feel for beauty. In the final analysis, his work as exemplifed by the Vaduz panel is starkly monumental, sturdy, airy and idealized and represent his personal contribution to Florentine painting of the 1510s and 20s, but it is still a work in dialogue with the *Battle of Cascina* cartoon more than any painting by Raphael. In these aspects Franciabigio is easily distinguished from his more sophisticated and ultimately more influential, not to mention materially successful, early companion – Andrea del Sarto. Less than to Sarto's art, however, it is in comparison with an altarpiece by a younger painter – Rosso's *Betrothal of the Virgin* in S. Lorenzo of 1523 (see fig. 148) – that Franciabigio's ultimate contribution to art in Florence reaches a natural limit.

9

ROSSO FIORENTINO AND THE REJECTION OF FLORENCE

COMPARED WITH RIDOLFO GHIRLANDAIO – an artist lacking almost any serious modern historiography – the place of Rosso Fiorentino in the history of sixteenth-century art has been much discussed, in part because of his more sustained exposure to Rome, but also because of his huge influence in France where he spent the last decade of his life (he lived from 1494 to 1540).[1] On a more general level, his production in Italy has been assessed according to two main critical positions: he was either an anti-classicist, a sort of proto-expressionist, antagonistic to the norms of the so-called High Renaissance, or he was a stylish and analytical recaster of the models of the High Renaissance, and so a Mannerist. His earlier work in Volterra in 1521 is most relevant for the first viewpoint and his Roman production of the mid-1520s for the second one. Both categorizations create problems, however, not least because they unfairly push his more accessible and fertile Florentine works to the side.

If we consider first the 'anti-classical' argument, the key work would be the Volterra *Deposition from the Cross* (fig. 138). Signed and dated 1521, the painting has represented his highest achievement as a painter for most critics.[2] Yet it is ironic that the work least known to his contemporaries has come to represent his highest achievement. It was produced for a relatively inaccessible provincial town south-west of Florence. Vasari did not see the painting and it had limited impact on sixteenth-century art. Only Daniele da Volterra by accident of his origins was later able to make use of the design in Rome. It is generally agreed that the basic structure of the *Deposition* was derived from the painting of the same subject by Filippino Lippi for the high altar of SS. Annunziata in Florence and completed after his death in 1504 by Perugino (now in the Accademia) – a model that can hardly be considered progressive in this period despite Lippi's role in its design. Perhaps Rosso's regional patrons even insisted on it as an appropriate and celebrated model. Formally, the two paintings share general compositional

138 Rosso Fiorentino, *Deposition from the Cross*, Volterra, Pinacoteca.

similarities, although Rosso favoured more circular rhythms to Lippi's diagonals. Rosso depicted the same moment in the narrative, when Christ's body is just being taken down from the Cross. Further below, the Maries support the disconsolate Virgin who has fainted at the sight of Christ's martyrdom. The inclusion of this motif was common in depictions of the subjects related to the Crucifixion. The intensity of the Volterra *Deposition* tends to dislocate it from an artistic tradition. In fact, it is less novel than has been admitted, with the exception of its technique and degree of compression. These qualities were more maturely expressed, as we shall see, in the major work painted immediately after the Volterran examples – the Dei altarpiece of 1522 (see fig. 147). While Rosso's handling of the design and iconography in the *Deposition* is undoubtedly surprising, they are both directly based on an earlier painting and, in several instances, traditional solutions. Indeed, the dependence on an altarpiece which was part of a discredited project at SS. Annunziata does not exactly recommend Rosso's picture to the history of art.

To study Rosso at his most influential and sophisticated, however, it is necessary to give special emphasis to the more mature works he created after his move back to Florence in 1522 when the full fantasy, intensity and formal suppleness of his style became most outstandingly evident. Counter to the anti-classical theory of Florentine painting, it does not appear that any notion existed of a single normative or ideal classical standard in Florence against which Rosso could react in his youth. There was the orthodox style represented by the workshops of Ridolfo Ghirlandaio and Fra Bartolomeo, of which Rosso undoubtedly would have been critical, but the painters shared at least three of the same Florentine patrons, who were obviously tolerant of their different styles. Rosso was perhaps in competition with their relatively banal styles in a general sense, but this would not have had much effect on his internal stylistic development, attitudes towards his career or even his gaining of patronage. Nor does he seem to have been alienated spiritually or socially in Italy. There are powerful tensions evident in the tight-knit, peremptory designs and facial expressions in his paintings, but these arose during the process of artistic creation and not, apparently, as has often been argued, through some uncontrollable personal antagonism to the values held by artists of a previous generation, or because of his reaction to traumatic events like the plague in Florence, the Sack of Rome or military activity around Arezzo at the end of the 1520s.

Rosso climbed from what seem to have been quite humble roots in Florence to work for sophisticated and distinguished patrons at all points in his career.[3] He made every effort to acquire social graces, obtaining Castiglione's *Courtier* soon after its publication and learning some Latin – not a standard

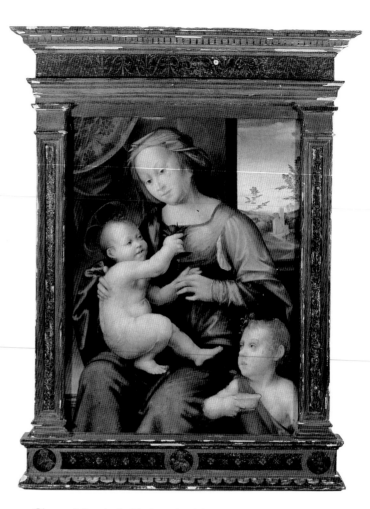

139 Giovanni Larciani, *Virgin and Child with the Young Saint John the Baptist*, whereabouts unknown.

accomplishment for an artist of this period.[4] Vasari, who met him, claimed that like Leonardo he was an able musician and of handsome bearing.[5] His art exhibits at times a visual wit and humour, displayed in most sophisticated form in the engravings, primarily with mythological subjects, that he designed for Jacopo Caraglio in Rome in the mid-1520s, which certainly made up a large part of his artistic personality. Only Vasari's extended description of the antics of Rosso's beloved baboon in Florence in the early 1520s seems to reveal an eccentric facet to his varied character, but such a colourful anecdote obviously fulfilled a powerful literary dimension that may have exaggerated the reality of the situation, as can also be perceived in the biography of Piero di Cosimo.

The overriding desire to press Rosso into a mould of eccentricity is most easily exposed by an examination of a historiographic episode relating to his earliest work, and the attribution to him of a number of stylistically distinct paintings, mainly devotional in nature, certainly by the so-called

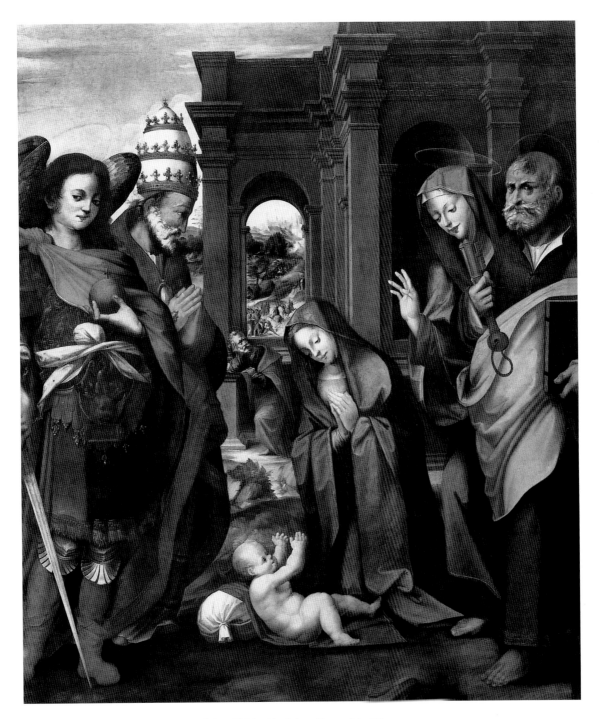

140 Giovanni Larciani, *Adoration of the Child with Saints*, Fucecchio, Pinacoteca.

'Master of the Kress Landscapes' (fig. 139). As this painter was classed by Federico Zeri as another of the *eccentrici fiorentini*, it is clear that scholars have felt it perfectly likely that Rosso's earliest art could be of a similar type, so much so that individual paintings were ascribed to either painter.[6] This incident has been brought to a stop thanks to an archival discovery by Louis Waldman of a contract for the altarpiece of the confraternity of the Virgin Annunciate in Fucecchio (fig. 140).[7] Through the documents relating to this commission, it has proved possible to name this artist for the first time as Giovanni Larciani, born in Florence as early as 1484 and, therefore, more a contemporary of Sarto and Franciabigio than Rosso. The artist's family traced its roots to the village of Larciano, near Vinci, in the general region west of Florence where his secure altarpieces were supplied. Larciani's growing corpus of twenty or so surviving works, including

some three altarpieces, suggests he was not especially prolific by the standards of his time, though this body of work will doubtless continue to expand.

Although it had been generally believed that he must be one of the artists mentioned in passing by Vasari (the probable painter of the *Battle of Cascina* cartoon replica at Holkham Hall – Bastiano da Sangallo – was one of the most widely accepted proposals), Larciani was, on the contrary, completely suppressed by the biographer. This neglect was probably not the result of malice on Vasari's part, if he even knew of the painter's existence, but of the provincial locations of his surviving major work, combined with his death earlier in the century in 1527. It is not difficult to imagine, however, that Vasari would have fundamentally disapproved of this painter's relaxed approach to design and overall eclecticism. None the less, this Larciani was not obscure institutionally in Florence: he was named one of the four captains of the painter's confraternity of Saint Luke in 1520. There is no evidence that he worked publicly in Florence, but he seems to have had major patrons in the Medici, possibly also the Niccolini – the family whose *spalliera* in the National Gallery of Art in Washington gave the artist his former name.[8] Presumably trained in Florence, Larciani had an imaginative talent in terms of open painting technique and an almost reckless attitude to form, whether human or of nature, as is especially evident in his smaller productions. If anything, the freedom of his handling can be associated with the type of painting produced away from Florence in places like Bologna, Lucca or Siena, although any possible travel to such places is undocumented. Paradoxically, his figure style comes closest among Florentines to that of Mariotto Albertinelli and especially Francesco Granacci, neither of whom are known primarily for their fantastic invention and lavish technique, given that both exist under the shadow of finer artists – Fra Bartolomeo in the latter case and Michelangelo in the former. The direct references in Larciani's art to Granacci's inventions of the early 1520s suggest, rather than a master–apprentice relation, perhaps even the beginnings of some type of partnership on the model of Fra Bartolomeo and Albertinelli, possibly brought about by Granacci's advancing age.

It is easy to underestimate the value of painters like Larciani because of his very anonymity and obscurity, both of which, beyond Zeri's important and astute article of 1962, prohibited research into his complete oeuvre. Similarly, the old attribution of his work to Rosso provides an example of the suppression of the possible existence of a painter of this type. The label of 'eccentric' provided a convenient pre-set framework in which to consider his few paintings, despite the variety and incompatibility of the artists Zeri labelled, not to mention the visual coherence detectable in this one master's

141 Rosso Fiorentino, *Dead Christ with Angels*, Courtesy, Museum of Fine Arts, Boston, Charles Potter Kling Fund.

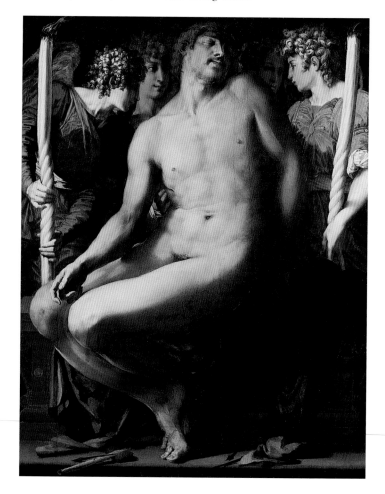

output. It is perhaps no coincidence also that so many of his paintings are homeless and the same ones can reappear quite rapidly on a stubborn art market, since the very lack of a name created a situation whereby collectors have had little interest in his art. His old alias of the Master of the Kress Landscapes, like so many labels, itself implicitly restricted the possible range of his production. In terms of understanding Rosso, besides representing a false start in the unravelling of his early work, this history reveals how a model of eccentricity may not be the most accurate one with which to approach him.

Rosso has also been classed as a Mannerist, but like the assessment based on the notion of High Renaissance classicism, this too has complications.[9] A key image here is the *Pietà* (fig. 141) because it can be located with absolute certainty in Rosso's Roman period. Identifiable as a work discussed by Vasari as painted by Rosso in Rome for the Florentine Leonardo Tornabuoni, the picture is also related to a panel painting described in a notarial document that Rosso had drawn up in Sansepolcro following the Sack of Rome, which allows for its dating to his previous Roman period. In its essentials, the style of the work is consonant, however, with what Rosso produced earlier in Florence, in particular the *Betrothal of the Virgin* for San Lorenzo of 1523 (see fig. 148). So exposure to Rome cannot be said in his case to have precipitated this stylistic progression towards greater elegance and restraint. Further, it seems likely that Rosso travelled to Rome about the time he went to Volterra, probably about 1520, and so the style promoted by the Raphael-trained Perino del Vaga on his fairly brief and, from a factual point of view, still mysterious visit to Florence around 1522–3 would not have contained novelties for him, and did not alter his art in any significant degree.[10] Perino's method of synthesis was, like Raphael's, so incompatible with the Florentine general approach that it is difficult to imagine how deeply he could have affected the actual working method of any artist in the city of his birth. Apart from a public fresco (now destroyed) in the Carmine church, the only finished painting Perino appears to have left in Florence was the extremely rapidly executed *Moses parting the Red Sea*, for which two different versions may exist. Even while exaggerating (and arguably totally inventing) the positive importance of his visit to Florence, the reference in Vasari, who is the only source for this sojourn, to the scepticism displayed by local artists towards Perino's promotion of a Roman style rings perfectly true.

Beyond Vasari's occasional and fairly loose allusions to the *maniera moderna*, there is no evidence that stylistic categories such as Mannerism, based on a broad perception of artistic innovation, existed in this period. So-called Mannerist art, like that Rosso has been considered to have produced in Rome, is defined as a compound of purely artificial and abstracted stylishness developed in an interactive way with earlier art of the High Renaissance, and from this a tautology has arisen in the criticism: Mannerism as 'stylized' or 'stylish' art. On a semantic level alone, these seductive formulations are highly problematic. All artists have styles that are more or less abstract and constructed and are, therefore, subjectively stylized or stylish. If the anti-classicist theory does not allow for the continuing defiance of received models in the artist's later work, the Mannerist thesis cannot allow us to accept that, even if different in appearance, there is a sort of deliberate elegance present in the little *John the Baptist* (in a private collection in Florence) as well as in the *Pietà*, just as a degree of tense severity and even brutality can still be found in Rosso's Roman and post-Roman production, especially in the Sansepolcro *Deposition from the Cross*. Even when he created his most sophisticated and euphonious works there is also a full measure of passionate intensity of expression. Indeed, Rosso's basic emancipation and unpredictability suggest a lack of stylization in a painter who is always definitive, but never reducible to formulas. In essence, a model based on allusive quotation of past masters applies better to the art of Giorgio Vasari than to Rosso. Raphael, for example, had almost no impact on Rosso, who is known to have criticized the late artist when he moved to Rome in the mid-1520s to take on the Cesi Chapel commission in Sta Maria della Pace. The attack on Raphael, who had worked in the adjacent field in the church, was so great that his pupils threatened to murder Rosso.[11]

Michelangelo, in contrast, was certainly more relevant for Rosso than any other artist, although he always reworked any observations of the former's imagery to suit his own ends. Similarly, some of the paintings in which references to Michelangelo exist, such as in the *Pietà*, are arguably deliberately chosen to placate the patron of the work and are not part of his creative decision making. Paradoxically, there is also an element of critical challenge in the cases where Rosso evokes precedents in Michelangelo by subsuming and developing these sources to fresh ends in treating the related motifs. Rosso's work assumes that the viewer should be sophisticated in interpreting in order to appreciate it most fully, as one would expect of those who directly witnessed many of the developments in Florentine art after 1500.

On the whole, it may be impossible to identify a less respectful and concessionary Renaissance painter than Rosso, who in his sole surviving letter of 1526 refers to his general reputation for arrogant behaviour in the context of apparent criticisms of Michelangelo's Sistine Chapel ceiling, perhaps now the single most important Renaissance work of art.[12] In studying Rosso's art the search for visual sources must

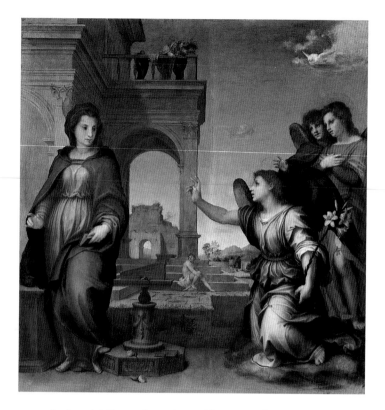

142 Andrea del Sarto, *Annunciation*, Florence, Palazzo Pitti.

not overwhelm an appreciation of the artist's varied originality and invention for which he himself strove, or devalue the rupture that his style constitutes from the ideals of a Perugino or a Fra Bartolomeo. A similar desire to avoid compromise is apparent in Pontormo, though with very different outward consequences. So rather than constantly judging the work of these artists in relation to the previous generation, it is more productive to consider what motivated their defiance and single-mindedness. It was only in Florence that painters of their type could have developed. Rosso and Pontormo were among the first to negotiate the challenging and recalcitrant examples of Leonardo and Michelangelo, who, direct visual sources aside, instilled in them a particularly Florentine arrogance and ingenuity towards artistic invention. Their art represents the natural outcome of a study of the wide experimentation of those earlier masters, but without slavish copying. This general attitude towards surprising invention affected not only artists of natural talent like Rosso and Pontormo, but also fairly mediocre ones like Sogliani or Francesco Indaco, both of whom clashed with important patrons during their careers precisely on the issue of creative control. The problem of public reception arose in relation to three of the four public works Rosso created in Florence, as an analysis of Vasari's text and the documentary evidence reveals. The price of autonomy and total integrity for a

Florentine painter, we shall see, could be self-imposed exile. No episode is more indicative of the gap that could exist between artists and patrons in Florence.

Rosso's full name was Giovanni Battista di Jacopo di Guaspare; he probably received his nickname from his red hair. His training remains mysterious as Vasari claimed he was so independent that he would not stay with any single master.[13] Certainly, Rosso's fixed and somewhat defiant attitude towards his career is evident from the start. With the rise of Leonardo and Michelangelo, it became apparent that an outstanding artist hoped to be perceived neither as a craftsman nor necessarily as having undergone a proper apprenticeship but as someone with a markedly individual talent. What is remarkable is how this attitude affected painters like Rosso and Pontormo at an age so young that it seems to have allowed them free rein over their own training. It also immediately brought Rosso into conflict with his early patrons.

One almost certain fact about Rosso's beginnings as an artist was his appearance in Andrea del Sarto's workshop. According to Vasari, he collaborated with Pontormo on a predella for Sarto's *Annunciation* (fig. 142), for the altar of the Castiglione family in the church of S. Gallo in Florence.[14] It is datable on stylistic (and inferred documentary) grounds to about 1513, so about the same time as Sarto's *Mystic Marriage* (see fig. 100). This painting provides the most secure point of contact between Rosso and Sarto but the link is nevertheless much misunderstood. Desirous of placing Sarto in a High Renaissance and Rosso in the subsequent Mannerist period, it is conventional to insist on describing the latter as a fully fledged pupil of Sarto in order to preserve the sequence, when in fact their careers overlapped. Sarto was just seven years older, not a whole generation, and the fact that Rosso was a more precocious painter only narrows this gap. Similarly, Vasari's fundamental statement that Rosso was antagonistic to all masters in Florence deserves respect. But the rejection of his first two major public commissions, the *Assumption of the Virgin* for SS. Annunziata and his altarpiece for the Hospital of Sta Maria Nuova, provides explicit proof of this stylistic fissure between Rosso's initial work as a painter and those masters active in the Florence of his youth: the rejection was based on his refusal sufficiently to respect previous models, either formal or technical. The so-called *Lute Player* in the Uffizi, which is datable on the basis of style towards the start of Rosso's final Florentine period (an added but trustworthy signature and date of 1521 have recently been revealed in conservation), supplies more potential evidence of the artist's difficulties in this period, because this fragment is all that remains from what was once an attempt at a larger altarpiece.[15] None the less, there can be little doubt that Sarto had the most stimulating workshop in Florence at this time

– when, significantly for Rosso's development, the older painter was at his most adventurous.

Rosso's first major public work on a monumental scale was to paint an *Assumption of the Virgin* in the atrium of SS. Annunziata, where it survives *in situ* (fig. 143). It is a tribute to his swift rise as a painter that he received the commission before Pontormo and aged five years younger than Sarto had been when he began working there, though Rosso also had a brother who was a friar there, which may have helped his cause at least initially. He apparently earned the commission after painting a trial piece, the *Virgin and Child with Saint John the Evangelist*, for one of the Servites.[16] That painting survives only in copies but it featured an extraordinary treatment of the Christ Child especially, with his back turned towards the viewer – an arrangement that suggests an awareness of Leonardo's developments in rethinking the spectator's relationship to the divine.

Payments survive for the *Assumption* from 1513 into 1514. Rosso's work concluded a subsidiary Marian cycle initiated in 1511 by Sarto with his *Nativity of the Virgin*. The choice of the Virgin for this tribute is not surprising given the Servites' particular devotion to her. Rosso's *Assumption* proved, however, to be less than satisfactory to the Servite judges, who had a selection of the most innovative contemporary Florentine art on their premises from which to make an assessment, by the hands of Sarto and Franciabigio. The sources are not clear as to which aspect of Rosso's fresco they disliked, but there is no doubt it was to Rosso's total humiliation in 1515 that the building supervisors at the Annunziata contracted Sarto to repaint the narrative, although in the end he never did and Rosso's first work remained – a curious relic of client dissatisfaction with an artist which it is tempting to parallel with Leonardo's self-destructing fresco fragment then visible in the Palazzo della Signoria.

It is self-evident that Rosso's *Assumption* is a harsh, even struggling effort in areas, especially in the lower section, where the overlapping apostles submerge any potential background, and not least the Virgin's tomb that one would expect to see. This relentless concentration on the figure alone betrays his search for originality as he rejected the various models available among the existing atrium frescoes for the arrangement of figures in deep landscape settings. The conception of a design created solely through agitated, large-scale bodies in relief as on a stone sarcophagus was, however, inspired by a more recent work – Michelangelo's *Cascina* design for another fresco for the Palazzo della Signoria (see figs 45–8), even if Rosso's somewhat awkward dependence on overlapping forms and the resulting staccato, precipitate rhythms are different from the drawn design. His focus on the apostles at the expense of the tomb may indicate the

answer to the question of which part of Rosso's *Assumption* disturbed the Servites. They could have felt that the subject was not fully represented in all its aspects without the standard sepulchre. His handling of the lower section is iconographically and formally most heterodox indeed.

Individual apostles in Rosso's fresco are attenuated and in motion, as is to be expected from an artist who would have studied at least some of the individual figures generated by Leonardo and Michelangelo for their battle cartoons for the Signoria. In conjunction with these qualities, the draperies are massive and consist of a few billowing folds, such that the apostles appear to be composed mostly of drapery, which contributes to the expressive potential of the poses. It is not easy to interpret the specific facial expressions of the apostles in the *Assumption* given the poor condition of the mural, and it can be hoped only that something of Rosso's intentions are preserved in what is extant. Many heads are highly agitated as they crane upwards to follow the Virgin's ascent, and it is apparent that Rosso's artistic language was directed to the expression of an expansive range of specific emotions. After all, inventive variety was itself a natural state for Florentine artists of any generation and Rosso was simply attempting here to position himself in a venerable tradition. As the case of Piero di Cosimo has shown, this degree of fantasy was not an eccentricity.

Rosso's inventiveness is particularly clear in the more successful upper section of the field portraying the Virgin rising to heaven. It was traditional to depict the Virgin in a glorified state on her Assumption into heaven, and Rosso complied with this here but interpreted the motif in a lively, idiosyncratic manner that became a characteristic of his style. He represented the Virgin ascending dramatically upwards into the golden firmament on lavender-coloured clouds with a chorus of angels at her feet. This daringly foreshortened, angled ring of naked children is surprisingly accomplished. Certain angels are seen in the same pose but shifted round, suggesting that Rosso painstakingly studied them first from purpose-made sculptural models in the studio, perhaps with the help of Jacopo Sansovino, who was also a close colleague of Sarto's in this period. Yet his technical confidence appears to have been somewhat misplaced, and the friars may also have been critical of it. At this moment, Rosso's ambitions as a young painter in Florence were for the most part more daringly uncompromising than his ability to bring them to successful fruition. We should recognize, however, the almost reckless fervour with which the young painter approached his first efforts, for it reflects the sort of artistic climate that had been generated in Florence around 1510 in the wake of the departures of Leonardo and Michelangelo.

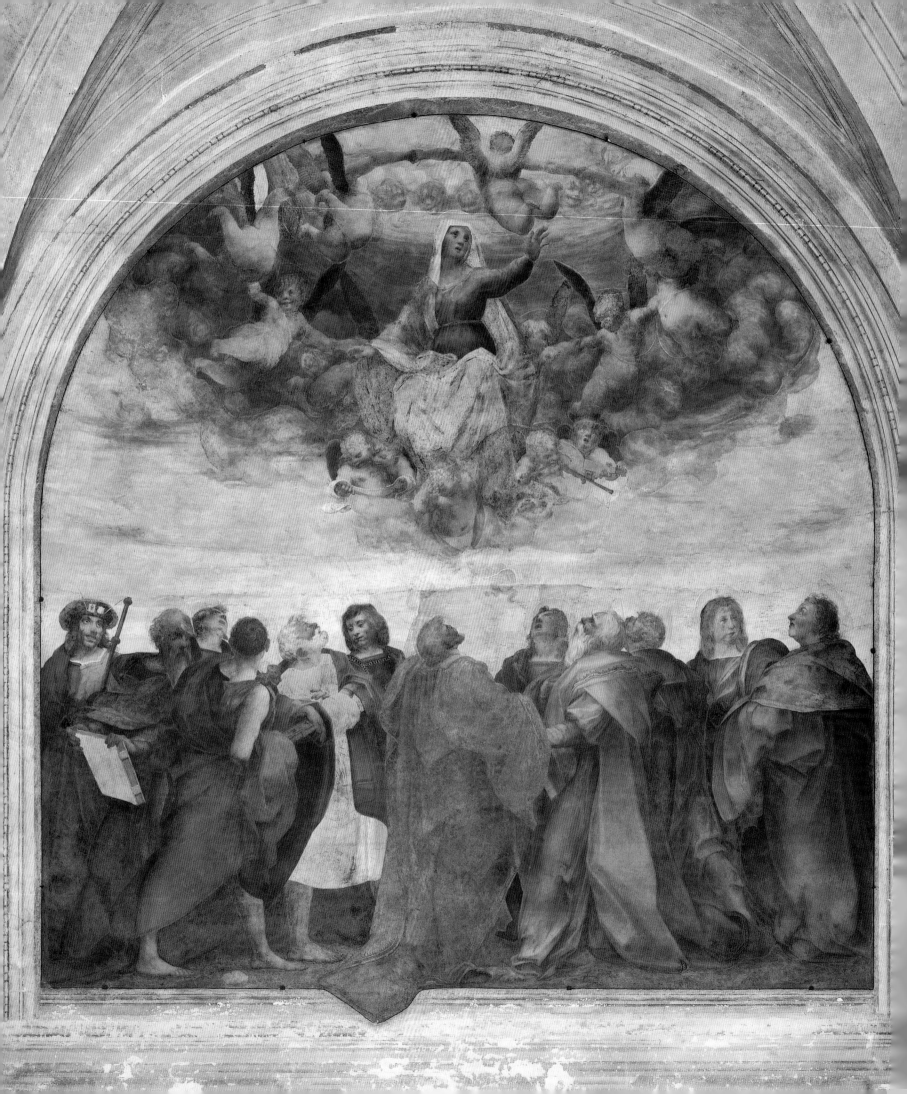

Rosso's Sta Maria Nuova *Virgin and Child with Saints John the Baptist, Anthony Abbot, Stephen and Jerome* (fig. 144) is of special interest as his first surviving altarpiece.[17] It is possible to document much more fully than for the SS. Annunziata *Assumption* the reasons for the negative reaction of a Rosso patron to his early style. The history of the work demonstrates how stylistic innovation did not always translate into success, even in Florence, and foreshadows Rosso's ultimate unhappiness in working in his native town. The panel was commissioned following a contract of 1518 for the church of Ognissanti by the colourful director of the Hospital of Sta Maria Nuova (and, as we have seen, important patron of Ridolfo Ghirlandaio's workshop), Leonardo Buonafede. His eventual disappointment with Rosso's painting meant that it was never installed on the altar for which it was painted. The artist originally depicted the Virgin and Child with four saints – John the Baptist, Jerome, Leonard and Benedict – but two of these prescribed saints were altered in the finished work. Leonard, Buonafede's name saint, was replaced by a Stephen shown with one of the stones of his martyrdom resting on his forehead. Technical examination has revealed two rings from Leonard's attribute of prisoners' fetters underneath the dark shadow by the Virgin's head.[18] And Anthony Abbot took the place of Benedict. He can be identified by the *Tau* cross on the front of his black cloak. The altarpiece thus originally conformed to the contract but some of its attributes were later changed, and a discovery of the picture's provenance proves that the saints were altered for a reason.

In fact, a discrepancy in the artist's fee provided the first occasion for the legal dispute between Buonafede and Rosso; two painters, Giuliano Bugiardini and Francesco Granacci, were elected to arbitrate a final fee for the contending parties. Their opinion is not recorded although, considering their training in the Domenico Ghirlandaio workshop in Florence, it would be fascinating to know their opinions. Whatever the decision, it is clear that Buonafede, while not feeling able to reject the painting outright, had a passionate aversion to it. This is made manifest by Vasari's record of a (now lost) *Virgin and Child with Saints John the Baptist and Romuald* by Ridolfo Ghirlandaio on the altar of the chapel in Ognissanti by 1568: Buonafede commissioned his preferred artist to paint a second, and for him more acceptable, altarpiece.

Further documentary evidence shows that, in addition to painting the replacement for Ognissanti, Ridolfo was paid to produce a frame for Rosso's unfortunate panel, which was sent to the church dedicated to Saint Stephen at Grezzano, north-east of Florence. This explains the transformation of Leonard to Stephen from the contract to the finished panel. Benedict was transformed to Anthony Abbot, through the addition of the *Tau*, to make the saint more appropriate to the hospital, as befitting one of their benefices. Anthony Abbot's attribute of the *Tau* is a symbol of his crutch, which is in turn a symbol of the hospital. It seems that Rosso's painting was dispatched to the relative obscurity of Grezzano by the director, who found a less prominent altar for the panel in one of the many outlying churches or hospitals under Sta Maria Nuova's patrimony (a model of patronage that Ridolfo's workshop had more typically been involved with for Buonafede). This transfer explains why the altarpiece had no apparent influence on sixteenth-century Florentine painting: it is quite possible that no other artists saw Rosso's picture. So it is the equally ill-fated *Assumption* that probably created the artist's immediate impact.

The Sta Maria Nuova altarpiece features the four saints standing round a centrally enthroned Virgin and Child. This pressing together of the figures at the expense of the background is familiar from Rosso's SS. Annunziata *Assumption*, although the characterization of the saints in the panel painting is even less conciliatory than in the fresco because of the smaller field. Motivated by the two angels at whom the Baptist points and Jerome blesses, the saints react to the Virgin and Child to focus attention on the centre. The attitudes of all the figures have a narrative impetus that seems almost to be inspired by a written source, but no text could explain their activity which must be interpreted in general terms, as in any other altarpiece of the Virgin and an assortment of saints. Despite the agitation of the figures, for an altarpiece the expressive content is unusually distanced from the viewer. This is partly because of the alert, starkly evolved physiognomies, but also because none of the saints looks out or points at the viewer in the traditional manner to intercede or draw attention to the Virgin. Rosso did not try to placate a viewer with traditional expectations of altarpieces, as Ridolfo and Fra Bartolomeo among others always did.

Buonafede must have considered himself justified in objecting to the characterization of Rosso's saints. The painting simply does not feature the solemn and hieratic interrelationships that the hospital director expected an altarpiece to sustain, based on his own experience with Ridolfo, Lorenzo di Credi and others. Rosso's figures are rather preoccupied with the Virgin and the book held by the angels, as if the picture was a narrative and not just a timeless gathering of assorted saints in the usual manner. Along with the sense of internal preoccupation more appropriate for a narrative, it is not hard to appreciate how the heightened emotions and stylistic aspects, like the unstationary poses, may have offended a patron accustomed to Ridolfo's inscrutable saints. Buonafede presumably wanted a particular type of economical altarpiece and not a painting by Rosso as such, and was

143 Rosso Fiorentino, *Assumption of the Virgin*, Florence, SS. Annunziata.

181

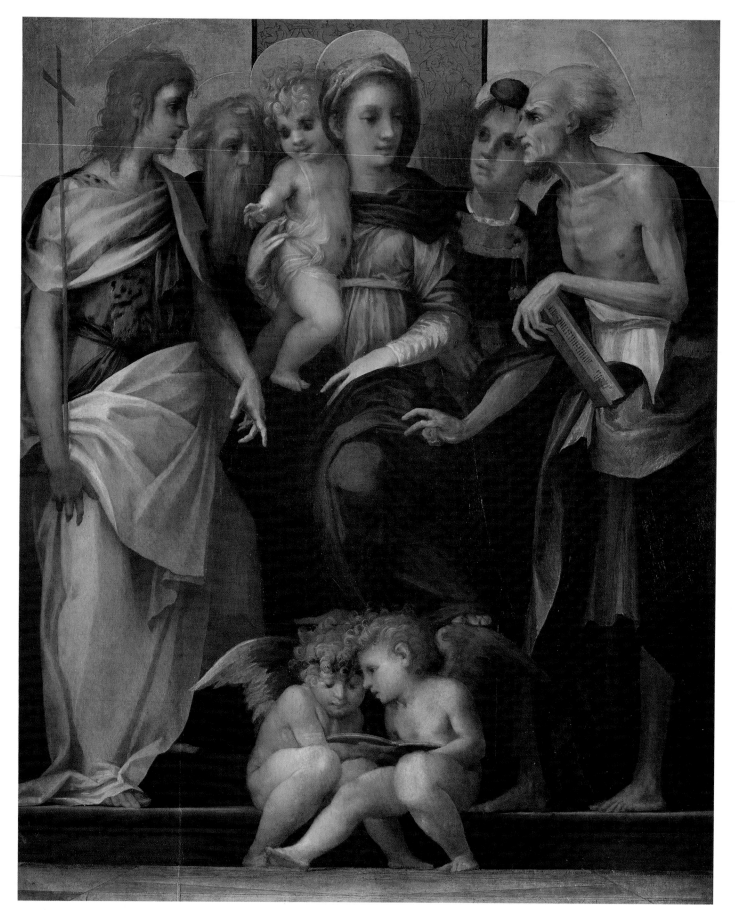

144 Rosso Fiorentino, *Virgin and Child with Saints John the Baptist, Anthony Abbot, Stephen and Jerome*, Florence, Uffizi.

impatient with the artist's desire for individuality at the expense of tradition. Looking at an earlier, smaller painting attributed to Rosso on stylistic grounds, the *John the Baptist in the Wilderness* (fig. 145), it is possible to appreciate yet more directly the potential for crudeness and asperity in Rosso's handling. The dwarf-like patron saint of Florence is represented almost as if shrieking, with his sharply foreshortened head straining to look heavenwards. Even the traditional band containing the inscription is angled in such a way that it becomes starker in its message: 'ECCE [AGNVS] DEI'. The pose is not fixed, but strained and constructed from rhythmic lines, against a background that is finished to different degrees.

Rosso clearly saw his expressive technique in these early paintings as a metaphor for the spiritual enlightenment of the saints – the 'desperate airs' of Vasari's text.[19] Certainly, the lively appearance of his Florentine production was appreciated by early commentators. For one sixteenth-century writer, Paolo Mini, Rosso's liveliness or vivacity (*vivezza*) was the distinguishing characteristic of his art.[20] Perhaps, in this aspect, Rosso was attempting to emulate Leonardo's belief that physical action could suggest emotional content. Like the earlier *Assumption*, and other early works, the Buonafede altarpiece is a precipitate and uneven image, but there are areas of almost raw beauty in the paint handling. It would be misleading to describe Rosso's energetic work as technically coarse without recognizing that the tolerance of open textures was not common in Florentine painting. The closest parallel for the urgent technique is Sarto's work, though he was too technically patient to create effects as stark as those in Rosso's painting. One cannot imagine, to press this point, one of Sarto's earlier altarpieces being rejected by its patron. In addition to a probable rivalry with a Sarto increasingly establishing a stylistic hegemony in Florence, the motivation for Rosso's freedom of expression may still be sought in the not entirely resolved precedents of Michelangelo and Leonardo from the first decade of the sixteenth century.

The experience of working for Sta Maria Nuova was a negative one for Rosso, which, combined with the previous controversy over the SS. Annunziata *Assumption*, left him without a major commission in Florence for four years and apparently forced him to look to provincial Volterra for work and a place of residence. The Buonafede altarpiece commission qualifies as an excellent example from this period of an artist's over-ingenuity and refusal to compromise leading to the offence of his patron. Whatever the precise reasons for Rosso's difficulties with these early works, the result was that the important commissions which should have launched his career instead practically forced him to leave Florence, on the back of a public humiliation decreed by his failure to pay

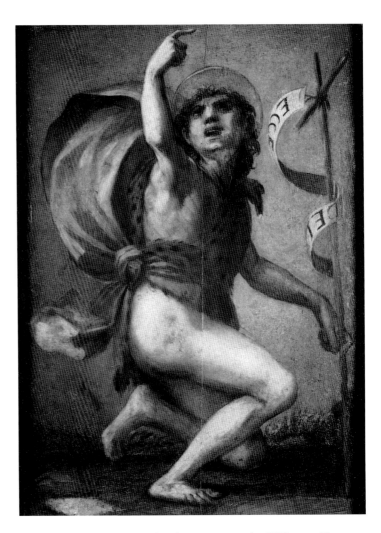

145 Rosso Fiorentino, *John the Baptist in the Wilderness*, Florence, private collection.

a particular debt. Ironically enough, it seems that fully accepting the creative implications of Leonardo and Michelangelo's Florentine work in his own art had alienated Rosso from his natural market. Even in an artistic centre like Florence the public was not yet advanced enough to accept all manifestations of the new art. The paintings Rosso produced in Florence were probably not generously appreciated until Vasari wrote his *Lives* some decades later and after the artist's death. Indeed, although Rosso's work satisfies all the qualities of good modern painting as extrapolated from the texts of Paolo Giovio and Vasari in the first chapter, in its basic vigour, monumentality and engagement but, above all, in the search for original invention, it did not immediately find critical acceptance, and so emphasizes again the retrospective and over-generalized nature of their commentary in dealing with a particular historical moment after 1500.

The force and even crudity apparent in earlier Rosso was perhaps needed to break from a certain model which he perceived as pervasive, reductive and over-refined, specifically

146 Rosso Fiorentino, *Seated Man with a Helmet*, Liverpool, National Museums and Galleries on Merseyside, Walker Art Gallery.

that of Perugino, Fra Bartolomeo or even Credi. His pictorial aggression can be interpreted as a conscious strategic model, as much as a personal tendency. It is ironic that while his work was rejected in Florence, he found success in peripheral areas, like Volterra, Sansepolcro, Arezzo and Città di Castello. Rosso met resistance from patrons in Florence who should have had sophisticated taste, though the fact that he also painted a few portraits in his native city implies some sociability. The *Seated Man with a Helmet* (fig. 146) was almost certainly painted in his native city around 1522. This badly damaged work, Rosso's only signed portrait, presents the subject in a seated pose with the arm of the chair defining the picture plane. The most exciting component is the splendid helmet placed in the lower right-hand corner with its colourful feathers and stuffing fully in evidence. Like all of Rosso's portraits, this example partakes very closely of his ideal for the saints in subject pictures and suggests that the more mimetic possibilities of portrait painting did not espe-

cially interest him. Rosso was, above all, occupied in producing a complex and visually stimulating physical object.

The next clash with the Florentine public occurred with the reception of Rosso's altarpiece of 1522 featuring the Virgin and Child and an unusually large assortment of laterally disposed saints (fig. 147). This panel was produced for the Dei family altar dedicated to Saint Bernard in their neighbourhood church of S. Spirito, where a copy and the original frame remain. The commission was initially given to Raphael, but he left the work incomplete on leaving Florence around 1508, and, after his death in 1520, the family presumably gave up all hope of receiving his work. They ordered a replacement from Rosso, then returning from Volterra, under circumstances that are still somewhat mysterious. The Dei had a special devotion to Saint Peter who appears prominently at the left. To reinforce their importance both Bernard and Peter are represented again in stained glass windows above the altar in S. Spirito. Rosso's altarpiece carries an insistently plastic style, exemplified by the Volterra *Deposition*, into a Florentine context, and it is significant that Vasari states again that it too did not meet with widespread immediate approval among Florentines.[21] Presumably, in this case, observers were disturbed by the compression of the saints to the frame, for the expression is certainly gentler and more elegant than that evident in the artist's earlier Florentine works. It is perhaps relevant to recall that over-crowding was a traditional complaint voiced against some religious art. Remarkably, in terms of his public acceptance little had changed for Rosso during his five-year absence from Florence.

In formal stylistic terms, the crucial public altarpiece of Rosso's second and final Florentine period is the *Betrothal of the Virgin*, signed and dated 1523 (fig. 148). This work sums up the stylistic possibilities of Rosso as a native Florentine artist and was the most influential single painting he created before leaving Italy for France. Still *in situ* in S. Lorenzo in the second chapel of the right nave, it was commissioned by the Florentine merchant Carlo Ginori, who, according to an earlier will of 1516, had projected a chapel in S. Lorenzo to be dedicated to Saints Anne and Apollonia. He also imagined at this stage an altarpiece featuring the traditional image of Saint Anne with the Virgin in her lap, along with an added Saint Apollonia. This reference identifies the two female saints kneeling at the bottom of Rosso's painting. They were retained from the patron's original idea, although the principal subject of the altarpiece was later changed to the Betrothal of the Virgin to recognize the dedication of the altar eventually purchased. A devotion to the Dominican Order is manifest in the third anachronistic saint, the preacher Vincent Ferrer, who is the Dominican friar on one knee at

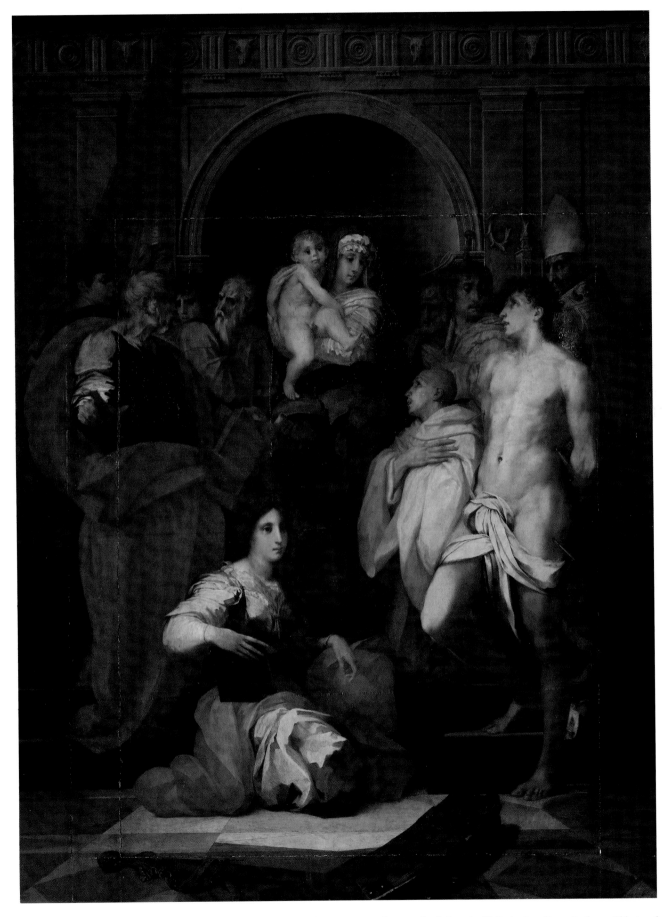

147 Rosso Fiorentino, *Virgin and Child with Saints Bernard, Augustine, Sebastian, Jacob, Joseph, (?)Catherine, Peter, Anthony Abbot and two other unidentified male Saints*, Florence, Palazzo Pitti (with additions).

the right edge of the altarpiece. He can be identified by the pictographic representation of a Last Judgement Christ with two trumpeting angels in his halo. The saint frequently appeared with the judging Christ depicted on a small scale in glory above his finger, and sometimes too with an inscription clarifying his prophetic message from Revelation 14.7. The gesture of the outstretched arm and index finger pointing towards heaven was also one of Vincent Ferrer's attributes and enough alone to identify him with certainty. Rosso brilliantly adapted it here to allow the saint to fulfil a traditional altarpiece function by gesturing towards the action while looking out at the viewer in the nave of the church.

For his family chapel Ginori finally accepted a rare dedication to the Virgin and Joseph. Rosso's picture is, therefore, an example of an altarpiece drawn from a single episode of a fuller narrative, but imbued with the devotional requirements of the iconic Virgin and Saints format. The result is wholly original and, while making general reference to centralized design structures in Florentine art, contains no specific quotations from other artists. Predicated on the placement of the figures on the steps outside a building, the image is tightly constructed rather than merely balanced with abundant playful asymmetries, as in the different posing of the two saints in the lower corners, or the imbalance caused by the placing of the Dominican at the right. The subsidiary characters are placed above in the background so as not to detract from the main subject. Rosso's desire for a positive focus to his altarpiece is most evident in his depiction of a youthful Joseph seen carrying his flowering rod like an attribute and striding in with a serene confidence to place the ring on the Virgin's finger. Raphael's altarpiece of the same subject (now in the Brera in Milan) provides the limits of a decorous idealization of Joseph. This is the most startling alteration from tradition in the painting. However reformed one's theological views were about Joseph, he remained an older man and an obedient husband and father. This case is important for reminding us of how visual representations could overreach and so ignore theological principles and notions of religious decorum, as well as learned texts, in the more powerful need for glorification and the promotion of fully pictorial ideals.[22] In conjunction with this, making a saint youthful was one of the most direct ways of idealizing them, as in the rather controversial case of Michelangelo's earlier sculpted *Pietà* for Saint Peter's, which drew complaints because of the Virgin's youth.

To attempt to place this image in a strict theological context is to underestimate its defiant originality and search for formal beauty. It is a most significant development of this period that Rosso, and other artists like Pontormo, accepted the content of a given work as an area available for deeply serious creative exploitation, as much as the formal aspects that had been the artist's traditional domain. This basic desire was doubtless ultimately motivated, again, by the examples of Leonardo and Michelangelo.

Another instance of the secularization of religious art is the painter's treatment of the drapery of Saint Apollonia, which is modelled on that of an antique figure. Rosso's willingness to obviate a sense of religious propriety would have been consonant with the priorities of Leonardo and Michelangelo. It certainly moves his devotional art into a different realm from that of the Dominican Fra Bartolomeo especially. The innovation in Rosso's work is that, like Leonardo and Michelangelo, he accepted no distinction between the demands of genres but, in sharing a prejudice counter to religious art as potentially the most beautiful, attempted to bring secular impulses to whatever commissions he earned.

Rosso's San Lorenzo altarpiece prefigures the interest in the saturated colour, sensual grace and supple movement of the works from his Roman period and to this degree his move there by the spring of 1524 is less of a surprise. Given the series of conflicts he had with Florentine patrons, with the one apparent exception of Carlo Ginori, it also might seem less unusual that he never worked in his native city again. The noble, exquisite and relatively relaxed style exemplified by the Ginori altarpiece had the most widespread and sustained influence of any painting of Rosso's Italian career. Its traces are evident in the work of artists like Domenico Puligo and especially Jacone, as in his altarpiece for the Calcinaio church in Cortona of the late 1520s.[23] Its entire composition was respectfully paraphrased in Carlo Portelli's *Martyrdom of San Romolo* altarpiece, signed and dated 1557, still in the church of Sta Maria Maddalena de' Pazzi in Florence.[24] In the stricter context of Florentine painting Rosso's true greatness in a work like the *Betrothal of the Virgin* was perhaps as the first artist after 1510 to display publicly and on a large scale a progressive style combining a disciplined execution and iconographic sophistication with a concern for luxurious ornamental detail. Even Sarto could not sustain the inertia of his development through the 1520s, though his style of this decade proved the more dominant in the longer term.

To summarize Rosso's stylistic development at the end of his final Florentine period: the stark, heightened, even harsh and informal expressiveness of his earliest work has given way to something more scrupulous and ornamental. It would be impossible to pinpoint every reason for this far-reaching shift in his style, but it is to be expected as the artist matured emotionally and his technique became more refined. A typically Florentine need to change and improve was also a factor in Rosso's wish not to repeat himself and develop away from

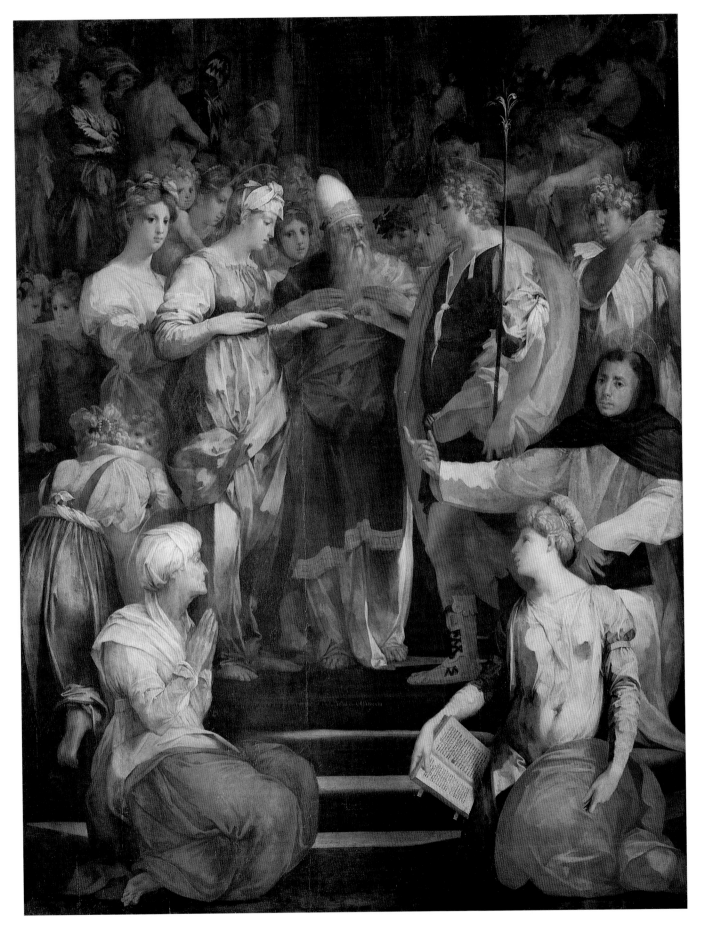

148 Rosso Fiorentino, *Betrothal of the Virgin*, Florence, S. Lorenzo.

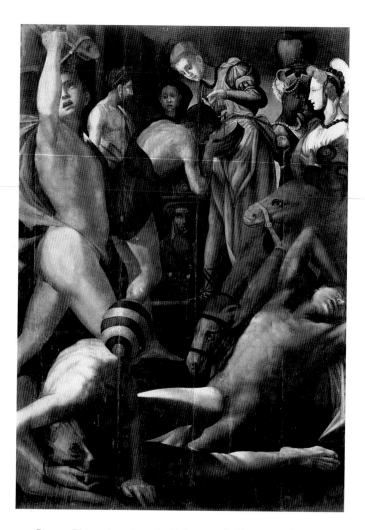

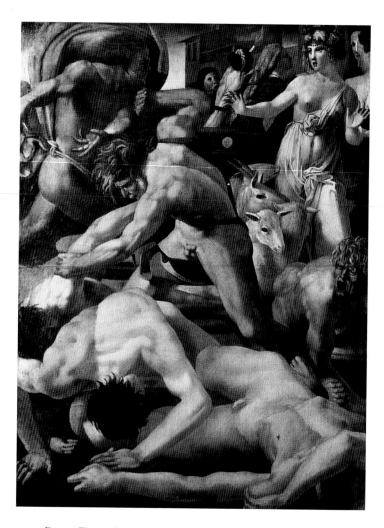

149 Rosso Fiorentino (copy), *Rebecca and Eliezer at the Well*, Pisa, Museo Nazionale.

150 Rosso Fiorentino, *Moses defending the Daughters of Jethro*, Florence, Uffizi.

his high-pitched and uncompromising earlier production. It has to be admitted too that it is difficult to believe that Rosso's art would have developed so definitely towards increased subtlety and richness had he not left Florence. The experience of travel, the sustained exposure to other artists and styles at an early age, particularly those available in Rome, would have encouraged the production of a more refined and considered style. Indeed, Rosso is the first Florentine painter discussed here for whom Rome appears to have tempered his approach to his career as much as to his style, and in this some of his incompatibility with Pontormo can be highlighted.

In terms of his chronology, this leap from youthful aggression to mature elegance can be pressed even further, for Rosso was arguably at his most inventive and synthetic not in his 'Roman Mannerist' phase but while working in the provinces of Umbria and Tuscany following the Sack of Rome and before his departure for France in 1530. It was in

this period that he befriended the young Vasari, who dedicated one of the most positive and critically uncomplicated of all the *Lives* to Rosso. The work Rosso produced in the final three years or so of his Italian period is not, therefore, of isolated importance. It had a formative influence on Vasari, who gave many of Rosso's innovations a wider currency than they would otherwise have enjoyed in Florence and elsewhere. Between 1527 and 1530, in SS. Annunziata in Arezzo, Rosso with the help of an advisor reconceived the iconographic and formal basis of the ecclesiastical mural cycle using unprecedented subjects relating to the Virgin. He also elaborated a retrograde iconography for his own formal and stylistic ends in his *Risen Christ in Glory* altarpiece for the cathedral in Città di Castello, ordered in 1528, with a result of almost beguiling complexity.

Rosso best exemplifies the Florentine painter of the first half of the sixteenth century who exported a distinctive style. His native city, in contrast, largely contained very few exam-

ples of his finished work, and was also over-harsh in the reception of those three that could easily be seen there, with the possible exception of the most evolved of these, the *Betrothal of the Virgin*. One of the last works Rosso executed in Florence, the *Rebecca and Eliezer at the Well*, which is now lost but known through drawn and painted copies (fig. 149), was even painted for Giovanni Cavalcanti for export to England. This advanced composition with its elaborate linkage of figural forms was much admired by Vasari, Jacone and Francesco Salviati, who made a full copy of it in a drawing now in the Uffizi.[25] The main subject is telescoped in the upper centre, surrounded by a sharply represented swirl of nude bodies, including also some highly elaborate decorative details that contradict the stark general impression. Similarly, the other main private commission of this period that also features an unusual Old Testament subject, *Moses defending the Daughters of Jethro* (fig. 150), does not appear to have remained in Florence for long. Painted on an inexpensive coarse-weave canvas, this work belongs to a venerable format of private domestic painting that had earlier been attempted by the likes of Botticelli and Piero di Cosimo. Rosso's painting features an equally abstractly arranged group of nude and partially clothed figures in a dislocated and unimpeded narrative treatment unfolding from the powerfully posed main figure in the exact centre of the field; the subject might not have been immediately legible, and the composition would have been unthinkable without the battle cartoons created by Leonardo and Michelangelo at the start of the century. Indeed, it openly quotes from those drawings. Considering its violent but also confidently sensuous treatment, it could easily be misconstrued as a mythological rather than a religious work, as Rosso violated the very boundaries of genre in his search for an unexpected personal invention towards the close of his last period in Florence.

Historiographically, Rosso's production of so few works overall – only about twenty-five survive from his Italian career – and his tendency not to settle have meant that his reputation was diffused, and it has suffered somewhat in all periods, compared with artists more loyal to Florence like Sarto. Because he never founded a local school this also affected the ways in which his few available works were later approached. Although his late Florentine designs attracted interest, from Francesco Salviati or Jacone for example, the aggressive and bravura nature of his painting technique, which stressed the uniqueness of the individual object as much as the compositional imprint, meant that Rosso was a relatively difficult artist to imitate. He could never have had the legacy of a Sarto for example, because of the complexity of his painting technique alone. Of course, celebrated Florentines since Giotto had travelled extensively, and to this degree Rosso was conventional. It would be pushing matters too far to suggest that by leaving he betrayed Florence and its artistic traditions. However, when so many Florentine painters, including Ridolfo, Sarto and even Pontormo at times, became increasingly complacent in their home setting, Rosso's act of abandonment has some defiance and, understanding the troubled background of his patronage and a corresponding desire to be more selective about his patrons, perhaps it even had a spiteful connotation. In any case, he was the most widely travelled major Florentine painter of his generation. It is a paradox that, far from indicating partial failure in his native marketplace, Rosso's success away from Florence provides explicit evidence for the general supremacy of what many might have simply and uncritically considered to be 'Florentine' style.

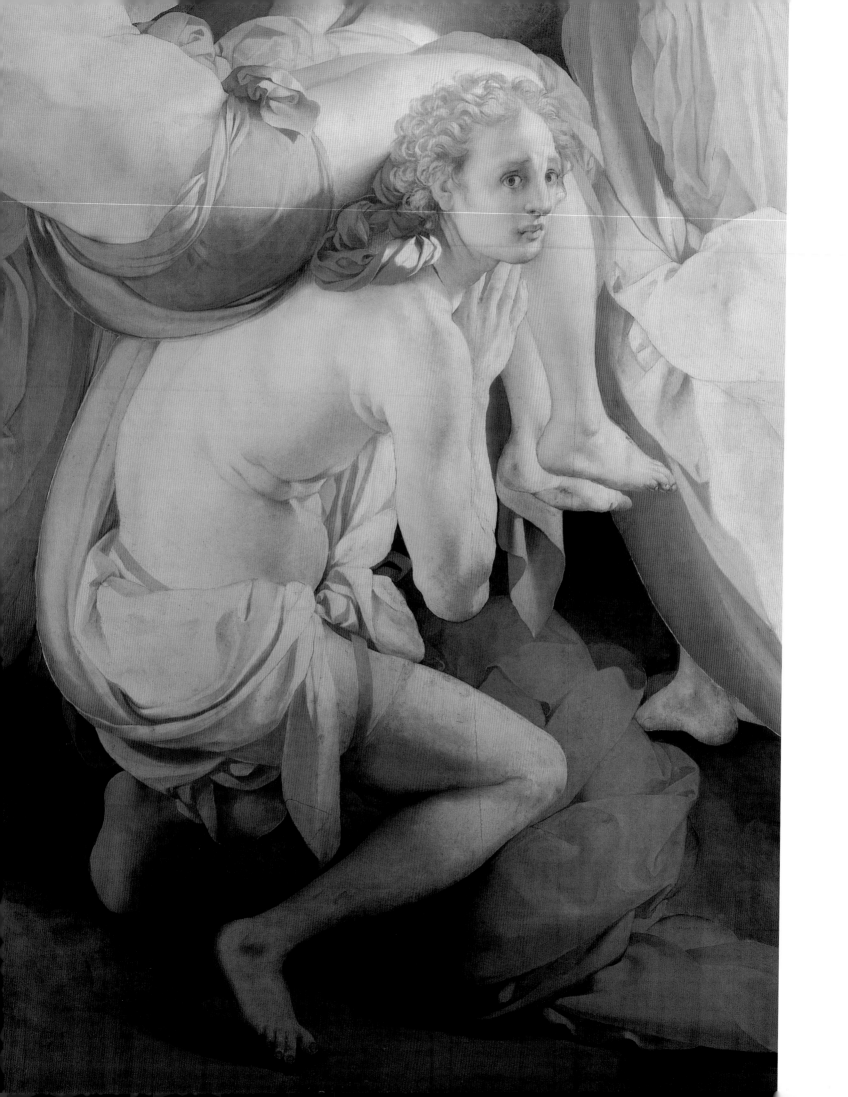

JACOPO DA PONTORMO:
THE LAST PAINTER OF THE FLORENTINE
RENAISSANCE

AT FIRST GLANCE, THE CENTRAL IMPORTANCE of Jacopo Pontormo for the history of sixteenth-century painting might seem unquestioned. Born Jacopo di Bartolomeo Carrucci in 1494 in the village of Pontorme on the outskirts of Empoli, he was responsible, with Andrea del Sarto and Rosso Fiorentino, for establishing what has been termed the Mannerist style in Florence.[1] Yet with the shifting of the origins of this style from Florence to Rome in some recent accounts of the period, Pontormo has become a marginalized figure, despite continued interest in his work. Brought to Florence at an early age, Pontormo is arguably the most compelling Florentine painter in the second half of the timespan examined here, and one who worked almost exclusively in the city and its environs in a career extending over half a century. Above all, there is a need to reconsider Pontormo's life and work more in context. Unfortunately, those few archival documents that do survive for his major public works are mostly brief payments recorded in ledgers and provide only a skeleton chronology. There is little or no insight into the original demands of his patrons, which would cast some light on his closely guarded freedom of expression.

Since the historiographical shift in the 1520s from Florence to Rome as the centrepoint for artistic developments, the most influential model for classifying Pontormo remains almost by default that of anti-classicism. As developed early in the twentieth century in the writings of German scholars like Friedlaender, it essentially puts 'Mannerist' works of art in direct stylistic conflict with those of the 'High Renaissance'.[2] It is arguable, however, that the opposite was true and that Pontormo was one of the most faithful adherents to a strand of the Tuscan artistic tradition, not so much as a repository of formal ideas, but one valuing invention through drawings as the basis for good art. Pontormo's Pucci altarpiece in S. Michele Visdomini is the crucial example in his

oeuvre for proponents of this older brand of criticism, but the standard interpretation of the painting along these lines is too hermetic to survive contextual analysis. Indeed, let us take the painting as a case study and an introduction to the work of this artist.

The panel, dated 1518, is still *in situ* on the second altar in the right nave of the church (fig. 151).[3] Produced for the altar of the Pucci family who lived near the church, it has been considered a revolutionary work in the history of sixteenth-century Florentine painting. The unbalanced design, with the Virgin displaced to the left of Joseph, has been characterized as a deliberate, even antagonistic, break from the reductive model of so-called High Renaissance altarpieces, as exemplified by those frequently produced in a quite different context for Dominican patrons by Fra Bartolomeo. Yet consideration of the chapel in relation to its dedication to Saint Joseph as founded by the patron, Francesco Pucci, allows a reassessment of the altarpiece. The rarity of altar dedications to Joseph in this period is relevant to a discussion of Pontormo's originality in the painting. In the absence of a widespread cult to the saint, a convention for public church altarpieces with Joseph as a focus did not exist in Florence. As an independent saint, Joseph was still searching for a canonical identity in the Renaissance, and he rarely appeared in an altarpiece as a saint on his own. Thus it is unlikely that the most predictable altarpiece format – a centrally placed Virgin and Child with four lateral saints – would have been seriously considered in this case. The usual way of dealing with an altar dedicated to Joseph was to depict the Betrothal of the Virgin. However, this solution was not satisfactory because it placed equal emphasis on the Virgin. Rather than as a protagonist in the Betrothal, Joseph would be familiar from his proximity to the Virgin and Child in other subjects like the Nativity, as well as in the ubiquitous devotional images of the Holy

Family. In other words, Joseph was still best identified by the context in which he appeared rather than by an external attribute.

Establishing this context helps to explain why Pontormo approached the design of his altarpiece as if it were a monumental Holy Family. He explored the interdependence of Joseph, Mary and Christ, thereby emphasizing Joseph's privileged and unique relationship to the Saviour and the Virgin. Joseph has no outward identifying attribute as might have been expected, such as a staff or the flowering rod. Pontormo looked at depictions of the Holy Family, like Sarto's recent *Virgin and Child with the Young Saint John the Baptist* (fig. 108), rather than other altarpieces in conceiving the core group. He was attracted by their treatment of the iconography. His picture derives its domestic, anecdotal character from its reliance on that genre.

The design of the Visdomini altarpiece is established by the figures set in a scaffold of two principal diagonals. In developing this design Pontormo seems to have rationalized the linear designs of his master Sarto into something more diagrammatically balanced. The composition is basically a tilted U-shape arranged on three levels of space. The left side is the most heavily accented, while the figures on the right are more forward, dispositions that accommodate a viewer approaching the work from the front of the church. A visual fragmentation sets up a sense of ceaseless motion and adds to the impression of spiritual force in the painting. The general darkness which the figures move in and out of has been attributed to the influence of Leonardo, but it is closer in its selective force to Sarto, who was serving as an important filter of the style of this absent 'old master'.

Respecting the Joseph dedication, Pontormo tried to accentuate the titular saint above the other adult saints in the design in two ways. First and foremost, he holds the Christ Child. Joseph's index finger awkwardly placed on Christ's shoulder emphasizes his possession of his son. Second, he takes a strategic place on the Virgin's right, her symbolically privileged side, where he acts as a pivot in a descending, outwardly turning diagonal terminating with Francesco Pucci's own father's name-saint, John the Evangelist. Not surprisingly, some of the other saints concentrate their attentions on him and not on the Virgin. Francis directs his inspired adulation towards the Christ Child on an angle that admits Joseph equally. The Baptist links the genuflecting Francis to Joseph by pointing at the titular saint while looking back at the friar. Joseph, John the Evangelist and Christ all gaze ecstatically in the direction of the painting's celestial light source, the meaning of which does not need to be underlined: the darkness accentuates the mystical element of the work. The strangest aspect of the composition is the deflection of attention away from the Virgin. Without being supplanted physically, her central position in the design had to be compromised by Christ's surrogate father. Far from merely demonstrating the artist's wish to break from tradition, which in this case did not properly exist, the asymmetry in Pontormo's altarpiece is symptomatic of his original and measured response to the challenge of an unusual dedication. Certainly, Pontormo undermines his inheritance with this remarkable painting by expanding the potential for altarpiece design, but he does so intelligently within that tradition, perhaps less aggressively than Rosso in his altarpiece produced for Sta Maria Nuova also in 1518, but with the same fundamental desire to revitalize that Florentine custom.

Pontormo's major public commission of the 1520s was to decorate the Capponi Chapel in Sta Felicita just across the Ponte Vecchio.[4] The patron was Lodovico Capponi, who acquired the first chapel on the right in the church in 1525, but who apparently was persuaded to use Pontormo through the agency of a common friend – the Knight of Saint John, Niccolò Vespucci.[5] The purchase date is taken to be the date at which Pontormo began to paint the chapel, but this is not necessarily a correct assumption and he may have started slightly later than 1525, though Vasari's very specific claim that it took three years to complete is not disputed.[6] One other document of 1525 is known for the chapel, when the altar was endowed with a chaplainship.[7] Neither document refers to Pontormo, but the second is particularly useful for establishing the altar dedication. According to this act, the chapel was dedicated to the Pietà, supplanting the previous decoration to the Annunciation.

For the Capponi Chapel Pontormo supplied the altarpiece (fig. 152), which remains in its original frame, as well as the *Annunciation* fresco on the side wall, that is, the facade wall of the church. He also painted the vault with a fresco of God the Father and the four patriarchs, with four roundels containing the Evangelists. For the latter he was assisted by his devoted follower Bronzino, born in Florence in 1503, with whom he maintained an *ad hoc* partnership at different points of his life. Bronzino may also have participated in the frescoing of the vault. The ceiling was later destroyed, with the exception of the four tondi, which were re-inserted into the new, disputed arrangement in the chapel.

Pontormo's altarpiece represents Christ being carried away from his mother as they are physically separated for the second and last time during their lives. It is the moment following Christ's placement on his mother's lap and the mourning by those followers who were present with him at the Crucifixion. The distraught Virgin holds up a tensed right hand that gestures towards Christ's receding body to give her final farewell before his burial. The downward slope of her

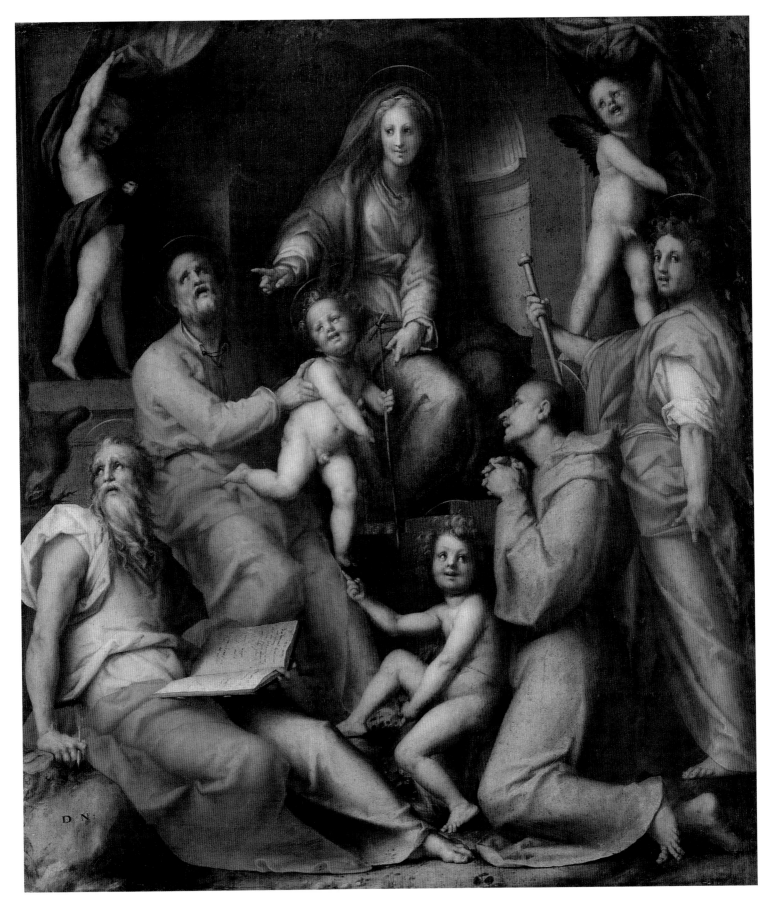

151 Pontormo, *Virgin and Child with Saints Joseph, John the Evangelist, Francis and James*, Florence, S. Michele Visdomini.

elongated body retains the trace of where her son was placed. The Virgin and Christ are still closely related through pose and gesture despite their physical separation. The elongation of their bodies makes them appear further apart than they are in fictive reality. That the Virgin is conscious stresses the respectful Marian aspect of the imagery and is a detail appropriate for the Pietà, as opposed to the Deposition from the Cross, where she frequently swoons.

The design is essentially convex, seeming to push out towards the spectator. The picture can be divided into two diagonal sections, one of which concentrates on each protagonist. Christ is carried by two young men both of whom look forward to where they are going. There is a general influence from the *Cascina* cartoon in the thin, muscular figures that crouch and turn, although Pontormo used interlocking figures in a way that Michelangelo rarely did. The spiralling green drapery in the lower right corner implies a downward movement, and the standing figure's hand is allowed to touch the body only through the unfurling winding cloth. Two young female figures also touch the corpse. One keeps Christ's left arm and hand from falling to the ground, while looking back towards the Virgin. The other artificially twists Christ's head towards the viewer, which also prevents the Virgin from witnessing the horror of his drained, purplish face. The Virgin is dressed, uncanonically, only in icy blues and blue-greys as if to enhance her despair. Other secondary figures act to assist and comfort the Virgin. The one with a rolled up sleeve who is turned away from the viewer steps into the picture holding a blue scarf. She may represent Veronica but she appears to be about to wipe the Virgin's face and her role and identity seem deliberately ambiguous. The androgynous figure behind the Virgin dressed in green and red and gesturing outwards may possibly depict John the Evangelist, but this is far from certain. A poised, chorus-like figure surmounts the design in the upper centre of the panel. Because of her noticeably smaller scale, she appears to be placed further in the distance than the others, and this is one of few indications of spatial depth in the painting. Although many of the figures look outwards, there are no direct glances at the spectator.

The painting thus concentrates on the rapport between Christ and the Virgin. The design literally revolves round those two figures. To this degree, the subject is more properly a Pietà than an Entombment. Pontormo brilliantly conceived of a variation on the subject, which was the second dedication of the altar in Sta Felicita. As usual in altarpieces, the dedication provided the artist with a starting point for the treatment of the iconography, to which he was required to refer, and in this case it allowed the artist to suppress the identities of the other figures to reduce the theme to its essentials. None of the usual protagonists in the story, such as the Magdalen, John the Evangelist, Joseph of Arimathaea or Nicodemus, is identifiable. The absence of any haloes makes the task of identification yet more difficult. It seems that Pontormo introduced a new cast of secondary figures who sustain emphasis on the central pair in order to exploit the inherent intensity of the subject.

The natural light in the chapel falls from the window to the right of the painting. The proximity of the light source inspired Pontormo to indicate a clear, bright illumination for the painting. There are few shadows, as Vasari noted, although the work has probably also been overcleaned.[8] For the purposes of legibility, Pontormo attempted to make a stronger overall impression in the painting with highly patterned areas. As if to demonstrate his sophistication in the sequence of his public work in Florence, he completely abandoned the principles of the Pucci altarpiece in which he had made the figures stand out in sharp relief against a dark background in the dark side aisle of the church. The brighter natural lighting in Sta Felicita doubtless encouraged this realization.

The completion of the Capponi Chapel overlapped with the start of the final Republican period in Florence after the Medici expulsion in 1527, which ended in disaster in 1530. Although unsettled politically, it was one of the most productive periods for Pontormo as a painter. His main public work was executed for the Benedictine church of Sta Maria in Verzaia, the rather severe Saint Anne altarpiece (now in the Louvre),[9] but he also created a number of smaller major works, including the *Martyrdom of the 10,000* (fig. 23) and the portrait of Francesco Guardi (fig. 153). Once identified as a portrayal of chillingly contemptuous oppression in the form of the young Duke Cosimo de' Medici, it is now plausibly considered to be a stirring image of republican defiance embodied in the fifteen-year-old Francesco di Giovanni Guardi – whose portrait Vasari said was painted by Pontormo at this time.[10] Over the course of his career Pontormo painted about half a dozen portraits – a genre he did not disdain as much as some of his contemporaries – all distinguished as here by their unconventionality. Guardi stands like a new David or Saint George before the walls of the city he will defend from imperial troops if called upon to do so; we know that men as young as Francesco were conscripted for that war. The timing of the siege of Florence in 1529 coincided with the coming of age of a single male heir for this most prominent branch of the Guardi family, when Francesco's father took control of all the family property. This coincidence of events, public and private, seems to have inspired the portrait commission.

Pontormo's *Francesco Guardi* takes a standing, three-quarter length format. The shape is basically triangular with the figure

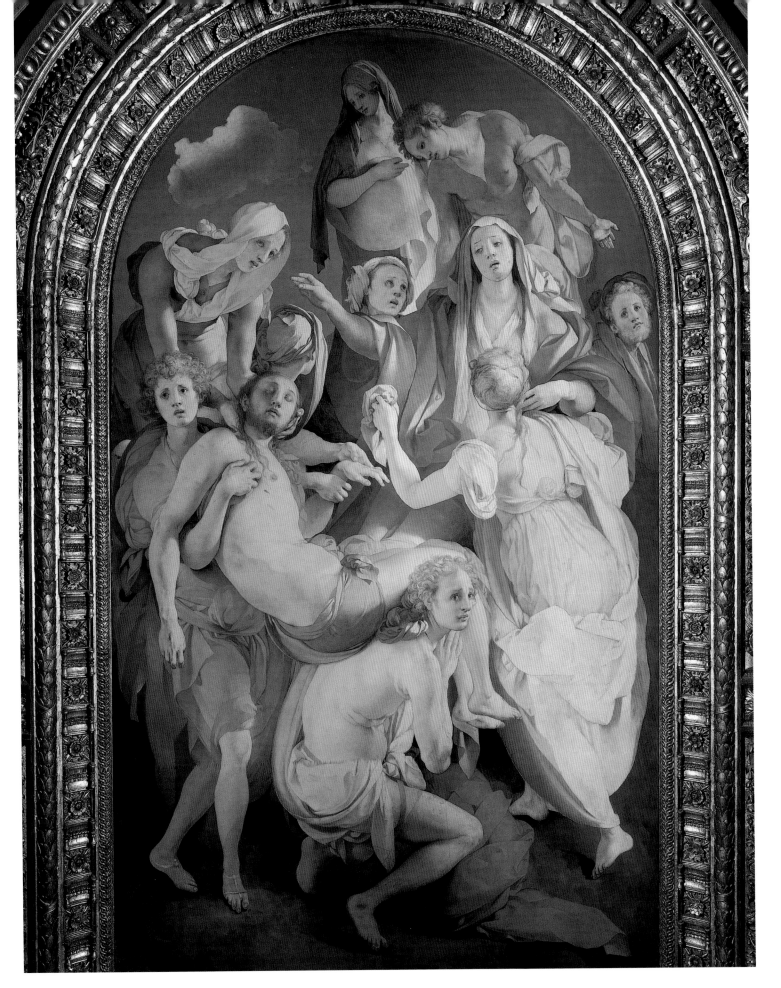

152 Pontormo, *Pietà*, Florence, Sta Felicita.

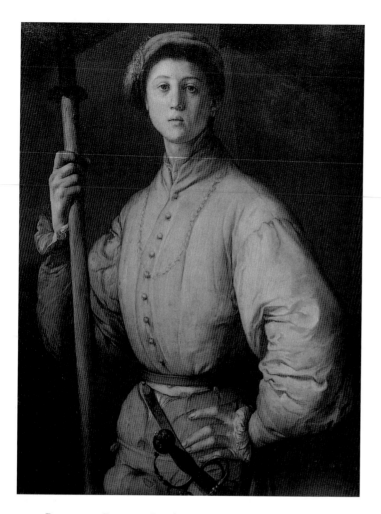

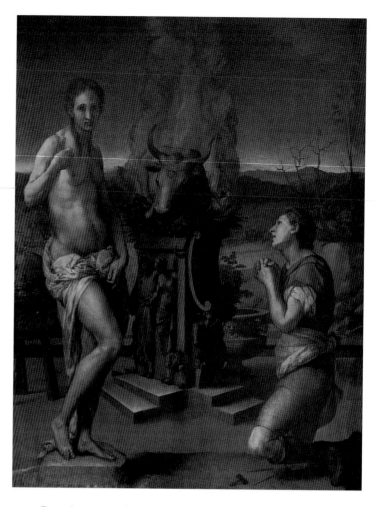

153 Pontormo, *Francesco Guardi*, Los Angeles, J. Paul Getty Museum.

154 Bronzino, *Pygmalion and Galatea* (cover for fig. 153), Florence, Uffizi.

compressed and slotted into the field. Guardi's left side is moved forward to balance the more dramatic pike arm, while the arms set akimbo create strong diagonals and curving angles for an active pictorial surface. The angled background of fortress architecture also allows the figure to stand out, assisted by the raking, left to right light. Distortions in the treatment of the sitter abound. For example, the waist is ridiculously narrow and the chest bulging, while the shoulders are sloping, which all create an hourglass figure. The hands are large, for greater expression. Pontormo's inventive use of attributes and background was of general inspiration for Bronzino's portraiture. Given the closeness of the two artists around this date it was fortuitous that this was Pontormo's most active portrait and the one with the most superficial visual interest; even more importantly, Bronzino was directly involved with its production.

The magnificent cover, *Pygmalion and Galatea* (fig. 154), was probably executed at the same time as the portrait. It is not

entirely clear how the cover would have fitted the *Guardi* because it is smaller. None the less, the identification of the work with the one cited by Vasari as having been executed by Bronzino for Pontormo's Guardi portrait seems secure enough. It was a true collaboration in which Pontormo supplied the drawings for his student – a division of labour like that of some of the Capponi Chapel tondi. Likewise, precisely how the image based on Book x of Ovid's *Metamorphoses* is related iconographically to the portrait of a fifteen-year-old youth on the reverse is not entirely self-evident, particularly since the inscription reads 'Oi Venus won'. Presumably, the miraculous bringing to life of the sculptor's ivory figure was meant to be paralleled by Pontormo's ability to breathe life into Francesco Guardi through art. Given the troubled time in which the work was created, it may equally relate to the hopeful image of peace suggested by the Venus taking the apple of discord from Mars in relief on the sacrificial altar. In images of private, indeed hermetic, sophistication like this

portrait and its cover, Pontormo was one of the few artists still able to evoke a memory of the late Piero di Cosimo's talent as a painter of secular themes.

It appears from these different examples all dated before 1530 that for Pontormo to be re-integrated into the mainstream of the history of sixteenth-century painting, his life and work need to be presented counter to the restriction of anti-classicism, which underplays both the context for a painting and Pontormo's awareness of Florentine artistic values, especially those promoted during his formative years by Leonardo and Michelangelo. Indeed, a reading of Vasari's Life of 1568 allows that rather than the supposedly eccentric Pontormo, or Piero di Cosimo earlier, it was the sometimes mediocre Vasari who was, ultimately, more at odds with Florentine tradition because of his more Romanized taste in art. Vasari shared this attitude in principle with another Tuscanborn painter who spent a considerable amount of time in Rome: Francesco Salviati. Further, Vasari's stern attack on Pontormo, like the less direct one against Sarto, casts more light on how he had manipulated Raphael's legacy to suit his particular needs in a Tuscan context. Compared with the other artists born around the same date, Pontormo was the most prominent painter in Florence towards the middle of the sixteenth century, just when Vasari was attempting to assert his dominance by defining an official avant-garde, past as well as present; so the two were in direct competition. This makes Vasari's biography of particular importance for understanding the ways in which the period might be classed in general. At the same time, it is necessary to unravel the Life of Pontormo in order to understand the basis for Vasari's antagonism to certain Tuscan artists, which he developed more fully than in the Life of Leonardo. Pontormo thus represents a totally different case in the history of Florentine painting from his contemporary Rosso, for example, who left Florence never to return in 1524. Vasari was able to approach Rosso's work from a comfortable historical distance and could glorify a style that impressed him unreservedly during his youth in Arezzo. Indeed, it seems a remarkable oversight that the painter was not mentioned in the preamble to the third part of Vasari's Lives where the likes of Rosso, Parmigianino and Polidoro are duly cited as exemplary masters of the third and final age in the history of art.

From the point of view of reliability, we might expect Vasari's biography of Pontormo to be one of the more trustworthy of the entire book. Even though Vasari did not know the reclusive artist well, he was a friend of his pupils Bronzino and Giovanbatista Naldini, who provided him with much circumstantial information. Vasari had also worked for Pontormo's major patrons in the Medici family, who may have

related anecdotes about the strange painter. Yet as with the account of Piero di Cosimo and others, Vasari's polemical biography of Pontormo is coloured by critical views that do not show the Aretine at his most objective: those who insist on believing that Vasari was totally biased towards Tuscanborn artists and the values of *disegno* over *colore* need to reread his life of Pontormo in which he condemns the middle and late styles of the painter. Despite his unprecedented range of knowledge about the history of art, Vasari's taste could be highly partisan, and recognition of this has implications for our assessment of Renaissance painting all over Italy. In Pontormo's case, we might arrive at a model for evaluating his undoubted importance for Florence by his very contrast to Vasari.

The Life of Pontormo is unusual among the biographies in that it features a fairly systematic analysis of the artist's stylistic development. Only the Life of Raphael contains a comparable account of the artist's various periods and styles, which was no coincidence for Vasari meant to contrast them. Raphael was an artist who developed to perfection in phases, whereas Pontormo was blessed with natural talent but deteriorated according to a comparably definite scheme. There is another repercussion to Vasari's choice of Raphael, because in the natural grace and variety of his art Vasari sought his own artistic image – as he did in more contemporary terms with Salviati, who produced similarly fluid and charming work. Indeed, his opinions about Pontormo attest to the relatively temperate nature of his views on art, because of which he did not always acknowledge the full extent of the innovation of artists born a generation or two before his own, and was not blindly sympathetic to their intentions, even if, like Pontormo, they were Tuscan-born. Vasari's major stress in the *Lives* on respect for patrons and variety of expression hindered an appreciation of Pontormo, whose goals were ultimately more rigorous and visually sophisticated than the younger man's, as well as more introspective.

Despite being a fairly early work dating with the Pucci altarpiece around 1518, for Vasari the bed panels featuring episodes from the life of Joseph the Patriarch (fig. 155) constituted Pontormo's most perfect style.[11] They were produced for the palace of Pierfrancesco Borgherini in the Borgo Santi Apostoli in Florence, as part of a cycle of paintings by some of the leading painters in the city such as Sarto, Granacci and Bachiacca.[12] Vasari emphasized liveliness, buoyancy and variety of invention and arrangement as the crucial factors in the excellence of Pontormo's early work. The completeness of the praise implies that Vasari felt that his talents were here in harmony, especially in the remarkable panel *Joseph with Jacob in Egypt*. It is the largest of Pontormo's contributions to

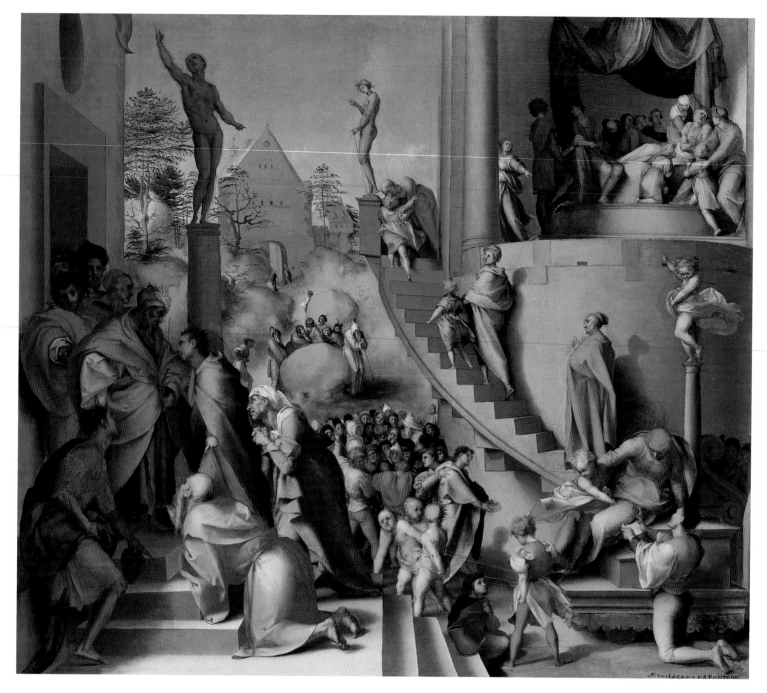

155 Pontormo, *Joseph with Jacob in Egypt*, London, National Gallery.

the ensemble and contains the greatest number of figures, including contemporary portraits. The stylistic characteristics represented by the Borgherini bed panels provided Vasari with a model of a tolerable Pontormo (the public equivalent is the Pucci altarpiece of 1518), because he could analyse them according to the general characteristics of his own art.

On the whole, in writing this biography Vasari had little to gain in political terms through attacking the style of a painter who had been dead for eleven years when the second edition of the *Lives* was published. While there may be some latent jealousy involved in his critique of a former long-standing Medici favourite (and the intrigues surrounding the rejection of Salviati as painter of the S. Lorenzo frescoes may well be relevant here), his own position with the Medici had been secured long before this time. Nor is there any evidence that Pontormo had ever attempted to undermine the Aretine's standing at court. Doubtless Vasari would have been only too pleased to celebrate yet another illustrious Tuscan

Disegno quarto, della Testata della Chiesa con il Coro, et l'Altar maggiore

156 Anonymous print showing the decoration of the choir and high altar of S. Lorenzo, Vienna, Albertina.

painter, particularly a deceased one. But he was not here writing plain panegyric, and he tried to support his more negative views with visual analysis. It was precisely because of Pontormo's popularity with younger generations that Vasari had to deal directly with the painter's overall contribution, and it is this that motivated his close critique as he attempted to warn artists away from his later art in favour of a different type of style and career, no longer according to inherently Florentine criteria, but based more on what Raphael had achieved in Rome.

Vasari attacked two periods in the artist's career. First, the years from about 1523 to 1527, when he frescoed the Passion cycle in the cloister of the Certosa di Galluzzo, the Carthusian monastery outside Florence. The frescoes themselves are now almost erased but later sixteenth-century copies by Jacopo da Empoli and others are preserved in the museum there.[13] Pontormo's desire for more potent visual expression led him to study the prints by Dürer of the same Passion subjects, although it must be added that these works were painted fairly informally and for a closed, private setting: the artist might not have expected the type of publicized scrutiny Vasari gave the works. Pontormo would not have

created them with much thought for his broader reputation in Florence.

Secondly, and more pointedly, Vasari attacked the fresco cycles Pontormo produced for the Medici in the final two decades of his life. Starting with the allegories for the loggias of the Medici villas at Castello and Careggi, both executed in the 1530s and 1540s, Vasari claimed that Pontormo was now only employed because of the veneration his patrons had for his earlier achievements.[14] The weather was destroying these outdoor frescoes even at Vasari's time of writing, so it was Pontormo's last major commission – the decoration of the choir of S. Lorenzo for Duke Cosimo – that subjected his style to public scrutiny in Florence. He worked on these frescoes from 1546 (which followed some controversial designs of two Joseph tapestries that did not meet with the approval of patron or weavers) until his death in 1557.[15] Already in 1549, however, Doni was writing enthusiastically and optimistically about what Pontormo would produce for S. Lorenzo.[16] This now destroyed programme, including a *Resurrection* and *Last Judgement* but mainly a cycle of scenes from Genesis, constituted Pontormo's final artistic testament. Drawings (figs 157–8) provide the basis for its reconstruction.

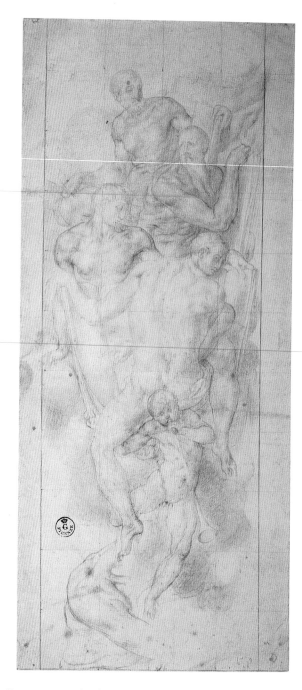

157 Pontormo, study for the S. Lorenzo *Christ in Glory* and *Creation of Eve*, Florence, Uffizi.

158 Pontormo, study for the S. Lorenzo *Four Evangelists*, Florence, Uffizi.

A print of the high altar of S. Lorenzo incidentally and roughly depicting the frescoes is another piece of invaluable evidence as to their overall appearance (fig. 156). And Bronzino's vast *Martyrdom of Saint Lawrence* fresco, still in S. Lorenzo, which was unveiled in 1569, provides some further indirect visual evidence for a reconstruction (fig. 159), though this work lacks the rarefied, spiritual air of the prototype.

Left partly unfinished at Pontormo's death, the cycle divided opinion from the moment of its unveiling, as can be

read in the diary of Agostini Lapini: 'to those who liked it and those who did not' ('la quale a chi piacque a chi no').[17] Vasari thought it so peculiar that he made the remarkable claim that it was 'foreign to his manner' ('è fuori della maniera sua').[18] Alongside this belief that Pontormo was working beyond what was acceptable, Vasari apparently feared an art that could not be analysed in some rational manner. If at the Certosa Dürer was the villain for Pontormo, at S. Lorenzo it was the artist himself because he spent eleven years

159 Bronzino, *Martyrdom of Saint Lawrence*, Florence, S. Lorenzo.

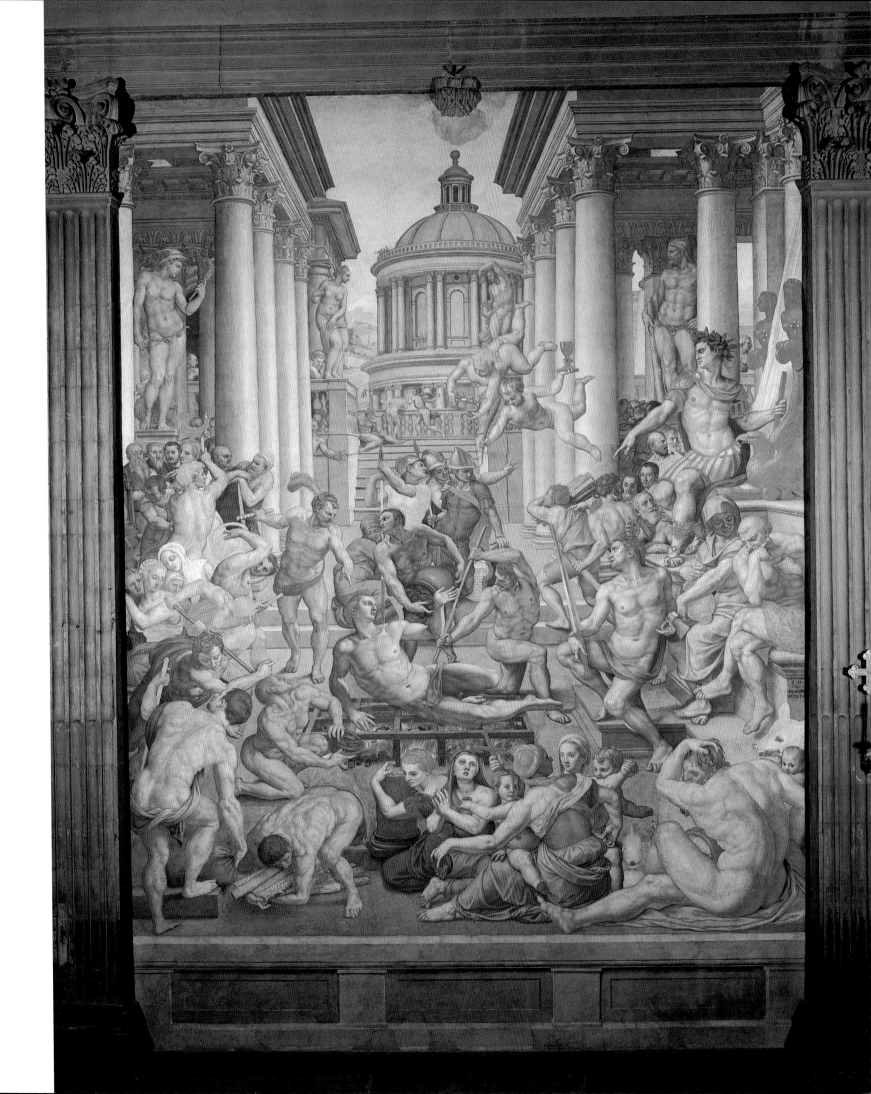

alone pondering the task, and so displayed excessive artistic licence in its formulation. Vasari could hardly contain himself in criticizing these frescoes. In his eyes, Pontormo here worked without 'any order of composition, or measurement, or time, or variety in the heads, or diversity in the flesh-colours, or, in a word, to any rule, proportion, or law of perspective' – a blunt attack on an artist who had been inspired by the possibilities of the creative process.[19] The frescoes genuinely seem to have bewildered Vasari, for whom Pontormo's introspective style was filled with melancholy and held no viewing pleasure. He could praise only one thing, namely the three-dimensional quality of individual figures and he pointed out that Pontormo used clay models to aid him in this aspect of the work.[20] Despite this sound method, his finished figures had over-large torsoes and legs, arms and heads that were too small. Vasari felt that Pontormo considered only certain parts and not the whole. It is ironic that this criticism is often levelled at Vasari's own painting, for it alerts us to the relativity of much stylistic analysis that can produce contradictory judgements from the same set of images. This is the context in which to point out that if Vasari even owned a Pontormo drawing for his *Libro de' Disegni*, he made no allusion to it in print.

While it remains relatively unfamiliar compared with his finished altarpieces, Pontormo's fresco cycle for S. Lorenzo might be considered as his final and most extraordinary homage to Michelangelo's example in its basic concentration on the nude for defining and limiting the space; it demonstrates how the *Battle of Cascina* cartoon had remained relevant for certain artists well into the sixteenth century. In his letter of 1548 to Benedetto Varchi on the issue of the *paragone*, Pontormo championed Michelangelo's paintings over his sculpture in general because of their greater variety.[21] Yet Pontormo's later drawings reveal a more spiritual and communicative style than that displayed in Michelangelo's design, evidence that Pontormo was eventually able after considerable, unrelenting struggle to evolve a different style from that seemingly monolithic model. Pontormo's great fresco was whitewashed in the eighteenth century – a graphic symbol of the lack of understanding and denial of this artist begun by Vasari that came to be shared by many others.

How then can Pontormo be spared from Vasari's presentation of his later work, as well as rescued from the historiographical limbo that presents itself with the reorientation of the stylistic progression of so-called Mannerism from Florence to Rome? There seems to be a need to highlight some progressive characteristics, which are: the desire for stylistic change through the inventive process, concentration on design at the expense of execution, search for perfection and, finally, personality and its relationship to expression. All

these aspects have exposed roots in the Florentine work of Leonardo and Michelangelo (and even earlier), since much of Pontormo's own dilemma as an artist arose from fully respecting their uncompromising approach until the very end of his life.

Pontormo's stylistic development and exploration was, first of all, as outwardly wide-ranging as any Renaissance painter's, to be surpassed to some extent only by a fellow Tuscan like Rosso. And indeed, one leitmotif of even Vasari's account is that Pontormo consciously attempted to alter his style, or *maniera*, with every commission. It is easy to overlook the fact that such a marked stylistic progression was not common in the Renaissance. Patrons would not have wanted to witness much change in an artist's style because they had often employed them on the basis of previous work, as has been seen with Perugino, Ridolfo Ghirlandaio and Sarto in the late 1520s. But even if painters seem in general not to have made such a premeditated effort to transform their styles, in part because of a desire to please new patrons, it was frequently undertaken in Florence by modern artists, for whom inventive range and not monolithic unity was their natural goal, even if the actual product suffered from it.

Yet the search for formal perfection was not straightforward or linear. It clearly frustrated and sometimes eluded Pontormo, leading to undeniably heterodox solutions that reached the limit of what art could achieve in the Florence of this period (and here the examples of Leonardo and Michelangelo again arise). His restless creativity appeared in his first major commission of 1513, the monumental *Faith and Charity* for the facade of SS. Annunziata, now in a ruined state (Museo di S. Salvi, Florence).[22] Vasari himself relates an anecdote about Pontormo's desire to repaint the entire fresco just after its completion because he felt he could improve it.[23] It would be interesting to know how he might have developed these restless, non-symmetrical *repoussoir* figures. It is relevant too that the payments of 1514–16 for the fresco commission following this one, the *Visitation* (fig. 160) in the atrium, cover a longer period than for any other painter's work, which confirms that already at this early stage in his career Pontormo took longer to plan his work than contemporaries.[24] Perhaps some of the 'classical' elements so emphasized now in describing this treatment of a Marian narrative are more the result of a laboured process in the production of a firm design and strongly delineated figure style than a direct homage to the past. The notably slanted construction is a sensible accommodation of viewpoint for the corner of the atrium, which was one of the less promising of the site. Vasari in discussing his work for the Servite friars adds a moral that Pontormo would not have shared: artists, in his view, should know when to cease painting. In this case,

160 Pontormo, *Visitation*, Florence, SS. Annunziata.

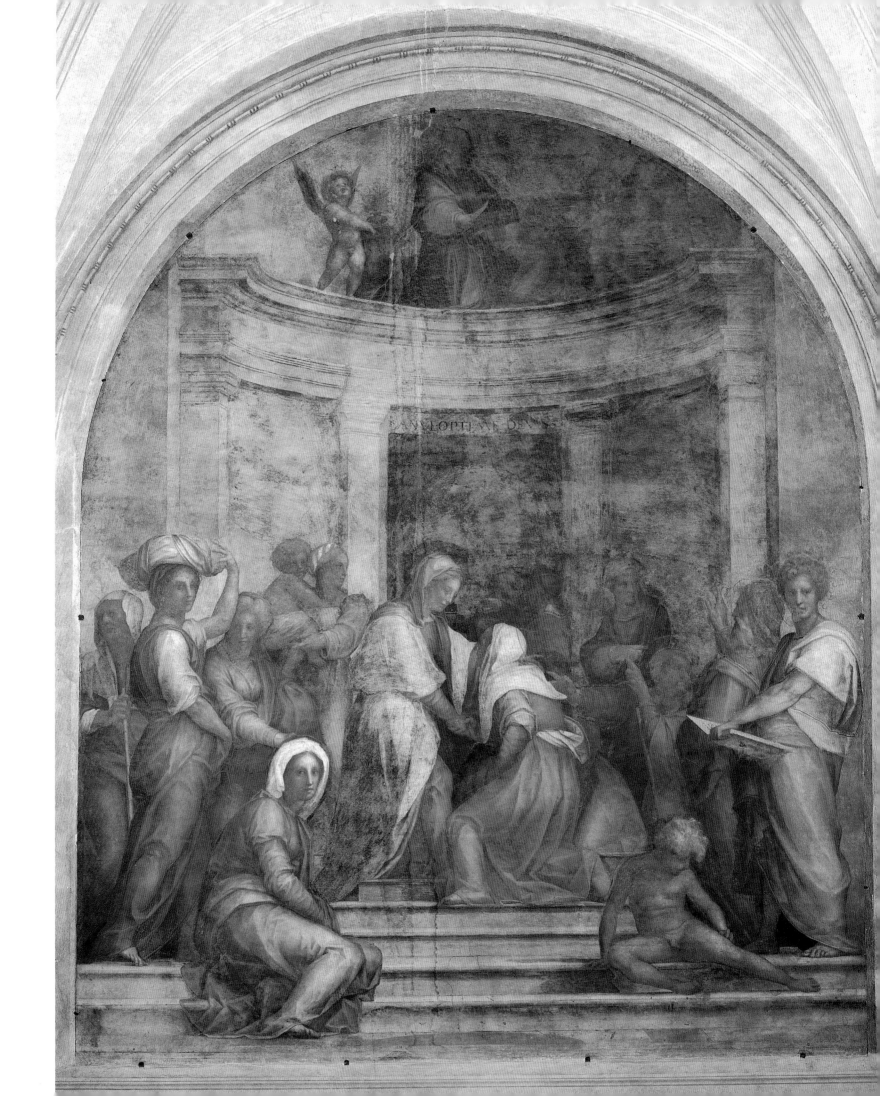

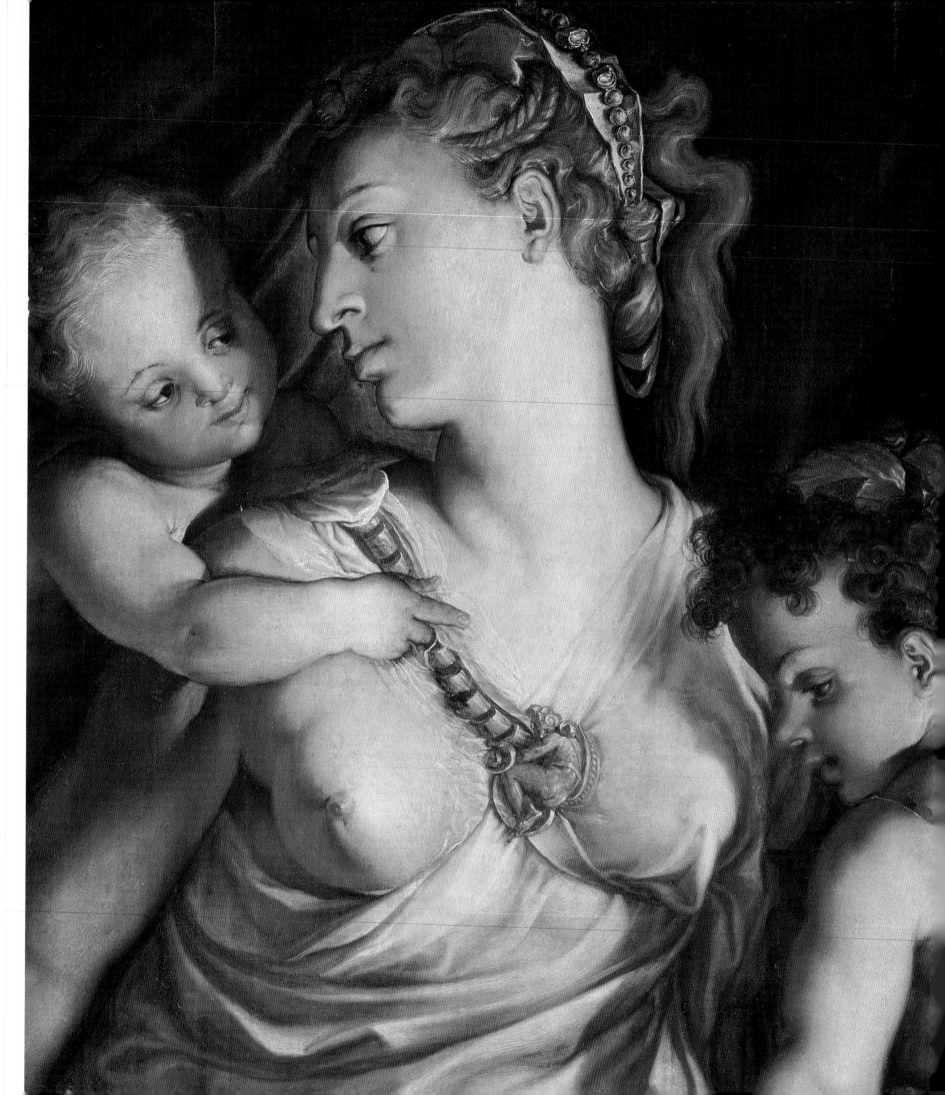

FRANCESCO SALVIATI: ROME IN FLORENCE

FRANCESCO DI MICHELANGELO DE' ROSSI called Cecchino, or Il Salviati, was born in Florence in 1510 to a tailor of velvets.[1] He took his popular name from an early protector, Cardinal Giovanni Salviati, whom he met on his first extended visit to Rome in 1531. A close companion of the young Vasari, his biography in the second edition of the *Lives* in 1568 is one of the most well-informed of the entire book. Not surprisingly, given his fondness for Tuscan-born artists like himself who found success in Rome, Vasari approved almost unreservedly of Salviati's style. Indeed, to a significant degree he viewed it in terms equal to his own, so his relevance here should not require much justification. Among painters working in Florence towards the mid-sixteenth century, Salviati's art is relatively more decorative, if always forcefully assured, than Pontormo's more internalized manner, or that of Ridolfo Ghirlandaio, who continued past 1550 to supply works in a unified, harmonious style nostalgic of one strand of the Florentine Quattrocento. Because of these differences Salviati did not find working in Florence without its hazards, even with significant institutional support at the newly dominant Medici court based in the Palazzo della Signoria, and the reasons for his lack of public acceptance, in contrast to Vasari's considerable material and professional success there, will have to be examined.

The artist was the most outstanding Florentine-born painter to establish himself publicly in both Florence and Rome. The only comparable artist is Perino del Vaga, who, despite a brief appearance in Florence, may be classed as more purely Roman because of his training and career. Piero di Cosimo, Fra Bartolomeo, Rosso Fiorentino and others all spent relatively short amounts of time in the papal city, periods that proved to be somewhat limited in scope or at least unusual in nature. Roman visits for Pontormo and Sarto, in contrast, are undocumented and presumed only on the basis of style. In any case, through the testimony of others, as well as prints, it would have been possible for Florentines to gain awareness of the contemporary art produced in Rome. Except for Salviati, and to some extent Rosso, precisely how much the styles of any of these Tuscan artists were affected by art produced in Rome is a matter for debate. Their general defiance is important, and it can be assumed neither that influence spread easily between the centres nor that work produced in Florence by artists based more regularly in Rome was universally admired. The controversies over the art made there by Perino del Vaga and Giovanni da Udine – both, coincidentally, in the early 1520s and both defended vehemently in retrospect by Vasari – are the most significant instances of this, but Salviati's experience provides a better documented case over a longer span of time. Vasari's prejudice towards Florentines who neglected Rome must be borne in mind too when interpreting reciprocal contacts and, more generally, for how art of this period may be classified. The Rome–Florence axis was a dividing line, as much as one representing opportunity in either direction.

It is not a coincidence that Salviati was also one of the first few Florentine-born painters of this period to have his designs dispersed to a wider audience through prints and book illustrations. Rosso made a partial precedent, but his interest in printmaking evolved most fully in a Roman and not a Florentine context, and Sarto was vocally negative about the aesthetic value of reproductive prints. Vasari's career had many parallels with that of his friend, but he was less naturally gifted and inventive, although the fact that he had more success than Salviati tells us something about artistic life around the middle of the sixteenth century in Florence, as well as Rome. While Salviati was a deeply cultivated, bountiful and ostentatious painter, his style seems eventually to have been one of which the majority of local artists were suspicious, to judge by the potent criticism in Florence: it lacked the sort of intensity and forceful concentration they expected the best art to display.

Restlessness is a constant theme in Salviati's career and this makes a biographical outline difficult to establish, although the chronologies of his stays in Florence are fairly clear. The situation is not helped by the perhaps surprising lack of documentary material for his life and works. Born about one

generation later than Pontormo and Rosso, and some seven years before Bronzino, he evolved in a much changed artistic climate from those artists, with models of a different nature. Reaching first maturity in Florence in the late 1520s, Salviati would have been aware of Michelangelo's presence as a working sculptor rather than as a painter, since he was then occupied with the massive individual sculptures for the Medici tombs in S. Lorenzo. If for Sarto, Ridolfo, Pontormo and Rosso, the *Cascina* and *Anghiari* cartoons were among their earliest points of reference for challenging and innovative works of art, for Salviati it was the Medici marble statues, the copying of which had a profound effect on his figure style, but naturally had little value for pictorial composition.

Salviati apparently had no true apprenticeship in the traditional sense of belonging to a structured *bottega*, of the type experienced by Fra Bartolomeo, Ridolfo Ghirlandaio or, later, Bronzino. Vasari informs us that he passed fairly quickly through workshops of vastly different quality and type, beginning with a goldsmith, Giuliano Bugiardini, Baccio Bandinelli, Andrea Brescianino and, finally, Sarto during the last years of his life from 1529–30.[2] Perhaps the unstable political and military situation in Florence in the late 1520s made a coherent training more elusive, though the examples of Rosso, Pontormo and others like Cellini show that such an early artistic life was not at all unusual. In spirit, of those painters working in Florence in the 1520s, Salviati was perhaps most attracted by Rosso, by then departed for Rome, and he later attempted to gain knowledge of even the final works of the artist's French period (he also travelled there in person in the mid-1550s long after Rosso's death). Salviati's two earliest Florentine works recorded by Vasari – the three scenes produced as part of a sacrament tabernacle designed by one of the Tasso woodcarvers for the Badia and the *Samson and Delilah* sent to France by the still mysterious Francesco Sertini – are sadly lost without a trace, not to mention the little picture ('tavoletta') done in Sarto's workshop that Vasari described of a 'soldier assaulted by other soldiers', which the biographer himself presented to Vincenzo Borghini – that assiduous collector of drawings and fine, small paintings, who also owned Pontormo's *Martyrdom of the 10,000*.[3] The latter image of Salviati is of particular interest for how it might have related to Leonardo's *Battle of Cascina* design for the Palazzo della Signoria. Since his early work is almost a complete mystery his first Florentine period is something of a false start in the study of his life.

In the early 1530s when artists were again in demand following the Sack of 1527, Salviati went to Rome to seek work. The Medici pope Clement VII appears to have attempted to recapture some of the excitement felt in culti-vated circles immediately after his election. By 1534 Salviati was enrolled in the Accademia di San Luca, which indicates a fledgling desire to transplant himself from a Florence receding in importance. He returned only briefly to Florence in 1539, the year in which he was flattered by the prominent letter writer Pietro Aretino as a 'giovane glorioso'.[4] There he worked with a group of artists, including Vasari and Bachiacca, on some of the temporary decorations for the marriage of Eleonora da Toledo and Duke Cosimo de' Medici, who had risen to power unexpectedly in 1537 following the murder of Alessandro de' Medici. So short was Salviati's visit that the grisaille decorations he undertook for the courtyard of the Palazzo Medici had to be completed by an artist named Carlo Portelli (who became Salviati's most faithful Florentine imitator), and his contribution to this project cannot have made much impact on the Florentine artistic climate.[5] Nevertheless, these contacts were useful because Duke Cosimo later proved to be Salviati's pivotal patron in Florence. He next made what was for a Florentine a somewhat unusual trip via Bologna to Venice, where he worked for the Grimani family on an impressive decoration in fresco and stucco in their palace featuring scenes from the myth of Apollo. In this he was part of a brief influx of Central Italian painters into Venice, including Vasari who was there around 1540–41.[6]

By 1541 Salviati had returned to Rome and to the service of Pier Luigi Farnese, son of Pope Paul III, not long after Michelangelo's *Last Judgement* had been unveiled. He was openly disgruntled in this period, however, because Raphael's former pupil Perino del Vaga had monopolized the most important papal commissions – discontent and querulousness were central leitmotifs of Salviati's life. So in the winter of 1543/4 he returned once again to his native Florence after a five-year absence, apparently with the hope that Cosimo de' Medici would offer him commissions in the Palazzo della Signoria, which was being renovated and decorated according to the wishes of the Duchess Eleanora as well. Clearly, Florence was perceived by some artists as a place of great opportunity at this time. His departure was not without controversy: Annibale Caro wrote a consoling letter to Salviati in February 1544 regarding Pier Luigi Farnese who was angry with him for having left Rome unannounced. The letter thus reflects in almost emblematic terms on the artist's difficult personality, but also the general problems he faced in gaining enough liberty from patrons: 'the lords do not understand much about your art and typically their wishes are too definite. Thus you would labour on, to little avail.'[7] This type of haughty, easily offended temperament is perhaps what we expect of many Renaissance artists, but it is worth stressing

that an awkward character could still produce a fluid, lyrical style, thereby cancelling any facile equation between style and personality in his case.

In Florence, according to Vasari, Salviati painted a much praised *Virgin and Child with the Young Saint John the Baptist*, with a frame executed by Battista Tasso, for Alamanno Salviati, the brother of Cardinal Giovanni.[8] This is also no longer identifiable but was probably executed towards the start of his Florentine period. There was a larger burst of activity in this period under Cosimo de' Medici in the Palazzo Vecchio, as part of a Medici self-aggrandisement project: Salviati received the commission, apparently at the expense of Baccio Bandinelli, to paint the great 'Sala dell' Udienza di Giustizia' on the second floor of the Palazzo della Signoria (or Vecchio). His proximity to the court is attested by the fact that in about 1545 he also painted the little soffit decorated with mythological scenes in the *scrittoio* on the same floor of the palace for Eleonora da Toledo, which survives in a very damaged state, as well as the so-called *Madonna of the Parrot* (fig. 168), identified with a private domestic painting for the private secretary of Cosimo's mother, Maria Salviati. The work updates the theme so favoured by Leonardo of the Holy Family preoccupied with a symbolic animal, in this case a parrot held by an angel that the Virgin appears to be trying to take from him, while the Christ Child draws back in trepidation, as if aware of his eventual fate. The foreground is dominated by the clashing profiles of the Virgin and standing angel, who form a strong arch under which the narrative enfolds with an emotional gentility with which Vasari would have been most comfortable. The presence of a meditative Joseph in the upper left corner accentuates the face that this figural group is weighted to the viewer's right. The background contains a deep view replete with ornamental interest, including an obelisk, but the overall impression is one of an almost suffocatingly sculptural density that violates the picture plane and the smoothness of handling.

The Sala dell' Udienza is now the most easily accessible of all the grand rooms Salviati frescoed during his career, and so the easiest through which to judge his spectacular merits as a grand decorator. It happens also to be the only large-scale fresco he produced in Florence and the one work that received the most attention during his stay there. The large room in a corner of the Palazzo della Signoria overlooking the Piazza della Signoria was already prepared for painting by 9 October 1543, but the project apparently had a long gestation. There are definite payments in 1544–5 for it, and Salviati seems to have worked very quickly on it until the autumn of 1545.[9] A Paolo Giovio letter of 11 September 1545 to Cardinal Alessandro Farnese refers to work done in the

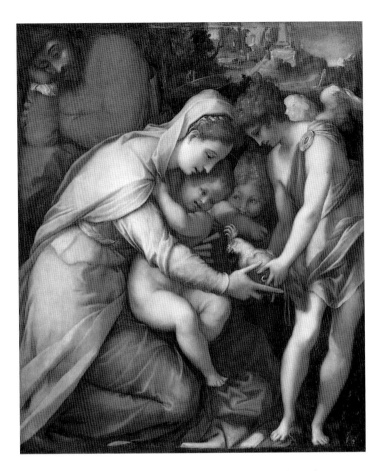

168 Francesco Salviati, *Madonna of the Parrot*, Madrid, Prado.

past tense ('ha facto'), but this must refer merely to the completion of perhaps one single wall.[10] The room was still in progress according to the dedication letter of 20 February 1547 in an edition of Alberti's *Della Pittura* translated by Lodovico Domenichi.[11] Finally, the frescoes are again mentioned in a letter from Anton Francesco Doni to Salviati from Rome on 3 June 1547 which implies that the room containing the frescoes of Furius Camillus is not quite complete, adding that it is 'Where one will see all that it is desirable in a perfect painter'.[12]

The main narrative frescoes are drawn from stories related by Plutarch (in Greek) and by Livy (in Latin) of the legend of Furius Camillus, a Roman Republican general of the fourth century, earlier represented in a solitary standing pose by Domenico Ghirlandaio in the adjacent Sala dei Gigli.[13] The principal subjects of Salviati's work on the dominant east wall consist of Camillus's triumphal entry after the siege of Veii, including the captured statue of Juno, and his battle with the Gauls to save the Capitol (figs 169–70). In addition to further stories from the life of Furius Camillus on the other, now more damaged walls, there are a number of inset

171 Francesco Salviati, *Allegory of Peace burning Arms*, Florence, Palazzo della Signoria, Sala dell'Udenzia.

than some of the supposedly living figures represented in the main scenes. Their relationship to the interior frescoes is made manifest by their depiction as part of Camillus's booty within the narratives. The painter's toleration of several simultaneous 'realities' is another feature of this room distinctive to Salviati's unrelievedly complex approach.

It is perhaps not surprising that Salviati's work should have caused a stir in Florence. So troubled were his patrons at experiencing a form of art that had been long familiar in the Vatican Palace that they apparently wanted to have the work obliterated. In this regard, the controversy resembles that generated by other important working visits by Roman artists, such as those of Giovanni da Udine and Perino in the 1520s. In general, no matter what the period, it seems clear that Florentines did not willingly tolerate the intrusion of those judged to be foreign, even those born in their own town but who had learned their art elsewhere. The Palazzo della Signoria frescoes were also explicitly attacked for the apparent speed with which they were executed and a lack of drawn preparation, while Vasari's passionate defence of Salviati from this particular criticism relates to his own practice: 'In which, in truth, they accused him wrongly, for, although he never toiled over the execution of his works, as they themselves did, yet that did not mean that he did not study them and that his works had not infinite grace and invention.'[15] Yet Salviati's refusal to employ large numbers of assistants and the amount of planning required through preparatory drawings meant that he worked much more slowly than some of his contemporaries, most notoriously Vasari himself. Paradoxically, in appearance his fresco has much greater lightness and fantasy than Vasari's more rapidly executed examples. It was to

Cosimo's detriment as an appreciator of the arts that he preferred Vasari to Salviati, though as a patron this is perhaps understandable. Clearly, we are here approaching another watershed in the history of Florentine art after Sarto's death in 1530, Rosso's move to France and Pontormo's decreasing activity as a painter after that date. The main protagonists in this period are Salviati, his colleague Vasari and those representing opposing styles – Ridolfo Ghirlandaio's workshop and Bronzino upholding the legacy of Pontormo.

The *Charity* (fig. 173) stands apart as perhaps the single most impressive independent painting of Salviati's Florentine sojourn, and a more accurate marker of the abilities of this generally quite uneven easel painter. It is probably the one Vasari cited as painted in Florence for a broker in precious stones named Ridolfo Landi, though Salviati produced other treatments of the subject around this time so an identification remains uncertain.[16] In this panel he filled the space with bodies set fairly close to the picture plane while allowing the figures sufficient room for complex movements. The formal sophistication achieved by Salviati is exceedingly elaborate in

172 Carlo Portelli, *Charity*, Madrid, Prado.

173 Francesco Salviati, *Charity*, Florence, Uffizi.

from correspondents in Florence to Vasari in Rome, where he was collecting gossip about the event, reveal that Bronzino's work was widely judged, perhaps not surprisingly given the context, to have been greatly superior to Salviati's.[18] Although the reasons are not precisely recorded in the extant documents, it is not difficult to imagine by this stage that some of the anti-Salviati sentiment among Florentines was merely reflexive and chauvinistic. The inclusion of a number of portraits of contemporaries may have contributed to the popularity of the *Christ in Limbo*, while the dominant focus on the male and the nude depicted with a highly polished finish must have been a further factor: Bronzino's painting realizes in the altarpiece format some of Michelangelo's basic artistic ideals, which by this date had become more publicly acceptable in Florence.

Sadly, neither of the very damaged originals is currently on view in Florence and the defining impact of their original display diffused. In Salviati's case other works in a similar style must be used to reconstruct the surface of the altarpiece. One is provided by the *Christ carrying the Cross* (fig. 177), undoubtedly produced in Florence, though for an unknown patron. It seems not to have been the work recorded in the Lenzoni Chapel in the Badia in Florence, as sometimes claimed.[19] The format of this much copied devotional image unexpectedly recalls the work of Fra Bartolomeo at S. Marco because the painting displays all the qualities of the new art in its exquisite refinement, amplified scale and emotional magnification. It may more properly be studied as reflecting the influence of Sebastiano del Piombo – so again betraying Salviati's defiant intention to introduce Roman pictorial values into Florence.

The work features an intensified treatment of Christ carrying the Cross, though the narrative is frozen for the viewer's contemplation. The image has a visceral power: the implied over life-size figure-scale and the depiction of Christ involuntarily crying from the physical pain are effective devices in this respect. Similarly, the high-adjusted viewpoint allows the viewer to look down notionally on the pathetic figure, just as the picture plane defined by the flat left hand is sharply broken by the halo for a three-dimensional effect designed to enhance the viewer's proximity to the Saviour. Yet the adeptly oblique treatment of the Cross, the handling of the hair with the minute precision of a goldsmith, with each eyelash distinguished, and the high, mother-of-pearl finish of the flesh are evidence of the artist's desire for supreme superficial effect to be admired as artistic discoveries that amplify the image's divine force. The main impression is one of extreme coldness – red and bluish white are the only colours in the palette – while the image itself is almost repulsive in its glossy surface and unctuous sentiment.

Executed in the heart of his Florentine period, the *Doubting Thomas* altarpiece (fig. 178) also supplies a clearer notion of Salviati's ruined altarpiece for Sta Croce. This signed painting was unfortunately transferred from panel to canvas in the early nineteenth century and the pictorial surface has been irrevocably somewhat flattened. Ordered in 1544 and completed in 1545 for Tommaso Guadagni for export to the chapel of the Florentines in the Jacobin (Dominican) convent in Lyons, it survives in the Louvre.[20] The monumental figures are placed in a box-like setting before a *pietra serena* background, recalling Roman palace architecture in its sobriety and sheer massiveness. The figural design clearly echoes that of the building in its architectonic clarity and density. Compared with Verrocchio's bronze sculptural group of this subject on the exterior of Orsanmichele, Salviati treated the main protagonists in a more detached approach, with Christ completely frontalized and the hand of Thomas kept at some distance from the wound. The head of Christ is depicted in profile, however, and he emits a great deal of blood, so that the image could not be dismissed as lacking some visceral force. Unusually, the massive Christ balances the tall cross with its red striped flag, one of the symbols of Florence, against his body with considerable dexterity. Notable is the smooth marble sculptural quality of the surface, as if the flesh and draperies were made of resistant materials. The pale and filtered light rakes the figures most in the foreground for a confident, dramatic effect.

The range of types present among the faces of the apostles in the background of the altarpiece makes it a useful touchstone for independent portrait attributions. Salviati certainly painted some portraits in Florence, though this is a vexed area for both attribution and chronology. Given our weak state of knowledge of the Florentine portrait after 1530 because of the lack of signed or dated examples, it seems premature to make certain attributions before a general study is undertaken; the other key problem to be investigated in this area is the contribution of the workshop of Ridolfo Ghirlandaio and Michele Tosini, if only because Salviati's portraits are still confused with theirs. It can at least be said that Salviati was active as a portraitist in Florence and received important portrait commissions there, though this aspect of his work requires a great deal more study. One portrait attributed to Salviati with good reason on stylistic grounds which might be a Florentine production of the 1540s, is the example at Vaduz in Liechtenstein of *Young Man with a Doe* (fig. 179), which has a Torrigiani provenance. The doe (*cerbiatta*) affectionately licking the man's hand near his ring presumably makes reference to a name, perhaps Egidio to whom this animal is sacred, as has been suggested.[21] In addition to its high quality, it also has the benefit of not having suffered from

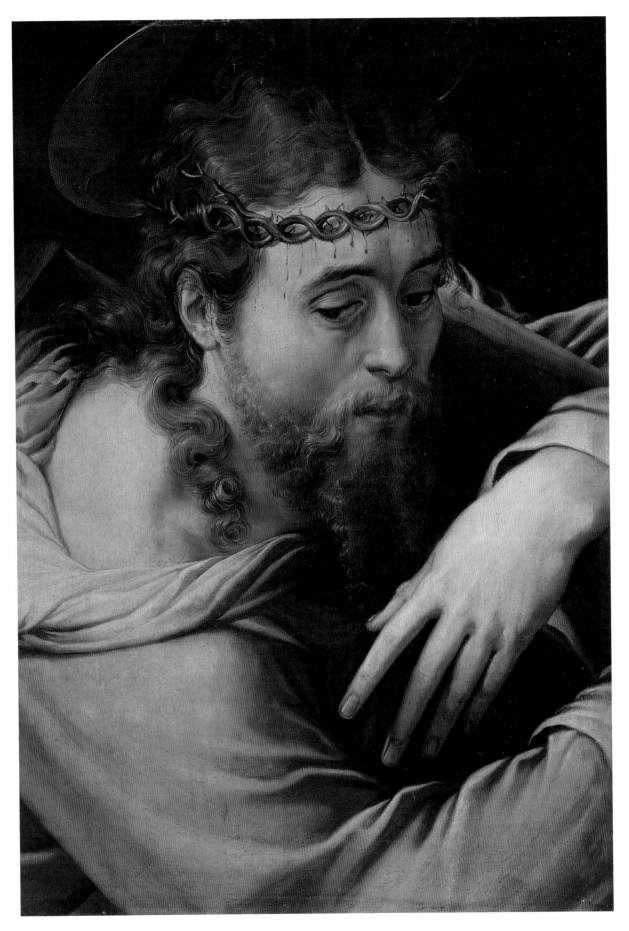

177 Francesco Salviati, *Christ carrying the Cross*, Florence, Uffizi.

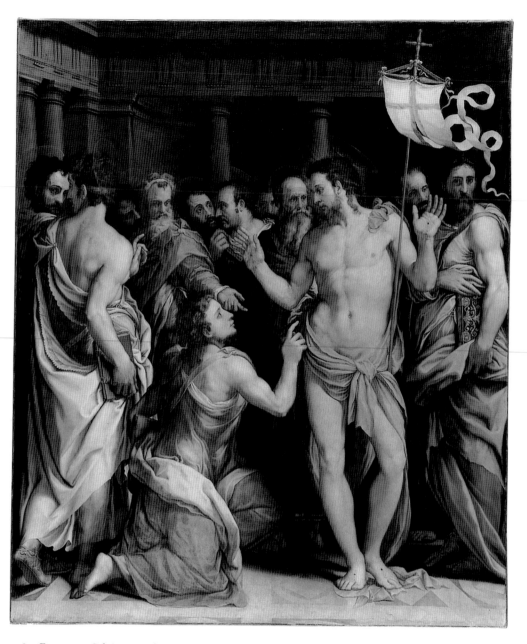

178 Francesco Salviati, *Doubting Thomas*, Paris, Louvre.

over-cleaning. The extremely sensitive and fluid handling is given structure by the firm treatment of the body. It is apparent from an example like this that Salviati as a portraitist was, like Rosso, more preoccupied with specific formal effects than an overall naturalism.

Given his articulate style, it is not surprising to discover that Salviati had contacts with the most learned figures in Italy, some of whom he had cause to portray. The 1547 edition of Alberti's *De Pictura* includes a dedication letter to Salviati from Lodovico Domenichi (already mentioned in relation to the Sala dell' Udienza frescoes) in which the painter receives the highest praise and is approached like an intellectual equal, who also understands the subtleties of literature.[22] Salviati earns the dedication of Alberti's book, not because he needs to read it, as Domenichi admits that the painter will even doubt the value of the text – an apparent admission of the futility of a literary source assisting in artistic practice and the sharp division between actual practice and what we might now classify as more academic art history. Following these general remarks the dedication letter shifts to refer to contemporary events and makes a highly public statement in favour of Salviati's work, attempting to counteract criticisms of the Furius Camillus frescoes in the Palazzo della Signoria – an interesting example of a

work still in progress generating excitement and comment among artists and public alike that can be paralleled by Fra Pietro da Novellara's comment about Leonardo's *Saint Anne* cartoon displayed at SS. Annunziata near the start of the sixteenth century. The severity of the debate is attested to by Domenichi's need to characterize the artists opposing Salviati as 'affetta et malinconica bizzarria'. This profile sounds suspiciously like Pontormo – a definition of an implicitly Florentine type of artistic character shared by Michelangelo, among others, that Vasari and Giovio also heavily criticized.

A second letter of 3 June 1547 from Rome written by one of Salviati's most dedicated and certainly most sophisticated admirers, Anton Francesco Doni, in reference to Domenichi's recent edition of Alberti reinforces some of these points. According to Doni, Salviati knew how to paint better than Alberti could theorize ('ragionare') about it. He continues to point out again that it was useless for Salviati the artist to consult such a text, except for purely intellectual interest.[23] While containing some hyberbole, these comments by Doni and Domenichi are important for stressing the theory–practice division in this period; that is relevant too for how the more theoretical parts of Vasari's *Lives* must be approached with caution as a source for analysing specific works of art. It seems clear that the tension between making art and writing about it was widely perceived in the period itself.

Given these alliances it is not surprising to learn that Salviati was involved also in pioneering the production of book illustrations, often with witty literary conceits.[24] For example, he designed a Sibyl for the frontispiece of Paolo Giovio's *Elogia Veris Clarorum Virorum Imaginibus* of 1546. This was an esoteric art form that more native Florentine artists of the 1540s and 1550s were attempting, with some notable exceptions such as Pontormo. Like Vasari, Salviati must have moved fairly easily in sophisticated literary circles to have been so celebrated. Doni again described him as a 'pittore vivacissimo' in the dedication of the *Rime* of Burchiello to the Venetian painter Tintoretto, published on 5 March 1553.[25] And he was the only artist Torquato Tasso is known to have admired publicly in his *Rinaldo* of 1562, where he refers uniquely to the painter Salviati's 'pennello audace' that scorns a jealous Nature.[26]

It is appropriate for the period leading up to 1550 in Florence that it was through a print rather than a monumental public painting that Salviati attempted to spread his style to a wider public (and potential patrons), as well as to other artists. This is the engraving (fig. 180) by the Parma-born Enea Vico of his design for a *Conversion of Saint Paul*, and it can be used to encapsulate some of Salviati's main public ambitions as an artist.[27] First published in 1545 and dedicated to Duke Cosimo de' Medici, it is a large horizontal print

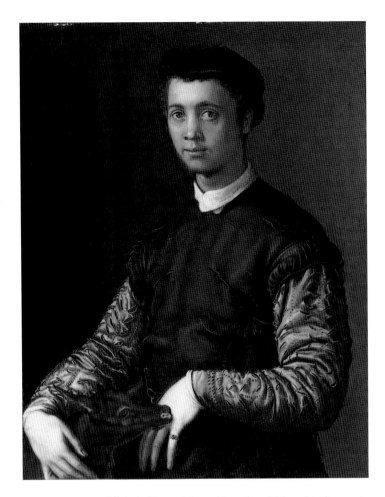

179 Francesco Salviati, *Young Man with a Doe*, Vaduz, Liechtenstein Collection.

made from two copper plates and printed on two large sheets of paper (so the Christ in glory is placed off centre towards the top). Despite the apparently modest medium, Salviati's *Conversion* is essentially a demonstration of the possibilities of a new conception of narrative, developing away from Alberti's premises that favoured restraint and coherence to tell a story. It features a host of figures charging in different directions away from the stricken and blinded saint in the lower centre. In the balletic figure style, there seems nothing especially Florentine about the image, particularly if one considers the solutions implied by the *Battle of Anghiari* and *Cascina* designs to have established the local mode for depicting violent action in the first half of the century. Indeed, in its basic search for variety the image might be loosely described instead as inspired by the Roman Raphael.

Pietro Aretino wrote an influential and full account to promote the image ('figure stampate') in a letter of the same year (Doni also mentioned it in a letter of 1549 to the engraver Vico), which helps to clarify how Salviati's design was perceived by an informed viewer of the period.[28] Aretino

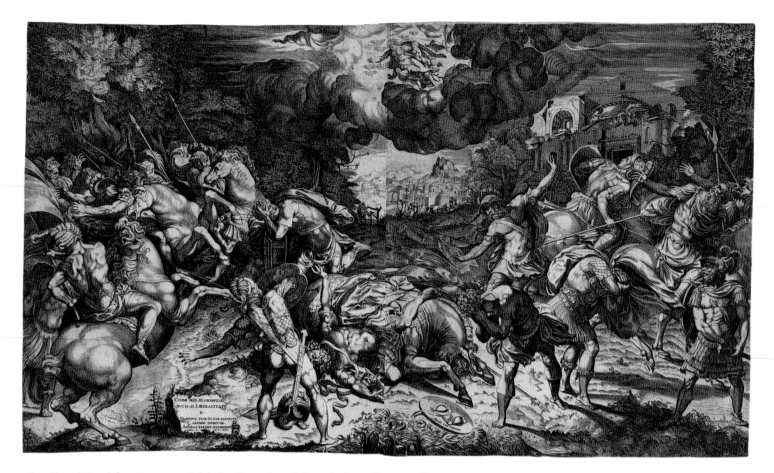

180　Enea Vico (after Francesco Salviati), *Conversion of Saint Paul*, London, British Museum.

was careful to compliment the printmaker and the technical prowess that allowed him to generate such a lively image. Nor is his description insensitive to purely formal effects, as in the treatment of armour and light. Above all, however, he praised Salviati's invention in his development of the subject matter and for provoking a strong reaction in the viewer. In fact, he analyses the artist's skill as a metaphor for the miracle depicted in the image.

The *Conversion of Saint Paul* constitutes a major example of the use of printmaking to advertise an artist's talents and to codify particular ideas – an increasingly widespread development in this period of Italian art, but one to which many Tuscan artists seem to have been resistant, including Sarto, Pontormo and Michelangelo. Positive earlier exceptions to this, in addition to Salviati, number among them Rosso and especially Bandinelli, who is perhaps the only Florentine artist of this later period to depend on prints to promote his ideas. While precedents in the work of Raphael can naturally be pointed to in the field of prints, it was perhaps Salviati's experience of Venice and Titian's example that inspired him to turn to this unusual means for the dissemination of his style. In seeking to attract new patrons, it is unmistakably a kind

of manifesto for wide distribution, and of a type that further isolated Salviati from his contemporaries in Florence, with the exception of Vasari.

Ultimately, it appears that Salviati was disappointed by the experience of working again in his native city. He was probably attempting to gain the order for the S. Lorenzo choir frescoes, but court intrigue seems to have lost it for him in favour of Pontormo, perhaps unfairly in retrospect, given the controversy caused by what was finally produced by the older painter. Salviati was also involved in a bitter if pedestrian dispute with Cosimo de' Medici over money, presumably for the Palazzo Ducale fresco commission, as can be ascertained from a letter of 22 February 1548 from Don Miniato Pitti in Florence to Vasari in Arezzo, which refers to Salviati's dissatisfaction that, though he received 800 scudi for his labour, his expenses totalled over 1000 scudi.[29] Given his increasingly precarious situation in Florence, and the deaths in Rome of Sebastiano and Perino in 1547, it is no surprise that Salviati chose to return to the papal city. He then came back briefly to Florence, but by the autumn of 1548 he seems to have taken up permanent residence in Rome. Yet he faced similar problems there under the papacy of Paul III and once again

he did not receive anticipated commissions. Nevertheless, this proved to be one of the most active and creative periods for him, especially in the production of major fresco cycles, starting around 1549 (he died in 1563). He returned to Florence yet again in 1554, but it is safe to say that his direct impact on the city of his birth had largely run its course by the late 1540s. Considering the depth of his talent, this could be described as a loss for Florence. With Pontormo relatively inactive and isolated at S. Lorenzo, Vasari developed a stranglehold on the important commissions, with only Ridolfo and Bronzino as serious rivals, both of whom he pointedly marginalized for posterity through the *Lives*.

It is perhaps Salviati's genius for monumental wall decoration that, above all, accounts for his ultimately abandoning Florence for Rome, where there were more possibilities to indulge his favoured medium and format. In any case, in Florence at mid-century, especially with the hegemony of so many local painters, there were apparently fewer opportunities for ambitious work of any kind for an interloper. In visual terms, Salviati's style, and not just that produced in Florence, is, to borrow Vasari's words, distinguished by its copious invention, fertility and speed, a fluid and gentle treatment of draperies that display the nude, as well as a skill for graceful heads with elaborate ornamentations and headdresses. In his own production Vasari strove to feature all these varied elements that he accounted for so positively and astutely in the work of Salviati, if with less verve, refinement or purity.

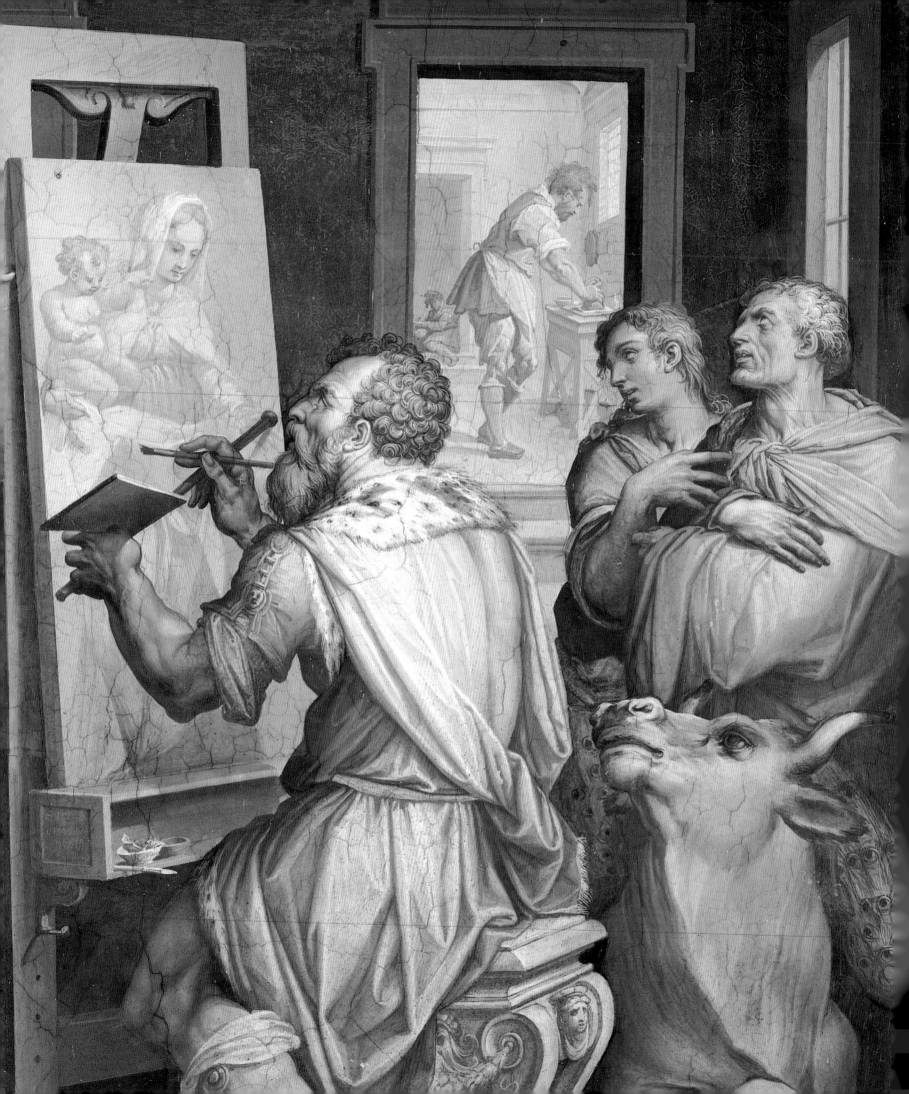

THE LIFE OF GIORGIO VASARI

IT IS DEEPLY IRONIC THAT Vasari is now more famous as the writer of the *Lives of the Artists* than as a painter.[1] He himself claimed on several occasions that he was an artist by profession and not a writer. Although we may detect conventional modesty in such remarks, particularly as the letters in which they occur were addressed to prominent writers and publishers, Vasari would have been surprised by how his historical importance is rated. The fact that his career is so well documented (aside from the *Lives*, his *ricordanze*, *zibaldone* and *ragionamenti*, as well as numerous letters, survive) seems to have discouraged much in-depth study of his visual art.[2] Excepting Leon Battista Alberti and Paolo Pino, he was the first practising artist to publish something approximating a critical theory of art, and this alone singles him out as an immensely significant character. Through his writings he attempted what was quite unprecedented for a painter, which was to write himself into the memory of his audience, present and future. Despite the exceptional nature of his written achievement, familiar even to students of other art-historical periods, there has been a long-standing tendency to reject the artistic value and relevance of his paintings, and those of his many followers as well, which are much overlooked compared with his rich and massive text. Given the state of Vasari studies, it may not yet be possible to test the assumption that Vasari's *Lives* had more impact in the sixteenth century than did his art. His painted efforts still require a great deal more basic study in order that we may come to general terms both with the *Lives* as a book but, more to the point here, with the very ways in which Renaissance art in Florence, and elsewhere, is viewed and categorized. At the same time, the impact of Vasari's publication is so enormous that the supposed mediocrity of his work as a painter should not be such an issue, given what can be gained by understanding his art in relation to his writings. The publication date of 1550 for the first edition of his book provides an appropriate terminus for our study: after that the history of art in Italy was irrevocably transformed.

Since Vasari was among the most materially successful Tuscan painters of the entire Renaissance, if not always the most respected by other artists, his art deserves especially close consideration, though there may be some point in dismissing the autobiography as simply a rearguard action against the criticisms of the artist's detractors. Having viewed Vasari more rationally as a painter, it should then be possible to appreciate how the descriptions of the works of even other artists in the *Lives* are as much a prescription for his own practice, and how he attempted perfecting it, as anything approaching an objective stylistic analysis. All artists perhaps refashion the work of their precursors in their own image, but Vasari is the first painter for whom this process of assimilation can be so explictly monitored. Recognition of this, while affecting how those specific accounts can be treated as evidence for a great many works of the Renaissance, will also help to conclude the main themes studied in this book.

By introducing Vasari's own testimonies alongside some of his paintings, a more sympathetic portrait of Vasari the painter may be generated. In general, the exercise reveals yet another strand of the art of the Renaissance period – in which fundamentally Tuscan properties are blended with more recently developed Roman ones, according to Vasari's model. This is in partial contradiction of Vasari's singular hope proclaimed in the *Lives of the Artists* to promote the glories of Florentine art history and patronage, in the name of which Perugino suffered so mercilessly at the start of the sixteenth century. One other significant conclusion emerges from relating Vasari's writings to his paintings, which is that it undermines the traditional view equating artifice with empty insincerity in relation to the type of art he produced himself around the middle of the sixteenth century. As this is one of the fundamental assumptions for scholars who would term the art of this later period 'Mannerist' – better applied to artists such as Perugino or Giovanni Antonio Sogliani, as has been discussed – this issue is of more than idle concern. Quite simply, until this derogatory viewpoint is abandoned in

relation to Vasari's output, this period of the history of art will be less than fully understood according to its own terms. It is in this context of coherent narrative expression too that Vasari's assessment of Raphael's style finally becomes most critical for how he classed his own work, as well as that of others practising in Florence. Specifically, it broadens the context for his critiques of truly major Florence-based painters like Franciabigio and Pontormo.

Vasari is so much less familiar as an artist than as a writer that a survey of his career is certainly required. Born the son of a potter in Arezzo in 1511, after receiving his initial training there with the French expatriate artist Guglielmo de Marcillat – best known for his stained-glass windows – Vasari was sent aged 13 to Florence, where he made contacts with the Medici family that sustained him at different stages of his career.[3] At this time by his own account he trained and studied further, first with Andrea del Sarto, with whom he later shared two important patrons in Silvio Passerini and Ottaviano de' Medici, and then with the sculptor Baccio Bandinelli. In Florence he would have seen the work of Michelangelo for the first time (and later he copied Michelangelo's Este *Leda and the Swan*, as well as Raphael's triple portrait, for Ottaviano de' Medici). He was never, as he claimed, a pupil of Michelangelo, but this artist had a particularly deep impact on his professional life and artistic ideals, even if in a partly negative way.

In 1527, after the temporary fall of the Medici, the Sack of Rome and a plague that took the life of his father, Vasari was obliged to return to Arezzo to look after his family. His early life of study and relative freedom was suddenly disrupted, and he became a working provincial artist forced to put his hand to any available minor commission. Instead of Sarto and Bandinelli, his colleagues in Arezzo were the painters of the lesser calibre of Niccolò Soggi and Giovanni Antonio Lappoli. It was in this period, however, that Vasari met one major artist who profoundly affected the direction of his career: Rosso Fiorentino, then occupied with large-scale public commissions for Sansepolcro, Arezzo and Città di Castello. Vasari's production was principally images in fresco and on canvas and panel of individual saints for churches in Arezzo and its outlying villages, all of which have now perished. This monotonous isolation in Tuscany was broken by military turmoil in Arezzo in the summer of 1529. Indeed, war in Italy dictated his movements over the next few years. Vasari, according to his account, went to Florence around this date to learn design in the house of Vittorio Ghiberti for two months, after which he moved to another workshop in the Mercato Nuovo to study the art of the goldsmith. He may have been contemplating a change of metier at this early moment in his career, as he studied with a series of gold-

smiths in Florence, Pisa and Arezzo for about nine months, until the spring of 1530, but he soon gave up this type of work.

Thanks to his two young Medici friends, Ippolito and Alessandro, Vasari was able to visit Rome in 1531 before returning to Florence the next year. It was in this period that he spent a great deal of time improving his drawing and design ability with his close contemporary Francesco Salviati. Ippolito died prematurely in 1535, but he was the patron of some of the painter's first efforts, including a group of rather involved mythological paintings, all now lost, which in his descriptions immediately call to mind images by Piero di Cosimo. In fact, Ippolito ordered what is Vasari's earliest surviving picture – the *Entombment* (fig. 181). It is documented to 1532 through a letter from painter to patron, when Vasari was just 21.[4] Formally, this devotional painting, presumably intended to be installed in a private room somewhere in Florence, is rather awkward (not surprisingly for a young artist), although full of ambition. The figures are already attenuated and strongly expressive if rather rigid. Its most original aspect is the pervasive narrative treatment of the subject. Christ is carried in a loose frieze of figures across the first plane to the tomb just visible in the lower right corner. An earlier moment in the story in which the corpse is carried from Golgotha is portrayed in the upper centre, while the Virgin swoons in the upper-left middleground. The inclusion of what appear to be male portraits at the sides of the *Entombment* betrays the social nature of so much of Vasari's enterprise, even at this early date. Certainly, the painter's concessionary personality and rare ability to complete work to deadline seem to have immediately endeared him to prospective patrons, as much as the style of his art. Unlike many artists of the period, Vasari did not have intractable disputes with patrons, and when conflicts did arise he was usually willing to defer to the taste of others.

With the assassination in 1537 of Duke Alessandro de' Medici, whom Vasari captured in a portrait of 1534 (fig. 182) not now considered aesthetically worthy enough for public display in the galleries – Alessandro had also ordered frescoes based on the life of Julius Caesar from the young painter for the Palazzo Medici – the Aretine had to alter the direction of his career once more. He again temporarily left the Medici circle to become a journeyman painter away from Florence. It was fortuitous that he received his second major career break from a series of ecclesiastical patrons, who virtually passed him round from monastery to monastery from 1537 throughout the 1540s, during which time he was able to see a great many of the works by other masters that would later be mentioned in his *Lives*. He was especially favoured by the Augustinians (Monte San Savino and Naples) and the

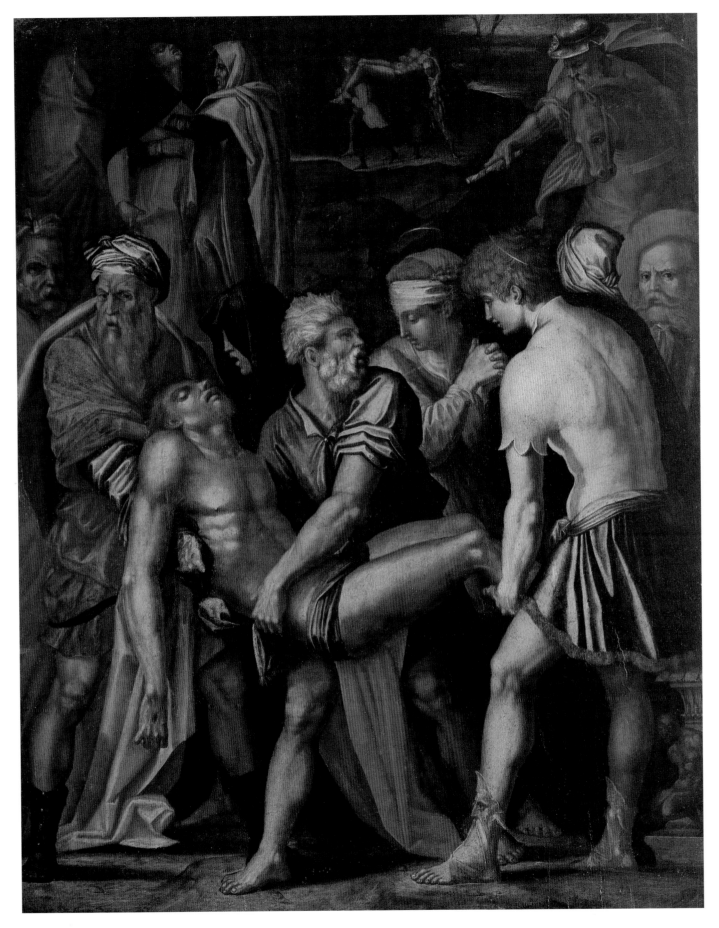

181 Giorgio Vasari, *Entombment*, Arezzo, Casa Vasari.

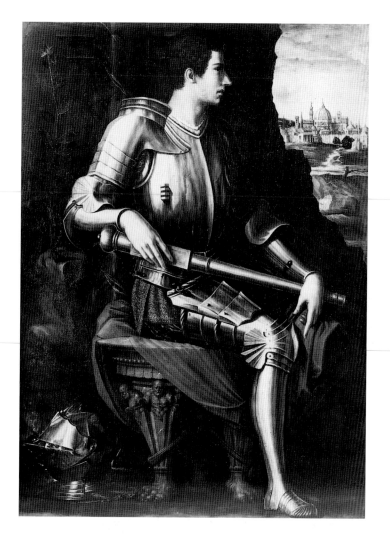

182 Giorgio Vasari, *Alessandro de' Medici*, Florence, Uffizi (deposit).

reformed Benedictines of the Olivetan (Bologna, Naples and Rimini) and Camaldolese Orders (Camaldoli and Ravenna). It is not an exaggeration to claim that this shift in his career has had far-reaching implications for the whole of art history, not so much through the limited direct impact of the works (which were produced for generally obscure or isolated locations away from Florence or Rome), but for its formative influence on Vasari's own attitude towards what constituted good art.

Through these experiences with ecclesiastical orders, his knowledge about religious art and iconography became unusually rich and sophisticated. He was also able to work repeatedly on a larger scale, with all the inherent problems of organization. His contacts with the most cultivated of clerics, including Miniato Pitti, Giovanni Pollastrino and others like Cardinal Alessandro Farnese in Rome, encouraged his early inclination to use symbols laden with literary meaning to express subject matter and emotional content.

This is already evident in his first secular works like the Alessandro portrait, or the even earlier *Lorenzo de' Medici* (in the Uffizi), neither of which could be easily or completely understood without some applied exegesis. If we keep in mind the obvious reference through the pose of the former to Michelangelo's *Giuliano de' Medici* sculpture in S. Lorenzo, it is apparent that this art could be intentionally reflexive. In contrast to Leonardo and Michelangelo, who both clearly believed in the unique power of the visual image itself to transmit meaning, Vasari felt more comfortable in adding significance through literate symbols and specifically loaded formal references. He mentions in the introduction to Caroto's Life the beautiful and fanciful inventions after an elaborate account of an iconographical scheme.[5] Far from being a sign of artistic impoverishment, Vasari clearly felt that his images gained in nobility from this allusive method and the diverse associations with past art evoked by it.

That Vasari's preference for ambitious, polysemic subject matter developed in conjunction with composite designs is particularly evident in his influential altarpieces produced in Florence. The painting that brought him to the attention of the Florentine public was his *Immaculate Conception* (fig. 183) produced for the chapel of Bindo Altoviti in the church of the Santi Apostoli in Florence, whose iconography, Vasari claimed, was developed in discussion with what he described as 'uomini letterati'.[6] Begun in 1540, the panel is currently not on view in Florence in spite of a recent restoration. It became one of Vasari's most celebrated works and was frequently replicated by his workshop on different scales which attest to its huge success. It is a crucial picture not least because of its influence on Vasari's approach to complex iconography, for which Piero di Cosimo's altarpiece in Fiesole provided the most artistically significant local precedent, particularly as Vasari does not appear to have been familiar with Sogliani's *Immaculate Conception* for Sta Maria a Ripa (now in the Accademia), a painting perhaps of the 1530s. In his autobiography Vasari describes the subject of the altarpiece at considerable length, from Adam and Eve bound at the base of the Tree of Original Sin through to the Old Testament kings tied to the branches, including Samuel and John the Baptist who have one hand free because they were sanctified at birth, through to the Virgin with one foot on the head of the serpent. It is striking here that Vasari hardly discusses the style or intricate composition, except for the motif of the light passing through the leaves of the tree, as it had literal relevance for his subject matter; the implications of this particular emphasis should not be overlooked. The model for the style and approach to subject matter was provided by Rosso's

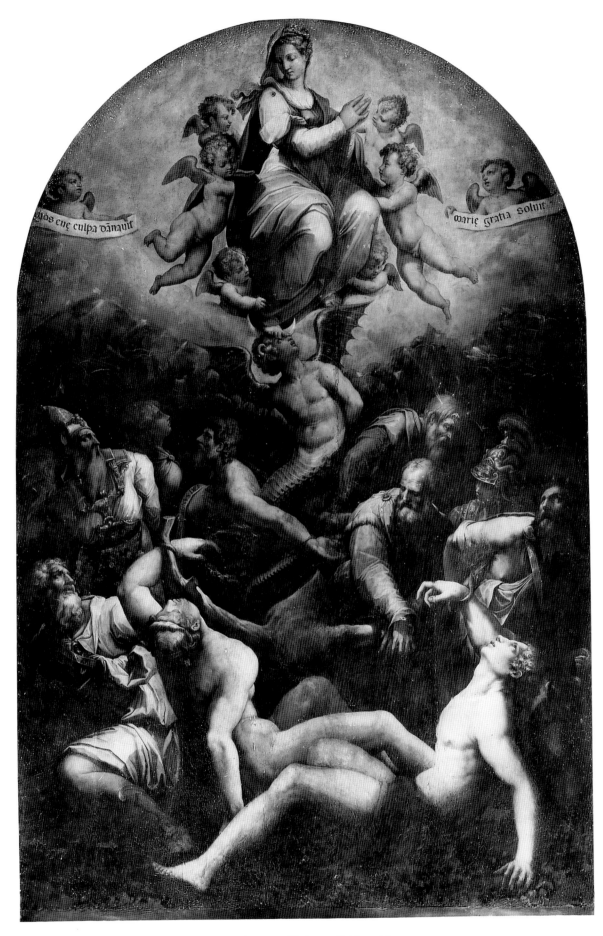

183 Giorgio Vasari, *Immaculate Conception*, Florence, SS. Apostoli (deposit).

designs for the vault frescoes with Marian subjects for SS. Annunziata in Arezzo. Although he did not paint them, the cartoons were apparently accessible for examination to interested parties in the town.[7] Like Rosso, Vasari represented the typological image of the 'Virgin' clothed with the sun and the moon, for example. The subjects for this project were created by Giovanni Pollastra, a canon of the Aretine cathedral, who happened to be Vasari's grammar-school teacher. Rosso's unprecedented designs contain a similarly bizarre mixture of allegorical, Christian and mythological ideas.

The relative rarity of the subject of the Immaculate Conception in altarpieces inspired the unusual genesis. It was, after all, not a simple theme to represent. Yet Vasari used this composite approach to subject matter even for more conventional subjects like the *Saint Jerome in the Wilderness* (fig. 185), known through different versions. To indicate the saint's lascivious thoughts, Vasari added a fleeing Venus with Cupid and a third figure described as an allegorical representation of Play. The prototype for this series of images was commissioned by Ottaviano de' Medici in Florence in 1541. There are more notorious later cases that demonstrate how extreme Vasari became in his search for iconographic originality – motivated in many instances by especially cultivated patrons for whom he was one of the main contemporary painters of choice – but these earlier examples reveal his abstract approach to subject matter, while it was becoming codified. With such images in mind, which show an awareness on Vasari's part of the potential meaning of his works, it is difficult to accept that this allegorical approach eliminated any kind of emotional sincerity, even if it is of a type that is now somewhat unfamiliar. On the contrary, the search for novelty was conditioned by an expansion and emphasis on communicative, if highly conceptual subjects.

Another painting of this period, the *Deposition* (fig. 184), produced about 1540 for the Camaldoli monks at their monastery outside Florence (there is a final payment for it in December 1542), is an export representative of his early style, with a familiar subject it might be added, as opposed to juvenilia like the Casa Vasari *Entombment*. Soon after, Vasari supplied a related version of this altarpiece to a Florentine merchant in Rome, installed in the church of Sant'Agostino (now in the Doria-Pamphilij collection, Rome), so he was clearly pleased with the basic design. Along with the *Immaculate Conception* and the *Saint Jerome*, these works fall in the period of his first maturity before the publication of the *Lives*, when the influences can be discerned of not only Florentines like Rosso, Sarto and Bandinelli but also the foreign-born artists active in Rome up to the Sack of 1527, such as Raphael and Parmigianino. Yet these influences on Vasari's art have perhaps been overstressed, as the almost preconceived

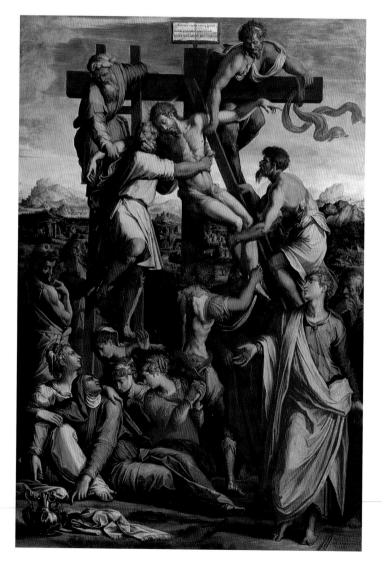

184 Giorgio Vasari, *Deposition from the Cross*, Camaldoli, SS. Donato e Ilariano.

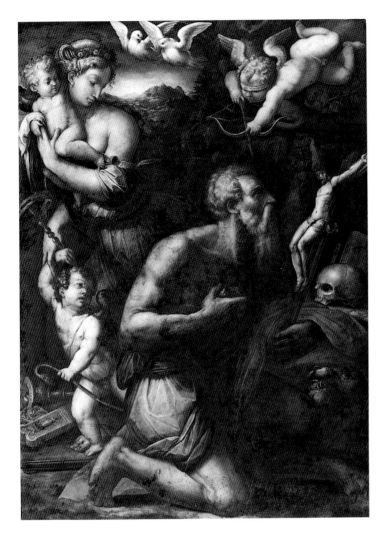

degree, whereas the direct quotations from Michelangelo in Battista Franco's *Battle of Montemurlo* (fig. 186) are noted by the writer with the implication that they compromised the credit Franco might have received for this work. Pushing the analysis further, it is possible to describe a Vasari with a personal and distinctive style and one with sincere, if highly pedantic purpose.[9]

What is immediately noticeable in these Vasari paintings of the 1540s is the stylistic refinement and abstraction. The metallic quality of the draperies and stiff poses in the Casa Vasari *Entombment* have given way to something more graceful, charming and refined in finish and rhythm. The main actions of generally attenuated figures are set in a planar, frieze-like mode with the figures arranged in almost striated layers. The effect is occasionally claustrophobic but legible because the principal activity is kept near the picture plane, typically in front of, rather than integrated with, the telescoped backgrounds. The desire to fill the space with a full range of figures and details inevitably produced rather disjointed designs that appear more like compilations than logically deduced and arranged structures. The paintings provide examples of his favouring of relaxed and discontinuous compositions over rigid ones. Quotations from antique and

185 Giorgio Vasari, *Saint Jerome in the Wilderness*, Florence, Palazzo Pitti.

186 Battista Franco, *Battle of Montemurlo*, Florence, Pitti.

notion that the father of art historians had an academic art-historical approach to his own work has been too tempting to resist. The model of an eclectic, anthologizing painter is certainly inadequate, accounting for only a fraction of Vasari's method. His paintings can be replete with deliberate quotations from the work of other artists, but he explicitly deplored impoverished copying in practice: he wrote at the opening of the Life of Mino da Fiesole that perfection in art could not be attained by imitating the style of another master (this is one of the few pronouncements by Vasari with which Leonardo would have agreed).[8] For the most part he attempted to integrate his source material, or in some obvious cases added power to his imagery through a deliberate reference that he had the means to transmit formally, as in the case of the portrait of Alessandro de' Medici with its evocation of Michelangelo's *Giuliano de' Medici*. To stress this point: for Vasari this was homage to an intelligent and acceptable

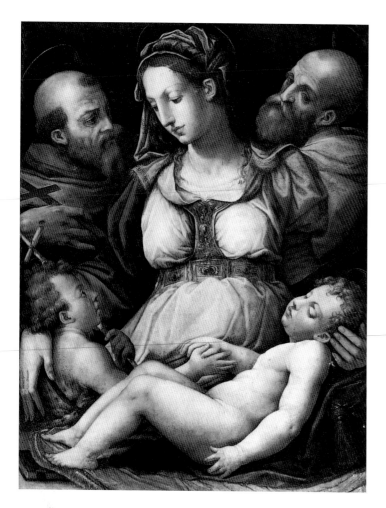

187 Giorgio Vasari (and workshop), *Holy Family with Saint Francis*, Bordeaux, Musée des Beaux-Arts.

designs. Colours can appear bleached as if seen in a bright, clean light, while the facture tends to be freely brushed, but smooth and enamelled at the expense of any tactility. Vasari did not experiment much technically, but valued consistency of finish. This description could be adapted to almost all of his production, since the developments in his style during the 1530s and 1540s were basically permanent. The *Holy Family with Saint Francis*, probably painted in 1543 for Francesco Vespucci (a descendant of the family of patrons so important for Piero di Cosimo) and known through workshop versions (fig. 187), provides a small-scale example from which to appreciate this same style. More imposing, monumental altarpieces dating some thirty years later, such as the *Doubting Thomas* in Sta Croce in Florence (fig. 188), are similarly quite easily

188 Giorgio Vasari, *Doubting Thomas*, Florence, Sta Croce.

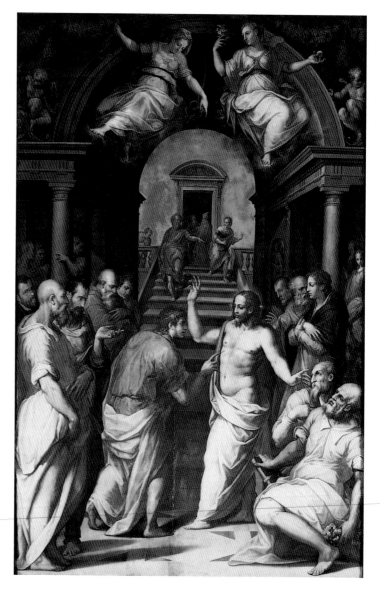

contemporary art are usually on display too, probably to gratify both Vasari's and the viewer's knowledge about art. Similarly, some nude form appears in his paintings to demonstrate a thorough knowledge of surface anatomy.

Individual figures in Vasari's work tend to be stocky and robustly sculptural, and animated in pose. The facial expressions are usually one of two types: either undemonstrative and fixed to indicate restraint or, when expressing stronger emotions, the heads are tilted upwards and the mouths held open. Expression is also carried through poses and gestures that are rhetorically inflated and exaggerated, but whether this tendency to filter expression into abstract form meant that he never attempted to express any direct emotion is an issue that will have to be re-addressed.

Ornamental details abound in his paintings, in clasps and coiffures – a recollection of Vasari's brief training as a goldsmith. Nearly all his female figures have intricate plaited hairstyles and fair, marbled skin. His polished and almost mineral-like surfaces seem appropriate for the highly wrought

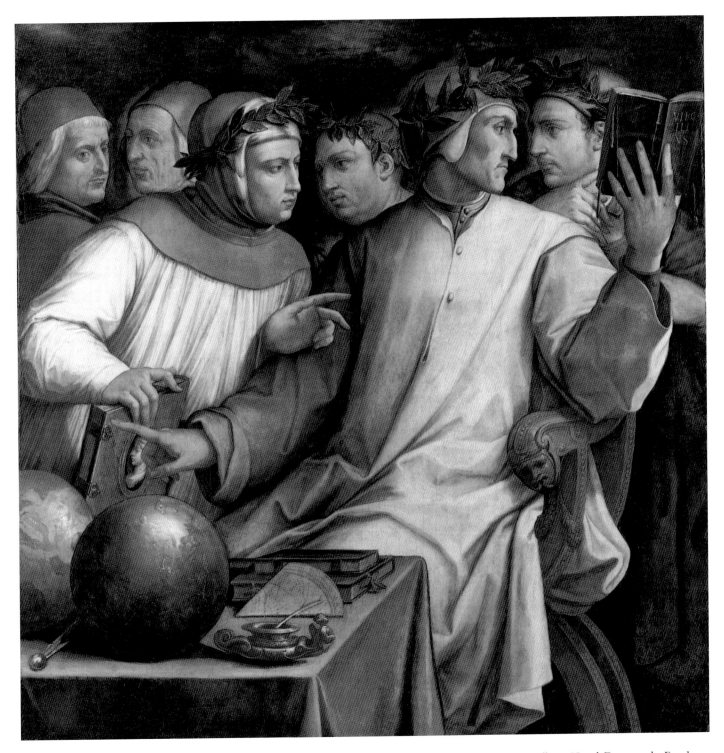

189 Giorgio Vasari, *Six Tuscan Poets*, The Minneapolis Institute of Arts, The John R. Van Derlip and William Hood Dunwoody Funds.

identifiable as Vasari pictures. It is not too unfair to say that in purely stylistic terms he explored few tangents because he established such a satisfactory and clear structure for his paintings relatively early in his working life. Consequently, it is unnecessary here to describe the formal qualities of other individual pictures in the same detail.

The literary aspect infiltrating so much of Vasari's early art, whether it is implicit in the intentions of patrons as in some of the works done for religious orders outside Florence, or explicit as in the portraits of Lorenzo and Alessandro de' Medici – or in his remarkable *Six Tuscan Poets*, first ordered in 1544 by Luca Martini (fig. 189) – introduces Vasari's other

vocation as the writer of the *Lives of the Artists*.[10] His links to the cultural elite in Rome and Florence led him to take on, perhaps as late as 1546, the task initiated by Paolo Giovio of writing the historical biographies of the most famous artists.[11] Although relatively ambitious for the period, Giovio's earlier attempts at art history were presumably considered by himself and others as insufficiently sophisticated to deal with the complex cultural situation that existed towards the mid-sixteenth century. There is controversy about the genesis of Vasari's book, but it is known that a manuscript was already completed by 1547, and in 1550 the first edition of his 'Lives of the most excellent painters, sculptors and architects' emerged from the local press of Lorenzo Torrentino. Michelangelo was the only living artist to be glorified with a full biography in the book. The practice of writing had not, however, been first pressed upon Vasari in the late 1540s, as might be imagined from the appearance of his paintings of that decade and earlier. In thanking him for an account of the decorations made for the Entry of Charles V into Florence that he had helped create, Pietro Aretino praised Vasari as a 'historico, poeta, philosopho e pittore', as early as 1536.[12] This reference was even published in 1538 in the ground-breaking first collection of Aretino's letters in the vernacular. While it is perfectly true that Vasari had assistance in the editing of his book from literary figures – initially Giovio, whom he had described as one of his 'protettori' as early as 1532, and later those historians and philologists in Cosimo de' Medici's circle like Vincenzo Borghini and Pierfrancesco Giambullari – it is fair to point out that these men were quite comfortable collaborating in the production of a major text with an artist who naturally knew more about the specifics of the subject than they did, and this reveals some skill from Vasari in writing and organizing.

Based mainly in Rome in the years following the publication of the first edition of the book, Vasari had, however, entered the service of Duke Cosimo de' Medici in Florence by the mid-1550s. Although he was not a trained historian, the painter continued, if sporadically, to work on his 'scholarship' by travelling and collecting material himself – as well as from various contacts across Italy – for the second edition of the *Lives*, which was eventually published, again in Florence, by the Giunti press in 1568. This now included an autobiography, second among the *Lives* only to Michelangelo's in length, as well as more discussion of still active artists. This stresses his sheer physical energy and prolificacy. And while the *Lives* are criticized for individual errors and biases, and, as is becoming increasingly clear, he had assistance in the compilation and composition of this unprecedented book, these points cannot alter the fact that the book is a work of herculean effort of visual memory recalled in words.

The sheer scale of the *Lives* reveals just how much Vasari did to dignify his profession and not just himself. He was acutely conscious of the roles the artist could play in a cultured society and did his best to live as well as to promote the part. He built and decorated two houses, one in Florence and another in Arezzo, to demonstrate his status and to codify visually the foundations of the entire profession, in addition to his own career. It is not surprising that he was instrumental in founding the Accademia del Disegno in Florence in the early 1560s and contributed its keynote fresco, *Saint Luke painting the Virgin*, to its chapel with the same dedication at SS. Annunziata (fig. 190) after 1565.[13] Vasari was also an unusually ambitious collector of drawings, and he certainly tried to inspire other collectors of graphic work. His now dispersed *Libro di Disegni*, which is thought to have filled seven volumes, was compiled partly to record the different styles of the artists described in the *Lives*, but on a more conceptual level was driven by a Florentine belief in the primacy of drawn design.[14] Even in death Vasari made a tangible contribution to the history of art, for after he passed away in Florence in 1574 his body was carried to Arezzo for burial in the church of the Pieve di Sta Maria in a family tomb earlier set up by himself with the financial assistance of no less powerful a figure than Duke Cosimo.[15] It was complete with a central altarpiece, the *Vocation of Saints Peter and Andrew* (fig. 191), whose original patron had been Pope Julius III himself (he died before receiving it). This ambitious structure on a scale unprecedented for an artist's personal tomb was later moved to the Benedictine Badia di Ste Flora e Lucilla in Arezzo in the nineteenth century, where it in part survives. Vasari's unusual ambition for his posthumous reputation, not to mention his soul, is revealed by the fact that he sponsored the foundation of a deanery at the Pieve, which would link his name to the very cult in this church.

With the growth of his stature and cultural ambitions when he was compiling and writing the *Lives*, it is perhaps not surprising that the nature of Vasari's commissions fundamentally altered in the final thirty years or so of his life, from individual works such as altarpieces to grand enterprises in different media requiring a controlling hand over a large body of assistants. The best example of the latter are the ceiling and walls of the main room in the Palazzo della Signoria in Florence, completed in 1565 (fig. 192).[16] In the two or three decades after 1550 leading up to his death, Vasari was allotted so many commissions that it would take pages just to list even those for Florence, let alone describe them individually. This is not a problem one would have in outlining the careers of most other Florentine Renaissance artists: the sheer scale on which Vasari operated was a new phenomenon, and explicit evidence of the uniqueness of his contribution to the

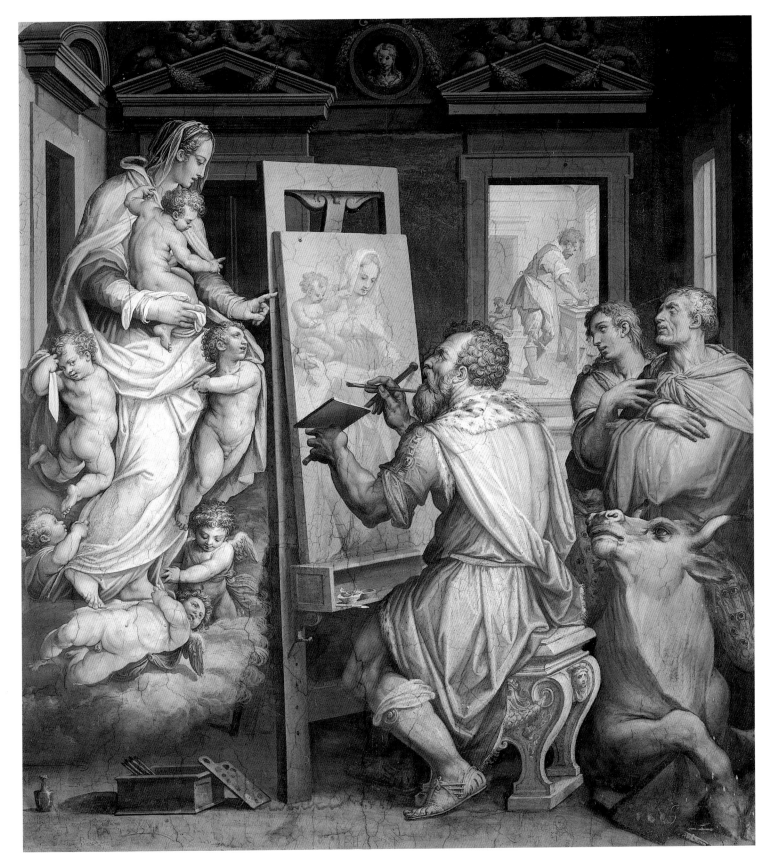

190 Giorgio Vasari, *Saint Luke painting the Virgin*, Florence, SS. Annunziata.

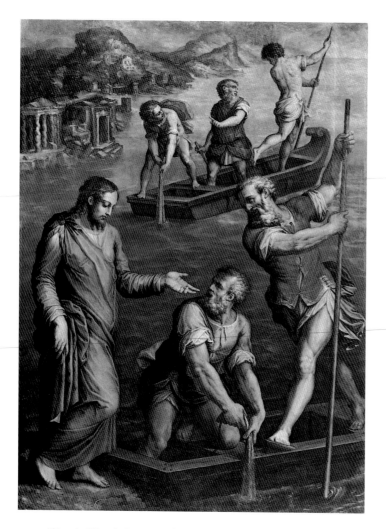

191 Giorgio Vasari, *Vocation of Saints Peter and Andrew*, Arezzo, Badia di Ste Flora e Lucilla.

those despatched to his native Arezzo. In stylistic terms, he settled into a reliable, formulaic and discursive manner of painting which is easily recognizable. It is perhaps no exaggeration to claim that in many ways Vasari had become a type of artist never before seen.

As Vasari so often wrote about his general preferences and intentions, the aim of his pursuits cannot be so easily misconstrued as they can be with painters like Piero di Cosimo or Giovanni Larciani, characters from whom we lack a single secure written or verbal utterance about their attitudes towards a fascinating artistic production. The rest of this chapter will concentrate on the relationship of Vasari's writings to his art practice, to determine loosely of which qualities an original and perfect work of art was constituted, including of course (with allowance for stereotypical humility) his own. Although Vasari never formulated a single prescription for the ideal painting, it is possible to compose a mental image of such an object from the judgements passed in his writings. This is of more than idle interest, for it is in such an attitude that Vasari reveals why he believed that a particularly Florentine way of painting had exhausted itself in his day, above all in the example of Pontormo, and why it was necessary to turn to Rome and especially the work of Raphael for a way out of the impasse. At the same time, this indirectly provides the context for Vasari's somewhat neutral attitude to the artist whom so many painters of his own day in Florence were rediscovering as their most sympathetic guide – Andrea del Sarto.

The relative lack of detailed investigation of Vasari as a painter is all the more remarkable in that he considered that he lived in a period when, in his own words, artists could 'attain to that supreme perfection which we see in the most highly prized and most celebrated of our modern works'.[17] Such a critical stance can no longer seem tenable in relation to Italian art of the mid-sixteenth century. Yet Vasari confessed to believe it perfectly demonstrable that some art and architecture of the last fifty years or so was perfect, more correct and natural than in the past, as if artistic innovation could be rationalized or objectified according to some formula. Compared to that the more exotic and visceral creators like Piero di Cosimo could never compete. This sort of attitude could also be utterly contrasted with Pontormo, for example, who must have accepted as beautiful and desirable any accidental discoveries made during a lengthy artistic process based on an unpredictable number of preparatory drawings.

For Vasari the ultimate perfection of the artists of the modern age might be analysed initially according to five critical values cited in the preface to the third part of the *Lives*: rule, order, measure or proportion, design and style (*maniera*). Familiar as these words now are, it is worth stress-

history of art there. He came to organize a vast workshop – much larger than that of Ridolfo Ghirlandaio, perhaps the closest parallel – on a scale unprecedented for a painter in Florence. Astutely, Vasari filled it with some artists more superficially talented than himself, such as Giovanni Battista Naldini, Poppi, Stradanus and Jacopo Zucchi. In general, it must be acknowledged that Vasari was a sound judge of quality in younger artists, with whom he tried to surround himself, as might be expected for someone who wrote so much about the history of art. His efforts in architecture also increased from that point in his career. Overall, he continued to involve himself with a wide range of patrons in Florence and elsewhere, while concentrating on projects of all different types eagerly received from Cosimo de' Medici. This is not to imply that he ceased to produce altarpieces and other smaller devotional images, frequently for export from Florence; he seems to have taken pride in such works as they continued to be produced until the end of his life, especially

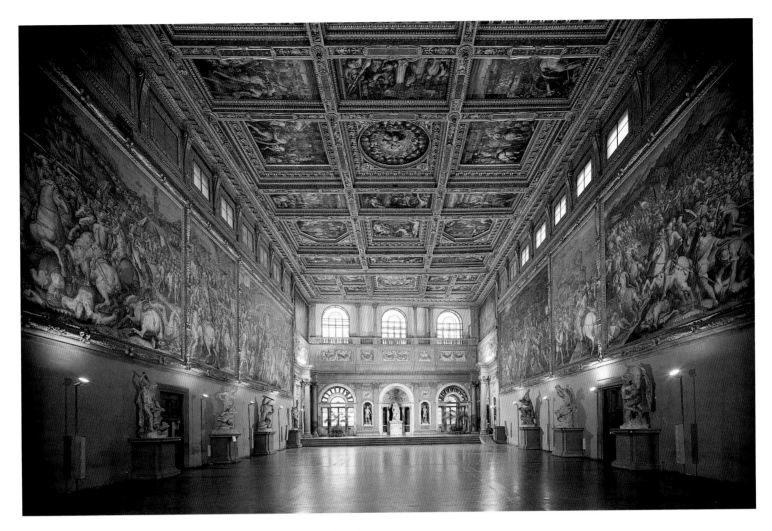

192 Giorgio Vasari, Sala del Cinquecento, Florence, Palazzo della Signoria.

ing that this is complex semantic territory for the visual arts because such terms were taken from the very different and more learned fields of rhetorical and literary criticism, in which painters were at a severe disadvantage both intellectually and institutionally. It is not surprising, therefore, that Vasari did not provide succinct definitions for these complex qualities but rather made points throughout the book towards cumulative meanings. Most of these terms were elaborated from the technical prefaces that preceded the biographies as a whole and, consequently, were firmly rooted in specific activities or practices. But as has been pointed out, by the time they had evolved to the third preface, the definitions tend to be more generalized and to relate more to the assessment of works of art than their execution, so revealing a significant shift in the intended audience for Vasari's enterprise (this degree of compromise towards the primary concerns of patrons is in complete contrast with Pontormo's later practice).[18] At the same time, the shift should alert us to the

unstable nature of such conceptual terms and how art in Florence in the first half of the sixteenth century can never be fully appreciated by recourse to period criticism alone.

Vasari related the notion of rule primarily to architecture. Modern artists achieved perfect rule by studying the remains of ancient buildings: mainly through a process of exhaustive copying an architect could learn good rule. It is known that Vasari measured antiquities as well as copying the antique works that were available in Rome, and the fruits of these copies appear in the backgrounds of his paintings. Rule also had a more general application to painting and sculpture, that of a model for regularity, as in well-proportioned figures. Of course, Vasari allowed for freedom within rule and it was one's eye that judged ultimately what was important. Indeed, like all his categories, it was not slavishly applied.

Order was also defined in relation to architecture. It is perhaps the narrowest of the qualities presented, being based on the idea that one should use the appropriate orders when

description of the subject he writes that 'I made every effort to give to all the figures, to the best of my ability, the proper expressions and the appropriate attitudes and spirited movements, and all that was required.'[25] His discussion of the paintings produced away from Florence in 1539 for the refectory of S. Michele in Bosco in Bologna supplies another example. He describes how he consciously tried to make all elements in the design of the *Christ in the House of Martha and Mary* differ from those in the *Supper of Saint Gregory* (figs 195–6), and then, writing of the Saviour in the former picture, relates how he tried to express 'the lovingness of Christ in instructing the Magdalen, and the affection and readiness of Martha in arranging the table, and her lamentation at being left alone by her sister in such labours and service; to say nothing of the attentiveness of the Apostles, and of many other things worthy of consideration in that picture.'[26] This would not be our initial reaction to the figural arabesques in the image, but

194 Giorgio Vasari, *Martyrdom of Saint Sigismund*, Lille, Musée des Beaux-Arts.

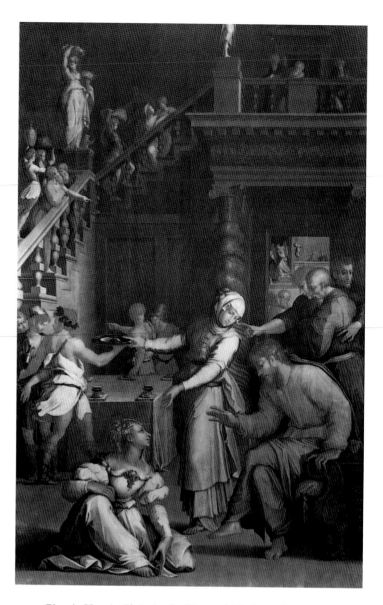

195 Giorgio Vasari, *Christ in the House of Martha and Mary*, Bologna, S. Michele in Bosco.

with an awareness of Vasari's concerns it is possible to appreciate the attempt at expressing with reasonable tenderness the exchange between Christ with his open-hand gesture and down-turned head and the Magdalen with her raised face and parted lips.

That Vasari valued the representation of emotions at least as an observer is corroborated by many analyses of other artists' works. For example, in examining Fra Filippo Lippi's *Martyrdom of Saint Stephen* in Prato Cathedral he concludes: 'All these conceptions are truly very beautiful, and serve to show to others how great is the value of invention and of knowing how to express emotions in pictures.'[27] Presumably, he attempted to translate the impact of this well-distributed image into his own treatment of the same subject painted

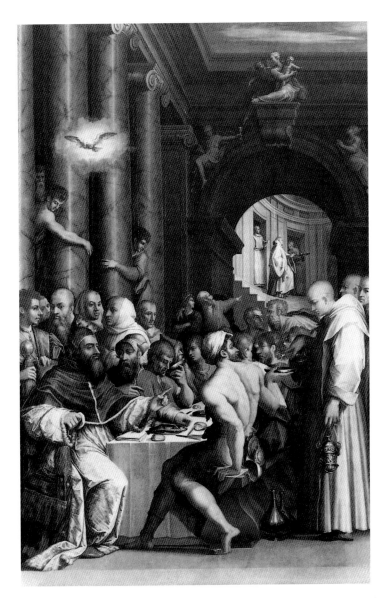

196 Giorgio Vasari, *Supper of Saint Gregory*, Bologna, Pinacoteca.

197 Giorgio Vasari, *Martyrdom of Saint Stephen*, Vatican, Pinacoteca.

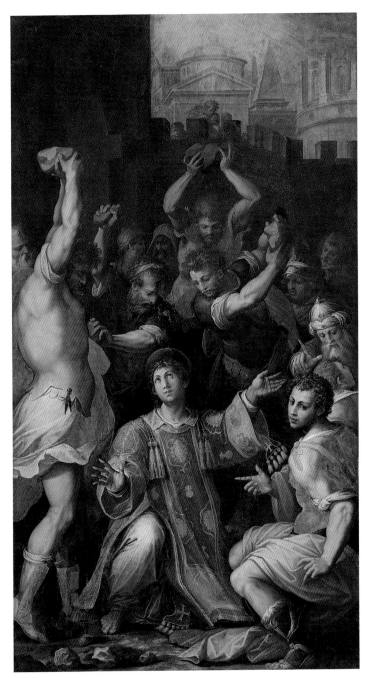

197 Giorgio Vasari, *Martyrdom of Saint Stephen*, Vatican, Pinacoteca.

late in life for a chapel in the Vatican (fig. 197). Yet in con-
trast to most earlier Tuscan artists, starting especially with
Leonardo, it was less by means of preparatory drawings than
through the borrowing of already tested gestures and poses,
often blatantly taken from other contexts, that Vasari created
what he considered to be effectively emotional paintings. It
is telling that his model for the disposition of Stephen in this
altarpiece was the (reversed) main figure in an early work by
Giulio Romano, who had been a pupil of Raphael – a painter
for whom problems of appropriate and varied expression
were a central concern.

Indeed, in this conceptual sense promoted by Vasari it is
possible to isolate the fact that Michelangelo's near-
deification was for him more symbolic than practical and,
correspondingly, that Raphael's significance for Florentine art

history was predominantly retrospective. This, in turn, has implications for how Fra Bartolomeo's importance may be over-accentuated because of his ties to the Urbinate master, just as Franciabigio was deliberately reduced in importance by Vasari by an artifical comparison with Raphael. Similarly, one might recast somewhat the emphasis recently placed on the brief sojourn of Raphael's follower Perino del Vaga in Florence around 1522–3, when he produced what has been described as a series of demonstration pieces. Perino, who has been born in Florence in 1500 but properly trained in Raphael's shop after a spell with Ridolfo, perhaps did not have the genuine impact on the advance of Florentine painting that Vasari retrospectively felt that he had, to judge by the stylistic development of Rosso and Pontormo particularly. For Vasari, those Florentine painters lacking sufficient experience of Raphael in Rome could never be truly modern and perfect, as we have seen in the Lives of so many different practitioners.

Is it naive, however, to link the somewhat formulaic testimonies and their implications in Vasari's Life to works of visual art? After all, from even a highly limited awareness of literary criticism Vasari would have known that to move the reader by referring to human emotion and behaviour was a chief goal of poetry. It is certainly clear that an emotional account of the characters in a story would increase the impact of such descriptions on the reader of the Lives, who may not have been familiar with the work in question first-hand. Yet it may be possible to overstate the role of literary models for the writing of Vasari's own Life, if the intention is to negate their wider importance for his enterprise in the very different field of the visual arts. While it may be a topos that art should be emotionally moving, it was one that inspired the painter in his art. Indeed, the demonstrable rapport between form and content Vasari could still recognize later on, as evidenced by his descriptions of projects and their related images, such as in the selection of Christ and the Magdalen in the Bologna picture, or in the deliberate plundering of a work by a Raphael follower for a key gesture in the narrative subject painting of the Stoning of Saint Stephen. The issue here is not whether modern viewers accept that Vasari convincingly expressed particular emotions, but that he believed he was able to do so in his paintings and that he had codified a visual language for achieving it. This focus on sound expression can thus be seen as one basis for Vasari's personalized 'High Renaissance'.

It appears then that an awareness of literary models influenced Vasari's method and inspired in part the rich narrative variety formally displayed in his paintings which seems to him to have been so central to his approach. Thus if for previous painters finding essentially visual, pictorial solutions was the primary motivation, perhaps of an innovative quality in relation to previous models, for Vasari it was necessary to satisfy theoretical, literary concerns and, in turn, to placate his audience as much as his own artistic integrity. This constitutes a profound turn in the history of Florentine painting and the attitudes of painters not only to the creation of their work, but also to how it should be evaluated. If Leonardo had considered other artists to be his best critics, Vasari deferred much more to the cultured patron that the Lives would help to educate. In this way, through his published writings Vasari attempted to create as well as anticipate an audience, while such artists as Leonardo, Michelangelo, Rosso and Pontormo might tend to ignore theirs. How well he succeded in what was essentially an attempt to dictate his own future would have to be judged by the longevity and strength of his legacy. In this social context, it is much clearer too how fundamentally independent painters like Pontormo and Jacone caused Vasari such distress. So Vasari attempted instead through various formal and iconographical devices to move his audience with a style that was eloquent, intellectual and concisely rhetorical. This is in contrast to the efforts of Michelangelo and Pontormo, which seem inspired, above all, by a search for charged and intrinsically expressive solutions, which could also be satisfied with an ambiguous response. It transpires, therefore, that Vasari had fundamentally different values from these other artists. All intended in their own way to be persuasive, but the means through which they achieved the desired result were incompatible, despite their shared Tuscan heritage. It is not surprising that Vasari made such artists suffer against his model.

These different points can be supported by an independent witness in a letter of 1540 from his fellow Aretine, Pietro Aretino, discussing a drawing by Vasari, who was then in Florence.[28] This account supplies a precedent for his letter of 1545, mentioned in the previous chapter, which describes the engraving of the Conversion of Saint Paul designed by Francesco Salviati for the printmaker Enea Vico (see fig. 180) – another declaration promoting what was essentially a non-traditional Florentine style. Like Salviati's, Vasari's model can also be much clarified by an examination of Aretino's account of his Gathering of Manna drawing. It might be added here that such letters by Aretino were not written casually to artists but with the intention of eventual publication, and so were composed to have a more general impact in promoting the writer's own ideas about contemporary events As the earliest surviving analysis of Vasari's work, it is an extraordinarily precocious critique of the sort of art Vasari later wished to promote himself as the superior type for his age. The preparatory sketch cited by Aretino is lost, but something like it may be recorded in a lithograph published in 1829 (fig. 198),

198 Giorgio Vasari (copy), *Gathering of Manna*, formerly Vivant Denon collection.

although it cannot record the lost original because it relates to a work of his Neapolitan sojourn of 1545. The subject was treated many times by Vasari, for example in a predella panel for Camaldoli around 1540.

As a response to Vasari's art, Aretino's letter is most perceptive. He specifically expressed amazement at three things. First, he wondered at the portrayal of the figures with their gesturing arms and inclined heads, transfixed by the fall of manna from heaven. Second, he admired the *affetto*, that is the emotional state as transmitted through pose and expression, of Moses giving thanks to God for the miracle. Third, he lauded the poses and attitudes of the crowds of figures. Aretino went on to compliment Vasari on his ability to differentiate the sexes and ages of the various figures in the narrative. Similarly, he commended the painter's handling of the nude and also the variety in his treatment of drapery. Just as in Vasari's autobiography, in the Aretino passage there is negligible formalist criticism. He demonstrates his knowledge of the more practical side of art production through the use of

terms like *invenzione* and *pratica*, but he does not analyse this. In the letter there is lucid expression of the force of the mode of representation known perhaps improperly as *istoria* (translated here for convenience as 'narrative'). It was one that required artists to represent vividly a full range of formal and iconographic elements. The immediate critical source of this term for Aretino and Vasari was Alberti's treatise *Della Pittura*, and codifying descriptions such as that of the mosaic of the *Navicella* designed by Giotto for Old Saint Peter's. Alberti was particularly impressed by the apostles who, upon seeing Peter miraculously saved from the waves by Christ, each 'one expresses with his face and gesture a clear indication of a disturbed soul in such a way that there are different movements and positions in each one.'[29] Vasari updated this iconography in another painting (fig. 199), from his Naples period of the mid-1540s, just before he began to write the *Lives*. For the sake of typical formal variety he alters the narrative sense of Giotto's image by having the apostles concentrate on saving themselves from the tempest rather than on the miracle. The

199 Giorgio Vasari, *Saint Peter walking on Water*, Dijon, Musée des Beaux-Arts.

contrast, brought directly up to the picture plane, between Christ's refined equipoise and Peter's delight could not be labelled as inexpressive even if it is treated in highly abstract and cerebral terms.

Aretino's letter concentrates on what an informed viewer of Vasari's work would respond to and anticipates the painter's criticism of his own art in its terminology and concerns. The writer is strongly impressed by the emotional content and the variety of the image, and most of his observations about the poses and expressions in the drawing recognize the painter's ability to express subject matter, and so touch upon Vasari's real motivations. An ulterior motive of no small importance for the history of Florentine painting is revealed at the end of Aretino's letter, which is relevant also for how Vasari would present the history of art of his day. When Aretino finally compares Vasari's *Gathering of Manna* drawing to the 'sweet and graceful' Raphael, he is advocating a varied and rhetorically sound art over the single-minded, potentially monotonous obsession of Michelangelo towards the male

nude. The attitude towards art held by Aretino was later codified in the dialogue bearing his name written by the industrious Venetian Lodovico Dolce and published in Venice in 1557. Ironically, these ideals infiltrated and conditioned Vasari's own analyses of Michelangelo's work, which is undeniably less varied than Raphael's. Vasari's account of the *Last Judgement* in the Sistine Chapel presses this point by emphasizing the apparently rich diversity of types in the image.[30] When he then continues to describe the colour and lighting of the painting and comments on the amount of detail, he might instead be describing one of his own works. Michelangelo, in contrast, certainly saw his basic purpose as more singular and consistent in the representation of the male nude in complex action and of the expression of awesome and profound emotions, especially in his astoundingly concentrated fresco in the Vatican.

To conclude: an examination of Vasari's painting primarily against his writings allows the discovery of what a major sixteenth-century artist thought mattered most in his own production; but Vasari was not just any artist. He is, rather, the one on whom we depend for so much of our information and critical language for the period under consideration. Understanding how his terms of reference relate specifically to his own art should reveal the danger of applying them too straightforwardly to the works of all artists of the Renaissance period and earlier, including those active in his beloved Florence. His 'theory' is the most elaborate that we have from the sixteenth century, but the temptation to equate it implicitly with that of other painters seems out of the question. Where such criticism had the most relevance, as in his notion of meaningful expression, it had already been manipulated to justify his own associative artistic style. The need to project an image of a fertile, reliable and highly respected painter was certainly one of Vasari's priorities in composing his Life (and so he suppressed mention of some of his more minor commissions, particularly of the type he continued to execute for Arezzo). In formal terms, variety and the expression of lucid emotional relationships were the main principles behind the creation as well as the assessment of his compositions, according to his own prescriptions. Paradoxically, the dense complexity and incoherence, not to mention formal allusiveness, of some of his painting result from striving too hard for this articulate and communicative variety, and not a desire to confuse or mystify the spectator as it has been typically interpreted. He would have been troubled by the claims of art historians that his style is all confused formal effect and emotionally passionless – of which he was explicitly critical in the various *Lives*. Put simply, artifice did not cancel out sincerity for Vasari, whose work can be viewed as articulate in a fully literary sense. Aretino's letter of 1540 reveals as clearly as

Vasari's own biography how the artist attempted, by creating expressive and varied narratives through the primary example of the Roman Raphael, to surpass the monolithic perfection of the divine Michelangelo – a fellow artist whom he had done so much to canonize with the blessing of most other Tuscan painters, but who was so difficult to imitate directly because of his very intensity and singular superiority.

★　★　★

In the *Lives of the Artists* Vasari presented the first elaborated history of Italian art. Beyond segregating a hard and dry fifteenth-century style from a more graceful, varied and natural modern one, he did not identify a particular 'High Renaissance', at least not one occurring around 1500. If pressed, he might have placed it nearer to 1550 – a view that no scholar now would ever consider. Far from suggesting that progress had been halted by about 1520 with the deaths of Raphael and Leonardo, Vasari believed that artists of his age had the potential to improve on the excellences of earlier art and share in that perfection. As we read in the preface to the third part of the *Lives*, 'I can testify with the greatest confidence both from seeing and from doing, and our pictures are clearly much more highly finished and perfect than those executed in former times by masters of account.'[31] Knowing he could not compete with such older artists on their own terms, he had the advantage of being in a position to use their work to create a new, different and perhaps even superior synthesis. Indeed, Vasari had the double advantage of being able to publish assessments of their work that supported his goals as a painter.

Such a view could not, of course, be held without a deep awareness of art of the past and without strong opinions on how to analyse it. In the first instance, Florentine art had provided the most obvious model for Vasari's account of his own progress, that is according to the terms initially used by Paolo Giovio to denigrate the art of Perugino and other foreign painters from the start of the sixteenth century. Inevitably, however, this failed him critically because of the desire to subsume Raphael's art under his own hybrid manner of painting that valued narrative expression, counter to Michelangelo's example. At the same time, however unfairly, the apparent refusal of Florentine artists like Franciabigio, and especially Pontormo, to respect the ideals that Vasari advanced at mid-century led to their ultimate disparagement in the *Lives*. This context reveals the key conceptual importance for Vasari of Francesco Salviati as a supremely talented Florentine-born painter with vast experience of Rome who transmitted a bold and graceful style. The prejudice Vasari developed against artists such as Sarto, Pontormo and, more implicitly perhaps, Ridolfo Ghirlandaio, who all worked in an increasingly restrictive local context, is equally brought into sharper focus. While their responses to Rome had not been an explicit issue in Vasari's accounts of Leonardo and Piero di Cosimo, for those artists in Florence more contemporary to him it became decidely crucial. Fortunately, it is still possible to retrieve the excellence of their work independently of Vasari's published analysis.

Vasari would never have accepted that art produced in Florence in the period just after 1500 by the likes of Raphael and Fra Bartolomeo was superior to that of his own day, and there is no suggestion that in holding this opinion he is engaged in a polemic, counter to a current critical view. Yet he manipulated these historical figures to promote a view of art that had truly contemporary relevance, which must now itself be retrieved. How Vasari could defend this viewpoint emerges from the examination of his Life presented here; in the end we may choose not to accept it but to apply our own models, while recognizing their equally subjective and prejudiced nature. Perhaps the ultimate lesson of this study is to see through formulaic and received views of past periods, and to open up new vistas, even on the seemingly familiar age of the first half of the sixteenth century in Florence.

BIBLIOGRAPHICAL NOTE AND ABBREVIATIONS

THERE IS A VAST AMOUNT OF literature available on most of the principal artists discussed in this book, but references will be kept to a minimum for reasons of economy. Typically, the first note in each chapter lists the major publications, usually books, on a given artist. Students can gain access to the art-historical literature easily now with *The Grove Dictionary of Art*, ed. J. Turner (London and New York, 1996), 34 vols, which is a convenient source for many of the artists and themes discussed. Two useful general reference books are *La Pittura in Italia: Il Cinquecento*, ed. G. Briganti (Milan, 1987), 2nd edition 1988; *Pittura Murale in Italia: Il Cinquecento*, ed. M. Gregori (Turin, 1997). Biographies and bibliographies for the literary figures can be found in *Scritti d'Arte del Cinquecento*, ed. P. Barocchi (Milan and Naples, 1971–7), 3 vols. Many individuals are fully presented in the *Dizionario Biografico degli Italiani* (Rome, 1960–). For issues of periodization in general see especially E. Gombrich, 'Norm and Form: The Stylistic Categories of Art History and their Origins in Renaissance Ideals', in *Norm and Form: Studies in the Art of the Renaissance I* (London, 1966), pp. 81–98, and 'Mannerism: The Historiographic Background', *ibid.*, pp. 99–106; and G. Previtali, 'The Periodization of the History of Italian Art', *History of Italian Art*, vol. II, ed. P. Burke (Cambridge, 1994; from the *Storia dell'Arte Italiana*, Turin, 1979), pp. 1–118.

For the High Renaissance in general the starting point is H. Wölfflin, *Classic Art: An Introduction to the Italian Renaissance*, trans. L. and P. Murray (Oxford, first edition 1952; first German edition 1898). Extremely influential is S. J. Freedberg's *Painting of the High Renaissance in Rome and Florence*, 2 vols (Cambridge, Mass., 1961). For a re-expression of Freedberg's views see now M. Hall, *After Raphael: Painting in Central Italy in the Sixteenth Century* (Cambridge and New York, 1999). A more open and nuanced view of the subject is provided by M. Levey, *High Renaissance* (Harmondsworth, 1975).

The pre-1960s' literature on Mannerism is summarized by E. Rosenthal, 'The Renaissance in the History of Art', in *The Renaissance*, ed. T. Helton (Madison, Wis., 1961). L. De Girolami Cheney, *Readings in Italian Mannerism* (New York, 1997), contains some, but not all, of the relevant texts in English. The term was thoroughly reassessed in the 1960s, and J. Shearman, *Mannerism* (Harmondsworth, 1967), was perhaps the most influential text. It tends to be forgotten that this book was written for a particular series on Civilization and so was intended to be more sweeping than a typical art-historical survey, and some of its observations have been habitually taken out of context to the detriment of the writer's argument. Also fundamental is C. Hugh Smyth, *Mannerism*

and 'Maniera', rev. edition (first published 1962) with a new introduction and bibliographies by Elizabeth Cropper (Vienna, 1992). A general summary is also provided by A. Pinelli, *La Bella Maniera: Artisti del Cinquecento tra regola e licenza* (Turin, 1993). The essays by H. Miedema, 'On Mannerism and *maniera*', *Simiolus*, X (1978–9), pp. 19–45; and J. Stumpel, 'Speaking of Manner', *Word and Image*, IV (1988), pp. 246–64, are, in my opinion, fundamental rebuttals of earlier directions in the literature on 'Mannerism' and merit special mention here. H. Zerner, 'Observation on the Use of the Concept of Mannerism', in *The Meaning of Mannerism* ed. F. W. Robinson and S. G. Nichols (Hanover, N.H., 1972), pp. 105–21, is also worth re-reading.

The entire period is surveyed by S. J. Freedberg, *Painting in Italy, 1500–1600* (Harmondsworth, 1971), and F. Sricchia Santoro, *L'Arte del Cinquecento in Italia e in Europa* (Milan, 1997). Most emblematic of the entrenched viewpoint against which I am attempting to argue is M. Wundram, *Renaissance und Manierismus* (Stuttgart and Zurich, 1985), paraphrased in entries in *The Grove Dictionary of Art* (London and New York, 1996), XXVI, pp. 186–9, for the 'High Renaissance', and XX, pp. 277–81, for 'Mannerism'.

Abbreviations

Alberti, 1547: L. B. Alberti, *La Pittura di Leon Battista Alberti tradotta per M. Lodovico Domenichi* (Venice, 1547).

Alberti, 1966: L. B. Alberti, *On Painting*, trans. and ed. J. R. Spencer (New Haven and London, 1966).

Allegri–Cecchi, 1980: *Palazzo Vecchio e i Medici*, ed. E. Allegri and A. Cecchi (Florence, 1980).

Aretino, 1957: P. Aretino, *Lettere sull'Arte*, ed. F. Pertile and E. Camesasca, 3 vols (Milan, 1957).

Barocchi, 1960, 1962: *Trattati d'Arte del Cinquecento*, ed. P. Barocchi, 3 vols (Bari, 1960–2).

Barocchi, 1971, 1973: *Scritti d'Arte del Cinquecento*, ed. P. Barocchi, 3 vols (Milan and Naples, 1971–7).

Barriault, 1994: A. B. Barriault, *Spalliera Paintings of Renaissance Tuscany* (University Park, Penn., 1994).

Fra' Bartolomeo, 1996: *L'Età di Savonarola: Fra' Bartolomeo e la scuola di San Marco*, ed. S. Padovani (Venice, 1996).

Berti, 1993: L. Berti, *Pontormo* (Florence, 1993).

Borghini, 1584: R. Borghini, *Il Riposo* (Florence, 1584).

Borgo, 1976: L. Borgo, *The Works of Mariotto Albertinelli*, Harvard University, Ph.D. thesis (New York, 1976).

Cellini, 1980: *Opere di Benvenuto Cellini*, ed. G. G. Ferrero, new ed. (Turin, 1980).

Cellini, 1983: *The Autobiography of Benvenuto Cellini*, ed. C. Hope (Oxford, 1983).

Cheney, 1963: I. H. Cheney, *Francesco Salviati (1510–1563)*, 3 vols, New York University, Ph.D. thesis (Ann Arbor, 1963).

Clark, 1939: K. Clark, *Leonardo da Vinci, An Account of his Development as an Artist* (Cambridge, 1939).

Condivi, 1557: A. Condivi, *Vita di Michelagnolo Buonarroti* (Rome, 1557), ed. G. Nencioni (Florence, 1998).

Condivi, 1987: *Michelangelo: Life, Letters and Poetry*, trans. G. Bull with P. Porter (Oxford, 1987).

Costamagna, 1994: P. Costamagna, *Pontormo* (Milan, 1994).

Cox-Rearick, 1964: J. Cox-Rearick, *The Drawings of Pontormo*, 2 vols (Cambridge, Mass., 1964).

Cox-Rearick, 1996: J. Cox-Rearick, *The Collection of Francis I: Royal Treasures* (New York, 1996).

Craven, 1975: S. J. Craven, 'Three Dates for Piero di Cosimo', *Burlington Magazine*, CXVII (1975), pp. 572–6.

Doni, 1549: A. F. Doni, *Disegno* (Florence, 1549), ed. M. Pepe (Milan, 1970).

Doni, 1552: A. F. Doni, *I Marmi* (Venice, 1552).

Fermor, 1993: S. Fermor, *Piero di Cosimo: Fiction, Invention and 'Fantasia'* (London, 1993).

Fischer, 1990: C. Fischer in *Fra Bartolomeo: Master Draughtsman of the High Renaissance*, exh. cat., Rotterdam (1990–91).

Fornari, 1549: S. Fornari, *La Spositione di M. Simon Fornari da Rheggio sopra l'Orlando Furioso di M. Ludovico Ariosto*, 2 parts (Florence, 1549), Canto Trentesimo Terzo.

Franklin, 1993: D. Franklin, 'Ridolfo Ghirlandaio's Altar-pieces for Leonardo Buonafé and the Hospital of Santa Maria Nuova in Florence', *Burlington Magazine*, CXXXV (1993), pp. 4–16.

Franklin, 1994: D. Franklin, *Rosso in Italy: The Italian Career of Rosso Fiorentino* (New Haven and London, 1994).

Franklin, 1998: D. Franklin, 'Towards a Chronology for Ridolfo Ghirlandaio and Michele Tosini', *Burlington Magazine*, CXL (1998), pp. 445–55.

Freedberg, 1963: S. J. Freedberg, *Andrea del Sarto*, 2 vols (Cambridge, Mass., 1963).

Freedberg, 1971: S. J. Freedberg, *Painting in Italy, 1500–1600* (Harmondsworth, 1971).

Frey, 1923–30: *Der Literarische Nachlass Giorgio Vasaris*, ed. K. and H. W. Frey, 2 vols (Munich, 1923 and 1930).

Friedlaender, 1957: W. Friedlaender, *Mannerism and Anti-Mannerism in Italian Painting*, ed. D. Posner (New York, 1957).

Gelli, 1551: G. B. Gelli, *Tutte Le Lettioni di Giovam Battista Celli, fatte da lui nella Accademia Fiorentina. Lezioni Petrarchesche* (Florence, 1551), ed. C. Negroni (Bologna, 1884), pp. 231ff.

Goguel, 1998: *Francesco Salviati o la Bella Maniera*, ed. C. Monbeig Goguel, exh. cat., Rome and Paris (1998).

Hirst, 1988: M. Hirst, *Michelangelo and his Drawings* (New Haven and London, 1988).

Hirst–Dunkerton, 1994: *Making and Meaning: The Young Michelangelo: The Artist in Rome 1496–1501*, by M. Hirst, and *Michelangelo as a Painter on Panel* by J. Dunkerton, exh. cat., London (1994–5).

Horne, 1980: H. Horne, *Sandro Botticelli* (Princeton, 1980).

Jacks, 1998: *Vasari's Florence*, ed. P. Jacks (Cambridge, 1998).

Kemp–Walker, 1989: *Leonardo on Painting*, ed. M. Kemp and M. Walker (New Haven and London, 1989).

Marchese, 1878–9: V. Marchese, *Memorie dei più insigni Pittori, Scultori ed Architetti Domenicani*, 2 vols (Bologna, 1878–9).

McKillop, 1974: S. R. McKillop, *Franciabigio* (Berkeley, Los Angeles, London, 1974).

Nelson, 1997: J. Nelson, 'The High Altar-piece of SS. Annunziata in Florence: History, Form and Function', *Burlington Magazine*, CXXXIX (1997), pp. 84–94.

Nikolenko, 1966: L. Nikolenko, *Francesco Ubertini called Il Bacchiacca* (New York, 1966).

L'Officina della maniera, 1996: *L'Officina della maniera: Varietà e fierezza nell'arte fiorentina del Cinquecento fra le due repubbliche 1494–1530*, exh. cat., Florence (1996–7).

Pagnotta, 1987: L. Pagnotta, *Bugiardini* (Turin, 1987).

Fra' Paolino, 1996: *L'Età di Savonarola: Fra' Paolino e la pittura a Pistoia nel primo '500*, ed. C. d'Afflitto, F. Falletti, and A. Muzzi (Venice, 1996).

Il Pontormo a Empoli, 1994: *Il Pontormo a Empoli*, ed. R. C. Proto Pisani and E. Testaferrata (Venice, 1994).

Richter, 1939: J. P. Richter, *The Literary Works of Leonardo da Vinci*, 2 vols (London, 1939).

Roskill, 1968: M. Roskill, *Dolce's 'Aretino' and Venetian Art Theory of the Cinquecento* (New York, 1968).

Rubin, 1995: P. Rubin, *Giorgio Vasari: Art and History* (New Haven and London, 1995).

Rubinstein, 1995: N. Rubinstein, *The Palazzo Vecchio 1298–1532* (Oxford, 1995).

Saalman, 1989: H. Saalman, 'Form and Meaning at the Barbadori-Capponi Chapel in S. Felicita', *Burlington Magazine*, CXXXI (1989), pp. 532–9.

Andrea del Sarto, 1986: *Andrea del Sarto 1486–1530. Dipinti e disegni a Firenze*, exh. cat., Florence (1986–7).

Shearman, 1965: J. Shearman, *Andrea del Sarto*, 2 vols (Oxford, 1965).

Shearman, 1971: J. Shearman, *Pontormo's Altarpiece in S. Felicita* (Newcastle-upon-Tyne, 1971).

Sricchia Santoro, 1993: F. Sricchia Santoro, 'Del Franciabigio, dell'Indaco e di una vecchia questione. I', *Prospettiva*, no. 70 (1993), pp. 22–49; and 'Del Franciabigio, dell'Indaco e di una vecchia questione. II', *Prospettiva*, no. 71 (1993), pp. 12–33.

Stumpel, 1988: J. Stumpel, 'Speaking of Manner', *Word and Image*, IV (1988), pp. 246–64.

Varchi, 1564: B. Varchi, *Orazione Funerale di M. Benedetto Varchi, fatta, e recitata dal lui pubblicamente nell'essequie di Michelagnolo Buonarroti in Firenze, nella chiesa di San Lorenzo* (Florence, 1564).

V-M: G. Vasari, *Le vite de più eccellenti pittori, scultori, e architettori*, Florence, 1568, ed. G. Milanesi, 9 vols (Florence, 1878–85).

V-V: G. Vasari, *The Lives of the Painters, Sculptors and Architects*, trans. G. du C. de Vere, ed. D. Ekserdjian, 2 vols (New York and Toronto, 1996).

Williams, 1989: R. Williams, 'A Treatise by Francesco Bocchi in Praise of Andrea del Sarto', *Journal of the Warburg and Courtauld Institutes*, LII (1989), pp. 111–39.

Zeri, 1962: F. Zeri, 'Eccentrici Fiorentini', *Bolletino d'Arte*, XLVII (1962), pp. 216–36 and 314–26.

NOTES

1 PERUGINO

1 For Giovio in general see T. C. Price Zimmermann, *Paolo Giovio* (Princeton, 1995).

2 The bibliography on Giorgio Vasari appears in Ch. 12, n. 1 below.

3 O. Landi, *I Sette Libri de Cathaloghi a varie cose appartenenti* (Venice, 1552), p. 498.

4 For the original text, with an Italian translation, see Barocchi, 1971, p. 19. For this episode see also A. Ladis, 'Perugino and the Wages of Fortune', *Gazette des Beaux-Arts*, CXXXI (1998), pp. 221–34.

5 Barocchi, 1971, p. 17. For the Costa critique see also G. Romano, 'Towards the Modern Manner', *History of Italian Art*, vol. 2, ed. P. Burke (Cambridge, 1994), p. 439 (originally published in *Storia dell'Arte Italiana*, Turin, 1979).

6 The conservation treatment of this painting will be presented in a forthcoming catalogue.

7 This painting was sold at Christie's, New York, 22 May 1998, lot 66. I am grateful to Everett Fahy, who proposed the attribution, for bringing this work to my attention and for discussing the versions of it.

8 V-V, I, p. 593. V-M, III, p. 586.

9 Nelson, 1997, pp. 84–94.

10 V-V, I, p. 594. V-M, III, pp. 586–7.

11 For Perugino's practice see R. Hiller von Gaertringen, *Raffaels Lernerfahrung in der Werkstatt Peruginos* (Munich and Berlin, 1999).

12 See A. Victor Coonin, 'New Documents concerning Perugino's Workshop in Florence', *Burlington Magazine*, CXLI (1999), p. 103.

13 For Perugino and Sansovino see V-V, II, p. 805. V-M, VII, p. 490. For the relief see B. Boucher, *The Sculpture of Jacopo Sansovino* (New Haven and London, 1991), vol. 2, p. 316.

14 The only published monograph on this painter is the highly unsatisfactory one by Nikolenko, 1966.

15 For this altarpiece see Franklin and Waldman, 'Two Late Altarpieces by Bachiacca' *Apollo* (forthcoming).

16 V-V, II, pp. 444–5. V-M, VI, pp. 454–6.

17 See, for example, the passage from Leonardo's notebooks translated in Richter, 1939, vol. 1, p. 310, entry 503: 'di questa varietà non tiene conto [a painter] fa sempre le figure sue in stampa che pare essere tutti fratelli, la qual cosa merita gran riprensione.'

18 V-V, I, p. 635. V-M, IV, p. 38.

19 I owe this idea to Nelson, 1997, p. 87.

20 There is no catalogue of Brescianino's work but for the best account see the entries of M. Maccherini in *Domenico Beccafumi e il suo tempo*, exh. cat., Siena (1990), pp. 290–311. For an important discussion of Leonardo's commission see J. Nathan, 'Some Drawing Practices of Leonardo', *Mitteilungen des Kunsthistorischen Institutes in Florenz*, XXXVI (1992), pp. 85–101.

21 Frey, 1923, vol. 1, p. 63, Lettera XIX.

22 For Filippino's commission see Rubinstein, 1995, p. 70.

23 V-V, I, p. 635. V-M, IV, pp. 38–9.

24 The translation is from Kemp–Walker, 1989, p. 273.

25 As discussed in Franklin, 1994, ch. 9.

26 V-V, I, p. 593. V-M, III, p. 585. My interpretation of this passage and similar ones concerning the nature of *maniera* as craft is deeply indebted to Stumpel, 1988, pp. 246–64. For occurrences of the word *maniera* in Vasari's writings see R. Panichi, *La Tecnica dell'Arte negli scritti di Giorgio Vasari* (Florence, 1991), pp. 242–3.

27 See Roskill, 1968, pp. 176–7, and the editorial comment on pp. 312–33.

28 This was pointed out some time ago in a discussion of these same sources by E. Gombrich, 'The Leaven of Criticism in Renaissance Art: Texts and Episodes', in *The Heritage of Apelles* (Oxford, 1976), pp. 111–31.

29 M. Equicola, *Institutioni* (Milan, 1541), printed in Barocchi, 1971, p. 259.

30 U. Verino's verse *De pictoribus et scultoribus flo-rentinis, qui priscis grecis equiperari possint* is cited by Horne, 1980, pp. 305–6.

31 Gelli, 1551, pp. 363–4. The text reads: 'Nella pittura si dà il vanto di essere stato il primo di haverla ritrovata a Giotto, cittadin nostro Fiorentino; perché se bene dipinse molti anni innanzi a lui Cimabue suo maestro: il quale fu anchora egli di Fiorenza, egli seguito anchora egli quella maniera la quale era anchora in uso per tutta l'Italia, chiamata Grecia: la quale può vedere molto bene ognuno per molte cose che ci son di que'tempi quale ella fusse, e quanto discosto da il vero: conciosia che tutte, quelle figure che facevono quegli che seguitorono questo modo del fare ò almanco le più, somiglino ò habbino aria piutosto di molte cose che di huomini. Dove Giotto, comminciando a trar tutto quello ch'egli faceva da il naturale (come quelche considerava che l'arte non è altro che una imitazion di natura), aperse di maniera agli uomini gli occhi a caminar per la via delle vere regole di cotale arte. . . . Seguirono, dopo Giotto, Giottino suo discepolo, Pagolo Ucciello, Masaccio, Fra Filippo, Andreino del Castagno, Lionardo da Vinci con molti altri, tutti i nostri Fiorentini, i quali caminando per quella via la quale era stata dimostrata loro da Giotto, e ponendo sempre l'uno il piede alquanto innanzi l'altro, la ridussero in tal grado, che a tutto il mondo pareva ch'ella si fusse perfettamente ritrovata, fin che Michel Agnol Buonarroti, anchora egli cittadin nostro Fiorentino, l'ha condotta finalmente a tal termine di perfettione, che non pare che sia restato più nulla ad alcuna da desiderare in quella.'

32 G. Tory (Torinus), *Champ Fleury* (Paris, 1529), third book, fol. xxxiv verso.

2 LEONARDO DA VINCI

1 V-V, I, p. 620. V-M, IV, p. 11: 'Lionardo da Vinci, il quale dando principio a quella terza maniera che noi vogliamo chiamare la moderna . . .'. The literature on Leonardo is

vast and only a few fundamental publications can be cited here. For Leonardo's life in general see the account by Clark, 1939. See also L. H. Heydenreich, *Leonardo da Vinci* (New York, 1954); J. Wasserman, *Leonardo da Vinci* (New York, 1968); C. Pedretti, *Leonardo: A Study in Chronology and Style* (London, 1973); M. Kemp, *Leonardo da Vinci: The Marvelous Works of Nature and Man* (London, 1981); P. Marani, *Leonardo da Vinci* (Milan, 1994); and M. Clayton, *Leonardo da Vinci: A Curious Vision*, exh. cat., London (1996). For his writings, among other publications, see the compendium of Richter, 1939 and C. Pedretti, *The Literary Works of Leonardo da Vinci: A Commentary to J. P. Richter's Edition* (Oxford, 1977).

2 B. Bellincioni, *Rime de l'arguto et faceto poeta Bernardo Belinzone fiorentino* (Milan 1493), cited in E. Verga, *Bibliografia Vinciana, 1493–1930* (Milan, 1931), vol. 1, p. 53.

3 This altarpiece, post-restoration, is discussed at length in D. A. Brown, *Leonardo da Vinci: Origins of a Genius* (New Haven and London, 1998), ch. 2. See also *Lo squardo degli angeli: Verrocchio, Leonardo e il 'Battesimo di Cristo'*, ed. A. Natali (Milan, 1998).

4 These texts were edited by K. Frey (Berlin, 1892).

5 S. Castiglione, *Ricordi overo ammaestramenti* (Venice, 1562), quoted from this edition in Barocchi, 1977, p. 2922. For P. Giovio's *Leonardi Vincii Vita* see Barocchi, 1971, p. 7.

6 The translation is from E. Müntz, *Leonardo da Vinci* (New York, 1898), vol. 2, p. 112.

7 *Ibid.*

8 For the *Benois Madonna* see *La Madonna Benois di Leonardo da Vinci a Firenze: Il capolavoro dell'Ermitage in mostra agli Uffizi*, ed. L. Berti, exh. cat., Florence (1984). For its influence on a Raphael painting see N. Penny, 'Raphael's "Madonna dei garofani" Rediscovered', *Burlington Magazine*, CXXXIV (1992), pp. 68–72; on a Fra Bartolomeo see E. Fahy, 'The Earliest Work of Fra Bartolomeo', *Art Bulletin*, LI (1969), pp. 143–7.

9 The translation is from Clark, 1939, p. 90. The original text is published in M. Bandello, *Le Novelle* (Lucca, 1554), vol. 1, p. 58.

10 U. Verino, *De Illustratione Urbis Florentiae* (Paris, 1583) fol. 17 recto: 'Et forsan superat Leonardus Vincius omnes; / Tollere de tabula dextram sed nescit, et instar / Protogenis multis vix unam perficit annis.' For a discussion and dating of this poem see Horne, 1980, pp. 304–6.

11 Giovio in Barocchi, 1971, p. 8.

12 See V-V, II, p. 444. V-M, VI, p. 455.

13 Giovio in Barocchi, 1971, p. 8.

14 B. Castiglione, *The Book of the Courtier*, trans. G. Bull, rev. ed. (Harmondsworth, 1976), p.

149. B. Castiglione, *Il Libro del Cortegiano*, ed. B. Maier, 2nd ed. (Turin, 1964), p. 252: 'Un altro de' primi pittori del mondo sprezza quell'arte dove è rarissimo ed èssi posto ad imparar filosofia, nella quale ha così strani concetti e nove chimere, che esso con tutta la sua pittura non sapria depingerle.'

15 V-V, I, p. 638. V-M, IV, pp. 44–5.

16 Fornari, 1549, p. 509. The passage reads: 'Fu Leonardo Vinci Fiorentino di bellezza di corpo, e gratia, di forza, e destrezza dalla natura mirabilmente dotata. Fu da uno suo zio indirizzato ad imprendere l'arte della pittura come colui, il quale à molte, e lodevoli scienze mettendo mano, e riuscendone benissimo, e con istupore di chi'l sentiva, ne suoi primi disegni mostrava ingegno, e inventione. Essercitò con molta laude non solamente una professione, ma tutte quelle, ove il disegno s'interveniva: in tanto c'hebbe ardire di concorrere co'l divinissimo Michelagnolo. Fu capriccioso, et vario: e formavasi nel concetto delle cose, che far dovea, la Idea tanto mirabile, che rade volte gli avenne di poterla conducere à fine, et perfettione. Fu havuto in pregio, et stima dal Duca Francesco di Milano, e dal Re di Francia, a in braccio di lui finalmente rese l'anima à Dio negli anni di sua età LXXV.'

17 M. Biondo, *Della Nobilissima Pittura* (Venice, 1549), ch. 22.

18 See, for example, with reference to Leonardo's unbuildable architectural designs, R. V. Schofield, 'Leonardo's Milanese Architecture: Career, Sources and Graphic Techniques', *Achademia Leonardi Vinci*, IV (1991), pp. 34–48.

19 See E. Gombrich, 'Keeping up with Leonardo', *New York Review of Books* (June 23, 1994), p. 39.

20 Barocchi, 1971, p. 7.

21 For Leonardo's *Adoration* see, most recently, R. Monti, *Leonardo da Vinci: From the Adoration of the Magi to the Annunciation* (Livorno, 1998).

22 The *Adoration* is discussed by O. Casazza, 'Al di là dell'immagine', in *I Pittori della Brancacci agli Uffizi, Gli Uffizi. Studi e Ricerche*, vol. 5, ed. L. Berti, A. Petrioli Tofani (Florence, 1988), pp. 93–101; and A. Natali, 'Re, cavalieri e barbari: Le Adorazioni dei Magi di Leonardo e Filippino Lippi', in the same vol., pp. 73–84.

23 See, for example, the passage quoted in Richter, 1939, vol. 1, p. 341, entry 584.

24 See *Il Disegno Fiorentino del tempo di Lorenzo il Magnifico*, exh. cat., Florence (1992), pp. 281–4, nos 14.10–14.12, entry by C. Caneva.

25 See esp. *Leonardo da Vinci: The Mystery of the Madonna of the Yarnwinder*, ed. M. Kemp, exh. cat., Edinburgh (1992). See also *Leonardo dopo*

Milano / La Madonna dei fusi (1501), ed. A. Vezzosi, exh. cat., Vinci (1982).

26 The translation is from Kemp–Walker, 1989, pp. 273–5. For a comparable type of interpretation see the sonnet published in 1525 edited by F. Cavicchi by G. da Casio, *Giornale della storia della letteratura italiana*, LXVI (1915), pp. 391–2: 'Per S. Anna che dipinse L. Vinci che tenea la M. in brazo che non volea il Figlio scendessi sopra un agnello'. I owe this reference to the kindness of David Ekserdjian.

27 As pointed out by M. Bury, 'Leonardo / non-Leonardo: *The Madonna of the Yarnwinder*', *Apollo*, CXXXVI (1992), pp. 187–9.

28 See M. Kemp, 'From Scientific Examination to the Renaissance Market: The Case of Leonardo da Vinci's *Madonna of the Yarnwinder*', *Journal of Medieval and Renaissance Studies*, XXIV (1994), pp. 259–74.

29 The relation between the two paintings was noted by Pagnotta, 1987, p. 196.

30 The basic book on the artist is G. Dalli Regoli, *Lorenzo di Credi* (Pisa, 1966).

31 The fullest account of the work with documentary references is F. Zöllner, 'Leonardo's Portrait of Mona Lisa del Giocondo', *Gazette des Beaux-Arts*, CXXI (1993), pp. 115–38.

32 For this image see D. A. Brown and K. Oberhuber, '*Monna Vanna* and *Fornarina*: Leonardo and Raphael in Rome', in *Essays Presented to Myron P. Gilmore. II. History of Art, History of Music*, ed. S. Bertelli and G. Ramakus (Florence, 1978), pp. 25–86.

33 The classic account of this commission is J. Wilde, 'The Hall of the Great Council of Florence', *Journal of the Warburg and Courtauld Institutes*, VII (1944), pp. 65–81. Arguments for a different location for the battle frescoes are presented by H. T. Newton and J. R. Spencer, 'On the Location of Leonardo's Battle of Anghiari', *Art Bulletin*, LXIV (1982), pp. 45–51. See also F. Hartt, 'Leonardo and the Second Florentine Republic', *Journal of the The Walters Art Gallery*, XLIV (1986), pp. 95–116. For the copies see F. Zöllner, 'Rubens Reworks Leonardo: "The Fight for the Standard"', *Achademia Leonardi Vinci*, IV (1991), pp. 177–90.

34 See, most recently, Rubinstein, 1995, p. 59 and n.

35 The image is most discussed by J. Snow-Smith, *The Salvator Mundi of Leonardo da Vinci* (Seattle, 1984), though the attribution promoted there is not tenable.

36 For this painting see, most recently, *L'Officina della maniera*, 1996, p. 382, no. 143.

37 For a review of the documents see Rubinstein, 1995, pp. 73–4.

38 F. Albertini, *Memoriale di Molte Statue et Picture di Florentia* (Florence, 1510), ed. H. Horne (Florence, 1909), p. 17.

39 Barocchi, 1971, pp. 8–9.

40 Doni, 1549, fol. 49.

41 Varchi, 1564: 'tanto terribile, e in così nuova maniera, che insino all'hora non s'era veduto cosa non che più bella, che à gran pezzo la pareggiasse'.

42 For Rustici, who lacks a monograph, see C. Avery, in *The Grove Dictionary of Art*, vol. 27 (London and New York, 1996), pp. 447–9. For more documented dates for Rustici's life and work see L. Waldman, 'The date of Rustici's 'Madonna' relief for the Florentine silk guild', *Burlington Magazine*, CXXXIX (1997), pp. 869–72.

43 V-V, II, p. 520. V-M, v, p. 247. The painting is discussed most fully by G. Agosti in *Il Giardino di San Marco: Maestri e Compagni del Giovane Michelangelo*, ed. P. Barocchi, exh. cat., Florence (1992), p. 129; and esp. C. Davis, 'I Bassorilievi di Gianfrancesco Rustici', *Mitteilungen des Kunsthistorischen Institutes in Florenz*, XXXIX (1995), pp. 107 and 121–2, n. 49.

44 See J. Shell and G. Sironi, 'Salaì and Leonardo's Legacy', *Burlington Magazine*, CXXXIII (1991), pp. 103–4.

45 As argued by M. Kemp and A. Smart, 'Leonardo's *Leda* and the Belvedere *River-Gods*: Roman Sources and a New Chronology', *Apollo*, III (1980), pp. 182–93.

46 For the term see A. Nagel, 'Leonardo and *sfumato*', *Res*, XXIV (1993), pp. 7–20.

3 PIERO DI COSIMO

1 For the artist in general see especially A. Forlani Tempesti and E. Capretti, *Piero di Cosimo* (Florence, 1996); Fermor, 1993; W. Griswold, *The Drawings of Piero di Cosimo*, Courtauld Institute of Art, London, unpublished Ph.D. thesis (1988); and M. Bacci, *Piero di Cosimo* (Milan, 1966). For the new birth-date see D. Geronimus, 'The Birth Date, Early Life, and Career of Piero di Cosimo', *Art Bulletin*, LXXXII (2000), pp. 164–70. Document published in E. Casalini, *La Santissima Annunziata nella storia e nella civiltà fiorentina, Tesori d'arte dell'Annunziata di Firenze*, ed. E. Casalini, M. Ciardi Dupré dal Poggetto, L. Crociani and D. Liscia Bemporad (Florence, 1987), p. 95, n. 97. For more documents concerning the end of Piero's life see also L. A. Waldman, 'Fact, Fiction, Hearsay: Notes on Vasari's Life of Piero di Cosimo', *Art Bulletin*, LXXXII (2000), pp. 171–9.

2 See Craven, 1975, p. 572.

3 This evidence will be presented in a forthcoming article by D. Geronimus.

4 For the Innocenti altarpiece and its physical context see L. Cavazzini, 'Dipinti e sculture nelle chiese dell'Ospedale', in *Gli Innocenti e Firenze nei secoli*, ed. L. Sandri (Florence, 1996), pp. 119–23.

5 See Horne, 1980, p. 362.

6 See F. Melis, 'Un'opera di Piero di Cosimo per Napoli', *Commentari*, XIX (1954), p. 154.

7 For the Incarnation altarpiece and suggestion of an earlier date see L. Cavazzini, 'Un documento ritrovato e qualche osservazione sul percorso di Piero di Cosimo', *Prospettiva*, 87–8 (1997), pp. 125–32, which is important for Piero beyond the discussion of this one work.

8 For the document see Craven, 1975, p. 576. The later dating is promoted on iconographical grounds by Berti, 1993, pp. 114–15.

9 For the *Immaculate Conception* see *4 restauri per un itinerario d'arte a Fiesole*, ed. M. Scudieri, exh. cat., Fiesole (1985), pp. 15–37. The arguments about the dating of this painting by J. Beck and A. Schultz, 'The Origins of Piero di Cosimo', *Source*, IV, no. 4 (1985), pp. 9–14, are spurious.

10 V-V, I, p. 657. V-M, IV, p. 141.

11 A classic work on this subject is M. Carmichael, *Francia's Masterpiece, an Essay on the Beginnings of the Immaculate Conception in Art* (London, 1909). See also N. Mayberry, 'The Controversy over the Immaculate Conception in Medieval and Renaissance Art, Literature, and Society', *Journal of Medieval and Renaissance Studies*, XXI (1991), pp. 207–24.

12 The suggestion that the satyr, who is not in Ovid's text, appears in a play performed in Ferrara in 1486, is alluded to in J. Dunkerton et al., *Giotto to Dürer: Early Renaissance Painting in The National Gallery* (New Haven and London, 1991), p. 350.

13 For Simonetta see especially C. Dempsey, *The Portrayal of Love* (Princeton, 1992).

14 V-V, I, p. 659. V-M, IV, p. 144.

15 For Piero's influence on Michelangelo see M. Hirst, 'La Cleopatra della Casa Buonarroti', in *Le due Cleopatre e le 'teste divine' di Michelangelo*, ed. P. Barocchi, exh. cat., Florence (1989), p. 8, citing Thode as the source for this observation.

16 For Vasari's ownership of this painting see C. Monbeig Goguel, 'Vasari's Attitude towards Collecting', in Jacks, 1998, pp. 120–21, 128, where a potential link to the Vespucci family is observed; and A. Cecchi, 'Giorgio Vasari's Collection of Paintings: Its Provenance and Fate', *ibid.*, pp. 147–8, 151.

17 *Circa 1492*, ed. J. Levenson, exh. cat., Washington (1991), pp. 251–2, no. 149, entry by M. Kemp.

18 V-V, I, p. 655. V-M, IV, p. 138.

19 V-V, I, p. 655–6. V-M, IV, p. 139.

20 E. Panofsky, 'The Early History of Man in a Series of Paintings by Piero di Cosimo', *Journal of the Warburg and Courtauld Institutes*, I (1937), pp. 19–28. This essay is revised under the title 'The Early History of Man in Two Cycles of Paintings by Piero di Cosimo', in *Studies in Iconology* (Oxford, 1939), pp. 33–67.

21 See C. Whistler and D. Bomford, *The Forest Fire by Piero di Cosimo* (Oxford, 1999).

22 So much so that P. Barolsky, 'The Trick of Art', in Jacks, 1998, pp. 25–8, suggested that the biography is a total fabrication.

23 I am indebted to Fermor, 1996 for its discussion of *fantasia*.

24 C. Trinkaus, *The Scope of Renaissance Humanism* (Ann Arbor, 1983), p. 42.

25 As suggested by C. Cieri Via, 'Per una revisione della tema del primitivismo nell'opera di Piero di Cosimo', *Storia dell'Arte*, XXIX (1977), pp. 5–14.

26 See N. W. Desloge, 'Italian Paintings and Sculpture', *The Saint Louis Art Museum Bulletin*, XIX (1988), pp. 29–33.

27 For a document mentioning Piero see I. Ciseri, *L'Ingresso Trionfale di Leone X in Firenze nel 1515* (Florence, 1990), p. 272.

28 V-V, I, p. 652. V-M, IV, p. 134.

29 This image of Leonardo's is analysed in J. Shearman, *Only Connect* (Princeton, 1992), pp. 33–6.

30 This was noted when the work was published by F. Zeri, 'Rivedendo Piero di Cosimo', *Paragone*, CXV (1959), pp. 36–50.

31 See G. Trotta and L. Bertani, *San Salvatore al Monte* (Florence, 1997), pp. 50–51.

32 For the Master of Serumido in general see Zeri, 1962, pp. 318–38; and A. Natali, 'Filologia e ghiribizzi: Pittori eccentrici, piste impraticate', in *La Piscina di Betsaida* (Florence and Siena, 1995), pp. 139–54. See also L. A. Waldman, 'The Rank and File of Renaissance Painting: Giovanni Larciana and the "Florentine Eccentrics"', in *Italian Renaissance Masters of the Fifteenth through Sixteenth Centuries*, exh. cat., Haggerty Museum of Art, Marquette University, 2001, pp. 28–33, for the intriguing suggestion that he may be Mariotto Dolzemele.

4 MICHELANGELO

1 The best introduction to Michelangelo is still J. Wilde, *Michelangelo: Six Lectures* (Oxford, 1978). See also C. de Tolnay, *Michelangelo*, 5 parts (Princeton, 1947–60); R. J. Clements, *Michelangelo's Theory of Art* (New York, 1961); *Convegni di studi Michelangioleschi* (Florence and Rome, 1966); H. von Einem, *Michelangelo* (London, 1973); H. Hibbard, *Michelangelo* (New York, 1974); D. Summers, *Michelangelo and the Language of Art* (Princeton, 1981); and A. Hughes, *Michelangelo* (London, 1997). Also indispensable is C. de Tolnay, *Corpus dei disegni di Michelangelo*, 4 vols (Novara,

1975–80). For a revisionist view of Michelangelo as a painter, with which I have some sympathy, see J. Manca, 'Michelangelo as Painter: A Historiographic Perspective', *Artibus et Historiae*, XXXI (1995), pp. 111–23.

2 Condivi, 1557, p. 57; and in English as Condivi, 1987, p. 63. For Condivi in general see the essays in this critical edition, as well as M. Hirst, 'Michelangelo and his First Biographers', *Proceedings of the British Academy*, XCIV (1996), pp. 63–84. Another English translation is *The Life of Michelangelo by Ascanio Condivi*, trans. A. S. Wohl (London, 1976).

3 See Roskill, 1968, p. 170, for the original.

4 Barocchi, 1971, p. 12.

5 Barocchi, 1960, p. 82.

6 Richter, 1939, vol. 1, p. 94, entry 39: 'Adoperandomi io non meno in scultura che in pittura, et esercitando l'una e l'altra in un medesimo grado, mi pare con piccola imputatione poterne dare sententia, quale sia di maggiore ingegno, difficultà e perfettione l'una che l'altra.'

7 *Il Carteggio di Michelangelo*, ed. P. Barocchi and R. Ristori, vol. 4 (Florence, 1979), p. 299, Lettera MCIX.

8 This incident is discussed in Franklin, 1994, pp. 132–3.

9 Cellini, 1983, p. 21. For the original see Cellini, 1980, p. 82.

10 As discussed by Hirst, 1988, pp. 18–19.

11 See J. Cadogan, 'Michelangelo in the Workshop of Domenico Ghirlandaio', *Burlington Magazine*, CXXXV (1993), pp. 30–31.

12 The works are presented with fresh arguments about their attributions in Hirst–Dunkerton, 1994.

13 See W. Wallace, 'Michelangelo's Assistants in the Sistine Chapel', *Gazette des Beaux-Arts*, CX (1987), p. 205.

14 As suggested by A. Cecchi in *L'Officina della maniera*, 1996, p. 112, no. 20.

15 Varchi, 1564.

16 For this event see M. Hirst, 'Michelangelo in Florence: David in 1503 and Hercules in 1506', *Scritti per Paola Barocchi* (Milan and Naples, 1997), pp. 2–3, repr. in *Burlington Magazine*, CXLII (2000), pp. 487–96.

17 For this date see L. Morozzi, 'La "Battiglia di Cascina" di Michelangelo: nuova ipotesi sulla data di commissione', *Prospettiva*, 57–60 (1988–9), pp. 320–24. The documentation for the whole commission is reviewed in Rubinstein, 1995, pp. 73–5.

18 V-V, II, p. 429. V-M, VI, p. 294.

19 Hirst, 1988, p. 44.

20 Fornari, 1549: 'Michelagnolo . . . Acquistò una gran fama ne principii co'l sculpire una Pieta in Roma, un Gigante in Fiorenza, e co'l dipingere in un cartone certi ignudi, ch'erano per lavarsi in Arno discesi, e intanto il campo sonando all'arme, s'affrettavano di rivestirsi. Dove tutte l'attitudini et affetti, che possibil fusse, che in simil caso avenissero, naturalissimamente si vedeano.'

21 Cellini, 1983, p. 21. The original reads: 'la sua virtù non aggiunse mai da poi alla forza di quei primi studi', see Cellini, 1980, p. 82.

22 For the history of the cartoons see Hirst, 1988, pp. 19–20, as well as C. de Tolnay, *The Youth of Michelangelo*, vol. 1 (Princeton, 1947), pp. 209–12. My account of the *Cascina* drawings is further indebted to the discussion of Hirst, 1988, pp. 65–6. See also M. Hirst, 'I Disegni di Michelangelo per la Battaglia di Cascina', in *Tecnica e Stile*, ed. E. Borsook and F. Superbi Gioffredi (Milan, 1986), vol. 1, pp. 43–58.

23 The most substantial publication on this painting is *Gli Uffizi. Studi e Ricerche, 2: Il Tondo Doni di Michelangelo e il suo restauro*, ed. L. Berti, exh. cat., Florence (1985). See esp. E. Buzzegoli, 'Relazione sul restauro del dipinto', pp. 57–70. See also E. Buzzegoli, 'Michelangelo as a Colourist, revealed in the Conservation of the Doni Tondo', *Apollo*, CXXVI (1987), pp. 405–8. See also R. Olson, *The Florentine Tondo* (Oxford, 2000), pp. 219–26.

24 For the Raphael portraits see *Raffaello a Firenze*, exh. cat, Florence (1984), pp. 105–18, nos 8–9; for biographical details about the family see A. Cecchi, 'Raffaello fra Firenze, Urbino e Perugia (1504–1508)', *ibid.*, pp. 41–2. A later dating of Michelangelo's tondo is tentatively proposed by A. Natali in *L'Officina della maniera*, 1996, p. 140, no. 34.

25 See A. Cecchi, 'Agnolo e Maddalena Doni: Committenti di Raffaello', *Studi su Raffaello*, ed. M. Sambucco Hamoud and M. Letizia Strocchi (Urbino, 1987), pp. 429–39. Other attributions include the Sienese woodworker Antonio Barile, Baccio da Montelupo and even Michelangelo himself.

26 See Nikolenko, 1966, p. 54, fig. 58.

27 *Il Carteggio di Michelangelo*, ed. P. Barocchi and R. Ristori, vol. 3 (Florence, 1973), p. 366, Lettera DCCCXLIV.

28 Doni, 1549, fol. 49: 'Sopra tutto fatevi mostrare un tondo d'una nostra Donna in casa d'Agnol Doni, et vi basti solo che io dica gl'è di mano del maestro de maestri.'

29 As noticed by L. Steinberg, 'Animadversions. Michelangelo's Florentine Pietà: The Missing Leg Twenty Years After', *Art Bulletin*, LXXI (1989), p. 499.

30 For this painting see A. Padoa Rizzo, 'Per Francesco Botticini', *Antichità Viva*, XV, 5 (1976), pp. 10–11.

31 As suggested by Dunkerton in Hirst–Dunkerton, 1994, p. 111.

32 The only monograph on the artist is C. von Holst, *Francesco Granacci* (Munich, 1974).

33 V-V, II, p. 53. V-M, V, p. 343. For this painting see also P. Tomory, *Catalogue of the Italian Paintings before 1800: The John and Mable Ringling Museum of Art* (Sarasota, 1976), pp. 24–5, no. 19.

34 Frey, vol. 1, 1923, p. 221, Lettera CXII.

35 See Pagnotta, 1987, pp. 222–3.

36 V-V, II, p. 312. V-M, VI, p. 205.

37 V-V, II, p. 54. V-M, V, p. 344.

38 The *Venus and Cupid* has never been the subject of a monographic study, but for a summary of the literature see Costamagna, 1994, pp. 217–21, no. 70.

39 The commission, over which there has been considerable past confusion, has now been thoroughly discussed by M. Hirst and G. Mayr, 'Michelangelo, Pontormo und das Noli Me Tangere für Vittoria Colonna', in *Vittoria Colonna: Dichterin und Muse Michelangelos*, ed. S. Ferino-Pagden, exh. cat., Vienna (1997), pp. 335–44.

40 V-V, II, p. 685. V-M, VII, pp. 164–5. For the *Leda* in general see, still, J. Wilde, 'Notes on the Genesis of Michelangelo's "Leda"', in *Fritz Saxl, Memorial Essays*, ed. D. J. Gordon (London, 1957), pp. 270–80.

41 The sources for the *Leda*, including Mini's letters, are reviewed by Cox-Rearick, 1996, vol. 7-4, pp. 237–41.

42 Condivi, 1557, p. 53; and in English, Condivi, 1987, p. 59.

43 Gelli, 1551, p. 364: 'che non pare che sia restato più nulla ad alcuna desiderare in quella.'

5 FRA BARTOLOMEO

1 The various exhibition catalogues written by C. Fischer represent the most thorough and up-to-date work on Fra Bartolomeo. See also *Fra' Bartolomeo*, 1996, and *Fra' Paolino*, 1996. The older monographs are G. Gruyer, *Fra Bartolomeo della Porta et Mariotto Albertinelli* (Paris, 1886), F. Knapp, *Fra Bartolommeo della Porta und die Schule von San Marco* (Halle, 1903), and H. von der Gabelentz, *Fra Bartolomeo und die florentiner Renaissance*, 2 vols (Leipzig, 1922). Marchese, 1878–9, collects most of the documents for Fra Bartolomeo, to which can be added V. Alce, 'Tre Documenti su Fra Bartolomeo della Porta', *Archivum Fratrum Praedicatorum*, LVI (1986), pp. 57–77.

2 This incident is fully discussed by P. Humfrey, 'Fra Bartolomeo, Venice and St Catherine of Siena', *Burlington Magazine*, CXXXII (1990), pp. 476–83.

3 C. von Holst, 'Fra Bartolomeo und Albertinelli: Beobachtungen zu ihre Zusammenarbeit am Jüngsten Gericht aus Santa Maria Nuova und in der Werkstatt von

San Marco', *Mitteilungen des Kunsthistorischen Institutes in Florenz*, XVIII (1974), pp. 273–318.

4 V-V, I, pp. 670–71. V-M, VI, p. 176.

5 The literature on early Fra Bartolomeo and the various influences is best summarized by E. Fahy, 'Ritornando alle origini: Riconsiderazioni della produzione giovanile di Fra' Bartolomeo', in *Fra' Bartolomeo*, 1996, pp. 3–11.

6 V-V, I, p. 673. V-M, IV, p. 180.

7 For Savonarola and art see the convenient extracts in G. Gruyer, *Les Illustrations des écrits de Jérome Savonarole publiés en Italie au XVe et au XVIe siècle et les paroles de Savonarole sur l'Art* (Paris, 1879). I owe this reference to Alexander Nagel. On the concept of simplicity and Savonarola see A. Muzzi's 'Eclettismo e devozione a Pistoia', in *Fra' Paolino*, 1996, esp. pp. 9–10. For the historical background see L. Polizzotto, *The Elect Nation: The Savonarolan Movement in Florence 1494–1545* (Oxford, 1994). Also of value is R. M. Steinberg, *Fra Girolamo Savonarola, Florentine Art and Renaissance Historiography* (Athens, Ohio, 1977).

8 Frey, vol. 1, 1923, p. 31, Lettera XI.

9 See the valuable essay by P. Scapecchi, 'Bartolomeo Frate e Pittore nella Congregazione di San Marco', in *Fra' Bartolomeo*, 1996, pp. 19–24.

10 For the contract see Marchese, 1879, pp. 594–601.

11 For the completion document see *ibid.*, 1879, pp. 596–601. For a new related document see Borgo, 1976, p. 118, n. 5.

12 For this painting see Fischer, 1990, pp. 144–55.

13 For the painting in France see Cox-Rearick, 1996, p. 76.

14 V-V, I, p. 675. V-M, IV, p. 186.

15 V-V, I, p. 679. V-M, IV, p. 195.

16 Borgo, 1976, remains the only monograph study.

17 M. Natale, *Peintures Italiennes du XIVe au XVIIIe Siècle* (Geneva, 1979), pp. 2–6, no. 2.

18 For the convincing proposal that the Frate provided Albertinelli with drawings for this altarpiece, see C. Fischer in *Fra Bartolomeo et son atelier*, exh. cat., Paris (1994–95), pp. 60–71, nos 31–8.

19 V-V, I, p. 682. V-M, IV, pp. 220–21.

20 The fullest discussion of this painting is L. Sebregondi Fiorentini, *La Compagnia e l'Oratorio di San Niccolò del Ceppo* (Florence, 1985), pp. 49–51, nos 2–3.

21 V-V, I, p. 684. V-M, IV, p. 223.

22 Alamanno Salviati, quoted in Scapecchi, in *Fra' Bartolomeo*, 1996, p. 24.

23 For Fra Paolino in general see *Fra' Paolino*, 1996.

24 V-V, I, p. 885. V-M, V, p. 130. For this Sogliani project see C. Fischer, *Disegni di Fra Bartolomeo e della sua scuola*, exh. cat., Florence (1986), pp. 157–60, nos 98–100.

25 V-V, I, p. 886. V-M, V, p. 132: 'molto piaceva la sua maniera, faciendo l'arie pietose ed in quel modo che piacciono a coloro che, senza dilettarsi delle fatiche dell'arte e di certe bravure, amano le cose oneste, facili, dolci e graziose.'

26 V-V, I, p. 676. V-M, IV, pp. 188–9.

27 See Cox-Rearick, 1996, vol. 5-3, pp. 168–71, with bibliography.

28 See the important reconstruction of this altar by Fischer, 1990, pp. 322–3.

29 V-V, I, p. 677. V-M, IV, p. 189.

30 See *Fra Bartolomeo la Pietà di Pitti restaurata*, ed. M. Ciatti and S. Padovani, exh. cat., Florence (1988).

31 See P. Turi, 'Un Disegno Settecentesco del "Ratto di Dina" di Fra Bartolomeo', *Memorie Domenicane*, n. s., XXV (1994), pp. 259–98.

32 V-V, I, p. 685. V-M, IV, p. 225.

33 V-V, I, p. 675. V-M, IV, p. 185.

34 *Dante con L'Espositione di Christoforo Landino et di Alessandro Vellutello, sopra la sua Comedia dell'Inferno, Purgatorio, e del Paradiso*, ed. F. Sansovino, Venice (1564): 'Fra Bartolomeo Frate di San Marco, lascio di se memoria honorata. Filippo di Fra Filippo parimente dipinse vagamente. Mariotto di Biagio fu notabile per molte sue belle parti. Giuliano Bugiardini dipinse con molta diligenza, e fu delicato assai. Ma Andreino del Sarto fu eccellente virtù nella pittura. Fu costui connumerato tra primi dell'età sua, e si veggono in Fiorenza molte delle sue cose belle.'

6 RIDOLFO GHIRLANDAIO

1 The study of Ridolfo's work is still dependent on articles. The most extensive article by C. Gamba, 'Ridolfo e Michele di Ridolfo del Ghirlandaio', *Dedalo*, IX (1928–9), pp. 463–90 (Part One) and pp. 544–61 (Part Two) is untrustworthy and should be used with caution.

2 H. Hornik, *Michele di Ridolfo del Ghirlandaio (1503–1577) and the Reception of Mannerism in Florence*, Pennsylvania State University, Ph.D. thesis (Ann Arbor, 1990). See also now H. Hornik, 'The Testament of Michele Tosini', *Paragone*, XLVI, 1–2 (1995), pp. 156–67.

3 For these two altarpieces see *Villa La Quiete: Il patrimonio artistico del conservatorio delle Montalve*, ed. C. de Benedictis (Florence, 1997), pp. 182–6 and 194, nos 57–8 and 64, entries by L. Venturini.

4 See H. Kiel, *Il Museo del Bigallo a Firenze* (Milan, 1977), pp. 123–4, nos 22–4.

5 This issue will be the subject of a forthcoming article by me.

6 For this painting see G. Mazzoni Rajna, 'Un nuovo affresco di Ridolfo Ghirlandaio', *Rivista d'Arte*, XXVIII (1953), pp. 137–44.

7 See Franklin, 1993, pp. 4–16.

8 See Franklin, 1998, p. 445.

9 Doni, 1552, p. 52.

10 F. Zeri, 'Raffaello Botticini', *Gazette des Beaux-Arts*, LXXII (1968), pp. 166–7.

11 V-V, II, p. 478. V-M, VI, p. 534.

12 See my forthcoming article for this.

13 V-V, II, p. 479. V-M, VI, p. 535.

14 For Ridolfo as a draughtsman the fundamental article is W. Griswold, 'Early Drawings by Ridolfo Ghirlandaio', *Master Drawings*, XXVII (1989), pp. 216–18.

15 For this portrait see C. Lloyd, *Italian Paintings before 1600 in the Art Institute of Chicago*, ed. M. Wolff (Chicago and Princeton, 1993), pp. 103–6. Another portrait of a man with a letter at Firle is also dated 1509, but in this case the attribution is disputed between Ridolfo and Franciabigio.

16 V-V, I, p. 768. V-M, IV, pp. 462–3.

17 The bibliography on Raphael's visit to Florence is enormous, but the best starting point is *Raffaello a Firenze*, exh. cat, Florence (1984). See also *Leonardo, Michelangelo, and Raphael in Renaissance Florence from 1500–1508*, ed. S. Hager (Washington, DC, 1992).

18 V-V, II, p. 479. V-M, VI, pp. 534–5. Vasari elsewhere mentioned that Raphael allowed Ridolfo to complete a still unidentified painting of the Virgin that he could not finish following his departure for Rome (V-V, I, pp. 716–17. V-M, IV, p. 328).

19 *Raffaello a Pitti: 'La Madonna del baldacchino' storia e restauro*, ed. M. Chiarini, M. Ciatti, S. Padovani, exh. cat., Florence (1991).

20 For Leonardo Malatesta see *Fra' Paolino*, 1996, pp. 180–90.

21 For the tondo see the entry by R. Bartoli in *L'Officina della maniera*, 1996, p. 122, no. 25.

22 The documentation of the Palazzo Vecchio chapel is assessed by Rubinstein, 1995, pp. 77–8.

23 *Ibid.*, p. 77 (and n. 293).

24 See Franklin, 1993, pp. 6–8.

25 The documents for the Saint Zenobius paintings are published in G. Poggi, 'Appunti d'Archivio', *Rivista d'Arte*, IX (1916), pp. 66–7.

26 See Cox-Rearick, 1996, vol. 5-7, p. 175.

27 See Franklin, 1998, pp. 446–8.

28 For the Prato *Assumption of the Virgin* documents see G. Marchini, *Il Tesoro del Duomo di Prato* (Milan, 1963), p. 118, n. 134. M. Hopkinson, 'Ridolfo del Ghirlandaio', Courtauld Institute of Art, London, unpublished MA Report (1973), pp. 25–7, provides further documentation. The altarpiece was commissioned on 5 October 1507 at a cost of 60 ducats. The final graduated payment was received on 31 May 1509 and the painting is

referred to as completed then. The traditional date for the Prato altarpiece of 1514 must be discarded in light of the documentary evidence.

29 Franklin, 1998, pp. 449–51.

30 For this painting see *Scandicci*, ed. D. Lamberini (Scandicci, 1990), pp. 201–22; and A. Bencistà, *Scandicci: Tre Pievi e una Badia* (Radda in Chianti, 1991), pp. 85–6.

31 Franklin, 1998, pp. 451–4.

32 V-V, II, p. 485. V-M, VI, pp. 545–6. For the document see Allegri–Cecchi, 1980, p. 31.

33 For this painting, copied from one by Ridolfo, see S. Padovani and S. Meloni Trkulja, *Il Cenacolo di Andrea del Sarto a San Salvi* (Florence, 1982), p. 24, no. 6. For the artist in general see F. Zeri, 'Antonio del Ceraiolo', *Gazette des Beaux-Arts*, LXX (1967), pp. 139–54.

34 See L. A. Waldman, 'The Rank and File of Renaissance Painting: Giovanni Larciani and the "Florentine Eccentrics"', in *Italian Renaissance Masters of the Fifteenth through Sixteenth Centuries*, exh. cat., Haggerty Museum of Art, Marquette University, 2001, p. 34.

35 For this document see L. Venturini, 'Il Maestro del 1506: La tarda attività di Bastiano Mainardi', *Studi di Storia dell'Arte*, V / VI (1994–5), p. 145, doc. 13.

36 For Puligo in general see G. Gardner, *The Paintings of Domenico Puligo*, Ohio State University, Ph.D. thesis (Ann Arbor, 1986).

7 ANDREA DEL SARTO

1 For Sarto in general the main monographs are Freedberg, 1963; Shearman, 1965; R. Monti, *Andrea del Sarto* (Milan, 1965; 2nd ed., 1981); A. Natali and A. Cecchi, *Andrea del Sarto* (Florence, 1989); and A. Natali, *Andrea del Sarto: maestro della 'maniera moderna'* (Milan, 1998). The exh. cat. *Andrea del Sarto*, 1986, contains much useful new information. See also J. Shearman, 'The Exhibitions for Andrea del Sarto's Fifth Centenary', *Burlington Magazine*, CXXIX (1987), pp. 498–502.

2 According to Vasari, V-M, V, p. 69.

3 Ibid., p. 71.

4 V-V, I, p. 834. V-M, V, p. 23.

5 *The Jack and Belle Linsky Collection in the Metropolitan Museum of Art* (New York, 1984), pp. 38–40, no. 9, entry by K. Christiansen.

6 See J. Kliemann, *Andrea del Sarto nella Villa Medicea di Poggio a Caiano* (Florence, 1986), and his 'Il Pensiero di Paolo Giovio nelle Pitture eseguite sulle sue "nvenzioni"', in *Paolo Giovio: Il Rinascimento e la memoria* (Como, 1985), pp. 197–220. See also L. M. Medri, *Pontormo a Poggio a Caiano* (Florence, 1995), and S. E. Reiss, *Cardinal Giulio de'Medici as a patron of Art, 1513–23*, Princeton University, Ph.D. thesis (Ann Arbor, 1992).

7 V-V, II, p. 342. V-M, VI, p. 248.

8 Barocchi, 1960, p. 70.

9 Doni, 1552, p. 57.

10 See Williams, 1989, pp. 111–39.

11 F. Bocchi, *Eccellenza del San Giorgio di Donatello* (Florence, 1571) in Barocchi, 1962, pp. 178–9.

12 Doni, 1549, fol. 49: 'che è sorella di quella di Michel Agnolo.'

13 The full text is S. Ammirato, *Gli Opuscoli di Signor Scipione Ammirato*, vol. 1 (1583), also in 1637 edition, vol. 1, p. 712; *Paralleli*: 1583 ed., p. 263, no. 50: 'D'Homèro e di Nicomaco. di Lodovico Ariosto, e d'Andrea del Sarto. L. Dice Plutarco nella vita di Timoleone ad un certo suo proposito; che la poesia di Homèro; et la pittura di Nicomaco, tra l'altre lor virtù haveano in se questa eccellenza; che parevano esser venute fuori agevolmente et senza niuno stento et sudore. Veramente à me pare, che il medesimo possiamo dire à nostri tempi di Lodovico Ariosto, et di Andrea del Sarto. la poesia et pittura de quali, come che prive di studio et di fatica per la lor facilità appariscano; onde a'dotti, et à gli indotti parimente dilettano; niuna cosa però è più difficile à mettere in opera, che una così fatta facilità.' This passage is discussed in Williams, 1989, p. 116, n. 13.

14 V-V, I, p. 823. V-M, IV, p. 12.

15 B. de' Rossi, *Lettera di Bastiano de' Rossi, cognominato lo inferigno, Academico della Crusca, a Flamminio Mannelli, nobil fiorentino nella quale si ragiona di Torquato Tasso* (Ferrara, 1585), p. 53: 'In quale altra nella pittura uno Andrea del Sarto, per lasciare tanti, e tanti altri famosissimi artefici in queste professioni?'

16 V-V, I, p. 828. V-M, V, p. 14.

17 Shearman, 1965, p. 31, in particular insisted on the Dresden altarpiece's influential position in the history of Florentine painting of this period.

18 A-M. Lecoq, 'L'art de la signature: Pratique artisanale du Nord', *Revue de l'Art*, XXVI (1974), p. 22, discusses Sarto's signature as an example of the emblematic monogram, and points out that the interlaced, graphic motif was more commonly used by engravers and northern artists than Italians.

19 See J. K. Lydecker, 'The Patron, Date, and Original Location of Andrea del Sarto's Tobias Altar-piece', *Burlington Magazine*, CXXVII (1985), pp. 349–55.

20 V-V, I, p. 832. V-M, V, p. 20.

21 For this document see Freedberg, 1963, vol. 2, pp. 74–5; and Shearman, 1965, pp. 391–2.

22 For basic research on Sarto's patrons at the church of S. Gallo see A. Cecchi, 'Profili di amici e committenti', in *Andrea del Sarto*, 1986, pp. 42–58.

23 See Shearman, 1965, p. 245, no. 56.

24 The Benintendi commission is discussed more fully in Ch. 8 below.

25 V-V, I, p. 831. V-M, V, p. 18.

26 V-V, I, p. 843. V-M, V, p. 35.

27 See Shearman, 1965, p. 96.

28 V-V, I, p. 848. V-M, V, p. 47.

29 Borghini, 1584, book 3, pp. 225–6.

30 See J. Shearman, 'Andrea del Sarto's Two Paintings of the Assumption', *Burlington Magazine*, CI (1959), pp. 124–34.

31 See P. La Porta, '"Sir Spillo" fratello d'Andrea del Sarto: un contributo', *Bollettino d'Arte*, LXXV (1990), nos 62–3, pp. 111–16.

32 There is no monographic study on Jacopino. The important articles are S. J. Freedberg, 'Jacopino del Conte: An Early Masterpiece for the National Gallery of Art', *Studies in the History of Art*, XVIII (Washington, 1985), pp. 59–65; F. Zeri, 'Rivedendo Jacopino del Conte', *Antologia delle Belle Arti*, II (1978), pp. 114–21; V. Pace, 'Osservazioni sull'attività giovanile di Jacopino del Conte', *Bollettino d'Arte*, LVII (1972), pp. 220–22; and I. H. Cheney, 'Notes on Jacopino del Conte', *Art Bulletin*, LII (1970), pp. 32–40.

33 The basic article on Foschi is A. Pinelli, 'Pier Francesco di Jacopo Foschi', *Gazette des Beaux-Arts*, CLXIX (1967), pp. 87–108. But see also now L. A. Waldman, 'Three Altarpieces by Pierfrancesco Foschi', *Gazette des Beaux-Arts*, CXXXVII (2001), pp. 17–36.

34 For Solosmeo see D. Franklin and A. Butterfield, 'A Documented Episode in the History of Renaissance 'terracruda' Sculpture', *Burlington Magazine*, CXL (1998), pp. 819–24.

35 A. F. Doni, *Il Cancellieri del Doni, Libro della Memoria* (Venice, 1562), vol. 1, p. 49: 'Dovendosi rovinare tutti i borghi, case et muraglie intorno alla città si ritrovava un tabernacolo dipinto di mano d'Andrea del Sarto, pittore mirabile quanto huomo che dipingesse mai: fuori della porta a Pinti; per la qual cosa Pier Capponi, huomo d'autorità chiamò un soprastante et gli disse Farai lasciare la pittura d'Andrea in piedi: perche la fama d'un tal huomo illustre, non è manco d'honore alla Città, che si sia d'utile il far la spianata.'

8 FRANCIABIGIO

1 The only monograph on the artist is McKillop, 1974, but see also the important article by Sricchia Santoro, 1993.

2 This poem was published by Sricchia Santoro, 1993, part 1, p. 43, n. 12: 'unicho: appresso sonatore di stormenti provvisante, chonponitore e perfetto dicitore alle chome-

die in diversi abiti etàe e arti, cho' linghuagi a proposito, dotato dalla natura e accidentale sanza maestri, tanto ch'egli è unicho'.

3 For this cycle see Ch. 7 above.

4 See my review of the exhibition 'L'Officina della maniera' in *Burlington Magazine*, CXXXIX (1997), p. 140.

5 See *ibid.*, p. 142, n. 3.

6 V-V, I, p. 824. V-M, V, p. 8.

7 See McKillop, 1974, p. 244.

8 See ibid., pp. 181, 244–5.

9 V-V, I, p. 825. V-M, V, p. 10.

10 *L'Officina della maniera*, 1996, nos 52–52b.

11 See D. Franklin, 'A Proposal for Early Andrea del Sarto', *Burlington Magazine*, CXXXIX (1997), pp. 106–8.

12 See *Fra' Bartolomeo*, 1996, no. 67, with bibliography.

13 For the date see O. Giglioli, 'Un affresco inedito di Franciabigio', *Rivista d'Arte*, XI (1929), pp. 212–15.

14 See *Andrea del Sarto, 1986*, no. XXXIV.

15 See, most recently, J. M. Massing, *Du Texte à l'Image: La Calomnie d'Apelle et son Iconographie* (Strasbourg, 1990), pp. 108 and 286.

16 See the introduction by A. Natali, in *L'Officina della maniera*, 1996, pp. 168–9.

17 For the documents see McKillop, 1974, p. 247, based on J. Shearman, 'Rosso, Pontormo, Bandinelli and Others at SS. Annunziata', *Burlington Magazine*, CII, (1960), pp. 154–5.

18 V-V, I, pp. 919–21. V-M, V, pp. 192–3.

19 McKillop, 1974, p. 248.

20 For this commission see Barriault, 1994, no. 19, with bibliography.

21 For this idea see J. Shearman, *The Pictures in the Collection of Her Majesty the Queen: The Early Italian Pictures* (Cambridge, 1983), no. 55.

22 See Shearman, 1965, vol. 2, p. 233 for this idea.

23 V-V, I, p. 922. V-M, V, p. 197.

24 For this artist in general see Zeri, 1962, pp. 231–6. For the document for the altarpiece see V-M, V, p. 200, n. 2.

25 V-V, I, p. 923. V-M, V, p. 200.

26 A. Firenzuola, *Novella di A.F.*, in *Prose*, ed. E. Ragni (Florence, 1971), p. 305. I owe this reference to Vera Silvani.

27 See Sricchia Santoro, 1993, part 2, pp. 12–13.

28 The best account of this painting is K. Christiansen, in *Liechtenstein: The Princely Collections*, exh. cat., New York (1985), pp. 197–9, no. 26.

9 ROSSO FIORENTINO

1 For the artist in general see Franklin, 1994. Prior to this see esp. E. A. Carroll, *Rosso Fiorentino, Drawings, Prints, and Decorative Arts*, exh. cat., Washington (1987); and E. A. Carroll, *The Print Images of Rosso Fiorentino* (Los Angeles, 1989). See also R. Ciardi and A. Mugnaini, *Rosso Fiorentino* (Florence, 1991), C. Falciani, *Il Rosso Fiorentino* (Florence, 1996) and the different essays published in *Pontormo e Rosso*, ed. R. P. Ciardi and A. Natali (Venice, 1996). For a new document: D. Franklin and L. A. Waldman, 'New Evidence for Rosso Fiorentino in Piombino', *Paragone*, L, 587 (1999), pp. 105–12.

2 See Friedlaender, 1957, pp. 29–32.

3 See L. A. Waldman, 'The Origins and Family of Rosso Fiorentino', *Burlington Magazine*, CXLII (2000), pp. 607–12.

4 Franklin, 1994, p. 315.

5 V-V, I, p. 899. V-M, V, p. 156.

6 Zeri, 1962, pp. 216–31.

7 L. A. Waldman, 'The "Master of the Kress Landscapes" Unmasked: Giovanni Larciani and the Fucecchio Altar-piece', *Burlington Magazine*, CXL (1998), pp. 456–69.

8 See *L'Officina della maniera*, 1996, p. 324, no. 116.

9 See Shearman, pp. 65–7.

10 For Perino's visit, which requires more study, see L. Wolk-Simon, 'Fame, Paragone, and the Cartoon: The Case of Perino del Vaga', *Master Drawings*, XXX, 1 (1992), pp. 66–74; and E. Parma Armani, *Perin del Vaga: L'anello mancante* (Genoa, 1986), pp. 51–4. The influence of Perino on Rosso at this moment was suggested by J. Shearman, 'The Dead Christ by Rosso Fiorentino', *Boston Museum Bulletin*, LXIV (1966), p. 161. It has been doubted however, by Freedberg, 1971, p. 685, n. 26.

11 See Franklin, 1994, p. 125.

12 See *ibid.*, pp. 132 and 306.

13 V-V, I, p. 899. V-M, V, p. 156.

14 V-V, II, p. 341. V-M, VI, p. 247.

15 See A. Natali, 'Marginalia per due opere del Rosso agli Uffizi', *Antichità Viva*, XXIV (1985), pp. 41–3, 210; and Franklin, 1994, pp. 50–51.

16 See Franklin, 1994, pp. 14–18.

17 See *ibid.*, ch. 2.

18 The recent conservation treatment of the work is published in *Rosso e Pontormo: Fierezza e Solitudine*, ed. A. Natali (Soresina, 1995).

19 V-V, I, p. 900. V-M, V, p. 158. For this episode see also P. Rubin, 'The Art of Colour in Florentine Painting of the Early Sixteenth Century: Rosso Fiorentino and Jacopo Pontormo', *Art History*, XVI (1991), pp. 175–91.

20 P. Mini, *Discorso della Nobilita di Firenze e de Fiorentini* (Florence, 1593), p. 107.

21 V-V, I, p. 901. V-M, V, p. 158.

22 E. A. Carroll, 'On Rosso's Volterra Deposition and Other Tragedies', in *Pontormo e Rosso*, ed. Ciardi and Natali, p. 120, n. 16, has argued instead that the young Joseph may represent an attempt to fool the devil about the divinity of the Christ Child.

23 For a colour illustration see *La maniera moderna nell'Aretino: Dal Rosso a Santi di Tito*, ed. S. Casciu (Venice, 1994), no. 3.

24 For a colour illustration see A. Luchs, *Guida Storico-Artistica del Monastero di Santa Maria Maddalena de' Pazzi* (Florence, 1990), p. 8.

25 Goguel, 1998, pp. 90–91, no. 4, entry by P. Joannides.

10 PONTORMO

1 For Pontormo in general the classic work is still F. Clapp, *Pontormo, His Life and Work* (New York, 1916). For the drawings see Cox-Rearick, 1964, which should also be consulted in the revised edition of 1981; and C. Falciani, *Pontormo: Disegni degli Uffizi* (Florence, 1996). The other recent monographs include A. Conti, *Pontormo* (Milan, 1995); Costamagna, 1994; A. F. Tempesti and A. Giovannetti, *Pontormo* (Florence, 1994); and Berti, 1993. Some of my arguments about Vasari and Pontormo have been anticpated by L. J. Feinberg, 'Florentine Draftsmanship under the First Medici Grand Dukes', *From Studio to Studiolo* (Seattle and London, 1991–2), pp. 14–22.

2 Friedlaender, 1957, part I. S. J. Freedberg, 'Observations on the Painting of the Maniera', *Art Bulletin*, XLVIII (1965), p. 195, prefers the term 'unclassical' for works of this type, but still understands artists like Pontormo and Rosso in contrast with those of the so-called 'High Renaissance'.

3 See D. Franklin, 'A Document for Pontormo's S. Michele Visdomini Altar-piece', *Burlington Magazine*, CXXXII (1990), pp. 487–9.

4 For this commission Shearman, 1971, remains the starting point. But see also Saalman, 1989, pp. 532–9; J. Wasserman, 'The Barbadori Chapel in S. Felicita', in *Architectural Progress in the Renaissance and Baroque: Sojourns In and Out of Italy*, ed. H. A. Millon, S. Scott Munshower (University Park, Penn., 1992), pp. 25–43; and B. Paolozzi Strozzi, 'Di Un Ramo di Gigli del Pontormo e di Molte Finissime Pietre', *Mitteilungen des Kunsthistorischen Institutes in Florenz*, XLIII (1999), pp. 49–79.

5 For an unpublished documentary reference directly linking Vespucci ('eques hierosolimitanus, preceptor preceptorie Sancti Sepulcri de Florentia') to Ludovico di Gino Capponi see Florence, Archivio di Stato, Notarile Antecosimiano, 778, fol. 207 recto–verso, 1526 (modern 1527), 5 February.

6 For this document see Saalman, 1989, p. 534, n. 12.

7 For this document, which remains unpublished, see Shearman, 1971, p. 8.

8 V-V, II, p. 359. V-M, VI, p. 271. G. Richa, *Notizie Istoriche delle Chiese Fiorentine divise ne' suoi Quartieri*, vol. 9 (Florence, 1761), p. 311, described it as 'lavata un imperito artefice' unless he misunderstood Pontormo's original intended effect.

9 See D. Franklin, 'Pontormo's Saint Anne Altarpiece and the Last Florentine Republic', *Revue du Louvre*, LI (2001), pp. 76–87.

10 The painting has been extensively studied by E. Cropper, *Pontormo: Portrait of a Halberdier* (Los Angeles, 1997).

11 V-V, II, p. 351. V-M, VI, pp. 261–2.

12 For this commission see Barriault, 1994, no. 18, with bibliography.

13 For the Certosa see now *Da Pontormo e per Pontormo: Novità alla Certosa* (Florence, 1996).

14 V-V, II, p. 367. V-M, VI, p. 283.

15 Cox-Rearick, 1964, pp. 315–16.

16 Doni, 1549, fol. 48.

17 A. Lapini, *Diario Fiorentino di Agostino Lapini dal 252 al 1596*, ed. G. O. Corazzini (Florence, 1900), pp. 121–2: 'Et a'dì 23 detto Luglio [1558], in sabato, si scopersono le pitture della cappella e coro dell'altar maggiore di San Lorenzo, cioè il Diluvio e la Resurrezione dei morti, dipinta per mano di maestro Jacopo da Pontormo, la quale a chi piacque a chi no. Penò anni x a condurla; et anco poì morse avanti la finissi, e gli dette il suo fine maestro Agnolo detto Bronzino eccellente pittore; qual se' in detto San Lorenzo, nella facciata del Sacramento, la storia di San Lorenzo; e si dipinse se stesso tanto e naturale che per proprio lui stesso, verso i chiostri.'

18 V-V, II, p. 370. V-M, VI, p. 287.

19 V-V, II, p. 370. V-M, VI, p. 286.

20 V-V, II, p. 370. V-M, VI, p. 287.

21 Barocchi, 1960, pp. 68–9. On Pontormo and Varchi see S. Lo Re, 'Jacone da Pontormo e Benedetto Varchi: una postilla', *Archivio Storico Italiano*, CL (1992), pp. 139–62.

22 This fresco is presented following conservation in *Il Pontormo a Empoli*, 1994, pp. 92–3, no. 6.

23 V-V, II, p. 342. V-M, VI, p. 249.

24 See Franklin, 1994, p. 19.

25 V-V, II, p. 370. V-M, VI, p. 287.

26 V-V, II, p. 248. V-M, VI, p. 91.

27 For Bronzino in general the best work on this artist is still C. Smyth's dissertation *Bronzino Studies* which is available from UMI microfilms. See also his *Bronzino as a Draughtsman: an introduction* (New York, 1971). C. McCorquodale, *Bronzino* (London, 1981) provides an accessible introduction to the artist, but his treatment falters in discussing the later stages of Bronzino's life. A. Emiliani, *Il Bronzino* (Busto Arsizio, 1960) is the best major work in Italian on the artist, but A. Cecchi, *Bronzino* (Florence, 1996) is equally invaluable.

28 V-V, II, p. 369. V-M, VI, p. 286.

29 Borghini, 1584, book 4, p. 39.

30 Barocchi, 1960, p. 68: 'dove che el pittore e el contrario, male disposto del corpo per le fatiche dell'arte, piu tosto fastidi di mente che aumento di vita, troppo ardito, volonteroso di imitare tutte le cose che ha fatto la natura co'colori.'

31 Freedberg, 1971, p. 702, n. 38.

32 For Jacone in general see U. Procacci, 'Di Jacone Scolare di Andrea del Sarto', *Accademia Etrusca di Cortona: Annuario*, XVIII (1979), pp. 447–73; and A. Pinelli, 'Vivere "alla filosofica" o vestire di velluto? Storia di Jacone fiorentino e della sua "masnada" antivasariana', *Ricerche di Storia dell'Arte*, XXXIV (1988), pp. 5–34. P. Costamagna and A. Fabre, 'Di Alcuni Problemi della Bottega di Andrea del Sarto', *Paragone*, XLII, 491 (1991), pp. 15–28, touches on a number of Jacone issues.

33 An account of the restoration is published in *Quaderno dell'Opificio di Pietre Dure*, vol. 2 (1987), pp. 122–4.

34 See C. Strehlke, 'Pontormo, Alessandro de' Medici, and the Palazzo Pazzi', *Bulletin, Philadelphia Museum of Art*, LXXXI, no. 348 (1985), pp. 3–15.

35 For his relations with his native town see *Il Pontormo a Empoli*, 1994.

36 V-V, II, p. 585. V-M, VII, p. 50. On the subject of melancholy and eccentricity see R. and M. Wittkower, *Born under Saturn* (New York, 1969), esp. p. 78.

37 V-V, II, p. 504. V-M, VI, p. 579: 'maniera cruda e malinconica.'

38 There are many editions of Pontormo's diary, but see Cox-Rearick, 1964, pp. 347–56, for the art-related extracts and an English translation.

39 The vast literature on the subject of this commission is handled by M. Firpo, *Gli affreschi di Pontormo a San Lorenzo* (Torin, 1997).

40 Borghini, 1584, book 4, p. 39.

41 My translation. V-V, II, p. 493. V-M, VI, p. 557. For this project see N. Dacos and C. Furlan, *Giovanni da Udine 1487–1561* (Udine, 1987), pp. 154–5.

42 Barocchi, 1960, p. 68.

11 SALVIATI

1 For Salviati in general see the recent monograph by L. Mortari, *Francesco Salviati* (Rome, 1992), as well as Goguel, 1998. Cheney, 1963, remains the fullest general introduction. See also C. Dumont, *Francesco Salviati au Palais Sacchetti de Rome et la décoration murale italienne (1520–1560)* (Geneva, 1973).

2 V-V, II, pp. 556–8. V-M, VII, pp. 8–10.

3 V-V, II, pp. 558. V-M, VII, p. 10.

4 Aretino, 1957, vol. 1, p. 130, Lettera LXXXIII.

5 V-V, II, p. 563. V-M, VII, p. 17.

6 For the Venice visit see M. Hochmann, 'Francesco Salviati a Venezia', in the 1998 Salviati catalogue, pp. 56–60; the relevant entries by D. McTavish in *Da Tiziano a El Greco: Per la Storia del Manierismo a Venezia 1540–1590* (Milan, 1981), pp. 81–7, nos 6–9; and M. Hirst, 'Three Ceiling Decorations by Francesco Salviati', *Zeitschrift für Kunstgeschichte*, XVI (1963), pp. 146–65. See also J. Scholz, 'Vasari at Venice', *The Burlington Magazine*, CIII (1961), pp. 500–10.

7 A. Caro, *Lettere Familiari*, ed. A. Greco, vol. 1 (Rome, 1957), p. 295: 'Voi sapete che i signori non s'intendono gran fatto de l'arte vostra, e che per l'ordinario le lor voglie sono molto acute. Cosi vi affaticavate pure assai, e molto poco satisfacevate.'

8 V-V, II, p. 566. V-M, VII, pp. 21–2.

9 For the Sala dell' Udienza documentation see Allegri–Cecchi, 1980, pp. 40–7.

10 As quoted in Cheney, 1963, vol. 3, p. 649, doc. 20.

11 Alberti, 1547, fol. 3 recto.

12 Doni, 1549, p. 109, no. 9: 'Dove si vedrà tutto quel che si desidera in un perfetto pittore'.

13 For the subject matter of the frescoes see K. Childs, 'The Literary Sources for Francesco Salviati's Frescoes in the Sala dell'Udienza, Palazzo Vecchio, Florence', Courtauld Institute of Art, London, unpublished MA Report (1998).

14 M. Poccianti, *Vite de Sette Beati Fiorentini Fondatori del Sacro Ordine de' Servi* (Florence, 1589), p. 29: 'Cecchino Salviati fu il primo che insegnasse gli abbrigliamenti, et il modo bello di dipingere le battaglie.'

15 V-V, II, p. 569. V-M, VII, pp. 25–6: 'Nel che il laceravano veramente a torto: perchiochè, se bene non istentava a condurre le sue opere come facevano essi, non è però che egli non istudiasse, e che le sue cose non avessero invenzione e grazia infinita . . .'

16 V-V, II, p. 571. V-M, VII, p. 28. For the problems of identification see the entry by Goguel, 1998, p. 190, no. 60.

17 For Carlo Portelli in general see V. Pace, 'Carlo Portelli', *Bollettino d'Arte*, LVIII (1973), pp. 27–33. P. Costamagna, 'La Formation de Carlo Portelli: Précisions et adjonctions au catalogue', *Annali Longhi*, II (1989), pp. 17–25.

18 For two such letters see Frey, vol. 1, 1923, p. 329, Lettera CLXX, and p. 332, Lettera CLXXII.

19 For this point see A. Cecchi, in Goguel, 1998, p. 134.

20 For the contract for this painting see R. Miller, 'Documents for Francesco Salviati's

Incredulity of S. Thomas', *Dialoghi di Storia dell'Arte*, vol. 6 (1998), pp. 122–6.

21 As observed by P. Costamagna in Goguel, 1998, p. 236.

22 Alberti, 1547, fols. 2 recto–3 verso.

23 Doni, 1549, p. 109, no. 9.

24 For this area of Salviati's work see A. Cecchi, 'In Margine a una recente monografia sul Salviati', *Antichità Viva*, XXXIII, 1 (1994), pp. 12–22.

25 Doni, 1549, p. 116.

26 T. Tasso, *Rinaldo* (Venice, 1562), Canto VII, fol. 36.

27 See D. Landau and P. Parshall, *The Renaissance Print 1470–1550* (New Haven and London, 1994), pp. 293–4.

28 Aretino, 1957, vol. 2, pp. 84–7, Lettera CCXLVII.

29 Frey, vol. 1, 1923, p. 218, Lettera CIX: 'Et Salviati si trova con poca gratia et mal sadisfatto che ha havuto 800 ducati, et si trova haverne spesi piu di mille; et il principe non ne fa altro, come quello che pensa sia sadisfatoo, et ha altre faccende, si che ognuno impare, che gli esempli ci sono.'

12 VASARI

1 Much of the best writing on Vasari is in article form, but I shall cite here only books for brevity's sake. For Vasari in general see Rubin, 1995. P. Barocchi, *Vasari Pittore* (Milan, 1964) remains the standard monograph, while L. Corti, *Vasari* (Florence, 1989), has useful illustrations. See also Jacks, 1998; R. Le Mollé, *Giorgio Vasari: L'homme des Médicis* (Paris, 1995); R. Panichi, *La Tecnica*

dell'Arte negli scritti di Giorgio Vasari (Florence, 1991); P. Barocchi, *Studi vasariani* (Turin, 1984); *Giorgio Vasari, La Toscana nel' 500*, exh. cat., Arezzo (1981); and T. S. R. Boase, *Giorgio Vasari: The Man and the Book* (Princeton, 1971). See also the collections of conference papers: *Giorgio Vasari: tra decorazione ambientale e storiografia artistica* (Florence, 1985); *Il Vasari storiografia e artista* (Florence, 1976); and *Studi Vasariani* (Florence, 1950).

2 Vasari's various writings are mainly collected in Frey, 1923 and 1930. W. Kallab, *Vasaristudien* (Vienna and Leipzig 1908), still contains insights.

3 V-V, II, p. 1020. V-V, VII, p. 651.

4 Frey, vol. 1, 1923, p. 15, Lettera IV.

5 V-V, II, p. 19. V-M, V, p. 286.

6 V-V, II, p. 1032. V-M, VII, p. 668.

7 Rosso's frescoes are discussed in Franklin, 1994, ch. 9.

8 V-V, I, pp. 475–76. V-M, III, p. 115.

9 V-V, II, p. 501. V-M, VI, p. 575.

10 For the Minneapolis picture (fig. 190) see J. Nelson, 'Dante Portraits in Sixteenth Century Florence', *Gazette des Beaux-Arts*, CXX (1992), pp. 59–77.

11 For the history of the first edition of the book see Rubin, 1995, esp. ch. 3.

12 Frey, vol. 1, 1923, p. 70, Lettera XXII.

13 See Z. Wazbinski, *L'Accademia Medicea del Disegno a Firenze nel Cinquecento: Idea e Istituzione*, 2 vols (Florence, 1987), and K. Barzman, *The Università, Compagnia, ed Accademia del Disegno*, Johns Hopkins University, Ph.D. thesis (Ann Arbor, 1985).

14 For the book in general see L. Ragghianti Collobi, *Il Libro de' Disegni del Vasari*, 2 vols

(Florence, 1974). This subject requires more study.

15 Richard Reed will treat this subject in a forthcoming publication.

16 For Vasari's work with documentation see Allegri–Cecchi, 1980.

17 V-V, I, p. 617. V-M, IV, p. 7.

18 See M. Baxandall, 'Doing Justice to Vasari', *Times Literary Supplement* (1 February, 1980), p. 111.

19 As recognized by D. Cast, 'Reading Vasari Again: History, Philosophy', *Word and Image*, IX (1993), pp. 29–38.

20 By C. Hope, 'Can you trust Vasari?', *New York Review of Books* (5 October, 1995), pp. 10–13.

21 V-V, II, p. 1063. V-M, VII, p. 710.

22 V-V, II, p. 1052. V-M, VII, p. 695.

23 V-V, II, p. 1042. V-M, VII, pp. 680–1.

24 The importance of this image is also presented by P. Rubin, 'Commission and Design in Central Italian Altarpieces c. 1450–1550', in *Italian Altarpieces 1250–1550: Function and Design*, ed. E. Borsook and F. Superbi Gioffredi (Oxford, 1994), pp. 201–4.

25 V-V, II, p. 1050. V-M, VII, p. 692.

26 V-V, II, pp. 1030–31. V-M, VII, p. 665.

27 V-V, I, p. 440. V-M, II, p. 624.

28 Aretino, 1540, in Frey, vol. 1, 1923, p. 107, Lettera XLIV.

29 The translation is from Alberti, 1966, p. 78. For the vernacular see Alberti, 1547, fol. 30 verso.

30 V-V, II, p. 687. V-M, VII, p. 214.

31 V-V, I, p. 621. V-M, IV, p. 15: 'Credosi ed affermisi adunque, che in questo nostro secolo fusse la giusta remunerazione, si farebbono senza dubbio cose più grandi, e molto migliori che non fecero mai gli antichi.'

ILLUSTRATIONS

Dimensions are given in centimetres, height before width.

1 Workshop of Filippino Lippi, *Deposition from the Cross*. Panel. 55.9 × 40.6. The Metropolitan Museum of Art, New York.

2 Filippino Lippi (completed by Perugino), *Deposition from the Cross*. Panel. 333 × 218. Florence, Accademia.

3 Bachiacca, *Baptism of Christ with Saints*. Pancl. 248 × 213. Badia a Buggiano.

4 Perugino, *Assumption of the Virgin*. Panel. 333 × 218. Florence, SS. Annunziata.

5 Perugino, *Vision of Saint Bernard*. Panel. 173 × 160. Munich, Alte Pinakothek.

6 Perugino, *Saint John the Baptist*. Panel. 160 × 67. The Metropolitan Museum of Art, New York, Gift of The Jack and Belle Linsky Foundation, 1981.

7 Perugino, *Saint Lucy*. Panel. 167 × 67. The Metropolitan Museum of Art, New York, Gift of The Jack and Belle Linsky Foundation, 1981.

8 Andrea del Brescianino, *Virgin and Child with Saint Anne*. Panel. 129 × 94. Madrid, Prado.

9 Andrea del Brescianino, *Virgin and Child with Saint Anne*. Panel. 129 × 96. Formerly Berlin, Kaiser Friedrich Museum (destroyed).

10 Leonardo da Vinci, *Virgin and Child with Saints Anne and John the Baptist*. Black chalk with white heightening on paper. 141.5 × 104. London, National Gallery.

11 Verrocchio assisted by Leonardo da Vinci, *Baptism of Christ*. Panel. 177 × 151. Florence, Uffizi.

12 Leonardo da Vinci, *Adoration of the Magi*. Panel. 246 × 243. Florence, Uffizi.

13 Sandro Botticelli, *Adoration of the Magi*. Panel. 107.5 × 173. Florence, Uffizi.

14 Leonardo da Vinci (after), *Madonna of the Yarnwinder*. Panel. 62 × 48.8. Edinburgh, National Gallery of Scotland.

15 Giuliano Bugiardini, *Virgin and Child with the Young Saint John the Baptist*. Panel. 125.7 diameter. The Nelson-Atkins Museum of Art, Kansas City, Missouri (Purchase: Nelson Trust).

16 Lorenzo di Credi, *Virgin and Child*. Panel. 71.1 × 49.5. London, National Gallery.

17 Leonardo da Vinci, *Mona Lisa*. Panel. 77 × 53. Paris, Louvre.

18 Lorenzo Zacchia (after Leonardo), *Battle for the Standard*, Vienna, Albertina.

19 Leonardo da Vinci (after), *Battle for the Standard*. Panel. 86 × 106. Florence, Palazzo della Signoria.

20 Attr. Giampetrino (after Leonardo), *Salvator Mundi*. Panel. 46 × 39. Nancy, Musée des Beaux-Arts.

21 Pontormo, *Martyrdom of the 10,000*. Panel. 65 × 73. Florence, Palazzo Pitti.

22 Giovan Francesco Rustici, *Conversion of Saint Paul*. Panel. 111.5 × 194. London, Victoria and Albert Museum.

23 Bachiacca, *Leda and the Swan*. Panel. 38.8 × 28.8. Rotterdam, Boymans-van Beuningen Museum.

24 Andrea del Sarto, *Leda and the Swan*. Panel. 102 × 76. Brussels, Musées Royaux des Beaux-Arts de Belgique.

25 Leonardo da Vinci (after), *Leda and the Swan*. Canvas. 112 × 86. Rome, Galleria Borghese.

26 Lorenzo di Credi, *Venus*. Canvas. 151 × 69. Florence, Uffizi.

27 Piero di Cosimo, *Immaculate Conception with Saints*. Panel. 184 × 178. Fiesole, S. Francesco.

28 Piero di Cosimo, *Satyr mourning a Nymph (Death of Procris)*. Panel. 65 × 183. London, National Gallery.

29 Piero di Cosimo, *Battle of Lapiths and Centaurs*. Panel. 71 × 260. London, National Gallery.

30 Detail of fig. 29.

31 Piero di Cosimo, *Cleopatra*. Panel. 57 × 42. Chantilly, Musée Condé.

32 Piero di Cosimo, *Giuliano da Sangallo*. Panel. 47.5 × 33.5. Amsterdam, Rijksmuseum.

33 Piero di Cosimo, *Mars and Venus*. Panel. 72 × 183. Berlin, Staatliche Museen.

34 Piero di Cosimo, *Forest Fire*. Panel. 71 × 203. Oxford, Ashmolean Museum.

35 Piero di Cosimo, *Virgin and Child with Saints Catherine, Dorothy, Peter and John*. Panel. 203 × 197. Florence, Museo dell'Ospedale degli Innocenti.

36 Piero di Cosimo, *Incarnation with Saints*. Panel. 206 × 172. Florence, Uffizi.

37 Detail of fig. 36.

87 Ridolfo Ghirlandaio, *Virgin and Child in Glory with Saints Julian and Sebastian*. Panel. 261.5 × 160. Florence, S. Martino della Scala.

88 Ridolfo Ghirlandaio, *Miraculous Raising of the Child by Saint Zenobius*. Panel. 202 × 174. Florence, Museo di S. Salvi.

89 Ridolfo Ghirlandaio, *Assumption of the Virgin with Saint John the Baptist*. Panel. 380 × 248. Berlin, Staatliche Museen, Gemäldegalerie.

90 Ridolfo Ghirlandaio and Michele Tosini, *Saint Anne, the Virgin and the Christ Child with Saints Peter Martyr, Augustine, Thomas Aquinas, Vincent Ferrer, Mary Magdalen and Catherine*. Panel 350 × 200 (approx.). Florence, S. Spirito.

91 Ridolfo Ghirlandaio, Michele Tosini and workshop, *Assumption of the Virgin with Saints John the Baptist, Sebastian and Romuald and a Bishop Saint*. Panel. Florence, Sta Maria alla Palma.

92 Ridolfo Ghirlandaio and Michele Tosini, *Virgin and Child in Glory with Saints James, Francis, Clare and Lawrence and Donor*. Panel. 245 × 202. Florence, Museo di S. Salvi.

93 Baccio Ghetti, *Virgin and Child with Saints John the Baptist, Mark, Andrew and Peter*, surmounted by the *Baptism of Christ*. Panel. 319 × 213. Fucecchio, Collegiata.

94 Domenico Puligo, *Portrait of a Man*. Panel. 94 × 71. Firle, Gage Collection.

95 Domenico Puligo, *Virgin and Child with Six Saints*. Panel. 175 × 124. Florence, Sta Maria Maddalena de' Pazzi.

96 Ridolfo Ghirlandaio and Michele Tosini, *Martyrdom of the 10,000*. Panel. 257 × 231. Florence, Museo di S. Salvi.

97 Andrea del Sarto (copy), *Saint Sebastian*. Whereabouts unknown.

98 Andrea del Sarto (with additions by Alessandro Allori), *Triumph of Caesar*. Fresco. 502 × 356. Poggio a Caiano, Villa Medici.

99 Andrea del Sarto, *Journey of the Magi*. Fresco. 360 × 305 (arched top). Florence, SS. Annunziata.

100 Andrea del Sarto, *Mystic Marriage of Saint Catherine*. Panel. 167 × 122. Dresden, Gemäldegalerie.

101 Andrea del Sarto, *Tobias and the Angel with Saint Leonard and Donor*. Panel. 178 × 153. Vienna, Kunsthistorisches Museum.

102 Andrea del Sarto, *Portrait of a Young Man*. Panel. 70 × 51. Alnwick Castle.

103 Andrea del Sarto, *Madonna of the Harpies*. Panel. 207 × 178. Florence, Uffizi.

104 Andrea del Sarto, *Portrait of a Man*. Canvas (?transferred from panel). 72 × 57. London, National Gallery.

105 Andrea del Sarto, *Disputation on the Trinity*. Panel. 232 × 193. Florence, Palazzo Pitti.

106 Andrea del Sarto, *Pietà with Saints*. Panel. 238.5 × 198.5. Florence, Palazzo Pitti.

107 Andrea del Sarto, *Saint John the Baptist*. Panel. 94 × 68. Florence, Palazzo Pitti.

108 Andrea del Sarto, *Virgin and Child with the Young Saint John the Baptist*. Panel. 154 × 101. Rome, Galleria Borghese.

109 Andrea del Sarto, *Holy Family*. Panel. 138 × 104. Rome, Galleria Nazionale.

110 Andrea del Sarto, *Last Supper*. Fresco. 462 × 872. Florence, Museo di S. Salvi.

111 Andrea del Sarto, *Virgin and Child in Glory with Six Saints*. Panel. 209 × 176. Florence, Palazzo Pitti.

112 Andrea del Sarto, *Assumption of the Virgin*. Panel. 362 × 209. Florence, Palazzo Pitti.

113 Andrea del Sarto, *Assumption of the Virgin*. Panel. 379 × 222. Florence, Palazzo Pitti.

114 Jacopino del Conte, *Virgin and Child with the Young Saint John the Baptist in Glory*. Panel. 123 × 92.5. Berlin, Staatliche Museen, Gemäldegalerie.

115 Pier Francesco Foschi and Master of Serumido, *Pietà with Saints Peter and Bernard* and predella. Panel. 315 × 325. Florence, S. Felice in Piazza.

116 Pier Francesco Foschi, *Immaculate Conception*. Panel. Florence, S. Spirito.

117 Jacopo da Empoli, *Trinity with Saints Michael and John the Evangelist*. Panel. 206 × 148. Florence, S. Giovanni Battista della Calza.

118 Antonio Solosmeo, *Virgin and Child with Saints John the Baptist, Francis, Giovanni Gualberto and Sebastian*. Canvas. 187 × 222. Poppi, S. Fedele.

119 Andrea del Sarto, *Virgin and Child with the Young Saint John the Baptist* (copy of the Borgo Pinti tabernacle), Birmingham, Barber Institute of Fine Arts.

120 Franciabigio (with additions by Alessandro Allori), *Triumph of Cicero*. Fresco. 580 × 530. Poggio a Caiano, Villa Medici.

121 Franciabigio, *Virgin and Child with Saints John the Baptist and Job*. Panel. 209 × 172. Florence, Museo di S. Salvi.

122 Franciabigio, *Angel*. Panel. 118 × 52.5. Florence, S. Spirito.

123 Franciabigio, *Virgin and Child with Saints Stephen, Bartholomew, Anthony Abbot and Francis*. Panel. 210 × 175. San Casciano in Val di Pesa, S. Stefano a Campoli.

124 Franciabigio, *Adoration of the Shepherds*. Fresco. 261 × 220. Florence, Museo di S. Salvi.

125 Franciabigio, *Virgin and Child*. Panel. 86 × 66. Rome, Palazzo Corsini.

126 Andrea del Sarto, *Virgin and Child*. Panel. 44 × 26. Rome, Palazzo Corsini.

127 Franciabigio, *Icarus*. Panel. 31 × 24.5. Florence, Museo Davanzati.

128 Franciabigio, *Calumny of Apelles*. Panel. 37 × 48. Florence, Palazzo Pitti.

129 Franciabigio, *Portrait of a Man*. Panel. 57.5 × 42.5 (original dimensions). Paris, Louvre.

130 Franciabigio, *Betrothal of the Virgin*. Fresco. 395 × 321 (arched top). Florence, SS. Annunziata.

131 Franciabigio, *Portrait of a Man*. Panel. 76 × 61. Berlin, Staatliche Museen, Gemäldegalerie.

132 Franciabigio, *Bathsheba and David*. Panel. 85 × 172. Dresden, Staatliche Kunstsammlungen.